THE LAST WILD MEN of BORNEO

ALSO BY CARL HOFFMAN

Savage Harvest: A Tale of Cannibals, Colonialism, and Michael Rockefeller's Tragic Quest for Primitive Art

The Lunatic Express: Discovering the World . . . via Its Most Dangerous Buses, Boats, Trains, and Planes

Hunting Warbirds: The Obsessive Quest for the Lost Aircraft of World War II

THE LAST WILD
MEN of BORNEO

A True Story of
Death and Treasure

CARL HOFFMAN

WILLIAM MORROW
An Imprint of HarperCollins*Publishers*

FIRST EDITION

Designed by Bonni Leon-Berman

Map by Nick Springer, © 2018 Springer Cartographics LLC

Library of Congress Cataloging-in-Publication Data has been applied for.

ISBN 978-0-06-243902-4

18 19 20 21 22 LSC 10 9 8 7 6 5 4 3 2 1

Nature's first green is gold,
Her hardest hue to hold.
Her early leaf's a flower;
But only so an hour.
Then leaf subsides to leaf.
So Eden sank to grief,
So dawn goes down to day.
Nothing gold can stay.

—ROBERT FROST

CONTENTS

AUTHOR'S NOTE

This is a work of nonfiction reconstructed through thousands of pages of original, contemporaneous journals, letters, news articles, films, still photographs; hours of in-person interviews in Indonesia, Malaysia, Switzerland, France, Austria, and Canada; telephone interviews; and two monthlong trips to Malaysian Sarawak and Indonesian Kalimantan, where I walked in many of the very same footsteps traveled by the characters in this story. There are a few tales here, however, that feel so wild they defy belief, with no corroborating witnesses or documents. I think they're true, but only the tellers know for sure.

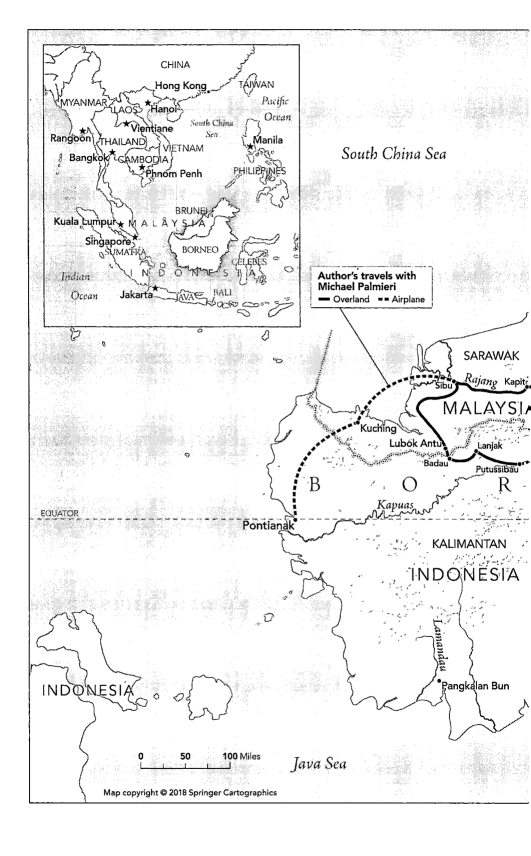

CHINA

Hong Kong

TAIWAN

Pacific
Ocean

MYANMAR

LAOS Hanoi

Vientiane

South China
Sea

Rangoon THAILAND

VIETNAM

Manila

Bangkok CAMBODIA

Phnom Penh

PHILIPPINES

BRUNEI

Kuala Lumpur MALAYSIA

Singapore

SUMATRA

BORNEO

CELEBES

Indian

INDONESIA

Ocean

Jakarta JAVA BALI

South China Sea

SARAWAK

Rajang Kapit

Sibu

MALAYSIA

Kuching

Lubok Antu

Lanjak

Badau

Putussibau

B O R

Kapuas

EQUATOR

Pontianak

KALIMANTAN

INDONESIA

Lamandau

INDONESIA

Pangkalan Bun

**Author's travels with
Michael Palmieri**
━━ Overland ▪▪ Airplane

0 50 100 Miles

Java Sea

Map copyright © 2018 Springer Cartographics

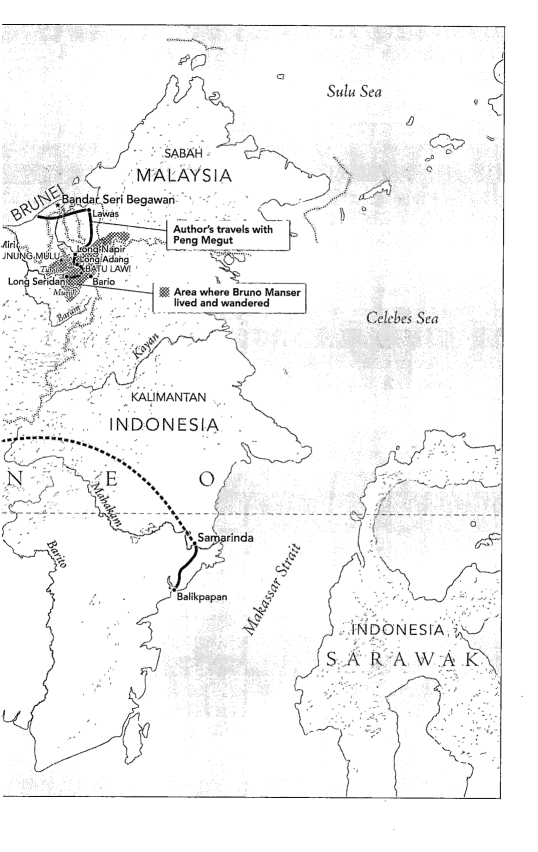

Sulu Sea

SABAH

MALAYSIA

BRUNEI

Bandar Seri Begawan

Lawas

Miri

GUNUNG MULU

Long Napir

Long Adang

BATU LAWI

Long Seridan

Madih

Bario

Baram

Author's travels with
Peng Megut

Area where Bruno Manser
lived and wandered

Celebes Sea

Kayan

KALIMANTAN

INDONESIA

B O R N E O

Mahakam

Barito

Samarinda

Balikpapan

Makassar Strait

INDONESIA

SARAWAK

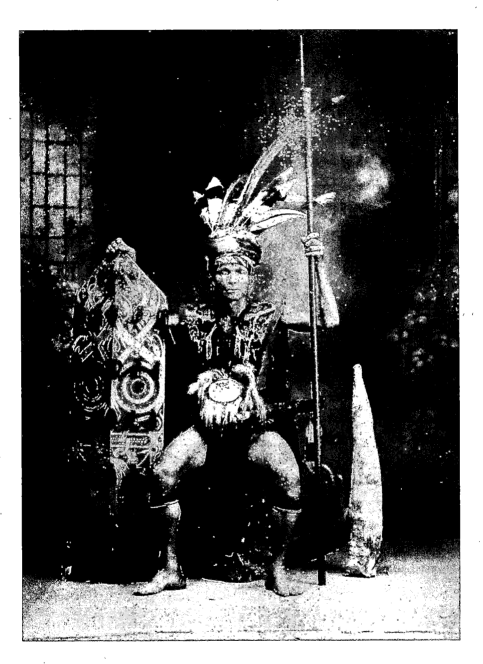

Dayak in full war regalia: hornbill feathers, shield, blowpipe, leopardskin vest, and head-hunting sword. (Collection Nationaal Museum van Wereldculturen. Coll.no. TM-60033041)

PROLOGUE

A Ghost Story

Michael Palmieri heard a crash. Thumps . . . heavy footsteps? It was the middle of the night; maybe it was a dream. He pulled himself out of the fog of sleep. The air conditioner was blowing, and the cold bedroom was lit like the inside of a movie theater from the seventy-two-inch flat-screen TV that he often dozed off to, plumbed right from his villa on the island of Bali to the heart of America via the Internet. College football. The USC Trojans versus the Arizona Wildcats. He loved the Trojans. But the sound was off. And as he registered this, he heard them again: footsteps. Upstairs. Pacing and stomping.

He jumped up, wrapped himself in a sarong, and quietly pushed open the ornately carved double doors to the living room. On the outside of the door hung a mask, all big eyes and gaping mouth and a long green tongue, with braids of black hair dangling animal teeth and shells and odd seeds, a guardian protecting the inner sanctum of his bedroom. The house flowed into a small garden, like many buildings on the island, and maybe someone had climbed over the garden wall and into his home.

He flicked on a light switch. There was a lot to steal: aged gongs dangling from coppery brown eaves; glass-fronted cases full of brass Buddhas; amber earplugs; traditional head-hunting swords with elaborately carved bone handles in equally decorated scabbards. The wall opposite the garden resembled a display in the Metropolitan Museum of Art: a four-foot-tall piece of two-hundred-year-old wood, carved in swirling, stylized branches,

reigned as the centerpiece, but around it hung masks with horn-bill feathers and haunting mirror eyes and an old wooden ritual vessel in the shape of a canoe, its prow carved in the likeness of a hornbill head, the sacred bird of the island of Borneo. On a stand stood an old shield bearing the same motif of intertwining branches and big watching eyes and fangs, and on his desk lay a bamboo quiver holding poison arrows, its handle carved in the shape of a crocodile.

Bang. Crash. More footsteps.

Michael turned left and headed up the stairs.

In the night Michael told me this story, he looked nearly identical to the septuagenarian actor Jack Nicholson. The same hair, the same complexion, the same facial structure and smile; more than once I watched as women, from out of nowhere, slid their arms around his big shoulders and lifted their phones as he leaned into them and cracked a smile while they took a photo, all without speaking.

"Do you know her?" I asked the first time it happened.

"No!" he said. "They think I'm Jack Nicholson. I go with it."

He was seventy-two years old, stood five foot ten inches, had gained some girth, but still emanated vitality, a former surfer with a gray soul patch below his lower lip and a twenty-two-karat-gold vajra thunderbolt on a shimmering chain around his neck. Back in the day he'd been Hollywood handsome—chiseled square chin, dark brown hair. He'd even appeared in *Playboy* magazine in 1972 amid a bevy of naked women. Now he was wearing a classic Hawaiian shirt with mother-of-pearl buttons, black shorts, a pair of black Toms shoes. The fruits of his labor, his years of buccaneering from Damascus to Kandahar, from Tehran to Goa, from Srinagar to Beirut, and finally

into the remotest heart of Borneo—which he'd loved most of all and where he'd ranged for forty years—filled the world's most prestigious museums. The Metropolitan Museum of Art in New York. The Dallas Museum of Art. The Yale University Art Gallery. The Fowler at UCLA, not to mention the private collections of millionaires in the world's greatest cities. Bali had long been the epicenter of Oceanic tribal art, with prices for the best pieces now hitting seven figures, a nexus of dealers and collectors with tentacles reaching Western wealth and culture in Paris, New York, Brussels, San Francisco, Geneva—and Michael had brought out many of its masterpieces.

To the thousands of Americans and Europeans pacing the streets of Ubud, the island's longtime artistic capital, yoga mats dangling from their shoulders in search of spiritual sustenance, the mystical energy of Bali had been discovered through Elizabeth Gilbert's mega bestseller *Eat Pray Love* (or through Julia Roberts playing Liz Gilbert in the film version). But westerners had been drawn to Bali since the 1920s and 1930s, and Michael had been here since the early 1970s. He and his friends had streamed to the island to the east of Java in the Indonesian archipelago in search of freedom, art, passion—paradise. The exotic, the transcendent, the white-sand beaches, the blue-green surf that stretched for miles.

Not to mention the cheap living, an Eden of palm trees and terraced rice paddies threaded by dirt roads and dotted with Hindu temples, the heady scents of clove cigarettes and incense drifting up to the Balinese gods. They were hippies then, gypsies escaping from conventional lives—and the draft—back home, wherever home was. Some had family money, the rest hustled, though it didn't take much in those days. Marijuana, for many. Crafts and jewelry and funky tropical clothing for others. And for a few with good eyes and good taste, it had been art from

Indonesia's thousands of islands, many still unexplored oases of
traditional cultures and old ways. They'd informally divided up
the land into exclusive zones: Alexander (Axel) Goetz took Java.
Perry Kesner claimed Sumba. And Borneo was Michael's.

Forty years later they were still here, even though the Balinese
paradise often appeared sullied now, at least on the surface. At
dinner that night, I was stunned when Goetz slipped a gold chain
out of his pocket. It was the finest piece of gold I'd ever seen, as
thick as my pinkie, so finely woven it felt like silk cloth, as fine
as anything in any museum, with a delicate bell on each end.
The bells tinkled sweetly. "Javanese," he said, "twelfth century."
From his finger he slid a gold ring. Heavy, shiny, thick, inlaid
with a ruby and two emeralds. Nine hundred years old. Later I
would discover that he always wore a heavy antique gold ring,
and it was always a different one.

Across from me at the table was Perry Kesner. He had a shaved
head, a gray mustache, heavy eyebrows, a thick New York
accent, a muscular body despite his sixty-two years. He wore
a deep V-necked tie-dyed T-shirt. Perry, Michael, Axel—they
were like men from another time, another place, living rem-
nants of the 1960s counterculture, now with creased brows and
crow's-feet wrinkles around their eyes; you'd never see anyone
like them walking the streets of my hometown of Washington,
D.C. Which was a funny thing. Art was a world of privilege and
wealth: Nelson Rockefeller had created the Museum of Primi-
tive Art in New York in 1954, a collection that in 1976 merged
with the Met, a museum standing at the very pinnacle of culture
and society. But that was just veneer; underneath the shine lay a
murkier world of deals and often shady provenance that the big
auction houses and museums pretended didn't exist. In 2016, for
instance, Nancy Wiener, a prominent New York art dealer, was
arrested and charged with buying and selling stolen antiquities.

"Defendant used a laundering process that included restoration services to hide damage from illegal excavations, straw purchases at auction houses to create sham ownership histories, and the creation of false provenance to predate international laws of patrimony prohibiting the exportation of looted antiquities," according to the complaint. Among her and her mother's Upper East Side gallery's clients over a fifty-year period were Jacqueline Kennedy, John D. Rockefeller III, the Met, and the National Gallery of Australia, which paid $1.08 million for a stolen Buddha it bought from Wiener in 2007.

I had no indication that Michael or Perry or Axel were involved in anything illegal, but these post-surfer-hippies around me were among the biggest players in Indonesian art; this was the red-hot center of the business, the real business that you didn't see when you stood before a beautiful piece in the Yale art museum or in a Paris gallery. They held no university degrees, didn't pop up on society pages. But if you owned a piece of Indonesian art, or admired one in a museum, there was a good chance it had come via one of them. They were buccaneers hiding in plain sight. And in certain places—the streets of Saint-Germain-des-Prés in Paris, the back rooms of museums and auction houses from Switzerland to San Francisco—they were famous, legendary, sometimes controversial. None more than Michael.

Meeting him had been pure serendipity. I had long been fascinated by the persistent Western obsession with remote tribal people, my own included, and I'd originally come to Bali with thoughts of a man named Bruno Manser. Born in Switzerland, Bruno traveled to Sarawak on the Malaysian side of Borneo in 1984 to live with the elusive, shy Penan—hunter-gatherer nomads who avoided the sun and inhabited the mountainous interior of this wild land. He cut his hair like the Penan, wore a loincloth, hunted with blowpipe and poison arrows, could walk

across the giant thorns of the forest floor barefoot, spoke their language fluently. Though at first they called him "Lakei Ja'au," Big Man, he'd gone so deep the Penan eventually called him something else altogether: "Lakei Penan," Penan Man. He'd crossed a line, done something rare in the Western mind—had become the exotic Other. I envied him; he'd done what I'd fantasized about doing in that longhouse back in 1987. Then, like a T. E. Lawrence of the jungle, he'd led them in a political revolt against the most powerful forces in the state of Sarawak, the Malaysian part of the island. With Bruno's help this small band of illiterate and nearly naked hunter-gatherers armed with nothing but blowpipes had brought its billion-dollar logging industry to a halt. Doing so made him a hero, a saint, a messianic cult figure to westerners—*Outside* magazine named him its Outsider of the Year in 1991—and to the Penan themselves, not to mention enemy number one of the Malaysian government.

His behavior, though, became ever more reckless, obsessive even. Then, in 2000, he vanished. Poof. Gone without a trace. Rumors abounded. That he'd been murdered by the Malaysian government. That he'd gone native completely, cutting all bonds with the outside world. That he'd slipped away to live as a hermit in the vast reaches of Siberia. Or that he'd committed suicide somewhere in the forest, a man driven mad by his failure to save it and its people. Or driven mad by something deeper and more fundamental—a collapse of his identity, a man who'd walked too far out of himself, who'd left behind his Swissness but could never wholly become Penan. "What had happened?" *Time* magazine Asia asked, putting him on its cover in 2001.

And now, before I'd even made it to Borneo to investigate Bruno's life, I'd stumbled upon this other westerner who'd spent decades plunging deep into the forests, with an altogether different purpose and trajectory, and I was eager to hear the story

he told me that night, a story that spoke to the very essence of what I imagined even Bruno in his own way—and everyone in Bali—was after.

W ide awake that night just three years ago, his senses alert, Michael climbed the stairs to his second-floor hallway. Empty, save rows of carved wooden statues, all hundreds of years old, some half a millennium or more. He opened the door to the bedroom above his. Empty, except for even more objects, including glass cases holding ancient Chinese greenware pottery and a stone bracelet seven thousand years old.

There was only one room left. He padded across the smooth floorboards in his bare feet. Pushed open the door. Turned on the lights. Nothing. No one. Only a single statue about three feet high, fresh from the rain forests, one of the greatest pieces of his career, in a lifetime of epic journeys among the rivers and villages of the Dayak—the indigenous people of Borneo, known for their rich, dynamic culture.

This statue had been created hundreds of years before, a guardian figure, squatting with bent knees and hands on thighs and disproportionately big round eyes in a heart-shaped face. Staring. Watching. Carved to guard the spirit of some long-forgotten Dayak noble tucked away and protected in a cave.

Michael had first pictured it in a dream. He maintained a network of local runners throughout Borneo who were on the lookout for good pieces, and almost a year before he'd gotten a text message from one of his contacts. Dayaks searching a limestone cave for the nests of edible swiftlet birds (a delicacy in Chinese cuisine) had found a statue. Was Michael interested?

He was.

But the Dayaks feared that disturbing the site might disturb

the swifts, which might stop coming and building nests to harvest. They backed away.

Nine months passed until the contact pinged Michael again. The community needed money to build a new clinic and they were ready to sell.

What does it look like? Michael asked.

I don't know, the man said. I haven't seen it.

Try to get a photo of it, Michael said. But he knew well the area where it had been found in East Borneo. It could be from the Modang, a Dayak subgroup known for its especially beautiful—and valuable—carvings. That night he saw the piece in a dream. Clearly. As if he was looking at a photograph. He texted his contact: *I'm coming. Meet me at the airport.*

He flew to Balikpapan, in East Kalimantan, the Indonesian part of Borneo, then drove hours on potholed roads to a village, where they chartered a speedboat and arrived upriver in the middle of the night. Tobacco, gifts, they smoked and talked and finally brought out the statue, wrapped in a dirty cloth. Unveiled, it took Michael's breath away. His adrenaline surged. He felt victorious. It was the piece in his dream—the exact same one! He'd had a vision and there it was. Whoa, he thought. It was beautiful. Powerful. Muscular. Ancient. A piece like this made him feel full and whole.

A few years ago he would have thought it two hundred years old, but recent carbon-14 tests of Dayak statues were revealing some to have been created possibly far earlier, controversial dates that if accurate upended many assumptions about the age of material wooden culture in Southeast Asia. To those who'd made it, the statue represented something beyond itself: a universe, a way of living in the world, a time of magic and portent and unseen dimensions. It wasn't just a beautiful carving, but a doorway to everything that embodied Borneo, a vast, drip-

ping, fecund island once full of leopards and giant hornbills and trees so tall you couldn't see their tops and tiny mouse deer and rhinoceroses and huge pythons and more insects than anywhere on earth, full of the men and women who'd made it their home for longer than memory and created beautiful things in a dreamscape of sacred, mystical consciousness. He had to have it. He had bought and sold thousands of pieces over the years, and he still owned hundreds, tucked away in hidey-holes around the world, but when a good one came along, well, it was an addiction. He had to own it.

They haggled all night. More cigarettes. Homemade tuak rice wine; the Dayaks like to drink.

Finally a figure: the price of a car, a mind-boggling fortune in a place like Indonesia and twenty times more than he'd ever paid before.

He'd shipped it home to Bali, put it in the upstairs bedroom, and now, just a few days later, he was hearing the crashes, the footsteps. But nothing was there. At least, thank God, the statue was safe.

Michael went to bed.

But the same thing happened the next night.

And the night after that, and the night after that.

Some people might have dismissed those strange sounds. Others might have been spooked, freaked out by what seemed inexplicable. But not Michael. He had been around long enough, had experienced enough of Dayak culture to know that this wasn't a problem of our world. He called a dukun, a Balinese shaman. Dressed in white, the white of purity—white sarong, white hat, white-buttoned cotton blouse—the priest walked into the house, walked up the stairs and into the room. His hair stood up. Goose bumps erupted on his smooth skin. He had fear in his eyes. "Hidup! Hidup!" he said. Alive! Alive!

The shaman and his wife laid down a poleng, a magically protective black-and-white-checked cloth, a wall that spirits cannot cross, and placed their sacred tools upon it. Holy water, offerings and flowers and incense. The shaman sat cross-legged, burned incense, rang a bell with a vajra thunderbolt on the handle, back and forth, back and forth, and a luminous high-pitched sound, clear and strong, a sound that pierced right to the heart of the world, rang out through the house as he chanted in Balinese and Bahasa Indonesia.

Then, just like that, it was over. "Sudah," he said. Finished. He stood up, a smile on his face. The weight, the dread, was lifted from the house. "Sudah. Sudah pulang." Gone home. He then purified every room and finally Michael himself.

Michael never heard footsteps again. "That spirit was in the house!" he said, sipping the last watery dregs of his scotch. "In the house! It was a guardian figure. Powerful. So strong. So powerful. He didn't like it here. He wanted to go back home. So we sent him back to Borneo, and what remained was the wood." A piece of wood worth a fortune to the collectors, auctioneers, and museum curators he knew in New York and Paris and London.

Hearing Michael's story in New York or Los Angeles, cities where you couldn't see the night sky and where technology and its magicians had become the gods, would have made my eyes roll. But this was Bali. Geckos slithered along the ceiling beams and frogs croaked and crickets hummed and a ceiling fan turned slowly overhead. Even in the new Bali of malls and swanky hotels stood a temple on every corner, the ground littered with the day's offerings. On any given night the bang and clang of gamelan orchestras carried on the breeze, and it was hardly uncommon for men and women to routinely fall into

trances as they communicated with the spirits. And Borneo was just north of Bali, a ninety-minute plane ride away.

I'd always been fascinated with Borneo, with the whole idea of wild jungle and rivers inhabited by highly cultured head-hunters. It was the third-largest island in the world (after Greenland and New Guinea), a mini-continent stretching eight hundred miles north to south and six hundred miles east to west, a place of vast fecundity harboring so much life—plants and animals and deep human culture, both physical and spiritual—that it was hard to imagine it for real. It was one of those places, like the Amazon, like Conrad's Congo, like New Guinea, that had long obsessed the Western imagination. It was where the heart of darkness lay, where orangutans the size of men swung through the trees and where Alfred Russel Wallace collected two thousand different species of insects in a single square mile. It was where the rich British gentleman James Brooke battled head-hunting Iban pirates to proclaim himself the White Rajah, where the legendarily beautiful Dayaks lived in longhouses that stretched three hundred feet end to end and covered themselves in swirling tattoos and stretched their earlobes to their shoulders with heavy brass bangles. Borneo's forest and its people were the very definition of exotic in the Western mind.

In 1987, at the age of twenty-seven, I'd taken a ten-day foray up the Mahakam River, where I'd spent two nights in a longhouse. It had been my first experience, albeit brief, with indigenous people, and the dislocation I'd felt in that long dark elevated wooden structure with topless women and men who hunted with blowpipes left me hungry for more understanding of what I'd seen, felt, experienced. I wanted to know them; in some unfathomable way I wanted to *be* one of them. The Borneo that filled my head as Michael's story unspooled offered a wistful promise of something mysterious and mystical. Of lost

worlds, lost tribes, a lost way of being: that somewhere out there in the bush was something bigger, something unknown, something that spoke to the very essence of our humanity.

M ichael and Bruno, I realized while listening to Michael's story that night, were completely different kinds of men. At least on the surface, their lives had nothing to do with each other. Bruno was an idealist, a do-gooder, a refugee from the modern world who despised the cult of Western consumerism and devoted his life to the Penan. Michael was a buccaneer, a man who spent his life buying and selling the Dayaks' art, the physical manifestations of their sacred universe, and in doing so had made himself more than merely comfortable.

But hearing Michael's story, with the haunting monuments to Dayak culture all around us, it struck me that he and Bruno were two pieces of a whole, Eros and Thanatos, Apollo and Dionysus, two men who spent their lives in pursuit of the sacred fire of "exotic" indigenous people. They had both fled their own countries at more or less the same moment, and they'd each been drawn in a powerful way to the same island. They'd both become obsessed with Borneo's people, were fascinated with sacred cultures and our romantic notions of their power. The two were hungry to touch a perceived Eden of our past, desperate to hold it in their hands and in their hearts, both trying to fill some piece of their souls with it, from it, in very different ways. They'd both been treasure hunters, I realized, and the prize hadn't been gold or priceless statues or even really the self-determination of a people, but a long and persistent Western fantasy: of the power, mojo, juju of native culture. Bruno had fought time and progress, while Michael had bought up sacred objects just as development and consumerism was dissolving the

cultures that produced them. They both plunged heedlessly into the same world, but one ended up aging in comfort, the other dead—and their stories represented two poles of possibility: a forest and its people saved against all odds from development, or a people absorbed by the modern world, their culture relegated to the walls of museums or collectors.

I asked Michael if he'd ever heard of Bruno.

"Of course!" he said. "Met him. In Borneo. I think it drove him crazy, going native like that. He and I . . ." He drifted off for a second. "He and I were different, but after just a minute of talking we both recognized a similar impulse. We were both obsessed. I wanted to be a Victorian pirate, the Rajah of Borneo. And he wanted to be one of them, a Penan. And, I don't know, but I think maybe we both tried to save it in our own ways."

That was it. I wanted to follow the stories of Michael and Bruno, two narratives that were really one. It was the story of the fate of Borneo: the place itself and an idea that we coveted, the last Eden of our imagination, a wild garden filled with spirits and magic and unconquered people. I would find out what happened to Bruno Manser and how well either of these wild men of Borneo had succeeded in fulfilling their dreams. Dreams of being adventurers in a strange land. Dreams of escaping Western culture and wrapping themselves in the powers of Borneo's indigenous people. And the most difficult dream of all—of saving its inextricably linked wildness and culture.

It was late and time to go. I put my glass in Michael's sink, slipped on my flip-flops, and asked one last question. What about the statue?

"Sold it to a guy in Paris," he said. "For the price of a house. A big house."

I

RUPTURE

I feel the irksomeness of civilized society
greater than ever, and its bonds shall not
hold me long.

—SIR JAMES BROOKE, RAJAH OF BORNEO

Penan of Ulu Benali, Sarawak, Malaysian Borneo. (James Barclay)

ONE

Bruno Manser walked into the forest alone. He carried a backpack stuffed with twenty pounds of rice, a rain tarp, a hammock, a fishing net, a few shorts and T-shirts, pens, watercolors, a sketchbook, a machete, a carbide caving headlamp, a 1-to-100,000-scale map of Sarawak, and a compass. It was June 1984, and as he left Gunung Mulu National Park, on the Malaysian side of Borneo, and hiked into the most spectacular virgin rain forest on earth, he had only the vaguest idea where he was going or for how long. He was days beyond any roads or airports, and no cell or satellite communications devices would be available for years to come. "Once more," he wrote in his journal, "my soul is amazed." He was thirty years old.

To the north, a few miles in a straight line stood Gunung Mulu, Sarawak's second-highest peak, reaching a misty, rain-shrouded seven thousand feet. To the east, the direction he headed, rose forest-covered mountains in ever-higher steps, the headwaters of the rivulets and streams that tumbled out of Borneo's central plateau to become mighty rivers like the Rajang and the Kapuas and the Mahakam, rivers so big you could sail a ship up them for hundreds of miles before hitting surging rapids, gateways protecting inner, hidden worlds. Somewhere in those mountain headwaters lived the Penan, and he was going to find them.

The forest was not for the most part the low, green, humid tangle that most people imagine when they think of a tropical jungle, but an ancient primary landscape of hardwood trees soar-

ing one hundred feet tall, some of them fifteen feet in diameter, with huge buttress roots that could dwarf a man. Beneath that high green canopy lay a cool, dim, shadowed place of smaller trees and shrubs fighting for what light reached the always moist forest floor, soft and spongy from untold millennia of rot and decay, sprouting mushrooms and wet leaves and rotting logs and moss and ferns, the whole a seething soup of life. The forest smelled of damp and old wood, the smell of death but also of life.

The age of this place he was entering was hard to conceive. Southeast Asia's forests are the oldest on earth, 180 million years, and when much of Africa and the Amazon became dry savannas the woods of Southeast Asia retained their hot, wet climates. Borneo, when it rose from the sea 130 million years ago, was colonized by those ancient forests. Without substantive changes in climate or seismic activity, the environment into which Bruno was walking had remained stable, intact, pristine, unchanged for years. "The tropical rain forests are one of the most complex ecosystems that ever evolved on this planet," writes Biruté Galdikas, who spent forty years studying orangutans in Borneo. "Nourished by the unyielding heat and high rainfall that prevail at the equator, these forests have been the crucible of evolution, spawning increasingly specialized forms of life inhabiting ever more narrow niches." She adds, "The term 'cathedral forest' is used as a metaphor, to suggest that great woods are like great medieval churches. But I have often felt that this is backward, that the stone cathedrals are a recreation of the forests where our distant ancestors once lived. This is why they strike a chord deep within us. The soaring ceilings of a medieval cathedral, the cool, damp air, the dark punctuated by beams of brilliant light colored by stained glass windows mimic our ancient home, our Garden of Eden. . . . A walk in the rain forest is a walk into the mind of God."

Bruno Manser was a newcomer to this tropical landscape. He had left Switzerland six months earlier, on January 4, flying from Zurich to Bangkok, working his way south by train and bus, just another Western backpacker, it would seem, wandering through Asia. But little was ordinary about Bruno. On the train he climbed up on its roof and jumped between the cars. He wandered off the road straight through rice paddies and slept under the stars. He explored Thai caves filled with millions of bats, closing his eyes to feel their vibrations, marveling at gigantic spiders. In one he spotted a strange-looking six-foot-long white snake. He was fascinated with serpents, couldn't keep his hands off them, had been haunted by dreams of them since he was a child. Heedlessly, he grabbed its tail, forced its head to the ground, and picked it up. "It was nice meeting you," he said, letting it go. He slept alone in that cave, screaming joyously when he felt the wind from the bats' wings on his face.

Hearing there were wild elephants living in the Malaysian state of Kelantan, he decided he wanted to look them in the eye in their natural state. He walked into the jungle alone, tracked them, and sneaked up to them in the night to pet them, a misadventure that sent him fleeing for his life.

He spent six weeks living on the deserted beaches and hot jungles of a tiny Malaysian island, Perhentian Kecil, as a modern-day Robinson Crusoe. Arriving with just six pounds of rice, some cooking oil, and a few onions, he sought to live off the land. When he noticed a plant with large, arrow-shaped leaves that reminded him of taro, he dug it out of the ground and bit into it. His mouth exploded. "I threw the root far and spit and ran like a monkey chased through the forest," he wrote in his journal. "I felt the need to vomit and each movement of my tongue felt like pins sticking in my mouth, and I hadn't even swallowed any of it!" Another plant made him so sick he couldn't rise from his

hammock for twenty-four hours. He ate a rat and a snake, snails, and finally learned to catch some fish in his nets. He was bitten in the hand trying to catch another snake, but didn't seem to learn his lesson. A few days later he wrestled a nine-foot python out of a tree with his bare hands. He was about to kill it, but decided he had enough fish in his nets to eat and set it free.

Now he was heading up into the mountains in pursuit of the Penan, the last nomads of the Borneo rain forest, a people who had remained mysterious until the early twentieth century. "Indeed," writes the anthropologist Bernard Sellato, "though certain relatively old sources mention the existence of nomads in the interior of the island, almost nothing in the literature prior to 1900 provides more than occasional very brief notes about them, and almost always these notes are based on secondhand information or unfounded rumors." Only in the 1950s did the first anthropological studies about them begin to appear, which Bruno saw in a library in Basel.

As he made his way into the forest in 1984, about seven thousand lived in two distinct populations: the Western Penan, who numbered around twenty-five hundred and tended to live in much larger communities of sixty to two hundred members and had long settled into small farming communities; and forty-five hundred Eastern Penan, who lived to the north and east of the Baram River. The majority had become semi-settled, but many remained nomadic and lived in small bands of twenty to forty. Pure hunter-gatherers. Men and women who lived, Bruno heard, like faeries of the forest. An egalitarian people unfettered by consumerism or possessions, who shared equally all of the little they had, who looked not to the stars and the moon, which they could barely see beneath the forest canopy, but to the streams and trees and animals, and could find their way by those alone and could even write in symbols crafted from leaves and

saplings. Men and women who knew the forest's rhythms and voices, who could speak to the animals and move barefoot and silent beneath its vaulted arches. A people who never stayed in one place for more than a few months and moved in pursuit of wild boar and sago trees, their favorite foods. In Bruno's imagination they were pure and free, untouched by time or history, had been living in perfect coexistence with the forest unchanged since the dawn of time itself. And while the neighboring Dayak tribes had a long history of violent head-hunting, the Penan knew no war, it seemed, eschewing violence for shy withdrawal.

All of which fit perfectly for Bruno, who'd been climbing and crawling in the woods since he could walk. He'd grown up working class, crowded into a two-bedroom apartment in Basel with three sisters and two brothers, so many kids that everybody shared bedrooms and their father slept on the sofa in the living room. The children attended church every Sunday, and in pictures the three boys looked like poster children for the 1950s: crew cuts, bow ties, sweaters, beaming smiles. His father, though, had a hard edge. He could be tyrannical, was often verbally abusive to Bruno's mother, and so Bruno and his two brothers escaped. They wandered, with a freedom incomprehensible to any urban parent today, in the woods and streams that were just a twenty-minute walk from their apartment.

From early childhood Bruno was precocious, especially in the natural world. Bugs. Dirt. The dark—every kid is afraid of the dark at some point. But never Bruno. He touched everything. Tasted everything. Put everything in his mouth. His curiosity was boundless. "He took each stone and looked under it," said Monika Niederberger, his younger sister.

Under his leadership, he and his brothers would steal out to the forest at four in the morning to listen to the birds and watch the forest come alive. They fished. Caught bugs, frogs, and newts, which he brought home, himself often covered in mud, sometimes even in his best clothes. One day when Monika went to take a bath, the tub was filled with swimming fish—not little goldfish, but fat trout from the river, which he then cooked and served the family for dinner.

He often escaped out to the little balcony at night and just stared at the sky. As fall gave way to winter, his mother watched him bring home long bundles of green ferns. Piles of leaves. Sticks and odd feathers that he began piling on the apartment's little balcony.

What are you doing? his mother asked.

Don't worry, Mameli, he said. I am building a bed.

He created a nest of sorts, remarkably similar to the bowers he would sometimes be forced to make years later when he was on the run in Borneo. He slept there most nights, even in the harsh cold of the Swiss winter. As he lay in his nest in the dark, Bruno's mind wandered far, to the jungles and deserts and deepest oceans. It wasn't just nature in and of itself that he loved, but adventure, and he grew ever more engrossed in the idea of self-reliance. He disemboweled an old sleeping bag and sewed his own pillow. He started carving his own buttons out of wood. He was quiet and shy in school, did not stand out, except for a series of odd yet articulate essays. Still in primary school, he faced the age-old school assignment of what he wanted to be when he grew up. "My profession should have something adventurous about it. If only I could go to Sumatra, Borneo and Africa and live like a cave dweller amongst gorillas, orangutans and other animals in the impenetrable jungle! I would always have a magnifying glass, a pipe, tobacco and matches with me,

as well as a large pair of binoculars and a lot of interesting books about nature. I shouldn't lack courage."

In the seventh grade his class went to the Alps, where they slept in the open hayloft of a barn. But just before dawn odd noises woke the group. Crawling sounds. Murmuring. Something rolling around in the hay. His teacher found Bruno lingering near the edge of the loft, about to jump off, babbling incomprehensibly. The teacher pulled him back from the brink, and as the sun rose, he looked into Bruno's eyes. His pupils were huge brown holes, wildly dilated. He was escorted down the mountain, and a few hours later as he came to his senses, all was revealed: he had eaten morning glory seeds he'd found on the hike that afternoon. He had, in a phrase, just taken his first acid trip. He was not repentant. He did not apologize. Instead he criticized his teacher: If you have never eaten the seeds, he said, you are not a real scientist!

He was growing up in the heart of the unprecedented economic prosperity and population explosion that would soon crack the whole world open. The boom of 1945 to 1973 was the largest in history, known in Europe as Les Trente Glorieuses—the Glorious Thirty. By the time Bruno turned fourteen, in 1968, Grace Slick and Jefferson Airplane were belting out, "Hey now it's time for you and me / Got a revolution." In Warsaw, student demonstrations shut down the university system. In Czechoslovakia, the Prague Spring erupted. In Rome in February of that year, students shut down nineteen of thirty-three universities in the country. And in Paris, hundreds of thousands of students and workers struck and rioted, nearly toppling the French government.

This worldwide movement was seeping into every canton and village on the continent. "It was a wild time, even in Switzerland," Bruno's brother Erich said. "People wanted to get

away from their parents, get out of their regular life." As Bruno neared graduation, he carried a stained, dog-eared copy of the writings of Lao Tzu nearly everywhere. He displayed no anger, no urge to burn or topple or·destroy, but he wanted freedom. Freedom from the state, freedom from things, and freedom from his family—his father most of all.

"Each of us wants to be ourself," Bruno wrote in a school paper, "but that is very difficult. I am not yet myself. . . . I hate imitating other people, although I do it. I have numerous ideals from the various protest movements (i.e., hippies, vagabonds, beat-niks, provos, yuppies). I will refuse military service—I am against the military. I am also against the police and any manifestation of authority. . . . I would like best to live like a protest movement leader, whose name I have forgotten and who I will try to quote: 'I have the vision of a rucksack revolution. Young people with rucksacks climb mountains to experience the sunrise. They read books on philosophy and freedom, they paint and write poems, for no particular reason, just because they enjoy doing so. They make children laugh, they make young girls happy and older ones even happier. They cheer up old people thanks to their joie de vivre and they help all those who need help.'"

It was Jack Kerouac, of course, an almost verbatim quote from *Dharma Bums*.

When he turned eighteen, Bruno's draft notice arrived. He explained his objections thoughtfully in letters and preliminary hearings, and finally he objected again, one last time, to seven military judges in November 1973. He looked the officers in the eye. "It is the task of every individual to show love through human co-existence and to respect all life," he told them. "I believe in goodness, love, peace and the power of prayer. Every human being is good at heart," he said, "and therefore my belief and my mind-set are not compatible with the military."

The judges were shocked less by his defiance than by his utter conviction and forthrightness. He didn't shout or yell, didn't quaver. When he stood in front of people to explain his vision, he became as surefooted as a Swiss mountain goat in the Alps. "He could be so funny and childlike," said Edmund Grundner, an Austrian antiques trader who was the last westerner to see him alive, "nearly too funny for me sometimes. He told me he was with a friend in a hotel once and the bed was so bouncy they jumped on it until their heads hit the ceiling. But I saw him speak to three hundred people and TV cameras without notes. His voice was strong and powerful and he spoke so calmly and so, I don't know, safely. He was charismatic. You felt good when he spoke."

He wasn't just some hippie who wanted to smoke weed and lie around listening to Jimi Hendrix. In fact, the judges had read in his report that he was already hard at work, had recently begun doing the most Swiss thing a Swiss could do: herding cows in the high Alpine pastures where the grass was sweet and fresh, the necessary ingredient to the Alp cheese that every Swiss savored. Judge Lieutenant Riklin watched Manser standing straight, wearing Gandhi-like glasses, tan and muscled from a long summer of backbreaking work up there in the mountains (everyone who met Bruno in the years ahead would remark on his almost inhuman physical strength and stamina), and took notes.

"At the moment he has not succeeded in loving every human being unconditionally. He is still working on this goal. He wants to accept, understand and love every single person as a fellow human, friend and brother. According to him, you can only defend what you absolutely need to live. To defend luxury is pointless and anti-nature. And the military is not needed to defend the essentials of life. He rejects any defence of anything

that does not belong to him, i.e., all the products of civiliza-
tion, industrial goods, imported items and financial resources
that create today's chaos. For him, material things are not worth
defending."

Bruno Manser's idealism did not save him from jail, however
impressed the military judges might have been by his principled
stand. Bruno did not care. When he emerged from prison four
months later he gathered a herd of cows and in 1974 headed up
into the pristine blue-and-green world of the high Swiss Alps,
the beginning of a sojourn that would bring him ten years later
to his search for the Penan.

L eaving Mulu that day in June, he followed well-worn trails that
quickly petered out, and he spent three days hacking his way
up and down muddy, steep thorny underbrush, remarking in his
journal that "the energy I have to expend is very high, especially
so if the goal isn't any closer and I make a mistake and have to
turn around—and I have to turn around continuously." Leeches
were everywhere; when he paused and gazed at the spongy car-
pet of rotting leaves underfoot or the shrubs around him, he saw
lip-red, inch-long, wiggling forms ever groping for their next
host. They covered his legs, magically worked their way into his
shoes, under his socks and shirt, grew quickly as they gorged and
left his legs streaming with blood when removed. Every once in
a while he climbed a tree to get his bearings, but quickly real-
ized he'd underestimated the scale of his map. By nightfall he
was exhausted, lucky to have advanced two miles.

After dark tiny biting flies penetrated his mosquito net, a
never-ending series of sharp pinpricks that made sleep impossi-
ble. He tossed and turned, pulled his sleeping bag over his head,
tried to distract himself by playing his harmonica, and finally

escaped the onslaught by submerging himself in a nearby stream for the rest of the night.

He had spent the previous month with a British expedition exploring the Mulu caves, among the largest in the world, and suddenly, after three days, "Mulu feet reappeared with all its force." The floors of the caves were sandstone, and during his days there sharp silica crystals penetrated his shoes. In the constant wetness of the forest the crystals worked their way into his feet, which caused "agony." "I'm groaning with every step. . . . Even touching fabric when I'm in my sleeping bag or putting on pants."

At the sunny, open banks of a small river he made camp, put his goggles on, and made "eye contact" with the fish. "What joy to see these scaly animals," he wrote. "Finger-long fish are glued to rocks in the shallow water and one of them has a long snout and long tail tips and another has funny warts on its nose and upper lip." He caught a large basslike fish in his net, and ogled huge flocks of butterflies, which he called "players of the air."

It was a momentary respite. He headed higher, cutting through thorns, the underbrush becoming denser and denser, until it was impenetrable. Moss-covered branches and epiphytes hung. He tried to follow deer and wild boar trails, but "I don't have the elongated head of these animals," so he dropped his backpack, cut his way through with his machete, and then returned for the pack. "It's depressing or maybe joyous if I can cover the distance in twenty minutes with the backpack that it took me four hours to cut through." He still had some rice, but he saw no streams, and without water in which to cook it, the rice was useless. He hadn't eaten in two days. He was weak, starving. By any logic, what he was doing was insane. He was in an alien wilderness, had no idea where he was going. Even with food, he might wander for months without seeing another human. Fecund for-

est though it was, it may as well have been the Empty Quarter of Saudi Arabia, a vast, empty desert. But Bruno didn't panic. Instead he turned to pitcher plants that grew abundantly around him. "One swallow of water per bloom and with my lips I filter the residue of the half-digested insects and the twitching larvae. When the victims are mostly ants, the water has a pleasantly sour taste; if it's greenish it tastes as bitter as gall."

Bruno had been wandering for eight days when the skies opened in torrents. He collected the luscious water in his tarp and cooked rice and tea, his first meal in forty-eight hours. His progress, however, slowed to a few hundred yards a day. Even he started to admit his folly. "I did not think the way to the indigenous people would be so hard all by myself in this godforsaken area. Breaking a leg would probably mean death, but I don't have any choice other than to keep going." He saw no game, nothing but birds. Hungry and exhausted on the saddle of a ridgetop, he climbed into a tree. Undulating green stretched in all directions beneath a vast sky of drifting clouds. And then there it was, tendrils of smoke spiraled into the shimmering tropical heat on the other side of the valley. "What joy! Or is it only a fata morgana?" he wondered. "Light green spots shine from the forest; are these jungle gardens or only fields of fern?"

With a renewed feeling of strength, he plunged into the valley, playing "S'isch mer alles eis Ding," a classic Swiss folk song often sung by parents to comfort their children, on his harmonica, until he felt something weird in his mouth. A leech. He pried it out, metallic-tasting blood spreading across his tongue, and drove himself on. He bushwhacked through narrow valleys that led to a gorge, tried to follow a stream, was forced to clamber over piles of tree trunks thick with moss, got tangled in "dense prickly palm growth that grabs me with its hooks." He battled the forest all day, and then he saw them: footprints.

Human footprints. And young trees slashed with a blade. At last, "I know I'm on a human track," he scribbled. But it was late. He was spent. He fashioned a bed from leaves and small branches and lay down for the night, contemplating the "painful last days," and watched giant brown ants an inch long catch butterflies lured to the light of his headlamp. His mind wandered. "I fly into other rooms and see beloved people at home and I send them my thoughts."

In the morning he awoke to a sound he'd hadn't heard in ten days: human voices.

*Michael Palmieri during a summer diving for coins on Catalina Island,
age twenty, in 1963. (Michael Palmieri)*

TWO

It was October 4, 1975, and Michael Palmieri perched on the roof of a hundred-foot-long wooden riverboat plowing up the Mahakam River. The sun burned overhead, the light white, washed out, the heat and humidity weighing like a heavy mattress. Below—sitting, lying, pressed against each other—hummed people from throughout the Indonesian archipelago: Muslim Javanese and Bugis traders and animist Dayaks returning to their villages with all their goods, cooking pots and galvanized roofing and fifty-kilo bags of rice. The vessel sat low to the waterline and open at the sides, covered with a flat roof. A waist-high outhouse jutted off the stern; whatever you did there, your head was always visible. Michael was thirty-two years old.

The boat pulled away from the rotting floating docks of Samarinda that morning, headed on a forty-eight-hour run to Long Bagun, two hundred miles upriver, the last navigable village before the Mahakam's fall line. There the river narrowed into a series of powerful and dangerous rapids (not far, in fact, from where Bruno would live) that shut off major river traffic and beyond which commerce slowed, travel reduced to narrow, shallow-draft longboats, as it flowed out of the central highlands high in the Muller Range near the Sarawak, Malaysian border—that is, when the water level was navigable at all, a narrow line between being too high during the peak of the rainy season and too shallow when rain was scarce. A hundred miles from its source lay the village of Long Apari, which Michael had tried to reach a few months before, without success. Hundreds

of rivers fed by thousands of streams flowed into the Mahakam along its route, the branching veins and capillaries that brought life and access to villages and longhouse communities inhabited by dozens of different Dayak tribes, a world of virgin rain forest without roads.

Michael was in heaven up on his perch, watching the river flow by. It was a half mile wide, chocolate brown, placid, as winding as the tail of a pig, twisting sharply left and right, the boat angling for the inside of the bends as it passed islands of floating water hyacinth and logs big enough to stand on, the gateway into a rich and complex intermingling of people and culture. To say that he'd seen a lot of the world was an understatement, yet this felt different from anyplace he'd ever been. He wasn't just traveling to a remote physical location, but to a metaphysical one, a place that coexisted with another dimension altogether—the rich spiritual world of the Dayaks.

The boat churned upriver past a wall of green and ramshackle villages of wooden houses with rusting corrugated roofs perched atop the muddy riverbanks. Notched tree log stairways led down the banks to floating rafts, each holding a waist-high outhouse similar to the one on Michael's boat. Around 6:30 p.m. the sun quickly set, a few minutes of grace and warm colors before blackness closed in. Every so often the captain's bright searchlight flicked on, a cone of white probing into the darkness, picking out logs and upcoming bends, before cutting out, plunging Michael into the darkness again. He lay on his back and shivered slightly in the humid breeze, wrapping himself in a sarong as cockroaches scurried back and forth under a universe of trillions of pinpricks overhead. He noticed a satellite tracking across the sky and marveled at the world that had sent it forth and his life in Southern California that he'd left a decade ago.

Indeed, it should have been no surprise to anyone who knew Michael back in Los Angeles that the young man who spent three summers diving for coins tossed from the decks of the incoming steamer from Los Angeles on Catalina Island was now perched on a Mahakam riverboat. Growing up, Michael might have been a character from some *Beach Blanket Bingo* movie, as quintessentially Southern Californian as you could find. He'd actually been born in New York City, but his parents had lit out for the California dream while he was still an infant and left him in the care of his Greek grandmother, who worked in the garment industry as a furrier's seamstress. He learned Greek before English, which perhaps accounted for his later ease with languages—he would eventually speak French, Spanish, Portuguese, Italian, and Bahasa Indonesia. (Bruno was equally adept, speaking French, German, English, Penan, and Bahasa Indonesia.) When his parents packed Michael and his sister into the car for the drive west when he was three, Michael saw his first swimming pool at a roadside motel and fell in love with the water, a love that would stay true and that made him feel at home on the rivers of Borneo.

He always had a certain flare: at five he liked to dress like a cowboy—hat and chaps and boots and vest, six-shooter cap pistol at his side, his hair in a classic 1940s flattop. He exuded a rambunctious energy, was always in motion. At ten he'd jump out of bed at 4 a.m. to meet his stack of freshly deposited copies of the *Los Angeles Times,* which he rolled with rubber bands and delivered on his bicycle. Like Bruno, he relished the early morning, the breaking dawn and the long skinny shadows the rising sun made on the palm trees, the sense of adventure of sneaking out of the house before anyone was up and riding the streets in solitude.

Michael loved going to school. Not the academics so much, but the people to talk to. The girls. Sports. He never cut class, even as he was kicked out of one school after another. His parents tried a parochial school for a bit, and it was Michael who was always dragged to the front of the class, forced to hold his hands out, palms up, for the stinging smack of the nun's ruler. But he couldn't help himself; before the ruler came down he'd laugh and whip his hands away, a move that infuriated them. Which then meant the inevitable visit to the principal's office, where he'd have to hold his ankles as the priest struck him with a wooden paddle. But he was incorrigible; the mirror on his shoe he used to look up girls' skirts got him the boot back to public school.

The classic extrovert, Michael took energy from people and the world. He read Kipling and Hemingway and roamed California's beaches searching for waves in a 1939 Packard hearse with tufted velvet and a mattress covering the coffin rollers in the back. When James Michener's *Adventures in Paradise* television show appeared in 1959, when he was sixteen, he made sure he was plunked down in front of the TV for every episode. Gardner McKay, the show's hero, was Michael's perfect role model: a six-foot-four Korean War vet who sailed the Pacific on his ninety-eight-foot schooner *Tiki,* moving cargo, dodging pirates, running before the wind. McKay made women swoon; around his neck dangled a small wooden idol not so different from the gold vajra thunderbolt Michael would wear fifty years later, and no place and no woman could hold him long: the sea and the wind and the palm trees called. Watching the show made Michael's heart race; it spoke to him like religion—and surfing on California's breaks and diving for coins on Catalina was but one step away from the *Tiki* life.

Michael's third high school was 80 percent Chicano, and he

was thrust into the world of the White Fence and Toonerville gangs in his blue jeans and two-toned saddle shoes, a walking punching bag. On the first day of his new school the young toughs spit on his two-tones and bumped him hard in the shoulder, but Michael soon had a Latina girlfriend whose brother was a gang captain, who offered him a certain kind of protection—he had to fight, yes, every week, but the captain kept it one-on-one, man-to-man, and there'd be forty or fifty guys there watching but the brother would yell, "No jumping in, no jumping in," and Michael would attack, boom, hard and fast. One Saturday night he and five buddies stopped at a gas station in Newport Beach en route to La Jolla, with five surfboards stacked on the roof of the hearse. A bunch of gangbangers yelled at the surfer boys and screeched into the gas station and aimed for Michael. He was the magnet, the pretty boy who looked like he couldn't defend himself. But it was a strange thing—little scared Michael, and he looked at the guy closest to him and in the fluorescent glare of the Californian night he said "Fuck you!" and dropped him to the pavement. A clean knockout. Michael had, even back then as a teenager, what he thought of as a third eye, an extra-sensory organ that could see behind him, to the side of him, and even more important, that could feel, intuit people's intentions and situations. It was like he knew, felt, smelled, saw in a wider arc than most people, and it always—well, almost always—kept him safe.

Those last summers in California were halcyon days in America, but the barometer was dropping fast. In February 1960 four black teenagers sat down at a segregated Woolworth's counter and refused to move. Three years later—Michael's last diving for coins—JFK was shot, Birmingham, Alabama, commissioner

of public safety Eugene "Bull" Connor attacked civil rights pro-
testers with fire hoses, Medgar Evers was murdered, two hun-
dred thousand people marched on Washington, and an Alabama
church was bombed, killing four young girls, all as American
military "advisers" were pouring into Vietnam, the very begin-
nings of the tides that would propel Bruno into the Alps ten
years later.

After graduating high school, Michael lived in a rented house
in Newport Beach with a bunch of other surfers, and in those
days it cost little, but real life tugged. Still, he didn't really want
to enroll in college, didn't know what he wanted to study, had
those itchy feet. His mother, who worked for the sheet metal
workers union, got him a job in a sheet metal shop in 1964
for the summer. He'd go to college that fall, he figured. On
the beaches of Southern California he was only dimly aware
of the details of the impending political and cultural storm, yet
he felt it, was part of it. It was swelling up within him just as it
was in millions of other teenagers of his generation, as it would
with Bruno. He was a Southern California surf bum, not a hip-
pie or a Beat; he wasn't hanging out in college coffeehouses
or listening to Dylan (he preferred Motown and Dick and the
Del-Tones) . . . but the war was coming, everybody could feel
it. He'd been taken with Henry Miller's *Tropic of Cancer* and its
bawdy tales of Paris, whose first official, legal American publi-
cation occurred in 1961. He hated authority and, like Bruno,
was tired of the straitjacket ways of his old man. He yearned for
something more than the working life his parents had strived
for, something greater than a nice house and a cabin cruiser for
the occasional weekend foray.

That fall a brief moment of inattention changed his life. At the
job his mother found for him, he worked a forming machine, a
giant piece of industrial equipment that bent flat pieces of sheet

metal into shapes. It was 3 p.m., late in the day, and he was tired, distracted, thinking of Roxanne and Valerie—his two girlfriends—and whether or not the surf was breaking that afternoon, and as he guided the piece of sheet metal into the former, the piece jammed. Just a little, but the smooth flow paused for a brief second, and he pushed harder. The piece shot forward along with Michael's left hand, both of which went straight into the high-powered rollers. When the metal and Michael's hand flew out on the other side in a flash, the last inch of his left index finger hung by a flap of skin. He exited the emergency room soon after without the last quarter of his finger. Years later he would say the gods had spoken, and their message was clear: *Michael,* they said, *you are not to work in a factory.* In fact, it would be the last real job he would ever hold.

Michael's parents were now divorced, his father's string of muffler shops gone sour. As 1964 came to an end there were twenty-three thousand American advisers in Vietnam, the Gulf of Tonkin Resolution gave President Lyndon Johnson unilateral authority to begin bombing North Vietnam, and Michael Palmieri received a $5,000 settlement for the loss of his fingertip. One hot sunny California morning in early 1965 the U.S. Army came calling: Michael was to present himself for a medical to evaluate his fitness as a U.S. soldier. He wasn't being drafted, not yet, anyway, but it was coming and he was against the war. It was time to go. He threw the letter in the trash, pocketed his five thousand bucks, hugged his mother, and headed south to Mexico. As with Bruno a few years later, it was the Army's call that finally sent him packing. Bruno accepted his fate and served his time; Michael escaped.

By the time the FBI knocked on his mother's door a year later, Michael Palmieri was so long gone, even she didn't know where he was.

Now, ten years later, as he headed up the Mahakam, he had
little idea of what he was doing, what he was after, his knowl-
edge and understanding of Dayak culture and its nuances not yet
honed. This was only his second trip up the river, and on these
early journeys he was mostly looking for handmade woven rat-
tan backpacks that were strong and supple and that every Dayak
carried. Back in Bali, where he'd moved a year before, the hip-
pies and surfers loved them and he wanted to buy as many as he
could, hundreds if possible, to sell back on the island's beaches.
On his first trip a few months before, he'd tried to get above
Long Bagun, but the river was too high, the rapids too fierce.
At a French logging camp he heard a pilot was coming in on a
floatplane and might take him past the rapids. The plane finally
appeared, made a low pass to check for debris. But as it came
in for a landing the tip of the plane's wing kissed the water and
Michael watched it violently careen upside down. Rescuers in
boats reached it quickly, but the pilot had been thrown out of
the plane and he was dead. And then, boom, the fuel slick bleed-
ing away from the plane exploded, thwarting Michael's dream
of traveling above the rapids.

In Long Bagun for a second try, he spent three days negotiat-
ing for a longboat and crew of three Dayaks, and buying supplies.
Diesel fuel. Rice and cooking oil. He'd been living in Indonesia
for a year now, had arrived after years in Goa and Kathmandu
and Kabul, and his Bahasa Indonesia was getting functional. As
roosters crowed and the sun rose, they set out on still water
in the twenty-four-foot boat. On and on they powered against
the current, the air-cooled long-shafted motor deafening. That
afternoon they hit the largest and most dangerous rapids on the
river. Engine screaming at full power, they surged against the
roiling current of boulders and standing waves. One boatman
stood at the bows with a paddle, fending off rocks and directing

the line, and another sat in the middle frantically bailing as they wove through raging whitewater. Not much scared Michael, but the rapids spooked him, provoking a bad feeling he couldn't shake. He thought of the dead pilot. But then the water calmed and they were clear at last. Michael was soaked and rattled but very much alive, and they motored onward, reaching the village of Long Pangai late that afternoon.

It was a fantastic, otherworldly place of people living in a long handmade wooden structure raised on thin stilts, accessed by notched logs, a dynamic community out there at the far edge of the world, and Michael felt like he'd crossed some gate into a land where everything was the same but everything was different. Inside, as he sat on the bare wooden floors, polished smooth from years of bare feet, as night dropped, the dwelling came to life. He was in a long open room fronted with a row of doors, each leading to the personal sleeping chambers and kitchens of individual families, the door in the center belonging to the kepala adat, the most important man in the community. Michael didn't understand what he was seeing, not yet, anyway, but it was all a blurry marvel. Beautiful women, pale and delicate-featured, with earlobes dangling bunches of heavy brass rings, some three inches past their shoulders, mostly bare-breasted, and finely muscled men. Skulls blackened from years of smoke hanging in baskets from the rafters. As a man played a four-stringed instrument called a sape, they passed around tuak, a liquor made from rice, tart and milky and smooth, and danced—one man or woman at a time, a slow stepping and turning, with hands clutching fans of black-and-white hornbill feathers. To shrieks and laughter Michael danced too, and he described Los Angeles, his hometown, and told them about American astronauts landing on the moon. At last people drifted off, the longhouse went silent, and Michael curled on the floor to drift off too.

He woke at 5 a.m. to roosters crowing and dogs barking, children shrieking, pans clattering. His hosts brought out rice, fish, eggs, and paku paku, the fiddleheads of wild ferns, and the wheeling and dealing began. The Dayaks weren't interested in cash—they had no need of it. That itself was a marvel. But Michael brought out a Buck knife, started cleaning his finger-nails with it. Did he want to trade something for it? a man asked. Michael might; what did they have? Baskets appeared. And so it went, as the men and women lost their shyness and it was clear Michael had lots of Buck knives, not to mention gold-colored earrings from Bali and batik cloth from Java, and slowly more and more bags emerged. A few small carved fetishes, but mostly baskets—that's what he knew he could sell back in Bali. After an hour of brisk trading, Michael and his crew packed the boat and set off upriver, repeating the process at every village, until they reached Long Apari.

On October 16, Michael's work was done; it was his birthday and he was happy—the boat lay heavy with goods and he wanted to head back downriver. Then the skies opened. It poured, as it can pour only along the equator, big heavy buckets of cold water gushing out of the sky in a torrent that obscured everything. The river rose quickly. All Michael could think about was those rapids ahead. The rain slowed and a thick, cold mist enveloped them. Then they heard it, the roar of water ahead. "Pull over to the banks," Michael pleaded to the boatman. "We'll unload the cargo and walk it past the rapids, and you guys can take the boat through first."

"Don't worry, Tuan," the boatman said. "We'll be fine!"

They hit the roiling whitewater fast, Michael's heart pound-ing. Waves crashed over them, giant white boulders loomed everywhere he looked, as they careened through the maelstrom. Then it happened. The boat slammed into a rock, swung vio-

lently broadside to the roaring water, and capsized. One second Michael was sitting amidships, the next he was under a violent blender of roaring water. He fought, he struggled, he was choking and gulping water, and his head popped to the surface for an instant and then he was under again, upside down, fighting to keep his feet pointing downstream, up and down, drowning, as sure of death as a man can be sure of anything, and then light and air and gasping and more water. He was in the belly of a dragon, the naga of Borneo, the water serpent, or was it Jonah and the whale, and then like Jonah the powerful thing that was eating him spit him out. Calmness. Floating. He was in flat water. Alive. He hauled himself to shore, crawled up the bank. Fifty feet upstream, two of his boatmen emerged from the flowing river, equally bedraggled. But of the boat and all of Michael's baskets and other tidbits and the third boatman there was no sign. Two days later the river gave him up, his swollen carcass floating to the surface miles downstream. Michael was alive, at least. His goods, a month of traveling and trading, were gone forever. But he would return as soon as he could, he vowed to himself, and he would go deeper. He had tasted something big and delicious and he wanted more.

Bruno Manser during his ten years as a shepherd in the Alps before traveling to Borneo.
(Erich and Aga Manser)

THREE

Bruno woke, heard those quiet voices. He stood, looked around in the green forest, saw no one. He called out and then saw them—two figures peering out from behind trees. Bruno spoke again. The man stepped closer; he wore long pants and carried a blowpipe. A woman stayed behind a tree. Bruno tried to explain himself in the bits of Malay he'd learned, where he was going, where he was from, but they merely turned and retreated into the forest. Bruno shouldered his pack, stumbled after them like a puppy, up a steep path. Up, up, after an hour of walking he heard dogs barking, and they stepped into a Penan encampment: thirteen people and two three-sided huts raised a few feet off the ground, made of thin branches tied together with rattan. A fire smoldered from the mud hearth of one of the shelters. It was a strange moment. No wild yelling or signs of amazement at this strange person in their midst. The Penan acted as if he wasn't even really there. He tried to shake hands, but the men and women avoided his gaze, brushed his extended palm with the lightest touch, the barest whisper of human contact. The men's legs just below their knees were ringed with thin strips of black rattan, other bands circled their arms just above their elbows, their wrists were thick with bracelets. Their hair was cut like mullets—bangs in the front, long below their shoulders in the back. Some wore traditional loincloths, others ragged gym shorts and old slacks from who knew where. The men had thick, powerful legs, the women long black hair. They had almond-shaped eyes and pale skin. The bare feet of both men and women

were twice the width of his, with splayed toes from a lifetime of walking shoeless in the slippery forest. He dropped his pack, fished out the last of the rice, offered it to them. Took out his wooden flute, played a song, gave them a Jew's harp as a present, noticed a man half hidden behind a hut carving arrows, light, soft flakes of wood falling around him. "He smiles when I greet him," wrote Bruno in his journal.

"Kumon!" a man said. Eat!

They gathered in a circle around a soot-blackened pot filled with a brown, gelatinous substance—sago, their primary carbohydrate—which they ate by spinning pronged sticks in the goop, lifting out small blobs that they popped in their mouths. A plastic bowl held tough, blackened meat, and then another pot appeared, this one filled with sago roasted in wild boar fat, which they ate with their right hands. They sat talking, laughing, as if oblivious to Bruno, the men carving arrows and the soft wooden plugs that fill the blowpipe and act like arrow fletching, and the afternoon ticked away. As darkness fell a hunter returned carrying a monkey and a bearcat, which were instantly thrown into the fire to singe off their fur. His hosts ate and ate—seven times that night—giggling and leaning on each other. They were thirty-five hundred feet high in the mountains. As the evening chill descended, the women built fires under the huts to warm the mangy, thin dogs shivering in tight balls against the cool mountain damp. Bruno couldn't understand the conversation, he didn't know the names of his hosts, he didn't know anything. But as fireflies flickered out in the dark forest, which hummed loudly with untold numbers of insect voices, and smoke curled among the heat of the bodies pressed together, he felt whole, complete, as if he'd found his place.

He had, in a sense, been preparing for this moment ever since he left prison.

When Bruno emerged from jail he briefly enrolled in the Plan-
tahof Agricultural School, and in June 1974 climbed into the
mountains near Nufenen, Switzerland, with a herd of thirty-
three cows, joined by his brother Erich, two years his senior.
Their destination was a simple wooden hut with no running
water or electricity above the tree line, owned by the farmer
whose cows he'd been hired to tend, for a life that seemed sim-
ple enough. Graze and milk the cows and make Alp cheese and
butter every day.

"The hippies all had this idea that it would be beautiful and
romantic," said Aga Manser, Erich's wife, who joined the broth-
ers sometimes, "all just lying in the sun in the mountains. The
farmers in the villages," she said, "they were very conservative
and they called us 'spinners,' crazy people no good in the head.
We were exotic! It was a happening, all these people from the
city like Bruno and Erich, some with long hair to their waists,
coming to the Alps, and they didn't know what we wanted, a
confrontation between the old culture and the new generation
who wanted to find a new kind of life."

"It was Bruno's idea first, of course," said Erich. "He wanted
to survive with nothing. He wanted to make his own leather
shorts, to hunt and to fish and to live with animals, away from
the system."

In reality, the life was brutal. When a friend joined the broth-
ers the following summer, he lasted a week. "It was too hard for
him," Erich said. "You have to be outside every day. Sometimes
it was raining. Cold. Sometimes it snowed and you couldn't run
away."

The brothers rose every morning at four, seven days a week.
They skimmed the cream off the milk gathered the evening
before to produce butter, built a fire, poured the milk into a
huge copper vat. The cows had to be rounded up and brought

back to the stable, then milked. "Sometimes we felt like we couldn't lift our arms afterwards!" said Erich. The milk had to be weighed, the amount recorded for the farmers, and then rennet added—curdled milk from the stomach of an unweaned calf. "You could buy the rennet," said Erich, "but Bruno refused to—he said we had to do it like the old ways—and that meant it had to come from the stomach of calves, and that was crazy; it was so much work." As they waited for the fat to rise they'd eat breakfast: bread, butter, jam, eggs, corn, and lots and lots of milk, "three or four liters right then, still warm, and it gave us power!" Next they'd divide the work: one would make cheese and butter, and the other would put the cows out and clean the barn and the milk utensils, and feed the pigs with the whey. Toward the afternoon they'd take the still soft cheese out, place it in salt water for twenty-four hours, then store it in a cave. They'd have to milk the cows again, then turn them out into the pasture for the night. "By 8 p.m. we were exhausted," said Erich. "Sometimes Bruno played guitar, but mostly we just went right to sleep, so we could get up at four again the next morning." They kept chickens and ten pigs, planted a garden of radishes and herbs and lettuce. "It was beautiful working with the animals, and since we were from the city, it was such a new experience for us."

As the days passed, Bruno took ever more dangerous hikes and climbs, always free-climbing without rope or harness. One day he and Erich were in the middle of their work when Bruno was seized by a sudden urge to scramble up Piz Ela, a nearly eleven-thousand-foot peak nearby. Erich pleaded no, they had work to do, but Bruno insisted and walked off the job, said he'd be back by 4 p.m. When he finally stumbled in the next morning, he was bloody and missing his backpack, with a typical Bruno story. Free-climbing a rock face, he'd pulled himself

onto a ledge from which he could move neither up, sideways, or even down. After trying through the long night, he'd finally somehow secured his backpack to the ledge and lowered himself down by it far enough to find a foothold and descend.

During the winters Bruno kept a rented room in the village of Nufenen in an old timbered house roofed with flat stone shingles, stacks of cordwood twenty feet high along its outside walls. He wandered far and constantly, visiting friends and relatives, exploring caves in France, learning to bake bread and work leather. After three years Erich left their life together and lit out on the hippie trail, living for the next two years in the Swat and Chitral valleys of Pakistan and Kabul north to Mazar-i-Sharif in Afghanistan. Bruno wouldn't budge, however, and in 1978, after four years with the cows, which required a working partner, he switched to the solitary life of a sheepherder, climbing up to a wooden hut the size of a one-car garage perched on the edge of a box canyon.

He arrived there on the first of July 1978 with his dog, Prinz, and 535 sheep, the details recorded with a ballpoint pen in his neat hand on the inside of the wooden door of the hut's closet. He would stay the next six summers, a period of beauty and solitude and backbreaking work, of becoming one with the animals and the environment. He rose before dawn, spending long days walking tens of miles up and down the mountains with his curved shepherd's stick and the sheep, which had to be constantly watched. He tanned his own leather, cut and sewed leather jerkins and lederhosen, made his own wooden backpack. Erich, returned from traveling in India and Afghanistan, and, ever inspired by his younger brother, took a herd of sheep to the alp on the other side of the mountain, and sometimes they hiked to the top to visit in the evening gloam.

In the summer of 1977, Bruno met Georges Rüegg. Ten years his senior, Rüegg stood over six feet tall, weighed two hundred

pounds, and had begun herding cows on a neighboring alp after
a six-year sojourn through North and South America. Rüegg
exuded a quiet strength and physical power, a self-confidence
that in later years made him one of the few people able to stand
up to Bruno. He had a deep well of experience and an articu-
late soulfulness; he had hitchhiked across America for years, had
wandered deep into South America, loved the natural world and
life on the Alps as much as Bruno. They met briefly at a dinner
held by a local farmer, and then, not long after, Bruno simply
appeared while Georges was sitting on a rock watching his cows.
"We sat and talked and talked and talked," Rüegg said. "We
talked about everything. History. Biology. Politics. Geography.
Women. Neither of us wanted things. We were collectors of
experiences. We both liked to collect songs and to sing."

Bruno, he said, "was always doing outrageous things." Where
they lived high in the Alps you could see anyone coming up
the paths to their huts for miles. "But Bruno, you never knew
when to expect him. He would never come up the usual path.
He'd climb up the back side of the mountain and sit there at the
top and watch you first, then appear suddenly in your midst. He
could never do things like anyone else."

Bruno learned to read the weather from the animals—when
the wild deer pranced and ran, snow was coming—and he
bathed naked in the rushing streams of melting snow. At a lit-
tle plateau jutting out from the steep hillside below the house,
he planted a grove of trees, which are now forty feet tall. He
carved a face in a tree stump and perfectly symmetrical swirls
twelve inches in diameter in the doors of the hut. His mother
and sister visited, friends came and went at times, hiking up
from the valley below. Once he and his little sister Monika
came upon a cow that had fallen and broken a leg. Bruno killed

it then and there, skinned it and butchered it. "He used to say that you should have everything you need to live inside a back-pack," Erich said, "and that if you wanted meat you should kill it yourself. If you wanted clothes you should make them." He kept ten goats, which liked to feed on the herbs in the highest, most precipitous mountainsides, and when it rained they often got stuck there. Yet they had to be milked every day, and Bruno would climb after them. And he hunted—poaching, in effect, because hunting was illegal in the Alps. "He would eat small animals," Rüegg said, "and say, 'God made everything and the animals are here. Why shouldn't we use it?'"

Bruno seemed a man without ambition, remarkably content to live for so long doing so little, in such a small world. But to say he had no ego, no ambition, was wrong. "Lately I've realized how far removed I am from the ideal of most people," he wrote to Rüegg. "I have come to terms with solitude in my own way. There is a profound sadness in this. It's true that I have certain gifts and skills that enable me to provoke oohs and ahs with a nature photo, a drawing or a crazy act. But I don't depend on superficial admiration anymore. If no one ever chal-lenges you, the game loses its appeal." Women loved him—he would meet them on his winter wanderings, and they would be taken with him, hike up to visit him in the summer. As they hiked down the mountain a few days later, they had no idea where they stood with him. He had a purity, a recklessness that attracted people, drew them to him, and a powerful ambition and competitiveness, not professionally, not with other men, but with himself. Up there in the Alps, "it is beauty and watching, watching until your eyes fall off, and being so intensely alive,"

said Rüegg. "But you are alone and you can't share it with any-
one and that makes you sad. We experienced so much. We were
close to the animals. Birds. Beautiful clouds. Eagles flying. That
created a cruel longing, not just in us, but also in the people
who met us. To long is a strong power for relationships. Bruno
had a lot of relationships, women who admired him because he
was so alone. He would share his diary with anyone. He didn't
keep it private. Women met him, read his diaries, said, 'How
can you do that?' We both had many very close relationships in
those days, but I'd say, 'You're not my girlfriend.' I was honest.
But he was a butterfly jumping here and there with women
who expected things from him and admired him and tried to
be there for him, to love him, but he would never confront
them. In that way he was weak. He was not able to stand tall
and say, 'Okay, I cannot be monogamous.' He avoided confron-
tation. That's why he and the Penan were soul mates, because
they both hated confrontation."

He—and Michael Palmieri too—craved original experi-
ence and a certain loneliness that came with it. "I had an aura,"
Michael told me, "when I returned from a couple of months in
Borneo. People looked at you differently and you felt different
from everybody else."

Bruno had a supreme belief in his own competence, a feeling
he had that he could do it, could read the risks, and he wanted
more, all the time, and that more for him came at first in climb-
ing trees and sleeping outside in the cold, as a child, and then
in the Alps in the form of work, plain simple work, and then
solitude. How much could he bear? And how many things that
he needed to survive could he make himself, and how far could
he walk? If all he really wanted was to live a quiet life, he would
have done so. He could have been a hermit, but he wasn't. He
was always on the move, always testing himself, poking, prod-

ding, learning. Did he plan to go to the jungle in those early days? Probably not. Did he plan to lead a revolt and become a saint? Definitely not. In later years he would be venerated for his selflessness, his generosity, his courage. But that was only part of his personality. He could also be self-indulgent, thoughtless, reckless. The rules didn't apply to him.

The idea of taking it all a step further grew in him on those long summer days in the Alps, the notion of going deep, somewhere, in some jungle, someplace of pure unadulterated nature. In late 1983, after his tenth summer in the Alps, in his local library in Basel he was researching nomads and stumbled upon a single photo of a Penan hunter with the caption "A hunter-gatherer in the forests of Borneo." He dug further but found almost nothing about the Penan, "and so I said," he would later tell an interviewer, "I want to go there." As luck would have it, he simultaneously heard of a British caving expedition planned for Sarawak.

The Mulu caves had first been discovered by Spenser St. John, then British consul general to Rajah James Brooke's kingdom of Sarawak, who tried to reach the summit of seven-thousand-foot-high Gunung Mulu in 1858. Around the base of the mountain St. John found "detached masses of limestone, much water-worn, with caverns and natural tunnels." He failed to summit, stymied by limestone cliffs, dense forest, and sharp pinnacles of rock. "It is almost impossible," he wrote, "to conceive the difficulty of ascending this mountain." It wasn't until 1932 that Mulu was climbed, and not until 1961 that G. E. Welford, of the Malaysian Geological Survey, first penetrated some if its caves. In 1978 Britain's most famous speleologist, Andy Eavis, as part of a fifteen-month Royal Geographical Society expedition exploring Mulu, surveyed thirty-one miles of caves, the start of many expeditions to reveal the underground formations as among the

largest on earth. Eavis returned to survey another thirty miles in 1980, and as he planned his third expedition to the caves slated for 1984, he received a note from Bruno asking to join the expedition. "They were the finest caves in the world and I had hundreds of people who wanted to come," said Eavis. "He sounded like an experienced caver, but I wrote back and said no."

Bruno didn't care. The caves were the most spectacular on earth and they were right at the doorstep to the Penan—the perfect excuse to get there. Bruno showed up anyway, at the end of his six-month sojourn in Thailand and Perhentian Kecil. "I was in base camp," said Eavis, "and I got a radio message from the forestry department that some guy named Bruno was there, trying to come up to the caves. I said, 'No! I told him he can't come!'

"'You have to take him,' they said. 'He's a tremendous Swiss cave explorer and we want you to take him!'

"The irony of it all is that the forestry department forced him on us. He arrived on the scene and initially we were cold and hostile to him. But the thing about Bruno was that not only was he a very interesting character, he was a very good, very skilled cave explorer. He could climb, he could swim, he could survey, and he soon became an integral part of the team. A lot of people talk, but he was just this really interesting, really competent human being who could do anything."

All of which meant that by the time he finally met the Penan at the ripe age of thirty, Bruno had been climbing trees and catching bugs and snakes and sleeping outside and marching up mountains and exploring caves and sneaking up on elephants for a very long time. He had been practicing all of its component parts for so long that the Penan recognized in Bruno, as did

Eavis, competency. Not the usual inept westerner in the forest, someone who got lost and couldn't find food and was entirely dependent on them, but—strange as it might sound—a kindred soul. And Bruno plunged right in, his back turned to the West, the rupture complete.

Michael Palmieri on a dhow sailing across the Persian Gulf to Iran in 1967.
(Michael Palmieri)

FOUR

Three years after Michael Palmieri hugged his mother good-bye in Los Angeles, he was on the move again. It was late June 1967, just weeks after the Six-Day War in the Middle East, and he sat huddled next to the binnacle of a wooden sailing dhow crossing the northern end of the Persian Gulf bound for Abadan, Iran. As usual, he was traveling light. A pair of blue jeans. A double-breasted navy pea coat. A pair of boots. A white cloth Ibiza bag holding a single change of clothes. That was it, except for thin wafers of gold sewn into the waistband of his blue jeans. June though it was, a cold wind whipped the Gulf into whitecaps, and Michael wrapped himself in his pea coat as spray and spindrift flew over the gunwales. Against the bulwarks around him sprawled men in turbans and heavy over-coats, and right in the center stood the helmsman, hands on an old spoked ship's wheel. A thousand and one nights. Persia. The footsteps of Alexander the Great. He was eastbound, free, his head filled with wanderlust and an exotic fantasy that had to be sated.

Like Bruno heading into the Alps for the decade after his release from prison, Michael too was deep into a ten-year sojourn that would lead him to Borneo. Michael was always handy with a camera, and over countless evenings in his house in Bali he dug more and more photos out for me, pictures of a journey so improbable it seems made up. Except it wasn't.

From L.A. that day when he said goodbye to his mother back in 1965, he'd jumped in a VW van with his friend Timmy and a bunch of other guys and headed to San Blas, Mexico, and then Mazatlan for a few weeks of surfing. He had no real plan, just a deep curiosity about the world, a hunger for experience, and a vague urge to get to Europe, France in particular, the citadel of romance in his mind. Not to mention his desire to escape the draft. In Mazatlan he and Timmy grabbed a bus for Veracruz, Michael paying for both of them, the $5,000 burning in his pocket like a bonfire. From Veracruz they shipped out to Cadiz, Spain, on a Panamanian-flagged freighter, where they chipped rust in the hold for the ten-day passage. Arriving in Cadiz, they took their pay in cash and stuck out their thumbs for Paris, where they crashed in the cheapest hotel they could find in Montparnasse.

"That was how it all started," he said, pulling out a photo of himself in a black turtleneck and vest, his hair glossy and black, leaning on a wrought iron Parisian balcony, looking so handsome and hip a stylist might have been standing just off frame.

Timmy soon disappeared. Michael moved to a room on the rue de Buci in the heart of Saint-Germain-des-Prés, enrolled in language classes at the Alliance Française, stayed ten days, got bored, dropped out. Wandering the streets he met a girl sitting on the sidewalk, a beautiful French hippie playing folk music on her guitar. He fell in love for a spell, and the next thing he knew he was speaking French and wooing one French lass after another with his cowboy boots and athletic good looks and they took him in and called him "mon petit cowboy" and life tasted sweet. By the early spring of 1966, his money gone, he headed to Alicante, Spain, hoping to crew on a yacht. He quickly found a big old schooner owned by a German couple. He swabbed the decks and hauled sails and served the guests as

they sailed the Mediterranean. The Balearic Islands. Sardinia. Corsica. Then Ibiza, full of musicians, artists, writers, hippies, junkies, a new vision of paradise for Michael, and where he ran into an old friend.

"Michael!" the friend said. "Oh my God, the timing is fantastic. I have three beautiful rich women, help me out!"

The friend took him to a luxurious villa overlooking the sea in Santa Eulària des Riu, owned by a forty-year-old French woman with a rich husband back in Paris. She reminded Michael of Simone Signoret. Her husband was elsewhere, and she took a shine to Michael, as women did. Michael jumped ship. They played all summer—Casablanca, Madrid, the Canary Islands—a young boy toy on the arm of an elegant woman. Cafés and shopping trips, and then September rolled around and she said, "Le soir est fini!"

But Michael had a Pierre Cardin sports coat she'd bought him in Madrid, nice shoes, a bit of money in his pocket. He flew back to Paris. And as fall turned to winter and his money dwindled again, he got an idea. He'd get someone else to cash his last $500 in traveler's checks, then report them stolen and double his money. In the Café Buci he befriended a young Moroccan, told him his scheme, said, "I'll give you a percentage." It was cold now in Paris, snowing, and Michael was in his Pierre Cardin and the Moroccan was wearing an old khaki-green coat full of holes, and they walked to Le Bon Marché, a big department store where, the plan was, the Moroccan would buy a few inexpensive items to effectively cash the checks. As Michael handed them over, the Moroccan said, "Wait a second. I'll look better if I'm wearing your jacket."

In short order the situation became clear: Michael would never see his traveler's checks or his Pierre Cardin jacket again. Penniless in the snow, he trooped to American Express and reported

the checks stolen, this time for real. His fantasy life was souring. He slept in cars and under bridges, was desperate, and couldn't go home because the Vietnam War was heating up and the FBI was now banging at his mother's door.

But fortune always had a way of smiling upon Michael, and that's when he met Rank Rick on the streets of Montparnasse. Rick was from New York, and he said to Michael, "I want to show you something. Come up to my room." Michael did, and Rank Rick opened a suitcase full of dollars, pounds, deutsche marks, French francs. Michael had never had seen so much money in his life. "Want to make some money?" Rick said.

"Yes! Of course!"

Rick explained his scheme, which involved flying to Lebanon and importing some contraband. "It's easy," he said, "you've got nothing to worry about."

Michael was always game in those days. He was twenty-three years old, heedless of consequences, fearless, hungering for intensity. Why not? They flew to Beirut, rented a car, and drove up to Baalbek, to a farmhouse lit with flickering kerosene lanterns. Rick made the deal, they drove back to Beirut, and Rick handed him a suitcase and an airplane ticket. "I'll meet you in Paris," he said.

Michael suddenly felt nervous, a moment of fear, but what the hell, he needed the money and he felt immortal and his luck had always held up and his third eye was pulsing, telling him to go for it. He approached the counter, handed the suitcase over. Overweight! No problem. He paid the overage, flew to Paris, and sailed through the nothing-to-declare line to find Rick waiting for him with two thousand bucks.

Nineteen sixty-six turned to 1967 and he was bored with Paris. He had that itch, and couldn't stop thinking about the exotic East, especially India. His taste for adventure and expe-

rience and risk was growing. In this way he and Bruno were the same. The cultural ethos they inhabited had broken down; the post–World War II Western dream of faith, family, a good job, those all–important milestones of success, was unraveling around them. The script had been the same for decades: a young man graduated from high school, maybe he joined the military, maybe he went to college, then he got married and settled down with a wife and kids and a house in the suburbs. Those were the rituals that young men went through, that defined them, that made them grown-ups, members of the Western tribe. But those rituals had suddenly lost their meaning, their relevance. In tribal societies pubescent boys became men by having their teeth knocked out or undergoing painful scarifications or circumcisions; in the world of the Dayaks they raided villages and took heads. They left their old bodies, their childhoods, behind and became adults, as had their fathers before them. But Michael and Bruno didn't want to be their fathers. They had sprung from a group, a tribe, that they didn't feel a part of any longer.

Michael stuffed a change of clothes into his Ibiza bag and bought a third-class train ticket to Naples, there to catch a Turkish Maritime Lines ship deck passage for Beirut. Like Bruno, he would test himself over and over, undertake ever-riskier endeavors. Wandering the alleys of Naples, he came upon a Gypsy with three cups and a marble—yes, that old trick, which he hadn't seen before—and in short order once again he'd lost much of his money. Someone told him if he had a gun he could sell it in Beirut. He bought a Beretta 950 semiautomatic .25 caliber pistol and climbed on board the ship and slept on deck. Stars. Blue waves. Athens. Istanbul. Beirut, where he sold the gun and pocketed the profit. A dolmuş, a public communal taxi, to Damascus, then on to Baghdad, where he checked into a cheap hotel in the old quarter. It was June 5, 1967, and Israel swept

into Egypt and Syria and war broke out and the police arrived, rounding up foreigners and herding them to a five-star hotel for deportation to Cyprus. But Michael had a way with people. He wore his hair short and he shaved every morning and he looked like a movie star, not some dirtbag, and a friendly police officer let him continue on to Kuwait. Which he did, hitchhiking in the back of trucks, arriving in the old harbor to find an encampment of a few dozen foreigners living in Bedouin tents. He stayed for weeks, selling his blood every three days at the hospital and buying one-ounce gold wafers with the proceeds. And at night the Kuwaitis would swing by the encampment and scoop them up in their Mercedes and take them out to their desert party tents for long nights of drinking and dancing.

He crossed the Gulf on a blustery day in 1967, sailed upriver to the port of Abadan, Iran, where he caught a truck for Isfahan, and from there across a mean, hot desert, sometimes riding in the bed of the truck, sometimes in the cab. They drove for days across sand-blown roads, sleeping under the truck at night, eating flatbread and goat cheese and hunks of halva. To Kerman, to Zahedan, across the Pakistan border to Quetta. He paid for nothing, slept in people's homes and ate their food, and then it was on to Kandahar, Afghanistan, and every day was better than the last. Every day was amazing. He was smoking hash out of chillums and wandering dusty streets full of men in pakul hats and turbans under a giant sky.

Michael was the tip of the spear; over the next few years a new tribe of hundreds and then thousands of Western hippies would follow his path across Iran overland into India and Goa and Kathmandu. But in the summer of 1967 he had the adventure largely to himself. In Kabul he found a café down in the old city center, by the Kabul River, with high ceilings and dirty

floors and men in shalwar kameezes and balloon pants and vests and pakuls or turbans, the whole panoply of Afghanistan, drinking tea and smoking hookahs at little tables, served by waiters in white jackets with frayed cuffs. He could sit there for hours and never get bored.

One afternoon, a tall Afghan strode up to him, leaned over his table, said, "My master would like to invite you for tea." As he did so Michael noticed a pearl-handled pistol tucked under his waistcoat. He pointed across the café to an Afghan who looked about the same age as Michael, wearing Levi's and a sweater.

"My name," the man said, "is Shah Mahmood Khan. Where are you from?" He spoke excellent English.

"California," Michael said.

"I've always wanted to go there."

"Where'd you learn English?"

"In England and France."

They shot the shit, the usual traveler small talk, and when Michael asked where he lived, he said, well, a really big house. "Would you like to come over for dinner tomorrow?"

Michael did, of course, and he was picked up the next day in a Mercedes limousine and brought to a hulking concrete house fronted with armed guards belonging to Mohammed Zahir Shah, the king of Afghanistan, who'd ascended the throne in 1933. Khan, it turned out, was his son. Michael didn't meet the king that night, but they ate sticky sweets in a library full of leather sofas and drank Johnnie Walker on the rocks. Khan was just three years younger than Michael, had been educated in Europe, and felt a thirst for the West. He liked Western clothes, Western cars—to him it felt exotic, sophisticated. For the next week they met at the café every day, and Michael told him about America, and the prince trundled him around Kabul, and as

Michael prepared to leave for India the prince said, "When you come back, find me."

Michael moved on. Kabul to Jalalabad and through the Khyber Pass to Peshawar to Rawalpindi to Lahore to New Delhi, India, where he sold his gold in the markets of Chandni Chowk in Old Delhi, a tangled bazaar full of smoke and the smell of marigolds and shit and sweat and it felt ancient to him, the world magnificent.

After two months of wandering, he headed back to Europe via Kabul, rendezvousing again with Shah Mahmood Khan. "Let me show you something," the prince said. They went to the big house again and Khan ushered Michael into a garage filled with cars. The long black limo. A Porsche. Lots of Mercedes. "Everybody in Kabul wants one of those," he said. "If you want to make some money, go get a Mercedes and drive it here and I'll help you sell it. Four-door. A sunroof. I'll handle it and you'll make a good profit."

That sounded good to Michael, who promptly went out and acquired a range of goods, from old Afghan jewelry to other "things," which he stashed in the false bottom of a suitcase. This time not across a single border, but across five: Kabul to Herat to Mashhad to Tehran to Tabriz to Istanbul to Sofia to Belgrade to Paris. It seems hard to fathom now, almost suicidal, but those were the days before hijackings, terrorist bombings, the war on drugs. Travelers were welcome in Iran, Pakistan, Afghanistan. Borders were open, no one was looking for anything, and guards just waved Michael through. Michael sold his goods in Paris, took a train to Frankfurt, bought a six-year-old four-door dark blue Mercedes sedan, and drove it overland back to Kabul, a round-trip journey of nine thousand miles. The prince promptly brokered the deal and Michael made a 300 percent profit.

He did it again. And again. Seven times in all, seven epic nine-thousand-mile overland round trips between Germany and Kabul, goods of one sort or another one way, the car the other, and each time he bought a better, newer Mercedes, and each time he made more profit. He started buying more jewelry; Michael had a good eye for beauty, for symmetry, and Afghanistan was full of old silver necklaces and bracelets and nose rings filled with lapis and turquoise that he bought by the kilo and that fetched a tidy profit in Paris. The process honed his eye, laid the foundation for his later dealing in tribal art. Had he settled down, had he studied art at university—even for a bit—and wrapped himself in the cloaks of a scholar, he might have gone to work for Sotheby's like Bruce Chatwin, who himself never managed to earn a degree. That he appeared a pirate, a buccaneer of sorts, in the eyes of some was only because he lacked a certain gloss, a pedigree. In truth Michael's hands were a lot cleaner than many in the art and antiquities market; he bought objects from the source, unlike many of the top-society dealers who turned a blind eye to the provenance of their merchandise.

In Paris in 1968 he watched the city unfurl in a burst of violence, threw a few bricks himself.

And then in 1969 in Kabul, in the midst of his fourth trip, the prince met Michael in their café, said, let's take a walk. As donkey carts clip-clopped by and the Hindu Kush rose in the distance in that special Afghan air that was at once clear and smoky and crisp, Prince Shah Mahmood Khan lit a cigarette and leaned in close. There were problems, he said. His father's cousin, Mohammad Daoud Khan, who had served as prime minister until 1963, was making trouble. The Marxist People's Democratic Party of Afghanistan, under the aegis of the Soviet Union, was growing in strength; religious fundamentalists, too, were agitating, and

the king's family feared for its future. (Rightly so—Daoud would
seize power in a coup in 1973 and the Soviet Union would invade
six years after that.) The prince knew that Michael had been
ferrying jewelry and other things to Europe—he reveled in the
tales of his American friend—and Michael had proved reliable
with the cars. We have some items we want you to carry to
Europe, the prince said. We'll pay you well.

What? said Michael.

Jewelry, said the prince. Family jewelry. A suitcase. You can
carry it on the plane. We need someone with no connection to
the family, no political agenda, someone we trust.

Michael took a breath, a big drag on his cigarette. Said okay.

It happened fast. The prince took him to a tailor in Kabul. New
slacks, a sports coat, and a light blue shirt with button-down col-
lars. Bespoke. Took him to a barber for a tidy haircut. Michael
left Kabul a few days later in a black Mercedes with little Afghan
flags flapping from the front fenders. Him, the driver, and two
Afghans he'd never met. To the Pakistani border, cruised right
through. To Rawalpindi to the airport in Peshawar. There he
and one of the men flew to Karachi. The man was big, serious,
didn't smile, didn't joke, looked to Michael like a Hollywood
Mafia hit man, and he carried a black leather bag, like a doctor's
satchel. They spent the night in Karachi, where the man said, I
have a ticket for you. To Geneva. Tomorrow.

I want to see what's inside the bag, said Michael.

No, said the man.

I need to see what I'm carrying, said Michael. I can't do it
unless I know.

They went to his room. He opened the bag. Some of the
pieces were in little silk bags, others in boxes lined with velvet.
A tiara. Earrings. Brooches. Bracelets. Necklaces. All studded

with rubies. Sapphires. Diamonds. Big stones. Giant stones. Like pieces in the Louvre. Michael had already seen a lot, yet the things on the hotel bed blew his twenty-six-year-old mind.

They drove to the airport the next day, Michael in his new clothes, his shoes shining. He checked his personal suitcase, and only when they got to the departure lounge did the man hand over the satchel. Michael had carried all sorts of things across more borders than most people ever crossed in their lifetime, but this time he felt gripped with nerves. His heart thumped, he broke out in a cold sweat.

Don't worry, the man said, putting his hand on Michael's shoulder, looking him straight in the eyes. It's all been taken care of. When you arrive in Geneva, someone will meet you at the airport and you'll give him the bag and he'll give you the money.

Michael was on his own. Minutes later he was sitting in first class, the crown jewels of Afghanistan between his feet.

In Geneva he walked smoothly through customs, collected his bag, and there stood another Afghan in a suit with a sign, "Mr. Palmieri," as if he was arriving for a convention.

Michael kept the bag. They drove to a hotel. Went to a room where the man put everything on the bed and checked each piece off against a list in a little bound book. Okay, he said, when the last piece was counted, and handed Michael an envelope of hundred-dollar bills. A lot of them.

It was springtime. Michael flew to Paris for a few months, then went to Germany and bought another Mercedes and drove it back to Kabul. Made another jewel run, same as before, same guys, bought another Mercedes and did it all again.

By 1969, Michael had so much money he walked into a Ferrari dealer on Rome's Via Veneto and bought an aqua twelve-

cylinder 1963 Ferrari 250 GT SWB Berlinetta. With cash. Which he promptly drove to Bremerhaven, West Germany, and then shipped to Los Angeles.

Here Michael's life becomes a blur that's hard to keep track of, a haze of countries and airports and parties as he shot around the world like a silver pinball igniting the map in a psychedelic glow. Feeling invincible despite his draft evasion, Michael followed his Ferrari home to L.A., his first time back in the United States in four years. He was rolling in cash, had a closet full of European clothes, was as handsome as ever, drove that lovely, powerful car with its Pininfarina curves and little air scoops in a city of glam, rented a house on a ridge in Laurel Canyon. He partied at the Candy Store with Jim Brown the football star, Warren Beatty, the up-and-coming Don Johnson. Jay Leno, he said, pestered him, always jealous of his car and his women. He palled around with Bernard "Bernie" Cornfeld, an extravagant mutual fund king, who, according to his obituary in the *New York Times,* shuttled "around the world from his ancient French castle with a coterie of celebrity jet-setters" before attracting the attention of the Securities and Exchange Commission and numerous prosecutions and lawsuits. In the midst of all this, Michael would jump on a plane for Europe, get a new Mercedes, drive it to Kabul, still making his last runs for the Afghan royal family. Then he met a long tall Cajun brunette wannabe actress from Baton Rouge named Danielle and bam, he fell in love. Crazy love. All-consuming love. Fuck it all, they said, and in 1970 he unloaded the Ferrari for a song to a Beverly Hills doctor and jetted to London and got married in a ceremony straight off the *Sgt. Pepper's Lonely Hearts Club Band* album cover. Velvet tuxedo with ruffles and flounces spilling out of his sleeves under a black cape. Hair to his shoulders and a curling mustache. Danielle in

a long white silk dress and white flowers in her cascading hair, beneath a little white bonnet. They bought a Morris Mini with wood siding and drove to Ibiza for a long honeymoon, then to Italy, where they met the fashion photographer Franco Rubartelli, who shot Danielle and sent them on to Milan to Ricardo Gay, who had a modeling agency. The wheels turned, the stars aligned; Danielle was soon modeling and appearing in TV commercials and getting into drugs, heroin, which Michael wanted nothing to do with. One morning he wrote her a note, said he was out of her life, was heading to India. He left everything and climbed on a bus to the train station. Went to Switzerland, bought a used mail truck, ripped its insides out, welded it full of hidey-holes, and started on his way to Kabul. But he decided to pass through Milan en route and say hi to Danielle, who wrapped her arms around him and said, I'm coming with you.

It was 1971. They drove to Kabul, loaded up on stuff to sell, drove to India, which was now full of hippies, drove to Kashmir, rented a houseboat on Dal Lake, where they lived in splendor with an albino houseboy. And what the hell, they got married again on Dal Lake in a gondola, both dressed in drapey, flowing white Indian clothes festooned with garlands of marigolds and beads, Danielle's ankles cosseted with bangles. Then headed down to Goa, to Anjuna Beach, where the tribe was assembling. Life there was like a hippie dream and they unloaded the goods and camped right on the beach and they danced and sang under the starlight. Michael was still winging it, though, here, there, everywhere. He took a house in Kathmandu, did a last jewel run for the royal family before the coming coup, started a clothing business out of New Delhi with an American business partner and his Hong Kong wife, a designer, started buying antiques and more jewelry in Rajasthan, bought Tibetan thangkas, car-

pets, bronze statues, antiques from Tibet and Nepal, and opened
a gallery near L.A. with the American partner. Danielle suc-
cumbed to her taste for drugs and peeled off. Michael made the
mistake of sleeping with his business partner's wife at an acid
party in the Fonseca Hotel in Delhi. The husband found out
and shut the business down and took everything, every penny.
Whatever. Michael was a whirling dervish: going up to Kash-
mir, Kathmandu, southern India, Bombay, Calcutta, buying
antiques, traveling for adventure, hanging by the Ganges River
and watching cremations. For half a decade he'd been a smug-
gler and had to look straight, his hair always short and well kept,
his face neatly shaved except for a little mustache. But in India he
surrendered, let it all go, grew long straight hair past his shoul-
ders, a beard, draped himself in beads.

It was around this time, passing through Delhi and having a
drink at a café, that Michael met a man named Charles and his
French wife. Charles was Michael's age, handsome. Charming.
Of indeterminate but vaguely Asian ethnicity. He spoke perfect
English and French. The couple wanted to buy him drinks, take
him out. Michael liked to party, loved to socialize, was usually
up for almost anything. He couldn't say what it was, but this cou-
ple gave him the creeps—his third eye again blinking, this time
big warning signs. He ran into the couple two or three times
on the hippie trail in India and each time he rebuffed them. It
just didn't feel right. Which was a good thing; a few years later
Michael recognized his picture. It was Charles Sobhraj, an infa-
mous serial killer, eventually convicted of twelve murders, who
preyed on his first victims on the hippie trail after escaping from
prison in France.

In 1973 he went to the Kumbh Mela, the once-every-twelve-
year mass Hindu gathering in Haridwar, the largest coming

together of people anywhere on earth, on the banks of the Ganges, and he was living in a tent when in walked a five-foot-ten blonde with hair past her waist and eyes the color of turquoise. She was draped in Rajasthani beads and necklaces, with long earrings, and again Michael flipped. Danielle had been gone eighteen months, and this was love at first sight. It was meant to be. It was fate. She was from New Jersey; her name was Erma Loraine Ferintinos. Michael's mother was Greek, her father was Greek: to Michael they fit together perfectly. She'd been traveling the hippie trail through Afghanistan and ended up living in Afghan villages, where she'd assumed the name Fatima. To Michael she was so beautiful he was certain even women couldn't take their eyes off her.

After three weeks at the Kumbh Mela, Michael and Fatima headed to Goa. Most of the hippies lived in shacks on the beach, but Michael had money—he always had money—and they rented a white stone house with a roof of red clay tiles on a bluff overlooking Anjuna Beach. They set up house in the mecca of hippiedom. There were no police. No authorities. LSD. Hash. Opium. It was all sold and consumed openly. The tribes streamed in from America and France and Italy and Spain and Switzerland, young and beautiful. The only thing that kept them in line was a 1960s-era understanding that they had to police themselves. They held full-moon parties that went on for days. Walked naked on the beach, slipping on the skimpiest loincloths for trips to the market. "We were all brought up in Western cultures," Michael said. "Taught to think a certain way. We were war babies. Baby boomers. But in Goa we found a totally different lifestyle with no authority. For the first time in our lives we were free. We had cut our chains loose from society and began our own society, our own clan. Just our peers; if we did something wrong, you

answered to your peers. You fucked up. Chill. It was all about going within, leaving your body. Meditation. Yoga. Elevating your shakti through your chakras. Sex drugs and rock and roll and then you'd go clean yourself in an ashram." The Goa season lasted from December to February, then they all moved to Kathmandu, then Kashmir and the cool mountains during the heat of the summer, then back to Goa again. Michael's photos from Kathmandu look like a fantasy, a hippie culture so iconic it appears make-believe. Crowds of young people with long hair playing flutes. Beating drums. Smoking weed. Beads. Bindis on their foreheads. Guitars. Women dancing with flowers and feathers in their hair and hairy armpits. Men in orange shiny shirts. Tie-dyed pants and sandals. Beards. Leis. Garlands. Guys with blue eye shadow and big red hibiscus flowers behind their ears and red tribal marks on their bare chests.

The hippie utopia of drugs and communal beach life was cracking, though, real life catching up. It was 1973. Heroin was everywhere, a serpent in the grass of paradise, and one after another too many of the tribe succumbed. That's when he and Fatima met Perry Kesner. Perry was the son of a New York used clothing dealer who'd dropped out of college, had lived in caves in Crete, and found his way to Goa. He had tales of a new place, a place that wasn't really on the hippie trail just yet, a place he said was better than all others: the island of Bali. One look at Perry's photos and there was no question. In early 1974, Michael and Fatima headed east, and his rupture, too, was complete. He would never again live in the West.

II

IMMERSION

The voyage will not teach you anything
if you do not accord it the right to
destroy you—a rule as old as the world
itself. A voyage is like a shipwreck, and
those whose boat has never sunk will
never know anything about the sea. The
rest is skating or tourism.

—NICOLAS BOUVIER, *LE VIDE ET LE PLEIN*

Bruno Manser in a Penan hut, Sarawak, May 1989. (James Barclay)

FIVE

The day after Bruno made contact with the Penan, they moved camps. Beneath heavy rattan backpacks stuffed with sago and meat, a few blackened pots, bamboo containers holding water and boar fat, with the littlest children perched on the very top of the loads, the nomads set off. Poison arrow quivers and machetes dangled from thin strands of rattan around their waists, and in their hands the men and boys carried blowpipes. It was everything they owned, the sum total of their worldly possessions. Even under heavy loads they hiked with power, descending narrow, muddy paths, climbing up and along ridgetops, a pack of mangy dogs yelping and barking among them. They didn't move far; after three hours they stopped near a barely trickling stream and reconstituted their material world.

Bruno watched in wonder. The Penan were as much a part of the forest as the trees or the birds or the ants or the rain. Their home wasn't a house. It wasn't a village or town. It was the forest as a whole. All of it. Everything they needed was there. With little discussion and incredible efficiency, like birds building a nest, men and women worked equally and swiftly, felling a multitude of the thin, straight-trunked young trees that everywhere fought for space under the high canopy, and gathering long strands of hanging, pliable vines the thickness of a human finger. They had been doing this all of their lives, as had their parents and grandparents, and they didn't waste a single motion. Two hard swings of the machete on each side of the thin trees to cut them; the bottom cut created a sharp point, the top a V. They drove

six uprights into the soft ground, one pair of limbs in the center four feet taller. Bound cross-pieces four feet above the ground, upon which they laid a floor of wrist-sized, bouncy limbs. Tied a second set of beams in the Vs to create the main roof joists. A quick sharp cut in the centers of long branches the thickness of two fingers left the branches hinged but not severed; those they laid twelve inches apart across the joists as slanted roof beams, the bent elbows resting on the high center joist. They laid fans of leaves over the beams to make a waterproof roof, hung leaves to create walls on three sides, the roof extending over the open face of the structure to form wide eaves. A notched trunk gave them a ladder, a small platform to one side created a hearth with a smoking rack above. In thirty minutes three brand-new houses with nary a nail or store-bought product stood in the forest.

Nearby Bruno tied his hammock between two trees, with a tarp over the top.

The Penan were shy and wary. It took him ten days to begin learning some of the men's names; the women, he wrote, "guard their names like a secret and one small boy screams like he's being tortured when I come closer."

A week later, though, the men let Bruno accompany them on a hunt. They tracked wild boar for six hours, Bruno slipping and falling, his body covered with mud and scratches, having to cut his way through the underbrush, while the Penan seemed to slide through it like wraiths. They walked effortlessly, with bare feet and those splayed toes that gripped the mud or fallen tree branches, following boar droppings, sighted a monkey in a tree and in a flash a hunter raised the pipe to his lips and fired with a giant breath. Their aim was uncanny. The monkey was hit, but climbed higher; the Penan whispered, worked together, and fired off arrow after arrow. After a few minutes the poison took effect and the monkey fell like a sack to the ground. They

cornered a boar, hit it with numerous arrows, chased it through the brush for thirty minutes, until it too collapsed dead. The boar weighed over one hundred pounds, and the Penan tied its hind legs to its forelegs and carried it like a backpack, the legs looped around their shoulders. Bruno carried the monkey, hoping its fleas wouldn't migrate to him.

"Medok! Medok!"—Monkey! Monkey!—kids yelled when they returned to camp. "Everybody wanted to touch it and lift the heavy prey at least once." The women fanned the always smoldering coals, burned and scraped off the fur, cut it up and gave half to the other hut—all food, no matter who obtained it, they shared equally. "When the father removed the eyes from the skull all the kids put out their hands begging for the delicacy," Bruno wrote. "The brain is also reserved for the women and children. With wooden forks they get pieces from the cracked skull."

Days turned to weeks. Bruno spent his time recording everything, sketching the pattern of a cicada's wing, how a dead gibbon's hands were tied so the animal could be carried, how the Penan drilled six-foot-long, perfectly straight holes to make a blowpipe. He hunted with them, watched them carve arrows, and studied their language. He learned to make cups for drinking water out of leaves and tongs out of split wood and leaf fans for bellowing coals. He learned how to read the signs they made as they walked: five notches in a tree meant five Penan were on the march; a cut branch indicated their direction; the longer the branch the longer the distance they were traveling. Leaves placed on the track back-to-back pointing in one direction meant "I'm walking forward, hurry and follow in this direction—we desperately need help, someone is sick." A small piece of wood wrapped in a leaf and clamped in a branch represented a blowpipe and the leaf the skin of a boar.

Except for a few pots and pans, the occasional ragged pair of slacks, and the steel of their parangs, all of which they obtained on occasional trading forays to the closest Dayak villages, they lived in a world without commerce or manufactured things. They lived without schedules or clocks. If they weren't hunting or cooking or whittling new arrows, they sang and played simple flutes with their noses and mouth harps that they created in minutes. The Penan "live completely in the moment; they have no calendar and don't know their age or place of birth," Bruno noted. "They don't hoard any food. If their belly is full today, they're happy, with little reason to think about tomorrow. When all work is done, dreamy sounds come from one or the other hut. Soft melodies find their way to my ears." Bruno felt suspended in time in a vast forest alive with constant sounds, the always wet ground crawling with ants and termites, the air busy with moths and butterflies and buzzing cicadas. Hornbills flew over the canopy, the beat of their big wings sounding like a train rushing by. Torrential rains poured down, soaking everything; damp, cold mists rolled through in the evening and the morning. At night the forest blinked with fireflies, and sometimes the fungus on the trees glowed a haunting green. Bruno seldom saw beyond the trees. "Usually the leaves . . . obscure the sky, so they have no relation to the night firmament. They don't even count the moon and the Penan don't think of years; time is an insignificant factor. . . . Only one thing is for certain. If the trees are full of fruit then the wild boars will also collect in hordes and they can expect a fat prey for their hunts." Indeed, the Penan lived to hunt and to eat; everything else was secondary. They gorged on meat and sago and fruit, seldom ate vegetables, which didn't grow in the heights at which they preferred to live, barely ever drank water.

In the evening, they sat against each other, gathered around

flickering lights from flaming amberlike pieces of damar tree resin that smelled sweet and piney, "speaking with humor about all of my questions and imitating what I'm doing while all laughing vigorously.

"The Penan are quite shy and never look you in the eye. Even when one greets you he looks away. Only the little girl Seleng, who may be about two years old, is exactly the opposite. She always looks for me and she likes to rub against me and she looks me in the eye so closely the tips of our noses almost touch. What secrets her eyes hold. The secret of life itself! But the small naked girl is covered in soot from head to toe like a child of the devil. There's probably tons of lice in her hair. . . . [But] the heart of the soul appears to be closed by doors, the key to which a little child can hold in her hands, or an indigenous person somewhere far away from civilization. Moonlight shimmers through the leafy forest; 'bad moon we don't want you!'—it indicates rain as the white moon indicates a clear sky. Soon drops drip down from the dahoon leaves. The sounds of pagang, a bamboo string instrument that only women play, have fallen silent. The people are tired. Kijang is weaving a bag from rattan in the glimmer of the resin light, whereas two men talk at the fire that has almost extinguished.

"There is no wild chaos in the jungle. Life develops according to a law that is inherent in nature. Even the smallest creature has its very specific living space. The many relationships form a harmonic whole that we as modern people only interfere with all too often."

As the weeks unfolded and he became increasingly proficient in the forest, Bruno said goodbye to his hosts, spent a few months across the border in Kalimantan to explore the Penan

there, but found them already settled. He returned to Sarawak
and began using the Kelabit Dayak village of Long Seridan,
which had an airstrip and regular mail service, as a base for long
forays into the forest to live with different bands of Penan in the
remoter upper Baram and Limbang watersheds, and it was there
that he would forge his deepest bonds. He recorded their stories
and fables, about the ghosts and spirits who were everywhere,
how the barking of dogs kept away malevolent spirits, and how
to imitate the sound of the argus pheasant and other birds who
would answer back. If he didn't look behind him when the bird
answered, they said he'd be turned into stone. He learned about
the god Bali, who sends thunder and lightning when angered,
and how to burn his hair and throw it into the wind to quiet
Bali's thunder. He was with them and yet independent of them
too; he would live with one band, wander alone through the
forest, able to hunt and find his way, until he hooked up with
another band. He slowly shed his need for most Western com-
forts. On December 31, 1984, his Malaysian visa expired; from
that day forward he was illegally in the country.

Bruno's copious letters and journals notwithstanding, he left
little record of what he was looking for, or expecting to find
among the Penan. He had never encountered indigenous peo-
ple before, but years later he would tell an interviewer, "In my
search to understand the deep essence of our humanity there
grew in me the desire to learn from a people who still lived
close to their source. I wanted to live with a people of nature,
to share their traditions, to discover their origins, to become
aware of their religion and life, to know these things." Bruno
was unusual, though his dream was anything but. He nurtured
a fantasy that had gripped the imaginations of Western travelers

and romantics for millennia, from Herodotus's tales of one-eyed monsters inhabiting Hyperborea to Daniel Defoe's Robinson Crusoe. The farthest reaches, Ultima Thule, that was where treasure lay. "The most outlying lands . . . are likely to have those things which we think the finest and the rarest," wrote Herodotus. Richard Burton had gone to Mecca, Gauguin to Tahiti, James Brooke to Sarawak, T. E. Lawrence and Wilfred Thesiger into the desert of the Bedouins. What were they after? It was never just nature, adventure, that the Western mind thirsted for. Uninhabited terra incognita might be alluring, but not half as magnetic as places filled with indigenous, the wilder, the more "savage," the more exotic the better, half-human creatures that could be saved or enslaved, or that could be escaped to and lived among in repudiation of all the myriad Western constraints shackling civilized man. "Man is born free, and everywhere he is in chains," wrote Rousseau; the noble savage was a potent idea to European consciousness. "I want to go to Tahiti and finish my existence there," wrote Gauguin. "I believe that the art which you like so much today is only the germ of what will be created down there, as I cultivate in myself a state of primitiveness and savagery."

 "For my temperaments and mode of thinking," James Brooke wrote in a letter to a friend shortly after inheriting £30,000 from his father, purchasing a 140-ton schooner, and setting out for Borneo in 1835, "there is nothing which makes prolonged life desirable, and, I would fain be doing something to add to the amount of happiness, especially in the way of life suited to my wild habits, wild education and ardent love for an undue degree of personal freedom. . . . Could I carry my vessel to places where the keel of a European ship never before ploughed the waters— could I plant my foot where white man's foot never before had been—could I gaze upon scenes which educated eyes never have

looked on—see man in the rudest state of nature—I should be content without looking for further reward." It wasn't enough just to go to a remote, difficult place and to return, but to go there and encounter the devil, ghosts, savages—to cross the River Acheron and journey into the underworld and meet "man in the rudest state of nature," and to cavort with them, often to make love to them, people without Victorian inhibitions. That's what Europeans and Americans hungered for, romanticized.

Even better if you could go so deep you'd become one of them yourself, a desire that Victor Segalen ridiculed in his famous *Essay on Exoticism: An Aesthetics of Diversity*: "The Lotis [a term Segalen coined after a French travel writer named Pierre Loti] are . . . mystically drunk with and unconscious of their object. They confuse it with themselves and passionately intermingle with it, 'drunk with their god!'"

What happened after they returned—and they almost always returned, at some point—was an equally important part of the myth. You had to cross that river and go to the ends of the earth, but you couldn't go too far or else coming back was no longer possible. The British government, for instance, never explicitly endorsed James Brooke's exploits in Sarawak, but upon his return Brooke "became a freeman of the City of London, courted by the ancient Goldsmiths' and Fishmongers' Companies, a member of the foremost clubs. The government upgraded his appointment to that of Consul General for Borneo at 2,000 pounds a year (the last thing he needed, for he was already fantastically wealthy), Oxford gave him an honorary doctorate. He met lords and ministers and military and merchants and churchmen and everywhere he did what he loved to do—talked about Sarawak. And finally he met the queen." He was a hero. Bruno did not go to the Penan seeking fame or fortune, but he too would be feted, mythologized, sought after, even paid, upon his

return. He too became a hero. It was one thing, after all, to take
home natives like captive zoo animals, as happened to the Polar
Inuits who were brought back to New York City and housed in
the Museum of Natural History like animals in a zoo; another
to have a white person become a native himself—"one of us"
becoming "one of them"— who could swing from jungle vines
one minute and dine in a tuxedo with you the next.

At its root, colonialism and the European travelers who came
from it carried with them a long-standing ambivalence—to
conquer on the one hand or to submerge oneself on the other.
The Native Americans Christopher Columbus first encountered
were Rousseauian wonders, the most graceful and most noble
people he had ever encountered. Michel de Montaigne, in *On
Cannibals,* published in 1580, glorified "the Brazilian cannibals,
a people untouched by artifice." Their lives, Montaigne said,
surpass "all the pictures with which the poets have adorned the
golden age, and all their inventions in feigning a happy state of
man." It was a place where "the very words that signify lying,
treachery, dissimulation, avarice, envy are unknown." Writes
Jamie James in *The Glamour of Strangeness,* "Shakespeare lifted
passages of the essay intact for Gonzalo's speech describing his
ideal state, in act 2 of *The Tempest.*"

But in a few short years those idealizing Europeans turned
the indigenous people into beasts. "It is noteworthy," wrote
Brooke's biographer Nigel Barley, "that in their relations with
Borneo the British switched easily between their two dominant
biblical myths of the wild—the notion of Sarawak as a paradise
to be preserved from corrupting 'outside' influence, and as a
wilderness to be roundly civilized." Either one was myth, over-
simplification, objectification, a long history of Western exoti-
cism that involved, at its heart, writes the novelist and essayist
Andrea Lee, "strangeness and desire, the desire for strangeness,

with a sense of risk but no real threat of danger. There is always an element of ownership and control about 'exotic'—because the dreamer controls the fantasy—which is the downfall of real contact."

In the postcolonial 1960s and 1970s, abetted by cheap air travel that brought far-flung worlds together as never before, the idea that so-called primitive people were either children of nature or savages to be civilized gave way to a new ideal—that they possessed something sacred that Western society had lost. These New Age noble savages possessed a spiritualism, a wisdom, a way of living with nature that was an antidote to the war and avarice and racism and consumerism that characterized Western culture. Biruté Galdikas, the orangutan researcher, expressed it well. In the early days of her research in Borneo she had been "seduced by the 'naturalistic fallacy.' Nature was pure and noble, beautiful and bright. Nature produced happy endings. In traveling to the tropical rain forest, [her husband] Rod and I were fulfilling our generation's dream of 'going back to nature.' Returning to the garden of Eden." Bruno denied that his attraction to the Penan had any romantic notions. "I was drawn to the Penan for the simple reason that I feel well in nature. It is nothing romantic. When you live in the jungle you realize that daily life doesn't permit romanticism. One walks, the legs hurt; there are leeches and rain, and then you see something beautiful—that is your wage. Then you remember we are all one heart." Yet he also said that in being among the Penan he had found his "paradise," as he called it, a place where he finally felt at home, "like the child in the arms of the mother." Paradise, the arms of the mother, all notions of Eden before the Fall, places of transcendent unity, expressions of God itself, as romantic and reductionist as it gets.

Then came the bulldozers.

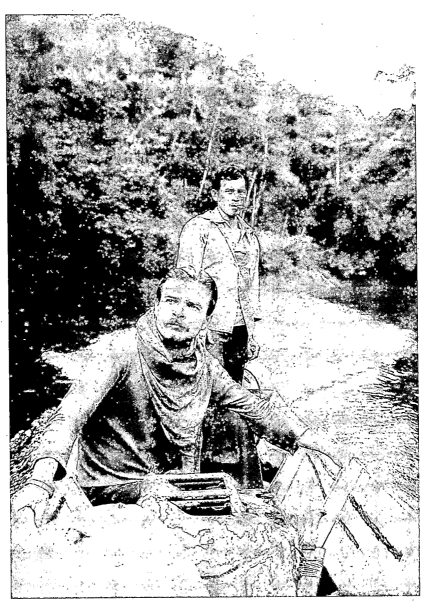

Michael Palmieri heading upriver in a longboat, Kalimantan, Indonesian Borneo, 1970s.
(Michael Palmieri)

SIX

Late one afternoon in the spring of 1974, Michael and Fatima climbed down from a horse-drawn wooden cart on a dirt road in the village of Legian, Bali. They had flown from Kathmandu to Surabaya, on the neighboring island of Java, and traveled by bus, ferry, and finally the cart. The air felt hot, humid, but sweet and balmy, a smell of cloves and smoke, the sky so cloudless it was cobalt blue. Palm trees dotted a grassy stretch in front of a wide beach, white sand as far as they could see to both horizons, north and south, before huge breaking barrels of aqua and white foam. Beyond the big swells lay an ocean of eighty-five-degree water so blue it was bluer than the sky.

It was instant love. There was no turning around. Bali was like no other place they'd seen, a miniscule, densely populated ninety-mile-long-by-fifty-mile-wide petri dish of extravagantly cultivated emerald rice fields rising in perfect, winding steps to three symmetrical volcanic cones, "their craters studded with serene lakes set in dark forests filled with screaming monkeys," in the words of Miguel Covarrubias, who arrived on the island in 1930, among a vanguard of Western artists to be seduced by its beauty. "Ravines washed out by rushing rivers full of rapids and waterfalls, drop steadily to the sea," this whole natural wonder presided over by a rich pantheon of gods and goddesses, the propitiation of which was—and still is—a full-time job for the Balinese.

Bali embodied all of the tropical fantasies of northern Euro-peans and Americans. Palm trees. Volcanoes. Beaches. The

eroticism of bare-breasted maidens, all wrapped in a mystical culture. The American writer Hickman Powell rhapsodized about the moment when "a scarf fell carelessly from a shoulder, and the bronze bowls of maiden breasts projected angular, living shadows." The island "dripped and shone with moisture like a garden in a florist's window," said the writer and musicologist Colin McPhee. "No other race gives the impression of living in such close touch with nature, creates such a complete feeling of harmony between the people and the surroundings," raved Covarrubias. "The slender Balinese bodies are as much a part of the landscape as the palms and the breadfruit trees, and their smooth skins have the same tone as the earth and as the brown rivers where they bathe . . . relieved here and there by bright-coloured sashes and tropical flowers. The Balinese belong in their environment in the same way that a humming-bird or an orchid belongs in a Central American jungle, or a steel-worker belongs in the grime of Pittsburgh." Bali appeared to western-ers exactly like the imagined tropical paradises of their dreams, like a real stage set for Michael Palmieri's childhood television hero Gardner McKay, except this exotic jewel was a tiny Dutch colony. While fantasy-laden destinations like Tahiti had long been evangelized by Christian missionaries, their once rich cul-tures largely destroyed, and Borneo just a few hundred miles away remained a vast and wild jungle, Bali still felt unsullied, yet compact, accessible, and open to them.

The Balinese were descended from Hindu Javanese who fled the spread of Islam and sought refuge on the island a thousand years ago. Art and beauty seemed to infuse all facets of their life. Every Balinese was an artist: they danced, they wove, they played fantastic orchestras of gongs and xylophones, they painted and built phantasmagorical temples out of carved wood and stone.

And perhaps most special of all, a fact that still holds today, the Balinese seemed to possess a unique capability of absorbing and accommodating their Dutch overlords (and later, mass tourism, consumerism, Indonesian Islam) without losing their rich, complex Hindu culture, their souls.

In a fortuitous twist for the hippies looking for something new after Goa and Kathmandu, it was the cool, misty mountains and lakes of central Bali that were the source of the islands' fertility and the home of the gods. "For the Balinese, everything that is high is good and powerful," wrote Covarrubias, "so it is natural that the sea, lower than the lowest point of land, with the sharks and barracuda that infest the waters, and the deadly sea-snakes and poisonous fish that live among the treacherous coral reefs, should be considered as tenget, magically dangerous, the home of the evil spirits." Which meant that when the first surfers and hippies started to arrive in the early 1970s, the enormous beaches of southern Bali—a strand of white sand that stretched for twenty miles, without question some of the most spectacular beaches in the world—were deserted and dotted with small villages inhabited only by the poorest Balinese.

No beachfront hotels. A handful of shacks. Just palm trees and dirt roads and horse-drawn carts and that rich Hindu culture full of temples and ceremonies and cremations and music, and it all cost nothing. Two Australians had just opened the Blue Ocean, a tiki bar and a few primitive rooms on the beach in the village of Legian, and Michael and Fatima jumped right into the burgeoning scene, along with other refugees from Goa and Kathmandu. "Every day everybody would go to that beach and we'd all be there at sunset smoking chillums and doing yoga and omming and we were butt-ass naked," said Michael.

A group of foreign investors had tried to open a fancy beach-

front hotel, the Kayu Aya, a few miles north of the surfer haven of Kuta, but the enterprise had come crashing down, and Michael met a Balinese man who owned the land and said Michael could move into the manager's house if he would manage some of the unfinished hotel's bungalows and try to rent them out to his fellow hippies. It was all without electricity or plumbing and they moved into a roomy thatched-roof house of coral stone and a broad verandah right on the beach where the Oberoi Hotel stands today. There was nothing but the sea and the romantic lights of their kerosene lanterns, the rest of the abandoned hotel filled with their friends from Goa, one endless party. "Once a week Fatima and I would go to the main market and she'd hire two little girls with baskets and she'd buy rice, oil, veggies, fruit and spend the whole afternoon there and take a bemo back with chickens and pigs to Kuta and hire a horse and buggy to take us down to our house."

That's when the magic of Bali—indeed, of the whole Austronesian spiritual and ancestral world he would soon plunge into—reached out and touched him for the first time. A magic that drew him in and kept him coming back to Bali and Borneo. Their bedroom was a loft with screen windows overlooking the sea, and one evening soon after moving in they were lying in bed when an apparition swept through the screen. A diaphanous essence of light. It didn't have any particular form, and it brushed their bodies and jolted them both. They could feel it. "What's that? What's that?" said Fatima, grabbing Michael.

Michael didn't know, had seen nothing like it before. "Something happened. We weren't stoned. We both experienced the same thing. We saw the light. It came back again. Moments later. Brushed up against me and brushed against her. This was touching magic. It reached out and touched us."

They didn't sleep that night. In the morning they described

what they'd seen, felt, to the houseboy. "Layaks!" he said. Evil spirits. Dead people. Right there in the palms off the beach behind where the house now stood, the houseboy explained, dozens, maybe hundreds of Balinese had been slaughtered, some of the one hundred thousand on Bali alone—the highest concentration of killings per capita in all of Indonesia—when the army had risen up and deposed President Sukarno in 1965. The houseboy brought the village priest to the house and Michael again described what had brushed against them. "Layaks!" the priest confirmed. He put out the checked poleng cloth and incense and rice and made Michael and Fatima dress in traditional Balinese sarongs and sashes, a kebaya for Fatima, an udeng headdress for Michael, and recited incantations and prayers. They were never bothered again in that house.

"Magic exists!" Michael said. "It exists!"

Soon after the Layaks incident they met a French couple who had just returned from Borneo. Borneo. The name resonated and ignited his fantasies. The wild men of Borneo. The headhunters of Borneo. He and Fatima didn't waste any time. Within a few weeks they returned to Surabaya, flew to Balikpapan, in East Kalimantan, made their way to Samarinda, and went up the Mahakam River.

Bali was a rich, tropical fantasy, but it was easy; there was nothing wild about it. But the upper Mahakam River felt untouched. Pure. A wilderness of women with distended earlobes and people covered in tattoos. They bought baskets, hundreds of them, brought them home, sold them at a weekly flea market on the grass near their house on Sunday afternoons. They sold them all and Michael returned to Borneo for another round.

Michael had fallen in love anew, this time with a place and a people, transported by the beauty and wildness and purity of the Dayak world. They read everything they could find on Dayak

culture, took notes, and he—and sometimes Fatima too—began venturing deeper, farther, longer, to look for not just baskets, but other things too, the products of Borneo's long and complex history. The island was a natural stepping-stone for onward journeys on the great migration and trade routes of a dynamic region, and over millennia its indigenous Austronesians were subject to wave after wave of increasingly sophisticated cultures. The Dong Son of Vietnam, beginning around 600 BC, brought complex Bronze Age technology. Buddhism, Hinduism, and Islam washed across its shores and penetrated its rivers between the fourth and thirteenth centuries. Along its coasts thrived opulent Malay sultanates, the legacy of Hindu kingdoms whose rulers later converted to Islam, and Chinese colonies of traders. The Portuguese, the first westerners to reach Borneo, landed briefly in what is now Brunei, on the northwest coast, in 1521 during Magellan's circumnavigation. The Dutch arrived in the late 1600s. In 1841 the rich British adventurer James Brooke declared himself rajah in the northwest, a reign that lasted three generations, and it wasn't until the turn of the twentieth century that colonial powers penetrated the central highlands.

The long romanticized head-hunting Dayaks in its interior—notoriously the wild men of Borneo—had been trading and fighting with the island's sophisticated downriver communities and the Penan in the deepest interior for thousands of years. Although there were hundreds of different Dayak tribes and language groupings, with subtly different spiritual practices, the heart of their cosmological world mirrored the physical one—a world of lush forests represented by the tree of life.

In Dayak consciousness, human beings originated in the feminine underworld, were born into the middle world, and ascended

into the upper world after death. The tree of life embodied that understanding—the roots in the underworld drew up water, the stuff of life, in the form of sap. It formed fruits and flowers that emerged as human beings, and in death their "spirits" migrated to the upper branches of the tree. It was from there that rain fell, returning life to the underworld.

In that cosmos ordinary animals and objects had souls, spirits played an active role in every daily event, and nothing happened by accident. If a hornbill flew across a man's path from right to left, it was a sign that hunting would be good. Integral to this idea was "the concept of a parallel universe, the other, darker side of reality," writes Biruté Galdikas. "The universe we see is a mirror image of the other. One might compare the two universes to a film negative and a photographic print; unlike heaven and hell in Judeo Christian and Islamic teachings, the parallel universe is not a distant place, accessible only in the next life. The parallel universe is real; it exists in the here and now. Humans can go there while still in this life, through dreams and visions," and shamans were especially adept at this, for they could not only travel among the worlds but interpret the dreams and signs, understand them, read them. The female god who ruled the parallel universe appeared in the here and now, for instance, as a serpent–dragon. Crocodiles, once ubiquitous in Borneo's rivers, were the dragon god's helpers, sent from that other universe, a fourth dimension, as real to a Dayak "as anti-matter is to physicists, or negative numbers to mathematicians."

Death, that always looming and most inconceivable and often sudden thing (especially in a society without modern antibiotics and full of wild predators and swollen rivers), made the most important rituals the funerary ones. Every death had two stages. At the moment the heart stopped beating the spirit left the phys-ical, corporal body, which was quickly buried or cremated. But

the spirit hung around, was reluctant to move on, wanted to stay close to all it knew and loved, where it wandered aimlessly and could make trouble for the living. To release that spirit required a secondary burial ceremony, which might be held a month or even years later. The bones were exhumed for a ritual cleansing, after which they were placed in an ornate ossuary and reinterred in elevated, equally elaborate carved hardwood family mausoleums, shaped like a house or a boat, or sometimes in caves or even big ceramic jars.

The Tiwah, as it was called in central Borneo, reunited the two parts of the soul, was the ticket that sent the dead on their way. If the ceremony did not take place, the body's soul could remain in limbo and become a ghost, bringing trouble to the community.

Life, death, the spirits of animals and of ancestors, they were all around the Dayaks everywhere, at all times, moving among the branches of the trees that surrounded them, the trees of life. The dead ancestors, properly guided to its upper branches through those secondary funeral rites, supported the living descendants on the tree down below. They protected them from enemies, ensured that healthy children were born, made crops flourish, and encouraged the fecundity of village animals. In return, the living were expected to venerate these ancestors who guarded them; it was a two-way street, you might say, each with a job to do, a contract between the living and the dead that resulted in the ubiquitous presence of ancestor figures in everyday life.

The Dayaks, like all humans, were creative and inventive, and living in such a fecund world of plentiful game, fish, forest fruits and vegetables, and bounties of rice, they had the time, space, energy to express themselves and their myths and cosmology in everything their hands touched, with artistic beauty

and power. The swirling, branching tree-of-life motif appeared everywhere—carved in longhouse doors, atop the spines of roofs, on totemlike poles topped with ossuaries, on ornate shields often adorned with human hair, in intricately woven and dyed textiles that sometimes took years for a woman to make. Wooden figures, often squatting, knees and elbows bent in positions of power, like the one that caused the ruckus in Michael's house, guarded villages, longhouses, rice fields; magical carved sticks hidden near traps in the forest lured pigs. Shamans carried ornately decorated boxes full of teeth and animal parts, and the bodies of men and women were covered in tattoos of those same swirling icons, received at important life milestones—the taking of an enemy head, for instance. And unlike most modern Western art, these images were sacred; they held power and meaning. They embodied spirits and souls, were inseparable from this living, dynamic multidimensional world.

Dayaks had a particular reverence for family heirlooms, known as pusaka, which were closely bound with a family's wealth and status. Textiles, head-hunting swords with handles elaborately carved out of animal or human bone, brass jewelry, trade beads, often ancient and from distant lands, were passed on within families for generations. Especially valued were brass gongs and Chinese ceramic jars, which first appeared on the island a thousand years ago and were an essential part of every ritual, from marriage ceremonies to ancestor worship to mortuary practices and ceremonies involving the drinking of rice wine. They lined the walls of family rooms and communal galleries in longhouses, and the number of jars showed a family's wealth and status. Their ancestors had paddled them up great rivers and carried them on their backs over mountains. The objects were venerated, surrounded with beliefs and legends. Carl Bock, whose

1882 account of his travels up the Mahakam, *The Head-Hunters of Borneo,* did much to romanticize them, reported that Dayaks believed jars were made of the same clay from which the gods "made first the sun, and then the moon." Others said that the jars themselves were fruits from the tree of life or that they could transform themselves into animals and people, or were oracles with the power to foretell the future.

By the time of Michael's forays, head-hunting had long been stamped out by Indonesian and Malaysian authorities (though it could and did flare up again, even as recently as 2001 during a period of ethnic strife), but 90 percent of the island remained virgin primary forest. Throughout its more distant reaches, houses and longhouse communities remained filled with pusaka, men and women still distended their earlobes with heavy brass weights, were covered in tattoos and hunted with blowpipes, and lived, they believed, in a mystical, magical world. But Michael arrived at a pivotal moment. Christian missionaries hungering for new souls were pushing farther into the interior, as were timber companies hungering for the great tropical hardwoods of its forests, and government officials came along with them. Modernity was creeping upriver. Traditional villages and cultures began to have access to cash and modern things, from transistor radios to electric light bulbs to Western medicine, and Michael could see the transformation happening, feel it, as he too pushed upriver.

During their first forays in late 1974 and 1975, he and sometimes Fatima mostly stuck to the Mahakam River and its close tributaries—all relatively accessible—but in June 1976, he pushed deeper, alone, into Central Kalimantan for the first time, and his

knowledge began to leap forward. He was still mostly looking for things he could sell at the flea market, baskets and necklaces and small trinkets, but he was increasingly taking note of larger pieces: jars and architectural elements and statues. Flying into Pangkalan Bun, he caught a scheduled boat one hundred miles up the Lamandau River to Nanga Bulik, and at 7 a.m. on June 21, 1976, he and three Dayaks headed up the Bulik River in a small, cramped dugout powered by a four-horsepower outboard and packed with supplies. They passed a lumber camp, a slash of treeless destruction in the jungle, presided over by roaring, giant yellow tracked engines with grippers piling huge gray tree trunks two stories high along the banks above the river, which was low and calm, and soon walled in green again. At first this logging didn't really register for Michael; the view soon returned to normal, punctuated by bands of long-tailed monkeys parading along the banks. They motored for twelve hours. The engine broke down seven times, often in the middle of rapids, once dashing the boat backwards over a waterfall, and all Michael could think of was his near drowning a year and a half before. In the darkness of night they reached a village, and Michael slept on the dock. They pushed on again at dawn, turning up the Kawa River. At the next village he saw poles supporting upside-down ceramic jars, and as they continued they hit rapids through water so low they had to drag the boat over the rocks by hand. They passed "trees shimmering with monkeys," Michael noted in his journal, others full of loud chattering flocks of green parrots, and spotted a wild boar rooting on the banks and a hornbill winging loudly overhead. By the time they reached Penopa it was "pitch black night and raining like hell," and he was soaked. He slept in the boat.

They continued upriver at dawn in a light drizzle—the sun

soon came blasting out—past villages with colorfully painted houses with carved Aso figures perched on the front tips of the roofs, and half-naked women washing by the side of the river. It was thick with fish "leaping out of the water everywhere." That night they finally reached their destination, Batu Kawa; from there Michael intended to strike out inland on foot. Immediately he was assaulted by villagers wanting obat—medicine. "Administered some anti-malaria pills, antibiotic eye ointment and cleaned and bandaged several wounds," he noted in his diary. "Wish I had more obat. Not too many old objects here—no statues, some masks—average," he wrote.

He slept on the floor of a local's house, and in the morning he traded tobacco for rice, coffee, and durian, and dispensed more medicine, and in the afternoon they hiked on, six miles through hilly, shaded bamboo forest over many small streams. The woods felt immense, endless, and yet filled with villages and people, and Michael loved being in it in a way he'd never felt in the deserts of Iran or even the chaotic beauty of Afghanistan, India, or Nepal. Those places had an edge, a danger, a hardness that was always on the horizon. In Afghanistan his Mercedes once had broken a fuel pump, and he'd been picked up by a VW van full of hippies that had subsequently been waylaid by bandits, the women raped inside the VW; he'd had to listen to their screams while the men held guns to his head. But Borneo had none of that harshness. The Dayaks were mostly gentle, and loved to laugh at him and to drink and dance, all in this overwhelmingly fertile place of rivers and trees and animals. Traveling through it was hard—he suffered heat and cold and rain and discomfort—but he loved it, embraced it in a way that most people never could.

Michael slipped, smashing his knee on a rock, but kept on, arriving in the "charming and original" village of Penampakan to the "sweet and overwhelming" scent of durian, a fruit often

described as smelling like vomit. Every house had a hornbill or water snake head carved in its roof, and instead of tombstones marking graves in the small cemetery stood ceramic jars. He administered more medicine and walked another four miles along a small river to Sependon, which was also beautiful, old, untouched, free of any trash, and with few machine-made products. The villagers laughed at his hair, told him he was funny-looking. "Do you have obat? Do you have tobacco?" they asked. "Can't understand; this obat getting out of control. Patched up six men, gave an eye ointment treatment, treated five toothaches with clove and gave three tiger balm massages." His knee was swollen, and he was exhausted, but as he curled up on the floor of a little guesthouse, he felt happy.

At dawn Michael woke to find twenty-five people standing around him, staring silently. He walked on, found the next village centered on a tall totem pole and two male wooden figures facing the river, but the village was mostly deserted, so he continued. His leg was so swollen he found it difficult to walk. By day's end he'd covered twelve miles, arriving in a village of two thousand, where he passed out after drinking arak with the Javanese police officer and his cronies. Some houses had twenty-foot-high poles topped with upside-down jars and carved heads and two human-sized carved figures, a man and a woman. No one wanted to sell or trade for them, but he bartered some bracelets and tobacco for five baskets, a purse, one huge papaya, one coffee, and a bottle of honey. He smoked a joint, heard music, and wandered into the night, where he found a funeral celebration in full swing. To the banging of gongs, Michael jumped in and they urged glass after glass of tuak on him. The jungle turned "vibey: every wild dog in the kampong is howling at the sounds coming from inside the jungle—insects hissing and howling and groveling and snarling, peeping and

creeping, like an orchestra, and the crickets—billions of them—
are the loudest, with a hypnotic purrrr." Suddenly in walked the
hantus—ghosts—men draped in leaves, their faces covered in
charcoal and chalk. One looked different and Michael suddenly
realized the man was imitating him—with a white-painted face
and black-painted mustache, holding an old transistor radio, and
the man danced around the room holding the radio up like a
camera, "pretending to take pictures of the roaringly drunk
Dayaks and pretending to take notes with a pad and pen. Then
he pulled out a dictionary and began translating words like old,
broken, baskets, bracelets, mandaus, statues. His imitation of me
was incredibly funny."

He awoke late, his head feeling like it had an ice pick sticking
in it and his stomach riled. He revived himself by jumping in the
river, followed by breakfast and a visit with the kepala kampong,
the village headman. He sported a full chrome-plated grill—
his teeth capped with silver—and three wives. Michael traded
3,000 rupiahs and five packages of looseleaf tobacco for an old
blowpipe, and then fifteen bracelets for a basket of bamboo and
rattan. At the cemetery he found women "wailing madly," but
when they saw Michael they yelled "Kodak!" and "laughed so
hard they almost dropped the coffin." He traded five more pack-
ets of tobacco for an old textile, all as the funeral ceremony
raged—forty hours straight—and that night he again fell asleep
to the banging of gongs and xylophones.

By the time the sun rose, his room was crowded with people
wanting to trade baskets for bracelets, and after breakfast, he
and his porters climbed in a boat for the trip back, this time by
river, which was shallow and full of rocks, forcing them to drag
the boat for hours. But when the river finally deepened, they
drifted slowly without the engine; it felt like "gliding on a dark
green mirror," lovely, quiet, slow. Monkeys crowded the trees

and birds screeched, and at the occasional rapid, they whooshed through, the driver at the bow impressing Michael with his deft paddling.

On the long trip back downriver, he encountered "Surabaya Chinese Frankie," a Jehovah's Witness missionary, "who laid a heavy barrage of bible rap on me in perfectly great English, which I haven't spoken in weeks. He also admits I'm a strange orang puti, not the usual surveyor or missionary that they see once in a while." The village had no traditional Ngaju Dayak cemetery and he soon learned why: twelve years before, Catholic missionaries had come, replaced the year before by Frankie the Jehovah's Witness. In pouring rain he walked to the next village, where he was happy to find no Christian influence yet. In its cemetery stood two male wooden figures, many coffins and jars and totem poles, and a special raised house for the bones of ancestors.

By July 3 he was on the last leg of river to Pangkalan Bun. Rain hammered down, the sun broke out, more rain came, Borneo's thick clouds rolling in and parting in constant motion. In new rain showers, as they turned up the Arat for the last five miles, the engine conked out again and again, forcing them to paddle the last mile. But the small city felt like New York, and that night he crashed on a soft bed draped in mosquito nets and wallowed in the luxury of it all.

Michael didn't rest long. Within a few days he took a flight to East Kalimantan and headed up the Mahakam again to Melak, arriving at 11 p.m. on July 8. It was late; he slept on the boat and woke up to find a rat stuck in his hair "squeaking and freaking." In the morning he caught a ride on the back of a policeman's motorcycle to the village of Borong Tangkak, where he encountered another missionary. "Father Kleiner avoided me at first, doesn't like tourists," but Michael was his usual persuasive self

and finally the father relented and invited him to dinner. "He gives Kalimantan twenty five more years before it's finished" from logging and mining.

Michael chartered a motorbike and continued exploring surrounding villages, some with longhouses; this was the heart of Tunjung Benuaq Dayak territory, an area long rich in exquisite carvers, but coming under increasing outside pressure. He found villages full of large carved figures, wooden coffins carved with naga heads—the heads of water serpents—and longhouses whose pillars were carved with beautiful swirling figures. But he also found many villages with cut-off stumps where similar figures once rested. "I'm told that around 1970 many figures were cut down from their posts at the request of missionaries." He wasn't trying to buy most of these things himself, not yet, anyway, but he was taking note of them, asking questions about them, listening to stories and legends and recording it all in his diaries. At one longhouse "I spotted in the rafters an ironwood carved box decorated with fetishes and spider webs. I am told that this particular box contained heads." He bought a bat tooth and bead necklace for 1,000 rupiahs, about 50 cents, added a spear to his collection, and headed back to Melak, arriving on July 12, market day. "Today I felt surely like a brother—many friends, good vibes. In the short time I've been here they've either seen me or heard about me—people today were not so shy and coming up to ask me if I wanted to buy things, for good prices." A man took him back to his house, pulled out his "magic obat stash," and proceeded to slice off pieces from two different miniature wooden statues for him, one to keep away ghosts while traveling through the jungle and one to protect him from poisoning. "He wrapped them up in old paper and told me to always carry them. Then he very secretly showed me another tiny wooden carved

fetish of a man. It was given to him by the witch doctor, which he carries wherever he goes."

He spent several days waiting for the big riverboat to head downriver, but none came, "stalled out as usual in Kalimantan." Finally he found a small one, full of familiar faces from villages he'd already visited, and they motored downriver "elbow to elbow, butt to butt, jam packed like sardines on the hardwood planks. My clothes are filthy, I've got a beard and I must look like hell and feel like it too, but I care little about my appearance at this point. I feel like part of the jungle I'm coming out of. Today was the day I was expected back in Bali, back into the bosom of my loved one, but for the last few nights it's been almost impossible to sleep. I spent most of the evening on top of the boat—just me, the moon, the stars, the glistening river."

He arrived in Samarinda at five o'clock in the morning, proceeded on to Balikpapan, then checked in for a flight to Banjarmasin, there to fly to Surabaya and on to Bali. "Fifty kilos overweight. Big hassle, almost missed the flight." He had been traveling for a month straight, by foot, riverboats big and small, motorcycle, bemos, buses, and airplane, with "one hundred and sixty pounds of treasure," and he was "completely exhausted. Today my body feels like dying, like the machine is broken. My clothes are thrashed with holes, my shoes have turned from white to the color of earth, and I need sleep!"

On July 18 he took wing from Borneo to Surabaya for the last leg home. "What a pleasure to fly. Now I'm ten thousand feet up looking down into the sweaty jungle." He had a lot to process. He'd seen the Ngaju Dayak villages of Central Kalimantan for the first time, still full of jars and statues and carvings and funeral ceremonies, and he'd strengthened his relationships along the Mahakam in East Kalimantan in and around Melak.

And he'd increasingly seen signs of logging and missionaries, signs that the traditional Dayak culture was starting to dissipate. Was he playing a hand in that acculturation? As he bathed in the freshness of the plane's air-conditioning and the exhilaration he always felt when homeward bound after a new adventure, he wrote feverishly about the larger forces at work, the very ones that Bruno would soon be embroiled in. "Timber companies have been on the Mahakam since 1971 and have promised to provide health education and care for the Dayaks and to replace the trees they have cut down. Instead of complying with their agreements, they have taken the short cut by paying off official inspectors to save time and money that they should have spent conserving and caring for the land and its people. The end result of the savage rape is certain death for Dayaks. The once fertile soil in the areas exploited have now become either swamps or robbed of its natural topsoil. After those timber companies have cut down the last tree they'll leave behind an unnatural graveyard. What was once a Lost Paradise will become a Dead Earth. Thousands of surveyors, timber people, mineral people, missionaries, merchants and government officials, plus transmigration islanders have come to Kalimantan to exploit it. Millions of dollars are being made by hungry profiteers while the officials who are hired by her people to keep Kalimantan still alive are turning their backs for payoffs so that the big companies can throw dirty punches to win the fight fast or make a quick billion or wash their hands quick so they can get out the mud or better yet before they see too much of what they have destroyed and start feeling guilty. The future of Kalimantan is too much for any human being to endure."

Logging road, Sarawak, Malaysian Borneo, 1980s. (Bruno Manser Fund)

SEVEN

To reach the Mulu caves and Gunung Mulu National Park when he first arrived in Sarawak, Bruno traveled from the coast by boat up the Baram and Tutoh rivers. Along the winding roads of brown water, he, like Michael, couldn't avoid seeing patches of copper-colored earth carved out of the green forest, sudden industrial tears in the lush jungle piled high with tropical hardwoods, often roaring with skidders and loaders as big as houses. Logging along lower sections of Sarawak's rivers had been happening piecemeal for decades, but the forests of Borneo were vast and the impact remained small overall.

In the 1980s, however, logging drastically accelerated. To grasp why, it helps to understand the history and politics of Sarawak.

For centuries, what is now Peninsular Malaysia consisted of independent Muslim sultanates. In the late eighteenth century and the first half of the nineteenth, British colonial administrators took control of most of that territory. The island of Borneo remained its own universe, however, a place of little kingdoms and Chinese merchants along the coasts and Dayak tribesmen inland along the rivers. The Netherlands controlled the eastern three-quarters of the island and the sultan of Brunei the northwest quarter. In 1841 the sultan ceded much of what is now Sarawak to James Brooke, creating a strange little independent kingdom ruled by Brooke alone, who called himself the Rajah of Borneo.

The Brookes' reign in Sarawak is surely one of the oddest

in history. While it was colonial and racist in the sense that
a white overlord unilaterally ran the state, James Brooke had
seized power and claimed his piece of Asia by attacking piracy
and "saving" the local sultan of Brunei. Once declared rajah, he
not only ended piracy but ruthlessly suppressed the powerful,
marauding Ibans, whose head-hunting raids terrorized less pow-
erful Kelabit, Kenyah, and Kayan Dayak tribes, and imposed a
peace that the territory had never known. He loved Sarawak
and its people, and to the indigenous tribes the White Rajah's
rule was more paternalistic than exploitative. The Penan, who
for generations had traded forest products with the much more
powerful, sophisticated, and violent downriver Dayaks, were
often cheated, so Brooke instituted quarterly market days during
which government officials monitored transactions on the Pe-
nan's behalf. And as huge rubber plantations were created through
much of colonial Southeast Asia and Africa at the end of the
nineteenth century, Charles Brooke, who'd taken over Sarawak
from his uncle James, said, "I hate the name of rubber. Congo
rules cannot be tolerated in Sarawak." For the most part, the
Brookes ruled with benign neglect, leaving trade in the hands
of independent locals. At the turn of the nineteenth century, at
the height of European colonialism, the Brookes ruled Sarawak
with just thirty Europeans.

 World War II changed all of that. Japan ousted the British and
the Brookes, but when they resumed control, the days of empire
were ending. James Brooke's nephew turned Sarawak over to
Britain in 1946; Peninsular Malaysia became an independent
nation, the Federation of Malaya, eleven years later. And in 1963
Britain finally ceded Sarawak and Sabah too, leading to the cre-
ation of the Federation of Malaysia with the Borneo territory
integrated into the new country as a whole.

 Here Malaysian and Sarawak politics become complex: the

territories of northwest Borneo (with the exception of the small
kingdom of Brunei) suddenly became ruled for the first time by
ethnic Muslim Malays in Kuala Lumpur who comprised more
than half of the population and dominated the new country's
politics, but earned only 1 percent of the country's income.
For a century the Dayaks and Chinese and Malays of Sarawak
(there minorities) had been more or less left alone under the
protection of the Brookes and Britain. They'd had nothing to
do with mainland politics. But now the Peninsular Malaysians
saw Sarawak as a vast mine of oil and timber and gold. Three
months before independence in 1963, the departing British gov-
ernment appointed the ministers of the new federal state of Sar-
awak: an Iban Dayak was named chief minister and a Malay
born in Sarawak, Abdul Taib Mahmud, was named minister of
development and labor.

For the first few years after independence the power in Sa-
rawak remained dominated by the Iban and Chinese, with
support from Britain, which maintained a garrison of soldiers
there. But a power struggle ensued between the federal govern-
ment dominated by mainland Malays in Kuala Lumpur and the
local Malays in Sarawak, who in turn wanted to wrest power
from the Iban. In 1966 the Malaysian government declared a
state of emergency and dismissed the Iban chief minister. In the
mayhem, Taib emerged as the minister of agriculture and for-
estry and deputy chief minister of Sarawak, soon rising to chief
minister, a position he held with an iron grip for the next three
decades.

Logging in Sarawak exploded. In his first six years in office
Taib handed family members and political cronies logging con-
cessions to more than seven million acres of virgin rain forest,
much of it in the highlands of traditional Kelabit and Penan
lands. In 1987 the *Wall Street Journal* reported that twenty-five

concessions awarded by his uncle Rahman Ya'kub to friends and
family were worth $4.2 billion. Six tropical timber conglom-
erates became giants overnight. In 1965 loggers cut down 2.3
million cubic meters of trees. To keep it sustainable, a United
Nations Food and Agriculture Organization forestry study
undertaken in 1967 and published in 1972 recommended that
Sarawak limit its annual timber harvest to no more than 4.4 mil-
lion cubic meters. But by 1981 the number had climbed to 8.8
million cubic meters, and by 1991 to 19.4 million cubic meters.
Annually, that is, year after year, a number that in 1987 hit 180
acres an hour.

All of which meant that within a year of Bruno's jungle dream,
timber companies began pushing into his paradise. Theoreti-
cally the logging was selective, taking only the biggest trees and
leaving the rest of the forest intact. In reality it was impossible
to harvest hundred-foot-tall trees ten feet and more in diameter
out of a roadless, steep, wet, mountainous wilderness with a light
footprint. Surveyors first tramped through the forest marking
the towering old hardwoods. Roads followed, roads that snaked
everywhere and roared with chain saws and bulldozers, followed
by lumber camps full of workers and all of their logistical needs
in what had been pristine forest. The trees were felled and then
dragged through the jungle with heavy equipment, obliterat-
ing everything in their path, then loaded onto forty-ton logging
trucks rumbling through the silence with another forty tons of
timber on their backs.

Not long after Bruno's arrival in 1984, logging companies began
building a bridge over the Tutoh River, the first step to access-

ing the mountains and highlands stretching from Long Seridan to the Kalimantan border—the heart of the land in which the Eastern Penan had hunted and roamed for centuries, dotted with Kelabit Dayak settlements in and around the villages of Long Seridan and Long Napir. In a letter to his brother Peter on March 9, 1985, from Long Seridan, just eight months after his arrival, Bruno mentioned it for the first time. "Hi my dear brotherheart," he wrote. "The jungle here is in danger. If there isn't a miracle soon, the bulldozers will roll over the last untouched areas and in a few months they will reach Long Seridan. I'm trying to mobilize the Penan against it, and at best I would like to bust the important bridge under construction into a thousand pieces into the air. But for now I listen in the quietness."

The appearance of loggers in a community was anything but simple or straightforward, and often contentious. Few community members, even tribal leaders, had the education or sophistication necessary to understand what was happening, what loggers proposed, what the ultimate effect would be on their lives, and if and how they might be compensated. Logging meant roads to the outside world and potential jobs and incomes for subsistence communities, not to mention the possibility of schools and the whole panoply of development and its potential. And Dayaks were no different from any other people. They liked stuff. They wanted electricity and televisions and modern conveniences that made their lives less difficult.

But what did logging mean to their forests teeming with monkeys and wild boar, bear and civet and birds, and rivers full of fish? How could anyone who had not experienced it fully comprehend the answers to that question? Bruno was obsessed with life in the jungle—to him it was paradise—and desperate to escape consumerism and its existential ills. But he was a freak even in his own country.

In early 1976 loggers 'entered the village of Long Keseh on the Baram River, and the results were typical. "I had just completed my second-to-last year at secondary school in Marudi and had gone back to my village for the Christmas holidays when a large meeting was convened in the longhouse," recalled Harrison Ngau, a Kelabit Dayak who graduated from law school and in 1980 founded Sahabat Alam Malaysia (SAM), the Malaysian branch of Friends of the Earth. "A timber company had been granted a logging concession for the land behind our longhouse. We knew nothing at all about it until WTK [the logging company] suddenly turned up with bulldozers, heavy machines and chainsaws. The people in our longhouse wanted to stop the loggers, but . . . many of them had never been to school.

"As the meeting was taking place," said Ngau, "the people from WTK turned up with a pile of things to eat—biscuits [cookies] and Coca Cola. Everyone started to eat, and nothing more happened." Whatever resistance the community felt vanished in a sugar rush of cookies and Coke, exotic delicacies to people who lived off fish and boar and simple fruits and vegetables. And, as was often the case, the community was hardly united in its opposition. Some people were against any and all logging, while some supported it, as long as they were compensated. In the case of Long Keseh, it turned out that two residents of the longhouse had formed a company with Taib's nephew, which received a large payment from WTK when it granted the loggers the concession. In essence, men from within the longhouse had sold out their very own community. WTK eventually agreed to pay the longhouse 60 cents for every ton of timber taken from its communal forest, a pittance compared to the hundreds of dollars per ton the company earned.

Twenty years later nothing had changed. In December 1986 officials from the Samling Timber Company convened a meet-

ing in the longhouse community of Long Anap. The heads of eleven nearby longhouses, most unable to read, were informed that Samling held the concession to their forest and logging was about to commence. After "a friendly talk," reported the *Wall Street Journal,* "ten of them signed or put their thumbprints on an agreement saying that they wouldn't interfere with the loggers. The agreement also bound the chiefs not to complain or seek compensation for water pollution, erosion, damage to the jungle, or the disappearance of wildlife. In return the timber company promised to pay small sums for any damaged fruit, coffee and cocoa trees, provided they once bore fruit. The company also offered each longhouse $800 annually for Christmas celebration money"—the value of two trees.

When Bruno expressed his first written anxieties about loggers approaching Penan lands in the spring of 1985, he had been among the Penan less than a year, and most of that had been divided between time in the forest within a few days' walk from the Kelabit village of Long Seridan and the village itself, where he frequently returned to send mail. But he had gone remarkably deep remarkably fast, had penetrated the lives of wandering bands of remote nomads, and had become known and trusted by them in a way that no whites ever had.

In October 1984, a twenty-five-year-old Swiss man named Roger Graf lit out for a wander in Peninsular Malaysia, where he heard about the splendors of Sarawak and its Mulu caves and Gunung Mulu National Park. Like Bruno, he traveled by boat up the Baram River from Marudi, spending nights in Kenyah Dayak longhouses. At one, he met a Dayak working for the agriculture department who invited him on his rounds bringing fruit trees to Kenyah and Kelabit communities. The last village,

he said, would be home to settled Penan. Graf jumped at the
chance. They spent just a few hours in the Penan village—"the
settled Dayaks thought of the Penan as uncultivated pigs and
just wanted to get back to their own people," Graf said—but
the Penan there kept asking him if he knew the "orang ingris"
(Englishman, in Malay) named Bruno. "It was a typical Swiss
name and I thought maybe this guy might be Swiss," Graf said,
but he had no interest in trying to meet him. "I didn't want
to share my adventure with some other foreigner just like me;
I wanted to imagine that I was the only one there!" But Graf
was intrigued with the Penan and with the idea of finding real
nomads, so when he got back to Miri he renewed his expiring
visa and returned upriver to the Penan longhouse on his own.

A young boy and his father took Graf into the forest for a week,
then deposited him in Long Seridan. There he met an itinerant
Pakistani who traded broken watches to the Penan for gaharu,
a fragrant wood that fetched high prices to Chinese dealers in
cities along the coast. The Pakistani told Graf there was a helipad
in the forest surrounded by a few houses the government used
for its occasional contact with the Penan, where he was going
in hopes of finding nomads, and he invited Graf along. "I was
naïve," Graf said. "It was terrible. We had no equipment. It was
raining. After two days and one night in the forest we finally
reached the place, but there were no Penan there." They built
their own raft and attempted to float down the Tutoh River to
the Kelabit longhouse of Long Bedian, another disaster. "It was
so fucking dangerous. I lost my glasses. The Pakistani couldn't
swim." The raft was tossed in rapids and their luggage floated
away and Graf had to save the Pakistani from drowning. "It
was horrible." Ironically, a camp of loggers saved them, and the
next day, Christmas 1984, they reached Long Bedian. Bruno
was there. "He was sitting with a family on one end of the long-

house and I was on the other, but we didn't say anything to each other, didn't even say 'hello.'"

A few people from Long Seridan were visiting relatives in Long Bedian, and they invited Graf to return with them, a two-day trip by boat upriver. As they motored into the village there was Bruno again, standing in the middle of the Magoh River fishing with a cast net. The Kelabits stopped to greet him warmly and he and Roger met, briefly, for the first time. "It was like, 'Oh shit! There's this white guy again!' I was so surprised and disappointed."

Long Seridan had two longhouses, one on each side of the airstrip, and Roger stayed on one side and Bruno on the other, the two avoiding one another. But after a week the inevitable happened. Graf was invited across the airstrip one evening, where he again encountered Bruno. This time Bruno invited him to his room, which he shared with an elderly woman. He showed Graf his journals, lushly illustrated with bright watercolors and pencil sketches, beautiful, rich renditions of the Penan and snakes and moths and butterflies and monkeys. "I was impressed," but the visit was short. "Mostly he wanted to know who I was, why I was there."

A few days later Bruno appeared at Graf's longhouse with a confession. He had managed somehow to steal Graf's diary, read it, and put it back without Graf knowing. Graf was horrified, felt violated. What kind of man was this? Bruno apologized, said he felt bad, said he'd misjudged Graf and his intentions (gleaned from reading his diary), and offered to draw him a map to reach bands of still nomadic Penan.

Graf accepted the apologies and the map, and soon after packed his bags and started walking into the forest. "I always traveled with local people, but for some reason that time I was so stupid to believe I could do it on my own. I left by myself, but

Bruno ran after me and said I was crazy, that if I waited a day, he would come with me." Graf agreed and the two set off the following morning, Bruno impressing him again, over and over. Though still dressing in shorts and sometimes T-shirts, he was already walking barefoot. He seemed unbelievably strong and fit, impervious to mud or rain. Wherever they went, "we met the Penan and they all knew him and greeted him warmly," his Penan language skills already well developed.

On their first day in the forest Graf was peeing on the banks of a river when two Penan men emerged on the opposite bank and started walking across the river. "They saw me and were frightened to death and ran away and I was scared too and I ran back to Bruno." Reaching a settlement the next day, Graf found himself in a damp forest world of pet dogs and gibbons and black meat over smoking fires. Only women and children were there—the men were off hunting—"and of course Bruno told them the story and they found it so funny and laughed and laughed, and then the men came back, the same men who'd run from me, and they just couldn't stop laughing too." He and Bruno spent two weeks there, and "to be part of their life a little in that forest, it was the nicest experience of my whole life," he said. Indeed, it changed his life. Soon, as the logging heated up, Graf became Bruno's point man in Switzerland, dedicating much of the next fifteen years of his life to Bruno and the Penan. "People looked at Bruno as something special, a hero, a saint, but I met him in Sarawak and he stole my diary and that made him human, and for many years Georges Rüegg and I were the only ones who would stand up to Bruno."

In 1980, in response to logging around the Apoh River, Kayan Dayak from three longhouses spontaneously entered a Samling

Timber Company camp and threatened the employees—the first recorded local resistance to the surging logging activity. Police were called, but the police were themselves locals who refused to intervene. Eventually Samling agreed to pay a commission to a cooperative created by the longhouses. A handful of other instances of resistance erupted, but they were small, local, and all carried out by the settled, longhouse-dwelling Kayan, Kenyah, and Kelabit Dayaks, who had some political power and who by nature and culture were far more aggressive, not to mention wealthier and more educated, than the shy, reclusive Penan in the recesses of the forest.

Slowly, however, the rapidly accelerating logging could not be ignored and Bruno and the Penan who lived close to Long Seridan were drawn in. Since he was modest about his role in the ensuing struggle—he would always say he just played "secretary"—it is hard to know exactly how much he was responsible for. Certainly the Kelabits and Kenyah had already been showing signs of resisting, but there seems little doubt that the fire about to engulf Sarawak and the Penan involvement in it was stoked by Bruno.

His journals are only occasionally dated, but sometime early that spring he wrote the first entry mentioning the coming struggle. "Now we're walking from the headwaters to the mouth of the Bare River for a meeting to plan a reservation in the forest. When we arrive in the evening, there are already Penan from the Siang to the Ubung River—the last jungle nomads are in constant worry about the destruction of their living space because of the logging. Wee of the Ubong River listens quietly to the fiery speeches. Large copper rings hang in his ears and many rattan bracelets adorn his arms and legs. I proposed to them to declare a reservation between the Tutoh-Magoh-Seridan River. . . . Yes, if all Penan would unite from the Tutoh to the Limbang River,

a reservation would have decent dimensions. I said I was willing
to play secretary for the Penan who don't know how to write if
they themselves muster up the motivation necessary to fight."

Soon after, in April 1985, a group of Penan and Kelabit—
with Bruno by their side—met in Long Seridan and authored
a letter to the government and logging companies proposing a
thirty-two-hundred-square-kilometer protected area. "Here it's
raining cats and dogs, always floods," he wrote to his family. "As
we've dwelled really close, a two-day march from Long Seridan,
I've dropped here to fix some things, finally send this packet . . .
and make a plan for a huge forest reserve that the indigenous
want to declare."

Their proposal went unanswered. "Any appeals by the Penan . . .
to representatives of the government," Bruno noted in his jour-
nal, "always go nowhere."

Bruno pushed harder. "Just yesterday I traveled from Long
Seridan to Miri," he noted to his brother, "to write articles to
journals about the destruction of the rainforest and declarations
to the government in the name of the indigenous peoples. And
return on the fastest way to Long Seridan and get out of there into
the jungle, because possibly I'll get in trouble with the Malaysian
government, and better get out of their way. Expulsion is pretty
much assured." Bruno sent pieces to most of the newspapers in
Malaysia and Sarawak, none of which were printed.

Even as his political consciousness increased, he wandered far-
ther into the forest for weeks at a time, deepening his connec-
tions with the Penan in ever remoter camps. He began trekking
north and east for a week and more into the mountains of the
upper reaches of the Limbang watershed, where he found Penan
even more removed from modern life, though most over the
years had had some contact with the government. There he met
Along Sega, a respected Penan elder as resistant to change as

Bruno. The two formed a close bond, Sega becoming Bruno's role model and de facto father. "Big Man, that's how he greeted me," Bruno wrote in his journal. "He bowed and wanted to kiss my hand. I was embarrassed and told him to stop. . . . I said that I was only a small man and that he did not have to look up to me. After all, he could be my father. He then apologized and humbled himself. 'I'm not a chief and I have no brains. The big ones all died off and I only speak for our clan because otherwise, nobody would speak up.'" The legs of Along's grown son Tapit were mysteriously paralyzed, and he carried him "in a box with a small sitting board. Some parts of the terrain are steep and slippery. The path is a climb over fallen tree trunks and between thorny vines. Along keeps stopping, trying to catch his breath. Loathing in self-pity, he complains that his older son is of no help. Should I? No—I'm not a hero when it comes to carrying loads. But my [pack] is light and I see how the old man struggles. So I take on the living load and it's going okay. 'We'll switch off again when we get to the stream,' Along says. Worried that I am going to slip with my load, I put it down even before then. When I offer to wash Tapit on the river and use soap to get rid of his lice, he declines. 'The water is too cold and the smell of soap is terrible.'"

Bruno participated intimately in Penan daily life. Early one morning he was awakened: "A child wants to come into the world." He watched as the pregnant woman's husband bound a few thin branches together into a kind of seat with a hole in it under the high canopy of the trees. "The very pregnant woman with the gigantic stomach has covered her nakedness with a . . . dirty sarong. Her brothers, her husband, and her sons–in–law massage her stomach to press her downward. Again and again the woman is instructed to drink hot uwut water to heat up the body and enforce labor. 'Drink, don't fall sleep, don't cry.' The women

only look, they don't do anything." Day turned to night; rain
began falling; the woman labored on. "A young tree is pulled
out of the ground and with mumbling the husband pulls it over
her stomach and drops it between the seat she's sitting on; this act
according to Tiburon is supposed to speed up birth and to put the
earth in a good mood. . . . Again and again rough-throated male
voices issue the same command to the woman who's moaning
and drifting off.

"The woman who is about forty is already a grandmother;
finally the time has come. Four or five men support the wom-
an's back and they cover her entire stomach with hands. When
the husband wants to look under the sarong, a woman standing
next to him tips him away. 'Mai jak!' Not yet! Then finally we
hear the crying voice of a child from the darkness below and the
child has dropped down on the ground. When nobody actually
seems to worry about the child lying in the dirt below, I myself
reach under the birthing seat to bring the little one into the
light and give him some warmth. But I barely hold the baby
in my hands, when an upset choir yells at me, 'Mai! Turud-la!'
And not knowing what's going on I have to place the baby back
into the darkness on the ground that's covered with wet leaves
and wood splinters. The dogs continuously circling around the
birthing seat are shooed away. To warm the woman who's given
birth a fire has been started right next to her. Rain drips down
from the leaves. For now, all attention is on the woman; they
continue to massage her stomach until the placenta appears ten
minutes later. Only then does the mother herself reach under the
seat and take the baby. With a bamboo knife, she cuts the umbil-
ical cord over a piece of wood near the placenta. With water
she rinses blood and slime, leaves and dirt and wood, from the
red-skinned baby, then she wraps a piece of her worn-out sarong
around the baby's stomach. Now, after all this tension, there is

peace and quiet. With bright big eyes she looks at her baby and I feel connected to them. The next day the father asks me if they can give the newborn child my name."

As the outside world pressed in upon them from all quarters, as the nomads slowly began wearing T-shirts and shorts and wearing watches that often didn't work as a form of modern jewelry, Bruno moved in the other direction, becoming more traditionally Penan than most of the Penan themselves. He shed his shorts and T-shirts and began wearing traditional fabric loincloths, sometimes even experimenting with ones made of beaten bark. He wore traditional bands of rattan just below his knees and bracelets covering his wrists. He cut his hair into a bowl cut, shaved high above his sideburns, in the oldest and most orthodox Penan style. "Huddled closely together, like a bunch of puppies," he wrote one afternoon, "we stretch our lazy bones. With my head resting in grandfather's lap, I enjoy simply being and thinking. A small boy is leaning on my stomach and has fallen asleep. Two little girls caress my hairy legs— there are clouds moving in the blue skies."

By May 1989 when this photo was taken, Bruno Manser dressed as a traditional Penan, with loincloth, poison arrow quiver, and blowpipe. (James Barclay)

EIGHT

In an age of mobile telephones and the Internet, it's hard to imagine that news can travel across time and distance without them, period, much less in a remote place of rivers and miles of forest and mountains. But villages trade with other villages, Penan wander from settlement to settlement, and people everywhere in the world love to talk, trade stories and news, gossip and gawk. Kim Kardashian's ninety-eight million Instagram followers and her concomitant wealth are simply a technologically enabled hyperexaggeration of that essential human trait. Western tourists and travelers were hardly uncommon in Sarawak, but most never made it out of the coastal cities of Kuching and Miri. The few who traveled upriver rarely made it past Mulu, and the barest handful visited relatively accessible longhouses or highland villages like Long Seridan or Long Napir. Roger Graf had been an exception, and even he had come, visited, and vanished, registering the barest blip in people's lives. Bruno was different. Malaysia's politically powerful and majority Muslims often looked down on the animist (and increasingly Christian) Dayaks and Chinese; the Dayaks and Chinese in turn looked down on the Penan. To Malaysians they were the lowest of the low, illiterate, disease-ridden, poverty-stricken creatures without culture, homes, clothing, little more than monkeys living in the forest. It was one thing to want to visit Dayak longhouse communities, but to live among the Penan? That was inconceivable to Malay elites.

Which meant that word about this strange white man liv-

ing in the forest had spread and spread quickly, from every Penan encampment to every longhouse to government officials throughout Sarawak. In early August 1985, James Ritchie, a Kuching, Sarawak–based Malaysian reporter for the *New Straits Times,* the largest newspaper in the country, was standing in a corral of government officials waiting for Prime Minister Mahathir Mohamad to inaugurate the opening of a new dam, when a member of parliament asked Ritchie if he'd heard of the Orang Putih—white man—who was living with the Penan.

"WHAT. . . . You must be joking," recounted Ritchie in a sophomoric book about Bruno that serves as a useful window into how Malaysians saw him and his relations with the government.

"I can't tell you much because we don't have anything on him," a "senior police officer" said. "All we know is that he is a Caucasian and has been living with the Penan."

Later, Ritchie ran into the same police official, and asked him if "our white friend is still around?"

"He is stirring a hornets nest in the logging country," the official said. As Ritchie remembers it, describing his own growing fascination with Borneo, the official continued, "People say that he now looks like a Penan, lives like one and speaks Penan. Apparently the Penan think that he is some sort of a Rajah . . ." Ritchie continues, "When he said that a picture of a white Tarzan and Jane with blonde and blue-eyed children came to my mind. I made up my mind that . . . my next assignment would be to track down this strange fellow. As a teenager I had this fantasy of meeting with a Yeti. . . . As such the story of a white man roving the forest . . . fired my imagination. If it was true, I must unravel the story about this wild man of Borneo."

To whites like Bruno and Michael Palmieri the wild men of Borneo were the indigenous people; to the Malays, the wild man of Borneo was a white.

Malaysian newspapers are government-controlled, and through-out his career Ritchie alternated between working directly for Abdul Taib Mahmud and writing fawning newspaper stories touting the government's official line. Ritchie became obsessed with Bruno, fearing him, repelled by him, fascinated by him, and for the next fifteen years he and Bruno played each other in a never-ending battle, Ritchie insinuating himself at every pos-sible turn (he showed up unannounced and uninvited at Bruno's brother's wedding in Switzerland) all the while reporting on him to the government. For his part, Bruno was fully conscious of Ritchie's loyalties and used him as a back channel to Malay-sian officials.

On December 1, 1985, Bruno wrote his brother, "For you it will still be November for six to seven more hours—which means by the time this letter reaches you Santa Claus will have long disappeared back into the forest—and I hope he hasn't taken you with him in the empty potato bag. I'm joking, but I have a long face because I can't report anything positive. At the moment I'm living in the jungle alone. . . . A logging hut went up into flames. Two nasty-minded Kelabits bad-mouthed me to the company as well as the government and police because of my activities con-cerning the realization of a forest reservation. As I'm without a visa, I've skipped an official meeting and have distanced myself here for now."

Undeterred, he ratcheted up the pressure on the government and logging industry by reaching out to Europe. In early 1986, back in Switzerland, Roger Graf began circulating a petition to "Save the Last Indigenous People of Sarawak." Bruno sent a letter to Rolf Bokemeier, the editor of GEO, a popular *National Geographic*–like German magazine, detailing the plight of the

Penan and inviting him to visit Sarawak and see for himself. And, for the first time, he and the Penan began discussing the idea of blockading logging roads.

In April, Bruno and a cadre of Penan walked to Long Napir to garner support for their forest reserve idea from its Kelabit chiefs. A police inspector named Lores Matios, a native of Long Napir home for Easter, noticed a white man wearing "John Lennon glasses." Upon learning his name, Matios radioed the Limbang police and at nine the next morning arrested Bruno for over-staying his visa. As they bumped along logging roads toward Limbang City in Matios's Land Rover, Matios and his driver sat in front, with Bruno in the back with a third man, a rifle across his knees. Ninety minutes later, high on a ridge over the Limbang River, the Land Rover ran out of gas. Matios always carried a five-gallon canister in back; the driver stepped out to refuel. They were in the middle of nowhere, and Bruno was just some unarmed tourist who'd overstayed his visa with nowhere to run to. So Matios walked a few feet away to pee. Bruno followed him; he too had to go. No big deal. As Bruno peed over the ravine he watched the river, darkish brown, and then noticed a rocky, overgrown bulldozer path, blocked by fallen wood, just below. Bruno inhaled the sweet scent of a yellow bloom on a hanging vine, looked at the policemen. Both had big guts. "Should I?" he wondered. "Yes, flee now!" he thought. Matios was just a few steps away. "Do you want to follow me?" Bruno said out loud, a brazen taunt. The policemen looked con-fused. "Do you want to follow me?" Bruno said again, pointing to the overgrown bulldozer road. "I'm going to go that way."

"Mai!" Matios yelled, but Bruno was tearing into the under-brush down the mountain toward the river. *Bang!* a shot rang out. *Bang!* a second shot from a pistol the policeman had under his shirt.

But Bruno was gone.

He crashed through the tangle to the river, hopped from rock to rock along its bank, reclimbed the hill back to the road, crossed it behind Matios, and headed up into the mountains. What few things he had were stored back in a house in Long Seridan, including a small bag of letters and his journal. He had to recover it before the police did. "All I have to travel with are a pair of long pants, a belt, a pocketknife, a lighter, and a comb. I tie the long pants as a bundle behind my head and walk naked; the garment only holds me back and makes me sweat. With the pocket knife, I laboriously harvest a young uwut palm heart that quenches my thirst; it will be my only meal for two days."

Night fell. Darkness and a cold rain. He crouched under a few leaves until dawn. In the morning, he hiked down the mountain until reaching a logging road. This was unfamiliar territory, so he stayed on the road, dashing from one hiding place to another. Then, a bridge, with no cover for two hundred yards. "When a vehicle parks by the bridge, I have to laboriously make my way through steep terrain and timber wasteland, sinking into erosion mud up to my knees."

He bushwhacked through the night, heard the gurgling of a stream in the darkness. "Water! My dried-out throat is sticking together. But the enticing location is blocked by many logs and only after carefully feeling my way through it do I reach the water. I would like to sleep, but time is of the essence and so I turn around to head forward again. Then, suddenly, I see another inhabited camp on the road. It is impossible to circumvent it in the pitch-black night and so I sleep in the fallen wood above the road.

"When I rub my eyes in the morning, I already see figures on the street. Like a lizard, I have to slide on my belly into the forest to avoid being seen. The land has been freshly torn up, and

the sharp rocks and splintered wood in the path of the bulldozers hurts all the more. The leek-like scent of niekup fruit hangs over the mountain crests."

After two nights and two days he found himself on a path that he recognized. He followed it, hurrying, as the sun dropped low and the skies opened, inundating him. He'd eaten nothing but palm hearts for two days. At dusk he reached rice fields and a village not far from Long Seridan. "I wonder if the coast is clear . . . ? I carefully approach a hut, peek my head in near a fire pit, and give a sign. There—the old Ti-jon immediately climbs down from his hut, gives me a teary-eyed hug, and pulls me by my hand to quickly enter. Immediately, all of the inhabitants encircle me, I get hugged and welcomed warmly like a child that has been thought dead and has been found again.

"They immediately bring me so much rice, sago, and game that I can't possibly eat it all. The rumor of my escape, the shooting by the police, had already reached the village and they feared the worst. Only a few hours before, an armed police squad visited Long Ballau and left in the direction of Long Seridan; I am too late"—his journal and letters had been found and taken by the police.

"Then they organize quickly; every inhabitant contributes something that I need to live in the jungle, and soon I'm equipped with bush knife, axe, sago, sleeping mats, blanket, shirt, flashlight and provisions. Siden, the village elder, gives me magic wax: one amulet is supposed to make [me] invisible; the other is supposed to divert enemy bullets from their target. Finally, I'm allowed to stretch out my bones in a rice storage shed to rest. But at three o'clock in the morning, I'm woken up again and told to eat—I'm still half asleep, but they are urging me to get going. After an unintended visit in the thicket, my guides

find our companions, who take us across the Seridan River by boat—back into the pristine forest."

I'm sitting . . . alone in a lonely hut and the raindrops are falling from the nightly sky on the canopy," he wrote his brother Peter a few days later. "Apart from a foot injury from some fierce thorn-tendrils I feel mediocre. A week ago I had a narrow escape from the cops, who are looking for me steadily, and I slipped through their fingers. But my studies, drawings, notes, letters, arrow-quiver, and blowpipe were stolen."

After they had gotten hold of him once, had seen his letters and journals, Bruno was suddenly no longer a ghost, a rumor, to the police and government of Malaysia. Even worse, his escape embarrassed them. He was now a wanted man.

Rolf Bokemeier, the editor from GEO, and a photographer arrived soon after his escape, and Bruno took them into the forest, showed them its haunting nobility and the effects of logging: the streams muddied and fish dead, the violently stripped hillsides, the ramshackle industrial logging camps, the shy nomads losing their home with nowhere to go. Those images were powerful, and the issue of saving the world's rain forests and its indigenous people was becoming a cause célèbre around the world—Amazonian rubber tapper Chico Mendes had recently burst on the scene in Brazil, only to be assassinated two years later.

But Bokemeier witnessed something more compelling, a living Western fantasy: Bruno himself. A white guy able to catch fish and snakes with his bare hands, who could hunt with a blowpipe and harvest and process sago, speak Penan, climb trees and forge streams and find his way unaided barefoot through dense tropical forest with freaky strength and power and stamina. It

was the stuff of journalistic dreams, Tarzan come to life, Law-
rence of Arabia leading the Bedouin, this time in the tropical
jungle, a real living noble savage, this Penan Man whom you
could talk to in flawless German—and French and English and
Swiss German—who was "one of them" but "one of us" too,
and soon Bruno's legend exploded throughout Europe and the
world in a full-color double-truck magazine spread.

In a letter dated "18, June 1986, somewhere in the jungle,"
Bruno wrote Roger Graf, "My only source of light is wild pig
fat in the lid of my pan, and the wick is a piece of cloth. At the
moment I 'sleep' through another malarial fog. Two nights I've
fought with the demons. Every pulse in my temples is like an
electroshock that almost brings my head to explosion . . . and
every movement hurts; unfortunately there's no medication
anywhere, since it was stolen by the police . . . who now stray
around in the area nearby. Tomorrow a Penan is traveling in the
direction of Limbang and I don't want to miss the opportunity
to send a message along for you, you old warrior. I am having
constant thoughts about the blockades. . . . All the participants
can expect a good kick in the ass and maybe even prison . . . but
we should try everything.

"Anything else important? Yes! The creek is howling, the
frogs are cracking and my lamp is slowly running out and so I
go to sleep. Ciao."

Then, in a postscript, he showed a flash of ego, calling anthro-
pologists "empty windbags," "with nothing meaningful to say"
about Penan culture. "When I have all my notes and studies in
one place, then they'll be the deepest ones about the Penan cul-
ture in the whole world."

By May 1986, Graf wrote that he'd collected fifty-one hun-
dred signatures from throughout Europe and Australia on his
petition, and would soon send it on to Harrison Ngau and the

Malaysian government. An attempt to draw in the World Wild-
life Fund in Malaysia had failed, though; the Malaysians were
frightened of the government. Small, disorganized blockades
were popping up throughout Penan and Kelabit lands, with
little effect. "The WTK company broke through the Penan's
Magoh River blockade," Bruno wrote to Graf. "The bulldozers
are digging now under police protection. . . . They're always
sneaking around and trying to find where I'm staying. As fast as
they can, they want to give me a kick in the ass. The right side
of the Seridan River is already widely sullied—the Penans from
Long Banan accepted a little 'compensation.' On the left side
of the Magoh River the company soon will reach the Tarum
River, but there the nomads from Magoh still want to defend
their ground. A journalist from the *New Straits Times* applied for
a meeting—so I'm on the road with some Penans. But I doubt
his reliability. We'll see. That's all for the moment. Today's prey
is a wild baby boar, an old male stump-tailed macaque, and a
langur. So—after an extensive meal—our group is cheerfully
sitting together. Just the sand flies are secretly making trouble—
apart from that the peace is absolute and even the bulldozers are
silent."

The journalist from the *Straits Times* was James Ritchie. For
months he'd been trying to find Bruno. He had, finally, gone to
see James Wong, who was not only Sarawak's minister of envi-
ronment and forests, but also one of its largest timber barons,
second in power in Sarawak only to Taib, and Wong offered his
support, including the use of his helicopter if necessary.

After their meeting, Ritchie hitched a ride in one of Wong's
trucks along lumber roads as far as he could, made contact with
a group of Penan, and walked with them to their camp. Though
a native of Sarawak, Ritchie had never met any nomadic Penan,
whom he disdained and feared. After hours of trepidation, he

finally brought up Bruno. Though it seems hard to believe, Ritchie insists in his book that he was trying to "rescue" Bruno from the jungle and his visa problems in Malaysia. "'If he is here, please tell me, I want to help him,' I told Busak. She pretended she didn't know what I was talking about.

"... I told them that I was a friend whose real intention was to help a man in distress. 'Saya tahu dia ada sini,' I said. [I know he's here.] Now they looked surprised. How could I know that he is around? I told them it was wrong for them to ask this Orang Putih to remain in the jungle with them. Their consciences had been pricked." Ritchie told them he was their friend, that they were like his father and mother, his brothers and sisters. As Ritchie described it, he said, "'This man . . . hiding in the jungle is your brother and mine too. We are all like one family. I came here with good intentions, I want to help him. If I had bad intentions, I wouldn't have come alone. I am not afraid . . . because I believe and trust you all. If I wasn't sorry for this man I wouldn't have come here. I came here with a lot of difficulty— alone—I came a long way, into your jungle, finishing all my money—all to help him. If I was a bad man, I would come in a different manner, with many men. But I have come alone. I am not afraid because I come with honesty.'

"Then Agan spoke, Busak paused then translated: 'We are hiding Bruno in the jungle.'"

They still wouldn't tell Ritchie where he was, so Ritchie wrote a note "telling [Agan] I'd be willing to help [Bruno] get back to his country if he wanted. I then told Agan that I would come back with a helicopter to take Bruno home." He would, Ritchie said, fly into a spot in the upper reaches of the Magoh River in eleven days between noon and 3 p.m. and they should make a big X marking so that the helicopter pilot would know where to land. As Ritchie left the camp, he felt repulsed. "The

deplorable conditions of [the Penan] are disturbing. How could this Swiss—if that was what he really was—from a country with European standards of living live in these conditions?"

On September 15, 1986, the appointed date, clearly working with the government, Ritchie flew by helicopter to the rendezvous bearing a special two-week visa from the Immigration Department for Bruno, allowing him—on the face of it—free passage out of the country.

On the second pass they found the X, landed, and were greeted by two Penan bearing a note from Bruno. He had never asked for help from anyone and he had no plans to leave. The only reason to meet, he said, was if Ritchie would "write a report about the Penan struggle and the problems they . . . face through logging." The helicopter must leave; only Ritchie and one other person could come; no pictures would be allowed, and he should plan on staying two days. Penan would guide him to Bruno's camp, and if he didn't follow the instructions, he would never see Bruno.

Ritchie refused to go. He was afraid of getting lost, afraid the Penan might lead him astray, afraid the walk would be too difficult, afraid of Bruno himself. Two weeks later, however, Ritchie's first story hit the front pages of the *New Straits Times:* SWISS ON THE RUN GOES NATIVE IN SARAWAK. "The illiterate Penan have expressed admiration for Bruno's concern and his style of 'fighting for them.' Fearing that their 'White Rajah' would be arrested, they have provided him with bodyguards and have hidden him in deep virgin jungle." Ritchie pumped up the White Rajah angle for all it was worth, writing that the Penan carried Bruno through the forest in a sedan chair.

Word of the piece, which was quickly followed by two more, reached Bruno, who responded in a letter to Ritchie that his stories were wrong on all accounts. As the two continued to

correspond, Roger Graf presented his petition to the embassy of
Malaysia on October 22, calling for the "immediate discontinu-
ance of deforestation" and the protection of thirteen hundred
square kilometers in the upper Limbang watershed, with 6,878
signatures. "The petition," wrote Ritchie, "was tantamount to a
threat . . . to the Sarawak Government."

Five days later Ritchie went to see Abdul Taib Mahmud,
seeking help for another helicopter flight in search of Bruno.
"By then Taib had read all my reports; he then wrote a note to
his deputy" to give Ritchie "'a lift . . . to go back and cover the
story on the . . . "Tarzan" from Long Seridan.'" Ritchie wrote
that he never used the note, but what happened next calls that
into question.

"A reporter of the largest Malaysian daily newspaper heard
about me living in the jungle," journaled Bruno. "With the
blessing of the current government, he wants to find me and
send me home, nicely packaged, bow and all. Because I did not
concur with his ideas, and probably based on misinformation
and lies, he wrote a serial and mixed it with headlines about me
which made me look insincere and notorious. James Ritchie was
careful not to say a word about the worries of the Penan, and the
destruction of their home because of the logging. Now he sud-
denly says that he wants to help the Penan, under the condition
that he can see me. I don't have much confidence. The whole
hubbub about myself is not what I want. After hesitating for a
long time, I agree. In these spare times, you have to grab every
helping hand."

In mid-November, Ritchie and a crew from Radio Televi-
sion Malaysia helicoptered into Long Seridan. At 7 p.m., the
summons came. "We dressed for an overnight expedition and
moved ahead. . . . It seemed like ages, but within fifteen min-
utes we passed the village school, walked along a muddy path

through secondary jungle and were at a small farm hut. Climbing up the notched log ladder we pushed open the door and there he was sitting on the floor.

"After all the stories I had heard about the great man called Manser, he now looked quite small and insignificant. I had imagined him to be a big, broad and over-bearing 'Tarzan.' In fact before meeting him, [his friends] had warned me to be careful as he had been labeled by the authorities as 'dangerous.' But . . . I was prepared to face the consequences.

"He had a scrawny beard and his light-brown hair was tied up in a bun. Bare-chested and wearing jungle-green pants, he was sitting cross-legged on the floor of the hut, wearing 'John Lennon' glasses. The contemplative Manser stared at the dancing flame of a candle perched on an empty glucose tin. His quiet manner made him appear a Gandhi-like figure in deep thought—or a man who was drugged. His eyes were glazed and he rarely looked up. . . .

"On his occasional smile I noticed his teeth were stained yellow. Standing about five feet five inches and weighing about 135 lbs he was small for a European. He could have passed for a Penan with his skin colour and general appearance. The yellowing of his skin indicated that he could still have been suffering from a serious attack of Malaria. He didn't appear like the normal European tourist, there was something about his eyes and mannerisms that struck me as quite strange.

"I sat about three feet from him. . . . I didn't want to get too near for fear that he could act irrationally. He was armed with a parang, which was placed on his left, while all I had was my ball-point pen. Would there be any action? I mean, if he was on some hallucinogen—then I could have a problem on my hands. There was no saying how many Penan . . . bodyguards were hiding outside. I stayed cool.

"I was also . . . concerned that if Manser still had Malaria, we could be infected by him."

They talked for several hours, Ritchie's notes from the meeting rambling and barely coherent. "As usual, the reporter arrived by helicopter," wrote Bruno, "and he conveniently brought along two television cameramen. We meet at night at a rice storage place on the edge of the Kelabit village Long Seridan. The . . . interview appears more like providing fodder for gossip stories and I ask him to get to the issue." Nevertheless, Bruno invited Ritchie to a meeting of Penan scheduled for the following day; it was their voices that mattered, not Bruno's, he told Ritchie, and it was imperative that Ritchie and the television crew hear their complaints directly.

At the meeting the next day in the forest, a short boat trip up the Magoh River from Long Seridan, thirteen Penan "chieftains," in the words of Ritchie, gathered; some had walked for two weeks to attend. "The Penan leaders spoke with emotion about their forests," Ritchie wrote. "From their composure and manner of expression I realized that they were eloquent speakers. It was new to me to hear them speak out like this, because during earlier encounters with the [Western] Baram Penan they had always seemed so shy and reluctant. . . . They were now apparently speaking their minds and were totally absorbed in their rhetoric. And they had a sad story to tell. At least, I thought, if there was one thing that Manser had done, it was to teach them how to speak their minds. Bruno watched from a nearby hut interjecting when necessary, sometimes to guide the Penan at other times to act as our interpreter."

Bruno saw it differently. "On the next day I even dare to allow myself to be photographed with Penan, which I had consciously avoided up to now. This way, two natives finally have the opportunity to talk about their concerns. But even before

the speakers realize it, the cameraman packed up his stuff and the reporters rushed away. They appear to have found the fodder for their story. As he says goodbye, Ritchie imitates cutting scissors and says: 'As a human being, I agree with you. But as a citizen of this country, I have to disagree with you. Don't be upset if the story is not going to be to your liking, my editor is going to cut some of it.' Have I once again been too trusting?"

Ritchie denied any role in what happened next, but after the meeting in the forest, Bruno returned to Long Seridan just as police in military fatigues armed with automatic weapons converged nearby. "Before they arrive, they shoot their rifles into the air a few times to demonstrate power," Bruno wrote. "They are looking for 'Bruno.' Disappointed that I'm not there, the second officer says: 'At home, he gets a bunch of money for his book and it will make him rich, but you are the ones who are losing. He's also going to infect you with malaria. The [police] who come after us will kill Bruno. You can forget about your forest reservation.'"

The police were closing in. Leaving the outskirts of Long Seridan the morning after he'd met with Ritchie, Bruno wanted to bathe in the cool river, and he warily approached the banks of the Magoh. He spotted a longboat tied up to the bank, a boat that shouldn't be there. Voices, male.

"Oh, Lakei Ja'au! Oh, Lakei Ja'au!"

Were these friends? He leaned out of the tangle of green. Damn! Just a few feet in front of him crept a policeman in military-style camouflage fatigues carrying an automatic weapon. Bruno looked behind him; two more were approaching from the rear. He pretended he was a rabbit, remained still, silent, his body pressed to the ground.

They were too close. The policeman spotted him, yelled, and Bruno took off. His quiver banged open, arrows fell, Bruno

stumbled to close it. Gunshots rang out and Bruno charged on, tossing aside the quiver and cumbersome blowpipe. He was fleeing on a narrow peninsula between two rivers. Trapped. Should he stop, surrender, allow them to catch him? No! The Magoh. The river was his only hope. He dumped his backpack and plunged into the silvery brown water. More shots, wild calls from the boat, which headed into the stream in pursuit. Bruno swam with everything he had. He could hear the motor, the boat coming closer, fast, but so was the opposite bank under his powerful strokes.

He bounded out of the river, crashed along the bank's thick tangles of half-inch-long thorns. The boat grounded for a split second on the riverbed, bounced off, and picked up speed, passing him, trying to cut him off. Bruno had no choice. He veered inland, into the thick jungle forest and straight up a mountain slope. After a few minutes he paused, listened, tried to clear his head. He heard no voices, no footfalls or crashing branches. His machete was gone, had slipped from its sheath in his flight. Bleeding scratches covered his arms and legs, a piece of flesh the size of a silver dollar torn from his foot.

He considered his options. He could look for friends up by the Bare River, but that was a two-day hike and he had nothing—no knife to build shelter or mark his path, no blowpipe or arrows with which to hunt, no hammock. And there were still people near Long Seridan he wanted to see. He crept back down the slope. The police were gone. He swam the river again, climbed out on the other side, found a group of his Penan friends waiting, hidden in the jungle. A boy brought him drinking water in a leaf, handed him a machete, and as night fell, they left him. As he lay on a bed of leaves, the ants attacked. Exhausted, Bruno cut thin trees and built a small raised platform on which to sleep away from the voracious insects. Light. Flashlights bouncing in

the night. The police? Did they see the smoke from his fire? Hear his chopping? He leapt up, slipped into the dark jungle. Finally, feeling safe and far enough away, he rolled up in a ball on the ground in thick underbrush. Sleep, he thought, just sleep. Tomorrow is another day.

But biting flies and mosquitoes attacked; he rose again, moved, settled between the gigantic buttressed roots of a beripun tree and covered himself with leaves and pulled his head inside, he pictured, like the head of a snail in its shell. To no avail. Sleep did not come; the army of insects continued to bite him and crawl across his skin. And he thought, what if the lights bouncing through the forest were friends, not police? He got up, brushed off the leaves and ants, and slowly circled his way back toward his first camp. It was 3 a.m. Someone sat next to a dying fire. Bruno grabbed a stick, threw it. The figure moved and in the glowing embers Bruno recognized him. A Penan. "Seluang!" he called, stepping up to the fire.

"Ahh, you scared me!"

Bruno was bloody, filthy, hungry. But he'd escaped from the police for the second time. Was still free. He curled into a tight ball by the fire and, as he would later write, "lay down, with relief, in the arms of the mother."

The next morning, as a Penan delegation traveled down the valley to Marudi, Bruno moved up into the mountains, accompanied by the "daring young hunter Seluang." He had, once again, lost everything, including a three-thousand-word Penan dictionary he had been compiling and letters from Graf and Bokemeier, which used a contact address in Long Seridan— anything with a star on the address was meant for Bruno. "They fired all over the place, threatened everyone who helped me with prison, and myself with death," he wrote Graf. He would now have to stay away from Long Seridan to protect not only

himself, but his friends there, who could be arrested for helping him. And he would have to find a new way of communicating with the outside world. "My basic peaceful nature is put to a hard test. Should I make my hand into a fist? To go for someone's throat can only be a last scream of hopelessness. I try to continue to follow the ideal 'Die before killing.' As Bruno built a hut and a fire rack and pondered it all, Seluang returned from the hunt empty-handed. "All we have to eat with us is a two-day ration of sago flour. Without any water container [necessary to make the sago edible] . . . we are going to go hungry."

Michael Palmieri on his riverboat shortly after acquiring one of his greatest finds, which today is on permanent display in the Dallas Museum of Art. (Michael Palmieri)

NINE

May 1979. Michael Palmieri walked along the docks of Sama-
rinda, East Kalimantan, looking for a boat and crew to charter
for a voyage up the Mahakam River. An old man surprised
him with a question: would Michael like to buy his boat? The
vessel in question wasn't some small, open longboat, but a tra-
ditional klotok one hundred feet long, the kind that plied the
river loaded with tons of supplies or dozens of passengers. The
idea didn't seem so crazy. He could roam the rivers at will,
always have a comfortable and private space to sleep, and load
up on treasure, big and small. Michael had the boat hauled and
checked for dry rot; there was none. He hired a mechanic to
look at the big diesel; the engine was sound. Michael forked
over $9,000 in cash, found a trusted Indonesian friend to put his
name on the title, and became the first, and perhaps last, Amer-
ican to own a traditional wooden Mahakam River freighter.

He made a few changes. The boat was one long open space
from wheelhouse to stern; he installed plywood bulkheads to
make a cabin. Hung curtains on the open sides for privacy. Built
a new outhouse off the stern. Spiffed up the galley. Then he
purchased a twenty-seven-foot-long dugout canoe with a long-
shaft, air-cooled engine to tow along behind, with which he
could navigate shallow tributaries. He loaded the whole thing
up. Propellers and spare parts. Pounds of coffee and tea. Hun-
dreds of pounds of rice. And goods to barter: transistor radios
and steel parangs, gold earrings and batik sarongs from Bali,
Buck knives and Swiss Army tools and binoculars. And a crew:

an engineer for the diesel engine, a river pilot, and a general vessel boy. Best of all, much of the boat had a raised deck over plentiful, covered storage space. He was now totally self-sufficient.

"It was to be Mission Impossible," he said. "Once we got under way everything was supposed to be kept secret."

Things had changed since his first foray into Borneo five years before. Indonesian antique dealers with galleries in Java had long been seeking good objects, but almost universally they were after antique Chinese ceramics, especially the big, very old martavan jars so prized by every Dayak family. After 1976, as Michael first began buying statues, he made the village of Melak, thirty-six hours upriver from Samarinda, his base. It was the last reasonably sized, easily accessible village before the river narrowed and the rapids began, and the final one with a hotel—a two-story plank structure on an unpaved street with a verandah overlooking the river—where you could buy a cold beer. Michael rented two rooms, one for him, one for his stuff. There he frequently encountered the other dealers.

"They wouldn't go into the far reaches above Melak," he said. "They were Muslims and the Dayaks didn't like them and they'd sit in this little café smoking cigarettes and drinking coffee while their runners went into the villages to buy things. All they wanted was ceramics. Then I came along and they would see me coming off chartered longboats from upriver with porters carrying these statues up to my room. 'What's with you?' they said. 'Why are you buying this firewood?' They thought I was silly and stupid. But a few years later they were all buying it too."

So were a lot of other people, as it happened.

Ever since merchants and explorers ventured out of Europe to Africa, India, the Far East, and the New World, they returned

with souvenirs of wild lands. Fetishes. Trinkets. The tooths of narwhals and the tusks of elephants. Spears. Drums. Daggers and effigies. Native American feathered headdresses and tomahawks. Crude oddities, it was thought, of exotic places and people, trophies of savage lands and heroic journeys to reach them, wonders meant to shock and fascinate, "to testify to 'the strangeness and inhumanity of their customs.'" Sailors tucked them in pockets and sea bags; captains hauled them into their cabins; natural historians took specimens by the thousands. These "cult objects and other savage utensils" were booty, often gifted to wealthy benefactors back in Europe, where they were displayed in private cabinets of curiosity. To have such a collection of wonders was fashionable, cool; it meant you had touched, if even remotely, distant, alien worlds that were unreachable for all but a tiny few in an age before photographs or films, much less cheap air travel. Back then public museums and art galleries didn't exist; scholarship and art were restricted to the rich, with the exception of reliquaries and religious art in cathedrals. Nor was there a distinction between artifacts of natural history—leaves of the tropical breadfruit tree, or the brilliant red feathers of a macaw, for instance—and objects like statues made by human hands. Or even, in many cases, between things and people themselves, a tradition that resulted, as recently as 1897, in polar explorer Robert Peary's return to New York after his fourth Greenland voyage with six living Inuit curiosities. Thirty thousand people showed up at the dock to see them. "The crowd . . . boarded the vessel to see the Eskimos, who had attired themselves in their native costumes for inspection," wrote a New York newspaper. "Avian and Minik, the children, attracted considerable attention, and were plentifully supplied with candy and peanuts which they seemed to enjoy immensely." The Inuit soon took up residence in, of course, the place where specimens were housed:

the American Museum of Natural History. Though promised a return home to Greenland, all but one would die in New York.

In the eighteenth and nineteenth centuries the first public museums opened, largely built on objects from the grandest private and royal curiosity collections. In 1753 the physician Sir Hans Sloane donated his collection of botanical, geological, and zoological specimens to Britain, which soon became the foundation of the British Museum, opened to the public in 1759. Many of the original ethnographic objects in the Louvre and the Musée du quai Branly originated from French royal collections. The cabinet of curiosities of the Danish kings led to the National Museum of Copenhagen. To fill these new museums, art and antiquities were cut down, sawn off, trundled back to Europe. Thomas Bruce, the 7th Earl of Elgin and ambassador to the Ottoman Empire—occupiers of Greece in the early nineteenth century—began cutting the ancient marble sculptures off the Parthenon in 1801, which he sold to the British Museum in 1816. Napoleon raided Egypt and the Valley of the Kings; his booty comprises the exquisite collection of Egyptian antiquities in the Louvre today.

Colonial conquest brought new ethnological museums, halls of wonder stuffed with lots of curiosity cabinets, like the Tropenmuseum in Amsterdam, originally opened as the Colonial Museum in 1864, and the Trocadéro Ethnography Museum in Paris, opened in 1882, that presented objects from conquered "primitive societies." Exotic flora and fauna and human-made ceremonial objects were one and the same in these museums of ethnology. They were objects of science, not art. After all, as writes Robert Goldwater, author of the landmark text *Primitivism in Modern Art,* who became the first director of the Museum of Primitive Art in New York, for Europeans in the nineteenth century "the touchstone of artistic value" was "the conception

of faithful naturalistic representation." Statues or masks made by Africans or Dayaks were wild, exaggerated, out of proportion, cartoonish, scary, haunting, anything but naturalistic.

At the Chicago Columbian Exposition in 1893, Franz Boas, the founder of modern anthropology, presented ethnographic objects in a new way: for the first time they were removed from glass cabinets and presented in faux scenes, dioramas of Native Americans around tipis or Inuit hunters standing around a stuffed seal, that simulated their original settings. (It was Boas, while working at the American Museum of Natural History, who suggested to Peary that he bring back some real live Eskimos.)

Just as Boas was creating his contextualized displays, avant-garde artists like Pablo Picasso became enamored of African masks. "All alone in that awful museum" (i.e., the Trocadéro), said Picasso years later, "with masks, dolls, made by the redskins, dusty manikins, Les Damoiselles d'Avignon must have come to me that very day, but not at all because of the forms; because it was my first exorcism-painting—yes, absolutely. . . . The masks weren't just like any other pieces of sculpture. Not at all. They were magic things. . . . The Negro pieces were intercesseurs, mediators. . . . They were against everything—against unknown, threatening spirits. I always looked at fetishes. I understood." In the objects Picasso spotted was something altogether different—a feral, expressive power, a totally new vision of aesthetic human form that would soon directly influence modern art. It was a vision that transcended pure aesthetics, a turning away from Western civilization and its constraints, a freeing of the ego, the artistic expression of the very themes inspiring everyone from James Brooke to Bruno and Michael Palmieri.

Primitivism notwithstanding, few really considered the stat-ues and masks that inspired it as art. And how could they? Afri-

cans or Dayaks or Asmat tribesmen in deserts or swamps or jungles were still lesser beings. The ethnological collection of the British Museum, after all, had long been known as the "Rag and Bone Department."

Slowly that began to change, pushed by the cubists and surrealists. In March 1935 the Museum of Modern Art in New York, founded just six years earlier by Nelson Rockefeller's mother, opened an "Exhibition of African Negro Art." "In commenting on the relation between African art and modern art," stated the museum's press release, "[the curator] has said: 'The art of the primitive negro in its mastery of aesthetic forms, sensitiveness to materials, freedom from naturalistic imitation and boldness of imagination parallels many of the ideals of modern art.'" All of the works in the exhibit were owned by European collectors.

Twenty years later, Nelson Rockefeller opened the aforementioned Museum of Primitive Art in New York. It was the first museum in the United States wholly dedicated to exhibiting objects made by unnamed indigenous people not as ethnological artifacts but as art in and of itself. Gone were the old glass cabinets. Gone were the tipis and taxidermied seals. African carvings stood atop white rectangles beneath track lights in white-walled rooms. "My interest in primitive art is . . . strictly esthetic," Rockefeller said, echoing the MoMA press release of two decades earlier. "Don't ask me whether this bowl I am holding is a household implement or a ritual vessel. . . . I could not care less! I enjoy the form, the color, the texture, the shape. I am not in the least interested in the anthropological or the ethnological end of it." To Rockefeller and Goldwater, his mentor and the museum's director, traditional sculptures and carvings from Africa or Oceania could be every bit as great as any painting by the great Western masters.

Rockefeller's own collecting—he bought his first piece of tribal art, a Batak fetish staff from Sumatra, now part of Indonesia, in 1934—legitimized tribal art in the United States. In Europe, with its long history of colonialism, the tradition was older, pushed by the Swiss art collector Josef Mueller, who exhibited part of his African collection in a local Swiss museum in 1957, the same year Rockefeller opened the Museum of Primitive Art. Twenty years later—just as Michael Palmieri was putting down roots in Borneo—Mueller's son-in-law, Jean Paul Barbier-Mueller, Europe's most important collector of tribal art, opened the Barbier-Mueller Museum in Geneva.

Mueller's and Rockefeller's interest in indigenous art had been an outgrowth of their interest in modern Western art; they were drawn to the pieces that had inspired it and they appreciated it on purely aesthetic, formalist terms. The pieces they acquired had come mostly from former colonists: soldiers, government bureaucrats, commercial traders, people who had traveled to the Congo or Benin or the Dutch East Indies in service of the colony. But Jean Paul Barbier-Mueller represented a new, post-colonial generation, people like Michael Palmieri and Bruno Manser, disaffected baby boomers who were turning away from their Western roots and seeking a new spiritual salvation in the East, in tribal people and their animist power and wisdom. Nelson Rockefeller had boasted of his utter lack of interest in the culture and spiritual beliefs that birthed the art he coveted, but in doing so he missed its entire purpose, its soul. All tribal art is sacred art. Even utilitarian objects like paddles or spears embodied souls and spirits; they had been created in sacred communion with gods and spirits and powers responsible for life and death that could summon good health or bad, that could move heaven and earth, that vibrated with unseen powers that Nelson Rockefeller didn't have eyes for. A shield carved by the Asmat in Papua

didn't just stop arrows; it was imbued with designs whose power could make an opponent drop to his knees with fear at their very sight. This new counterculture generation suddenly took interest in the original, full meaning of the objects and the cultures that produced them. A pure aesthetic interest in plane and plasticity and form wasn't enough. "There became an underlying embrace of the Other," said Jean Fritts, senior director and international chairman of African and Oceanic Art at Sotheby's. "You have to understand the ceremony, the ritual. Why is this different from that? There is a curiosity! You can *feel* something from the object."

Bruno and Michael weren't outliers in their turn to the East; they were fully in and of their time, from the Beatles' embrace of Indian gurus to *Ring of Fire*'s Blair brothers, whose mother first brought them to Jakarta as a follower of the Indonesian mystic founder of the Subud movement. "Bruno wasn't unique in what he wanted," said Bruce Carpenter, a scholar and collector and sometimes dealer in Indonesian art, who visited Bali for the first time in 1975, a year after Michael Palmieri. "We were all running away from our own cultures and wanted the magic and rituals and spiritual meaning behind things."

"My generation came of age amidst this great spiritual quest to find meaning in life," said Thomas Murray, among the foremost dealers in Indonesian sculpture and textiles, a former member of the U.S. Cultural Property Advisory Committee and past president of the Antique Tribal Art Dealers Association. Murray, born in 1951, grew up idolizing his uncle Fenton, a sea captain who visited the family every few years and "turned us on to octopus and sushi and stories of head-hunters and cannibals." His mother's death when he was twenty-two—the same year Bruno was drafted—sent Murray reeling. He lived in a yoga ashram, dabbled in vision quest and shamanism, and "with a

mystical yearning" went to the "Holy Land," where he ended up buying a number of "Palestinian dresses that were beautiful and had talismanic properties," some of which he sold at the Marin Flea Market. "It wasn't about money," he told me. "The idea was about how to support your travels, to sell something at the flea market to get a ticket." He traveled through Bolivia, Guatemala, bought and sold textiles here and there. He was pondering medical school when he met a doctor at the flea market who had traveled in Borneo. The doctor invited Murray to his home, where Murray saw his first Borneo textiles, ikat, in which tiny knots are tied on each strand in a process similar to tie-dye, and then woven—a time-consuming and difficult process that could take a woman years to finish. "Man!" he thought; the textiles "blew me away, the patterns outrageous," even more so when he discovered they had been woven "to attract the gods in head-hunting ceremonies." This was the kind of doctor Murray wanted to be. The doctor then said to Murray, "You should go there." It might have been a crazy idea just a few decades before, a journey by ship and who knows what else that could take months. But now anybody could jump on an airplane and for a few hundred bucks soar across the world in hours.

"I'll go when I'm finished with school," Murray said.

"No, go now, first," the doctor said. "You'll be the only medical school applicant who's been to Borneo and you'll distinguish yourself."

It was late 1978. Murray was in love with a Swiss woman; he'd recently made two "spiritual" wedding rings for each of them, and he convinced her to meet him in Asia. He flew to Hong Kong, spent ten days in China, flew on to Bali, "this tropical paradise full of living culture," where, soon enough, of course, he encountered none other than Perry Kesner and Michael Palmieri. The year before, Michael and Fatima had

coauthored a chapter on Borneo textiles for *Threads of Tradi-
tion: Textiles of Indonesia and Sarawak,* published by the Lowie
Museum of Anthropology at UC Berkeley. They were inspi-
rations, romantic, larger-than-life personalities, hippies with
money living a life that the more straitlaced Murray admired
even as it frightened him. He found Perry Kesner, who was in
those days selling objects to Jean Paul Barbier-Mueller from his
hammock on the beach; Michael and Fatima in their beauti-
ful house overlooking the ocean. "They both had this aura of
physicality," Murray said. "Fatima was so beautiful. These guys
had sort of carved out areas, but for some reason no one went to
Batak," in Sumatra. Murray went, bought five hundred dollars'
worth of textiles and a carved stick the Bataks were famous for,
most of which soon turned out to be fakes. "It was a huge loss
for me." But he was inspired, saw the potential of a new way of
making a living.

He and his girlfriend arrived in Kuching, Sarawak, in 1980
with a hundred dollars left. They traveled around the rivers a
bit, watched dances and ceremonies, but in an antique shop he
spotted some ikat textiles that took his breath away. He'd seen
enough by this time, had read Michael and Fatima's essay, and
the ikats in front of him, he was pretty sure, were special. He
went all in: he convinced his girlfriend to sell their wedding
rings and bought the textiles. Out of money and time, they
returned home through Switzerland, where they stopped off at
the Museum of Cultures in Basel, Bruno's hometown, and went
to see the curator. "I got all stressed out," Murray said. "I'm
saying to the guy, 'I'm sorry, there are some holes in them,' and
he looks at them and says, 'These are the best Borneo textiles
I've ever seen. We must have them for the museum!'" Murray
sold them, then sold some more to Jean Paul Barbier-Mueller in
Zurich. "He pulls up in a limo and says to me, 'These are great

textiles, but you need to study sculpture. No one has space for textiles; you can't put them on a table.'"

Suddenly people like Tom Murray and Bruce Carpenter (and others who would soon spring up), who had been drawn east, were finding a market in the objects that represented the spiritual power and mysticism of these last wild places. It was there, in them, inside the statues and textiles of Borneo, and even if you couldn't run away to their source like Bruno or Michael, you could buy them, own them, gaze at their power in your living room. Selling them to eager private collectors like Barbier-Mueller or institutions like the Dallas Museum of Art or the Met in New York meant they could maintain their lifestyles in Bali or pursue further travel, without nine-to-five jobs; they could be surrounded by fetishes of indigenous people and exotic places, could indulge in their tropical fantasies and associations in total freedom and make a good living doing so.

But there's no market unless there's an inventory. And collectors like Barbier-Mueller weren't after souvenir shop trinkets; they wanted masterpieces, the older the better, authentic pieces that had been made not as Christianity and logging and transistor radios were dissipating the cultures, but with full sacred intent, ideally before any Western contact at all. You could, with luck, find pieces in the Chinese antique shops of Kuching or Jakarta, as Tom Murray had proved, or you might buy something off an old collection—though those pieces were expensive and rare—but the real treasures remained up there, in there, in longhouses and remote villages of the upriver wilds.

Getting those was anything but easy. To find the best pieces, authentic sacred antiques, required a deep cultural understanding and knowledge combined with an explorer's fortitude and a psychologist's grasp of human nature. You couldn't just fly into some remote Borneo village and select objects off store shelves.

You had to travel by crowded boat or foot on slippery forest paths for weeks. You had to be comfortable with intense physical hardship, with heat and rain and cold and cockroaches and biting no-see-ums and the threat of disease and hard floors and strange people and ceremonies, not for a night, but for weeks or months. You had to stomach eating whatever was in front of you, even if it was monkey, and you had to be okay with drinking potent homemade rice wine until you could barely walk. You had to have a way with people; you had to understand them, know what they wanted, what moved them, and then you had to develop deep connections with them. Real friendships, which took time and repeated visits. You had to speak their language fluently. You had to have cash, lots of it, and not be afraid to carry it or spend it when necessary, and yet you couldn't just throw it around. You had to know how to bargain, how to deal with officials and policemen in a place where there was no real rule of law. You had to have a high appetite for risk—risk of drowning in rapids; risk of breaking a leg, which could be disastrous in a dozen ways; risk of arrest or death from a thousand sources. You had to have time and patience. Time to travel, time to barter, the time and patience to wait out delays of every imaginable kind. You had to be able to maintain self-control even in a world in which you had no control at all. You had to have an eye for quality and, as time passed, for fakes. And you had to have no ethical or legal qualms about buying a culture's most sacred objects, a gray area if there ever was one.

In sum, you had to possess all of the skills and personality traits of Michael Palmieri.

Lots of people went into Borneo for a week or a month and had a little adventure, bought a few things, had their picture taken in a longhouse or by the side of a river. But no Western art

dealer went in longer and deeper and more often over a longer period of time than Michael.

"No, I didn't pull pieces out of longhouses like Michael," said Thomas Murray. But in doing so, he said, Michael "brought out many of the great pieces."

"I loved traveling in that world," said Bruce Carpenter, "but after a while I had enough of the disease and the dirt." And both men expressed ethical discomfort with buying objects directly, a somewhat disingenuous qualm considering their readiness to acquire the objects once they'd been sold to a middleman.

So it was that Michael, now captain of his own ship, headed up the Mahakam one dawn in 1979. Morning is Borneo at its best. A heavy mist lay over the brown river. The world felt old and wet and big and still, save for the deep *chu chu chu chu* of the boat's thumping diesel. The Mahakam had thousands of tributaries, and he'd hardly been up them all—yet. By 1979 he had a good idea of what was where, his Indonesian was fluent, he knew people, and was known, throughout Kalimantan. He had been drawing big, detailed maps of his own pinpointing river tributaries and villages and rapids, and he had stacks of them. And while he had first been more or less sightseeing and collecting baskets and trinkets, he was now going after everything: textiles, architectural elements, ceramic jars, fetishes and amulets, head-hunting swords, and, most important of all, carved wooden statues, and he knew what separated the best from the mediocre.

He was now a father—his son Wayan shot into his arms at home in Bali in 1977—and his sense of what he was seeing, buying, had become much more refined. Most of the best art from Kalimantan had long been simply labeled Kayan or Kenyah, but

Michael believed there were further gradations, that the most interesting, most powerful and soulful carvings were made by the Modang, Bahau, Busang, Wahu, and Long Galat, and it was those things he especially wanted. Now, with his own vessel and crew, he could go farther and deeper and collect more than he ever had before, like he was ranging through Borneo with his very own tractor–trailer truck.

"As soon as I got the boat, the game really started," he said. He would range for two months at a time. "I went up to Modang territory, up to Sungai Kedang, Long Segar, Jaip Dan, Sungai Telen. Go up to a village, tie up, be greeted by kepala kampong, the kepala adat [the village political or spiritual headman], and welcomed. Then in the evening there'd be a big event, always. Everybody came to see me. I'd be sitting there with hundreds, swapping stories. Then I start pulling out stuff. A little magic charm or a bamboo sumpit [poison arrow quiver] container. 'Listen,' I'd say, 'I want to buy this kind of stuff. You have one?' And they'd say, 'Sebentar,' wait a moment, and slowly stuff appeared. The more money I'd show, the more stuff came out. First came the men, then women. Sixty, maybe seventy percent was bartering."

He stayed among Dayak women with distended earlobes wearing brightly woven sarong skirts in red and blue and yellow, and men in loincloths, many of them covered in swirling, mystical hand–tapped tattoos. "They were unadulterated. Pure. Amazingly healthy-looking. The children of God in all their natural beauty. No hand phones, no electricity, no hotels, just village life, and the way they treated me was wonderful. I think they truly enjoyed my company. Sitting down in the evenings with groups of men and women and children talking and then the women and older men would go to sleep and I'd sit around with the young men and talk and we'd exchange stories, West

versus East, and I loved those stories. And every evening was like that. Throughout all my travels, every evening was these encounters with the people in the village.

"I would go out at night looking for durians, and one night a man and I were talking about spirits and magic, hantu, ghosts. And I said, 'Have you ever seen one?'

"'Yes!' he said. 'Would you like to see one?'

"'Yes! Of course.'

"So he and I and his son walk out of the village along a path and we had flashlights. Then suddenly he stopped and turned off the torch and I looked in the distance and I saw this thing glowing. Like a neon greenish, bluish light. Shimmering. And then we turned on the flashlights again. It was a tree that was covered with millions of fireflies. Nesting. Mating. He wouldn't get any closer. He was afraid. 'That's a spirit,' he said. 'One of our spirits.'"

One night on a tributary of the upper Mahakam, way above Melak, Michael stumbled into a Bahau village midceremony. "Someone had died and they said a man from another village had put a spell on him. They had to have a cleansing ceremony for the whole village." Two hundred people crowded the long, open verandah of the longhouse. Black, piney smoke rose and twisted into the eaves from damar resin–fueled lamps, the eaves black with soot, the room full of shadows and the smell of sweat and pine and aged wood. Pigs and dogs rooted below the raised floor. Rows of doors to individual family compartments lined the verandah. "The shaman was an old man with tattoos wearing a loincloth and he had a leopardskin hat with black-and-white hornbill feathers and a necklace full of fangs from wild cats and bears' teeth and beads and little carvings of people and he was repeating these mantras and people were beating drums and women were dancing in a trance. One by one people came

up to him and he'd cleanse them and bless them—they had
killed some chickens—and he'd put a little bit of blood on each
forehead: everyone, from the children to the oldest person in
the village. And then he came up to me and pointed at me, and
I was like, 'Ahhhhh.' I started shaking, my whole body, like I
was between two worlds, and he reached in and pulled me into
their world and I was down on my hands and knees and he was
above me reciting incantations and touching me with blood on
my forehead and putting holy water on me and suddenly I went
into a fucking trance. I started crying. I cried and I cried and I
cried, like a volcano erupting. And then *whoosh* he blew some
smoke on me and that was it. When I got up I felt fantastic. Like
a new man. Like I'd been reborn. Everything felt clear. He had
cleansed me."

But it wasn't just about the ceremonies, the culture, the
people. Michael was a man on a treasure hunt as surely as young
Jim Hawkins in Robert Louis Stevenson's *Treasure Island*. On
the Wahau River he arrived just as the village was moving, and
inside a communal meeting house was a carved wooden panel
fifteen feet long. "I want to buy it," he said.

"No," they said, "it's not for sale."

Someone else might have accepted that and moved on. But
not Michael, who was in no hurry to get anywhere. He spent
several days in the village trying to understand what they
needed, wanted, what would induce them to sell the panel. He
ate with them, drank tuak with them, bathed in the river with
them. Finally it came out—they wanted a generator. Perhaps
the villagers thought it was so fantastical, so expensive and
unrealistic, that they'd never have to actually follow through.
But Michael sent one of his crew back to Samarinda for a
brand-new Honda generator. "It cost fifteen hundred dollars.
And I had to pay for the ceremony to replace the carving. So

many chickens and pigs slaughtered for blood, and the shaman had to do a ritual to release the spirits from the old panel. It was a very long process. It took weeks."

The word got out.

Michael, like everyone who went to Borneo, was interested in the village of Long Wai, owing to nineteenth-century European accounts of its rich store of arts. First mentioned by a Dutch explorer in 1849, the village was visited thirty years later by Carl Bock, author of *The Head-Hunters of Borneo*. "Shortly before ten in the morning we reached Long Wai," wrote Bock in 1879, "the capital town of the most powerful Dyak tribe in Koetei, and the residence of the great Rajah Dinda. . . . [He is] a powerfully-built man, standing 5ft. 9in., very muscular, and with limbs of Herculean dimensions. He is descended from an old dynasty which has held authority in Long Wai from *tempo deolo* (olden times), as the Malays say." Bock spent seven weeks in the village and even met a band of Penan hunters who emerged from the forest to trade with the Dayaks. "In the evenings there were always some amusements while the Poonans were at Long Wai," Bock wrote, echoing the experiences of both Michael and Bruno a century later. "One of them would play on a bamboo flute with his left nostril, while a few Dyaks would sit round the dim and smoky *damar* torch, made from the resin of a forest-tree, and enjoy a cigarette or pipe.

"Sometimes they would give a war-dance . . . on the great floor under Rajah Dinda's house, where a couple of Dyaks, each with a shield and sword, would face each other in all sorts of attitudes, changing them with a remarkable rapidity to the accompaniment of a two-string fiddle. . . . The music, however, would be drowned by an endless shouting and yelling, proceeding from the audience as well as the performers."

Bock's curiosity had been "keenly excited" by "Dyak tombs"

he'd glanced along the riverbanks on the way to Long Wai, even more so when he heard "frequent rumors of the grandeur of the burial-places of the Rajahs of Long Wai. Ké Patti described them to me as large carved structures, which no stranger was ever allowed to visit." Bock's entreaties were turned down; "time after time I persecuted him for permission to visit the forbidden ground." Finally Dinda agreed. They paddled a few miles downriver, ascended a smaller tributary for another mile, before walking along a narrow path to a small clearing. "Here, surrounded by the graves of a number of his subjects, lay the bones of Rajah Dinda's fathers, and other members of his family. The tombs of the Rajahs were most substantially-built and elaborately-decorated structures of ironwood. . . . The roofs were of laths of ironwood, imbricated. The walls were carved, and . . . painted with representations of birds or quadrupeds, the favorite crocodile of course not being omitted, and the gables at each end were elaborately carved." Bock drew an intricately detailed color sketch of the structure in which Dinda's father lay: a house suspended high atop pylons, its roofline and walls carved with Aso dragons and classic Dayak swirling branches of leaves of gold and fruits of ivory—the tree of life that united the lower and upper worlds—the top of the structure four times the height of a man. Inside, "Rajah Dinda's father was buried with all his clothes, his sword, shield, and paddle—with which he is supposed to paddle himself to heaven in his coffin, which represents a prau. In his hands he is said to have had a quantity of gold dust." High above the head of a man in the drawing dangled a stylized human figure with wide, watching eyes and thin legs and arms and prominent genitals.

By the time of Michael's roving, the great village of Long Wai had vanished. It was common to move villages every generation or two, after their slash-and-burn dry rice fields wore

out, and even villages with the same name might be in very different places. But of Long Wai, a village so legendary in the history of Western explorers, even in name, there was no trace. Michael asked about it everywhere, to no avail. But one day he found an old man who said he knew where it was. They traveled downstream for an hour in the longboat, turned up a narrow tributary, and pulled over at banks of thick jungle green, then bushwhacked for a bit until they came upon an abandoned, rotting longhouse. The only trace of what might have been the mighty village was an Aso, a dragon, attached to the roof's gables. Michael sawed it off. Was it Long Wai? Who knows. As for the great ossuaries described by Bock, there was no sign; time and jungle had swallowed it up.

By then everyone knew about Michael, the river telegraph chattering; people knew he was there, what he was doing. Soon after his trip to Long Wai, he got wind that two Dayaks had been fishing in the river, low at the time, when their net snagged on something strange. They pulled it in to find a carving entangled in the net. "Immediately I left the mother boat and we went up through the rapids," Michael said. "Took us the whole day, like the last village on a tributary of the Telen River. We arrived in the village, late afternoon, people were just coming back from the fields, and I asked where the man lived who had the statue. His wife was there. 'My husband isn't here, he's hunting,' she said. 'He won't be back until tomorrow.'"

Michael wanted to see the statue anyway. She took him out to the kitchen. Resting on the bare timber floor against corrugated metal walls leaned a carving nearly six feet tall. A two-foot-long roughly four-inch-square piece of wood, broken at the top, descended to a large carved head with prominent, wide eyes, a long nose, and an oval mouth at the end of a downward-tilted protuberance. Made of tropical ironwood that's nearly impervi-

ous to rot and long buried in the mud, away from oxygen, the carving was remarkably preserved. The face was alive, expressive. The head connected to a small body with a prominent chest. The arms were broken off at the shoulder and only a stump of its left thigh remained. At the intersection of the piece of wood and head was a square hole, the remains of what had once been the female end of a mortise-and-tenon joint. The wood was deep brown, weathered, with long vertical cracks in a few places, but otherwise superbly preserved. Most remarkable of all, the carving appeared almost identical to the human figure dangling from Rajah Dinda's father's ossuary in Long Wai, described and drawn by Carl Bock exactly one hundred hears before.

"As soon as I saw it I knew," said Michael. "Wow. I knew it was special, a great piece," though he didn't immediately make the connection to Bock's drawing. He knew it was old, the style archaic Modang. He asked the woman how much she wanted, and she said she had to talk to her husband. "I spent the night and he didn't arrive. I wasn't going to leave without it. I spent another night and late that night he came back and we had a long chat. They hadn't carved it; it didn't belong to them. It was so old they had no idea who had made it, and it had no religious meaning to them. It was just a lost spirit in a river, a life, but not theirs, not one of their ancestors'. Finally I asked him how much he wanted for it. We bargained and he settled on one Swiss Army knife. I spent that night there and all night long I prayed he wouldn't change his mind. Quickly the next morning we put it in the boat and headed away."

Michael sold it shortly thereafter to an American dealer named Steve Alpert for a price so high he refuses to name it. Alpert sold it to the Dallas Museum of Art, where it remains on permanent display, one of the museum's prized pieces. "Indonesia's finest traditional sculptors were masters at using angle, incidence, and

natural lighting to heighten the psychological drama surround-
ing their creations," wrote Alpert in a monograph about the
museum's collection. "In its plasticity and complementary vol-
umes, this statue reflects a deep understanding of how to use
these attributes to the best advantage. Much like someone flex-
ing his or her muscles to lift a heavy weight, the torso's expan-
sive chest, arching back, and compressed and squared-backed
shoulders strain and interact in perfect unison to successfully
balance a massive head on a much smaller body. Even in its cur-
rent fragmentary form, minus most of both its arms, lower legs,
and male sex organ, it remains a compelling work of art. This
figure's combination of dynamism and elegant simplicity is the
hallmark of a master carver." It has been carbon-dated to the
thirteenth century.

Michael loaded up. In front of the village of Long Nyelong,
he found a strange-looking figure carved into the end of a ladder
leading up the riverbanks with a body of S-curves and a huge,
looming face with deep-set eyes and an angular jaw, its iron-
wood deep black with age. The villagers cut the figure off the
ladder with a chain saw and gladly sold it to Michael. Today that
statue sits atop a white cube in the Yale University Art Gallery.

He pulled out rare, carved baby carriers with heart-shaped
faces and eyes of bone, the faces remarkably similar to those
on Dong Son–era bronze drums, traces of Austronesian wan-
dering. Guardian figures of every shape and size. Six-foot-tall
longhouse doors carved with winged dragons. Five-hundred-
year-old ceramic jars. It wasn't gold or emeralds or rubies, but
it was every bit as valuable, treasure that in today's dollars was
worth millions.

When the boat was full, he headed back downstream for
Samarinda. Riding low in the water, obviously carrying a big
load, he was always careful to pile the roof high with card-

board boxes stuffed with baskets and bric-a-brac and leaves and whatever junk he could find, with the real cargo hidden under the ship's deck boards. Police and military patrols occasionally stopped boats looking for contraband of any kind, especially if a boat sat low in the water. And of course, there were always thieves, hustlers; if anyone understood that Michael was carrying valuable treasure, not to mention cash, he'd be a ripe target. So he had to operate with care. With discretion.

In Samarinda he crated it all up and shipped it home to Bali. He had been gone two months. He would go home for another couple of months, then return again, and again, as long as his luck held. He was now bringing out more Dayak art than anyone, his house filled with precious, ancient objects. There were plenty of dealers around, but Michael had brought objects from the source itself, had touched the mystical Dayak and their wild lands, had disappeared for months at a time—this before mobile phones and the Internet—to emerge suddenly, unexpectedly, bearing those fruits of ivory and leaves of gold, sacred objects from the great tree of life in the metaphorical language of the Dayak. The things he brought back were fresh; they had power, manna, juju. "Whenever I got home I had this power in me that people could see. An aura. People were fascinated with my stories and my stuff and they wanted to touch and feel that thing that I was transporting from the jungle."

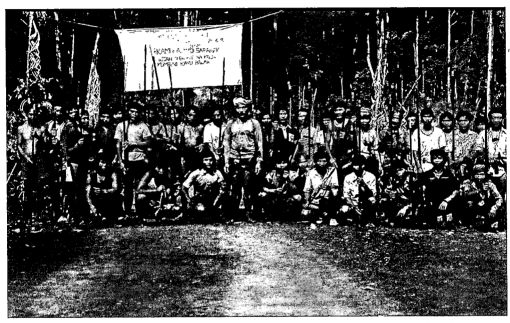

Penan blockades, nothing but ragtag bands of Penan and Kelabit Dayaks in front of small limbs tied together, brought logging in Sarawak to a halt for months in 1987. (James Barclay)

TEN

After weeks hiding alone in the forest, Bruno needed company. It was the spring of 1987. "On secret paths and in the dark of night, I reach the small village at the edge of the logging road," he wrote. "A cold wind blows over the mountain crest and into the embers of fire pits that are growing low; hardly anyone notices the visitor. Two or three women start organizing and soon a double wall and a tepa mat have been built and I disappear behind the wall. The moon stands like a tender sickle over the mountains. The cooking fires shine from the dark forest—the symbol of unified resistance. The jungle peoples have risen up."

In January, not long after Bruno's second escape, Malaysia's newspapers received a press release: "A Message of the Penan people of the Tutoh and Limbang Rivers region to the people of Sarawak, Malaysia, and the world." Roads were being constructed and timber removed without the consent of the Penan, it stated. Compensation was nonexistent, except for token handouts. All efforts of the Penan to have the Tutoh and Limbang Rivers region set aside as a communal forest reserve had failed. Petitions to the government were unanswered. The Penan had no other options. "The communities that signed the above declaration have decided to carry out a total blockade of all logging activities on their traditional tribal lands. . . . The blockade will commence on 23rd March, 1987, and will continue for as long as it is considered necessary."

In a coordinated action, one hundred families of men, women, and children threw barricades in the middle of dirt logging roads at twelve key points, preventing trucks and workers from going in, or timber from getting out. They were nothing, really. Just thin trees mixed with typical Penan huts made from the same spindly trees, and cooking fires, erected across roads that were muddy brown slashes deep in the forest, manned by illiterate half-naked men and women carrying blowpipes, all standing in the way of forty-ton logging trucks and the bulldozers and chain saw—wielding men who filled them. Any one of the trucks could have driven right through the barricades. But that very power imbalance was in itself powerful, an iconic symbol of everything that was happening in Sarawak. It was visual and unmistakable, these people with nothing, standing in front of giant, modern machines operated, in essence, by the most powerful and richest men in Sarawak.

The Malaysian government and timber barons were shocked. Stunned. For as long as anyone could remember the Penan had been shy, subservient, uneducated, powerless, the lowest of the low. Other Dayak tribes, the Kenyah and Kayan and Kelabit, had occasionally resisted, but the Penan? They didn't even have real homes, real villages, or a traditional hierarchical power structure or headmen. And those occasional earlier resistances had been isolated incidences; no one outside of Malaysia knew about them or cared, and they were easily broken by force or quick deals involving gifts or token compensation.

But these sudden blockades were altogether different, not least because they were far bigger and more widespread and broadcast around the world by Bruno's growing network in Europe and within Sarawak itself. Troops and police, the lumber companies themselves, could overrun them in a second, but at what

cost? Malaysia was a modern democracy in good standing with the world community, a nation of laws striving toward leadership in Southeast Asia. On paper, at least, those laws seemed clear: primary forest was under state control and was allocated for commercial logging. Sarawak Land Code recognized "native customary rights," but only for land used by native communities prior to January 1, 1958. Use meant land cleared for farming or occupied by longhouse communities, including burial sites and rights of way and any other "lawful method." But the Penan didn't live in settled longhouses; the whole forest was their community, their land, their dead were scattered throughout the vast jungle and mountainsides, and they had cleared nothing prior to 1958. The Penan, in effect, were simply unaccounted for in Malaysian law.

Even worse, the blockades called attention to the way Taib, the chief minister of Sarawak, and James Wong, its minister of environment, and their families and cronies were the largest beneficiaries of this vast forest wealth. What laws were the Penan really breaking? And complicating an immediate response was the fact that most of the police, at least initially, were locals. "Police squads appear repeatedly at the locations of the disputes, doing their duty," wrote Bruno. "But nobody is apprehended and they only admonish everyone not to use force. Luckily, even among the officials there are people that are sympathetic to the cause of the jungle people." Still, there was an easy scapegoat: Bruno and his European henchmen. "The daily newspapers are full of headlines. Again, the illegal foreigner is blamed for everything to distract from what is important."

In reality, Bruno's role in the blockades was not straightforward. Shortly before his second arrest, he met a young Kelabit Dayak named Mutang Urud. Mutang was born in the late

1950s—he doesn't know the exact date—into a large, high-caste family from Long Napir. A wave of fervent evangelical Christianity had swept through the Kelabit longhouse communities in the 1970s, and "I was part of that and our community was on the cusp of modernity," he said. His father died when he was young and his three much older brothers went away to boarding school in Limbang, leaving him "quite sad, longing for my father, and when I was just seven I had to go into the forest to fish and get meat to help my family." Like Bruno, like Michael Palmieri, he possessed an innate curiosity and wonder about the world, a daring hunger to know more. Long Napir lay in a valley surrounded by mountains, and "I often climbed forest trees to get fruit—I was known as the daring one—and I used to hang in the trees for a long time, wondering what was beyond the mountains. I had such a longing."

When he was still small the family hosted an American Peace Corps volunteer for a year. Their guest told them about Buckingham Palace in London and skyscrapers in New York. "I had thought all white people were the same and that they all came from the same place. I didn't even know there was this place called America!" That this American was alone in their longhouse without his family was mind-boggling to the Dayak. "Why is this white person here? Don't they have brothers and siblings who care about them? For us it was incomprehensible to believe that someone would go somewhere alone without their community." But when news reached Long Napir that John F. Kennedy had been assassinated, their guest broke down in tears. "I saw that he was human, that he really loved his president."

Eventually Mutang's brothers raised money for him to attend a series of inexpensive Chinese boarding schools in the downriver cities of Limbang and Lawas. After high school and then three years of business school in Kuala Lumpur, he won a con-

tract cutting the grass at the Bintulu airport—an opportunity to employ fifteen people, mostly relatives from Long Napir. In the late 1960s his much older brother had drafted maps delineating traditional Kelabit lands, the key to establishing native custom- ary ownership of the land and thus compensation for logging rights. Mutang was deeply religious, and he felt that what was happening with logging was a powerful injustice. "The biblical story of David was my model." He had been instrumental in organizing some of the first Kelabit blockades, in which they'd unsuccessfully sought compensation for traditional gravesites that had been bulldozed. He met Sahabut Alam Malaysia's Har- rison Ngau, and had heard about Bruno, who'd stayed with his relatives back in the longhouse, when he applied for another contract to cut the grass around municipal roads of Limbang. He won that contract too, but a week later it was yanked away from him "because they said I was antilogging, antigovernment." To be denied a livelihood was the breaking point for Mutang, who felt that a much bigger, more coordinated effort was needed, one that had to include not just the Kelabits, but the Penan.

It was the early fall of 1986, and "Bruno was constantly in the news," Mutang recalled. While Bruno was rarely present at the blockades that ensued and always insisted he only played secretary to the Penan, his stature among the Penan was undis- puted. Which complicated matters for Mutang, because Bruno's first arrest had occurred in the Kelabit village of Long Napir— Mutang's home—an incident that left the Penan, said Mutang, with a deep distrust of all "the settled communities, who were suspected collaborators with the authorities." Mutang decided that in order to get the Penan to fully support big blockades, "I needed to meet with Bruno to get the authority to organize them. He was the guy who the Penan consulted. He was their adviser. He was the one who said you have to do this. And I

was very curious about this white man who didn't seem to care about his own family and who everybody said was so curious, always catching snakes and cicadas and drawing them."

It is a revealing and even remarkable comment: an indigenous Kelabit Dayak saying that the key to recruiting the last nomads in Southeast Asia was some little white dude from Switzerland. The blockades and the ensuing political struggle could never have happened without leadership from native Sarawakians like Mutang and Harrison Ngau. They publicly led it and carried it forth, organizing its meetings and logistics and the tangled communications web within and without necessary to sustain and benefit it, and they were the ones who suffered most for it. They were fighting for their own land and their own communities within their own political structure, which they knew and understood, and without them it would have had no legitimacy. They were the ones who were putting their very freedom at risk, who were subject to local laws and cultural pressures and had no foreign passports to save them.

But the blockades—or more precisely the Penans' participation in the blockades—might never have happened without Bruno. Bruno and the Penan themselves were Rorschach inkblots upon which people projected their fantasies, hopes, dreams. Idealizations about noble savages and idealizations about white, Western power were both equally at work, and you see this time and again with people like Bruno and Michael Palmieri. Bruno and the Penan fetishized each other. Bruno represented something for everyone, and it would ultimately be his tragic downfall, his inability to escape an identity, or lack of one, that he himself constructed. To Bruno the Penan were noble, untouched, uncorrupted, and he wanted to preserve them as such. "In a way," said Lukas Straumann, the executive director of the Bruno Manser Fund, "Bruno was naïve; he saw the Penan as a people

without history." As time passed, and as he would soon convince Mutang, he increasingly hardened against anything short of a total ban on logging and a forest reserve big enough to let the remaining nomadic Eastern Penan live in their state of nature— ideally with him living in its Eden. Part of that was a belief that no fair compensation could ever be realized, that any attempts to negotiate a genuine fair share of the profits would be futile, but he was also a purist, a refugee from the world of compensation and profits and all that they might bring.

In a perfect world to Bruno the Penan would have seen him as just another Penan. One of them. A brother, a cousin, a son. A fellow hunter. No more, no less. Bruno had no aspirations to leadership of anything, much less a band of nomads he idolized for their very egalitarianism. But he was no more able to transcend and escape culture and history than the Penan themselves. For the Penan were no more untouched by history or no more living time capsules of an earlier form of humanity than any other people. Even uncontacted tribes living in the Amazon today aren't really uncontacted at all, but small groups of people who broke away from larger bands to flee encroaching loggers and miners and settlers, to hide in the forest. There is increasing belief, too, that our view of the Amazon basin and its people as a world where small tribes like the Yanomami and Kayapo lived unchanged for millennia—that anthropologists' first encounters with them were windows into an unchanged past—are incorrect. In fact, it appears that long ago population densities were far higher in the Amazon than today. Culture, as it turns out, is never static or purely linear.

In fact, by the time Bruno hiked into the forest, the Penan had been involved in a complex symbiotic relationship with the outside world for as long as anyone could remember. They were anything but untouched. Since at least the first European explor-

ers encountered them, the Penan "occupied a specific niche in the economies of central Borneo," writes the anthropologist Peter Brosius. They supplied forest products, everything from their finely woven rattan baskets and mats to damar resin used for fuel, to deer antlers and rhinoceros horn and bezoar stones (gall-stones from gray langur monkeys) that were used in traditional medicines, to downriver Dayak tribes, which then found their way to the coast for export. In exchange they received metal for blowpipe spear points, cloth, salt, and tobacco. There is some evidence that, long ago, Penan didn't even manufacture their own blowpipes, but acquired them through trade from long-house Dayaks. Amid the warring Dayak tribes, "the presence of a Penan band in an area meant access to forest products and to the income generated by trade in those products," according to Brosius. "Longhouse aristocrats were proprietary about 'their' Penan, and jealously guarded their prerogative to trade with cer-tain groups. Various longhouses frequently competed to monop-olize their relationships with particular Penan bands. Historical records detail numerous disputes brought to colonial authorities resulting from attempts by longhouse aristocrats to lure Penan from one watershed to another. In short, Penan were regarded by longhouse peoples as a form of wealth.

"The relationship between longhouse people and neighbor-ing Penan was . . . highly paternalistic. Penan relied upon long-house peoples to act as mediators with the outside world, the conduit by which both information and material goods from downriver reached them. This was a system maintained both by Penan timidity and by indebtedness to longhouse patrons."

The Brooke regime had extended the paternalism, deepened it, protecting the Penan from their Dayak exploiters by regu-lating their relations and, in 1906, creating quarterly markets, called Tamu, where their exchanges with wily Dayak buyers

occurred in front of government agents so the Dayaks' couldn't cheat them. The Brooke government also forbade Iban and Kenyah Dayaks from entering their lands to collect and hunt for themselves. The Penan existed in the first place probably not because they were simply the last, oldest, purest indigenous of Borneo, but because centuries before, they'd fled into the hills to escape their marauding, violent Dayak neighbors—and even then they had been almost indentured servants to them and their power. And who had liberated them? The White Rajah, James Brooke. For a century the Brooke family protected them, left them alone, wanted nothing from them but their jungle prod- ucts, fairly priced, no less. World War II had suddenly ended that protection. The Malaysians who took over Sarawak and became the Penan's new overlords were every bit as foreign to them as the British. But this time, these new foreigners thought of them as monkeys, people who were a slight to the new modern nation and at best needed to be dragged into the modern world and civilized and at worst had no rights at all. In a strange and ironic twist on imperialism and colonialism, the Eastern Penan of the upper Baram and Limbang and Tutoh watersheds looked upon the British as saviors, protectors; for them, the late nineteenth and early twentieth century was a golden time.

Though they seemed to be remote hunter-gatherers living out of time, even the remotest and oldest Penan knew of whites and the British and felt a mythological nostalgia for them. And then there appeared Bruno. This white man who spoke their language, who valued them, affirmed them, marveled at their ways, seemed fearless and comfortable with the forest, just like them. He was a brother, someone they trusted—after all, they called him Penan Man. But he wasn't one of them; he was a white man, a westerner, and as such represented an outside power and affluence out of the Penan's reach and from which he could

never escape, that he could never wash off no matter what rivers
he bathed in or how he cut his hair or how well he hunted. To
the Penan he was more than just an odd, white Penan, he was a
link to that golden time, the time of the White Rajahs. When
he talked about saving the forest and encouraged the Penan to
speak their minds and to resist the chain saws and bulldozers,
they believed him, believed *in* him, saw him in a historical con-
text. He dressed like them, spoke their language, but he had a
power and privilege they could never have, and when he said
they should rise up and speak for themselves and fight for their
historical land, his belief and his presence strengthened them.
Bruno gave them courage. Heart. They believed in the power
of the white man, and his power gave them power. And that'
historical connection helps explain, too, the Malaysian govern-
ment's visceral reaction to him. Bruno stood at the very center
of history, a character with a potent legacy, not just to the Penan,
but to the Malay politicians like Mahathir Mohamad and Abdul
Taib Mahmud, the very men who had brought the nation of
Malaysia from shameful subservience to independence. To them
he was the Brookes returned, the very essence of colonialism,
an iconic threat to their dreams of independence and Malaysian
self-determination.

In October 1986, Mutang went to see Bruno. Accompanied by
his cousin, who shared his convictions and was a close trading
partner with the Penan, he walked two and a half days from
Long Napir to Long Seridan. "We avoided logging roads and
slept secretly in Long Seridan, and then went by boat three hours
down the Magoh" to where Bruno was hiding. "I came into the
hut of Sala, who was a respected elder, and it was evening and

Bruno was sitting down, talking and writing. He was wearing a loincloth and his hair was cut in the Penan style. He was gentle and calm and so miniature. I told him what I wanted to do and that I wanted all the Penan to support us and we talked all night and all the next morning and he wrote a letter for all the Penan, until I left for Long Seridan again that afternoon."

Bruno wrote of the encounter in his journal. "I give my friend the name Spring because his soul is as refreshing as water that bubbles over river rocks. He had already planned a blockade by the population of his home village Long Napir and hoped for an alliance with the Penan. The goal was to get compensation and profit sharing from the company destroying the land. I gave him my opinion that it was not worth fighting for money, which, as experience has shown, leads to betrayal among the villagers, and that an alliance with the Penan makes sense only if there is a unanimous demand for a forest reservation where logging is forbidden." Bruno wrote that Mutang's help was "a blessing" because he knew the bureaucracy and "can build bridges between the uneducated natives and the civilized power people in this fight. As a local, he can move about without restrictions; the government can't stop him."

Bruno convinced Mutang for the first time that compensation and profit sharing wasn't enough, that nothing short of a total ban on logging was the solution. Mutang became his chief contact, the conduit for all of his growing communications to Roger Graf and Georges Rüegg, and his family, in Switzerland, and the swarm of journalists in pilgrimage to see him when the blockades broke out.

In one of the strange twists of their relationship, when Bruno fled the police in November the authorities once again came into possession of a trove of letters, including ones between

Bruno and Mutang. Soon after, Mutang's distant cousin, who was a policeman, contacted him and invited him for dinner in Bintulu. Mutang was suspicious, but wasn't sure what to do and figured nothing could go wrong since it was his family. But he arrived to find not just his cousin but the head of Sarawak's secret police there. "Bruno is an outsider," they told him, "and it's not in your interest to cooperate with him. You are a citizen of Sarawak and your allegiance is to your country, not to outsiders." "They said hard things," he said, "that they knew what I was doing seemed good, but that I had to be a good citizen." He was stuck. Mutang became a police informer, a double agent, consistently reporting mundane details even as, he maintains, "I never betrayed Bruno." And, indeed, he would not only be arrested again and spend weeks in jail without charges, but have to flee the country and seek political asylum in Canada.

The first blockades broke out on cue in late March 1987, and soon more Penan joined and erected more obstructions—by October they had sprung up at twenty-three sites guarded by twenty-five hundred Penan, Kelabit, and Kenyah from twenty-six bands and settlements, and logging was brought to a standstill.

Police and soldiers and logging workers, often Iban Dayaks, camped outside of the blockades, watching, waiting, cajoling, threatening, and hunting in the surrounding forest with shotguns and powerful lights, laying waste to the wildlife and food sources of the Penan. "The bulldozers are quiet now," Bruno wrote in June. "The fuel reserves of WTK Company are exhausted." A few loggers left the camps, but most, hoping the blockades would soon be lifted, hung around, hunting in

the forest for recreation and food. "The virginal Magoh River is incredibly rich with fish and the Iban loggers . . . now attack these riches with nets, harpoons, poison, and self-made detonation devices. With sorrow and anger, the nomad looks on powerlessly as sago palms are cut down and the loggers now become direct competitors for food. The police and field force squads, which constantly surround the blockades, also go into the larders of the Penan to hunt. Equipped with halogen floodlights, they illuminate the embankments of the logging roads from their jeeps. The eyes of the blinded game glow and make for simple targets for the deadly bullets. At the blockade, Libai complains that the uniformed men shot six deer, two wild boars, and an anteater in a span of two nights and that they refused to give the natives part of their prey."

Officials came and went by helicopter. Penan women taunted their opponents by pulling up their sarongs and spreading their legs. "Furiously, some of the mad women throw off their sarongs," Bruno wrote, "and sit with legs spread in front of the hoity-toity civilization, and some of them even pee . . . and the men they address turn their heads in embarrassment. 'You probably think we are stupid to show our pussies?—No, there is a reason for this! Why should we talk and talk, over and over again, if you don't listen to us anyway?!' Indeed, the males are cut down to size when they look at the very place from which we all came into this world."

Bruno became famous overnight. Headlines about him exploded across the world; the twenty-four-page *GEO* piece was reprinted in Spain, Japan, South Africa, Italy, and Norway. Bruno ignited centuries of Western tropes as reporters and filmmakers and environmental activists flooded in, bent on seeing Bruno as much as covering the Penan and their shrinking forest.

"He wears John Lennon spectacles and looks frail in rare photographs," wrote the *Wall Street Journal.* "He suffers from malaria and says he has survived three snakebites. Armed with a spear and a flute, however, Bruno Manser, a 32-year-old Swiss artist, has roamed Sarawak's remotest jungles . . . and he has enlisted in their fight to save their tropical rain-forest homeland from logging-company chainsaws and bulldozers.

"Officials in Sarawak, a state that is dominated by timber politics and money, have denounced Mr. Manser as a 'Communist' and a 'Zionist.' Malaysia's largest newspaper . . . ridiculed him in an elaborate April Fools' Day spoof."

"The Wild Man of Borneo Leads in Blowpipe War," shouted the *Observer* in England. "To the government of Sarawak, North Borneo, Bruno Manser is a subversive. His picture has been circulated to jungle police posts. A squad of the State paramilitary Police Field Force is hunting him.

"But to the Dayak tribesmen, many of them former headhunters, he is *Tuan Bruno,* Chief Bruno, a Tarzan figure who is going to lead them to victory against the authorities who are taking away their land. It's a battle of blowpipes against bulldozers, led by a man in the role of Robin Hood."

"Swiss Chieftain of the Blowpipe War," blared the Swiss tabloid *Blick.* "Hunted mercilessly through the jungle inferno of Borneo and revered by the blowpipe warriors . . . Swiss Bruno Manser is one of the last great adventurers of our time."

James Ritchie helicoptered in to one blockade. "As we circled the blockaded area the Bell [helicopter] . . . set to land upon the restless natives. It was a pathetic sight—the visibly untidy and skimpily dressed Penan gathered there were living in flimsy and ramshackle open huts perched on a raised embankment near the blockade. When I met them, they appeared a disorganized rabble, who were quite unaware of what was happening around

them. They were living off the surrounding area, but many had left their settlements for days and had not much food. It appeared as if all their hopes hinged on that slender piece of log lying across the dusty timber track; a sad, forlorn symbol of their protest, their hope of getting the forest reserve that Manser and his environmentalist friends were trying to pressure the government into."

In August Bruno wrote Roger Graf. "Doris and the photographer Harold from *Stern* [magazine] have left. Thanks to our friend 'Spring' who organized the meeting. . . . We had a good time together, but with this article I've realized that it's less about the Penan and more about me—I am a bit disappointed that during the whole time the photographer only wanted to take pictures of me and showed less interest in damaged forests, huge trees, and Penan faces. But I played the game and made jumping jacks for Harold in front of the camera. I then laid it to Doris's heart not to make a cult of personality around me, but to put the fight of the indigenous in the foreground.

"In the next days, three other British journalists (BBC London) want to meet me, and in October for a full month a Swedish film group (four men from Stockholm) are coming.

"Our friend Spring is on his way to KL [Kuala Lumpur] to get the money that Roger has raised for me and to buy a video recorder. So I hope to be less dependent on white journalists, whose arrival at the place of trouble is always problematic."

The whole thing was growing; to turn it into an effective, worldwide media campaign required a new level of coordination. But Bruno was a wanted man somewhere in a trackless jungle. The blockades were a stain the Malaysian government wanted to hide. Reporters couldn't just fly in and travel upriver or by road to see him; immigration officials were on the alert; police manned roadblocks along logging roads to the blockades

and forest beyond. Reporters had to be sneaked in from Brunei or Kalimantan or by sea, and then Bruno had to be located. Activists and reporters in Europe needed to be in contact with Bruno; letters, audio, and videotapes had to flow in and out.

Before any of them really understood it, grasped its all-consuming energy, Mutang and Roger Graf and Georges Rüegg found themselves dedicating their lives to Bruno and the Penan, even as they all had full-time jobs themselves. "I was his friend, not an environmental activist," said Rüegg, "but slowly it just grew bigger." Georges had a friend in Penang, Malaysia, and he created a "letter bridge": Bruno got things to Mutang, who sent them to Penang, where they were sent on to Georges in Switzerland. "Letters, tapes, thousands of pages of his diary, they would all come to me and I'd send them on to Roger or to Erich and Aga," said Mutang. Soon the friends started communicating by fax, Georges running to the neighborhood post office to send twenty pages to Penang, where it would then be printed and sent to Mutang. "People were calling me, faxing me, writing me, from France, Switzerland, Australia, Singapore, America," said Georges, "and my phone bill was three thousand Swiss francs a month! It took more and more time!" And to keep it all going required an increasing amount of money. Bruno wanted nothing to do with money, but Georges insisted, making Bruno sign a power of attorney appointing him Bruno's agent.

As his friends worked overtime in Switzerland and the blockades unfolded, Bruno roamed the forest alone, only occasionally visiting the blockades themselves. "I've built a hideaway in the inhospitable terrain of the gorge," he wrote. "Even a trained police squad would hardly come upon this inhospitable place where every step is laborious. The Limbang River is said to be wild farther toward the headwaters of the mouth of the Rayah

River. There are deep ponds between steep rock shoulders and you cannot follow the water—I was told to stay away from the area. Forbidden things are enticing and one day I set out on an excursion after my friends have gone down the valley to block the logging companies. My only equipment are small shorts, a knife, and a bush knife. I plan on circumventing the gorge by land and then swimming down the valley. I have to climb high up a mountain and then steeply back down on the other side until I reach the stream. There are traces of wild boar and deer. The sky gets more and more black while picking jakah palm heart and I suddenly get worried: what if there will be high water while I'm swimming down valley in the gorge, with no way to escape?

"I hurry down the mountain until I reach the banks of the Limbang River, put the palm heart in the back of my shorts, and swim downriver. My Penan friends exaggerated a bit: the inhospitable and hard-to-walk riverbanks are no obstacle for the swimmer. I leave the water above the rapids and circumvent them, only to hop back into the water below the rapids. The threatening clouds lift and I leisurely swim on my back down the valley."

A pattern developed that would be repeated over the next thirteen years: Bruno's actions and passions and obsessions inspired others, who did the heavy support of logistics and communications and dedicated their lives to him and his cause, even as he often disappeared for days at a time to indulge his nomadic curiosity.

The Malaysian government fought back. In June, after Sahabat Alam Malaysia brought twelve Penans to Kuala Lumpur to meet with ministers, it invited its own delegation of Western Penan to the capital. With cameras clicking, it offered them a power-

boat and cash payments. Penans "say yes to logging," dutifully reported the *Borneo Post* the next day. But they had been settled for years; it blamed the Kelabit Dayaks and semi-settled Penan's shifting slash-and-burn rice cultivation for far more destruction of the forest than "selective" logging.

Finally, in October, the government began moving against the blockades, dismantling them in exchange for vague promises of everything from money to outboard motors to typewriters to a forest preserve, none of which were given out. Forty-two Kayan were arrested at one blockade. "In pressing heat and sand flies," Bruno wrote Roger Graf, "some hundred armed men are scanning the jungle close to the blockades, searching for me. So the fearful Penan have urged me to leave the area for about two to three weeks. During this time, the hopeless opened up the blockades and allowed the company to transport about 4,000 tons of logged timber down to the valley.

"At the moment my head is humming from all those talks, news, lack of sleep and sticky heat . . . and the demoralized, partly hungry Penan are said to have given in, after being led through prayer by the government representatives—without any written guarantee, compensation, or whatever."

A few weeks later the Sarawak State Legislative Assembly passed an amendment to the Sarawak Forest Ordinance making it illegal to obstruct a logging road, irrespective of the legal status of the land, punishable by up to two years in prison and a 6,000–Malaysian-ringgit fine. "The Europeans should blame the Penans instead of the Government for destroying the forests," Malaysian prime minister Mahathir Mohamad told the *New Straits Times,* "but of course, they would rather blame the Government and logging concessionaires. And the Penan should stop moving from place to place for shifting cultivation but instead stay in one area and manage the land properly."

"Govt to Act Against Swiss Fugitive," declared the *Straits Times* in Singapore on November 25. "'Malaysia will take stern action against Swiss fugitive Bruno Manser, who has been declared a subversive element, a Sarawak state minister has said. Appropriate action will be taken against him once he is arrested,' Minister for Industrial Development Abang Johari Abang Openg said on Monday. Mr Abang Johari said that local sympathisers 'who are involved in harbouring Manser are liable to face legal action.'"

Nevertheless, throughout 1988 new blockades sprang up and more filmmakers and outsiders poured in. In July the European Parliament passed a resolution limiting the import of Malaysian timber (a plan later rejected by the European Commission). In November eleven Penan and Kelabit were arrested at a blockade near Long Napir, followed by twenty-one Penan in December. In January even more blockades sprang up, followed by the rapid arrest at five sites of 105 Penan, who were held in custody for two weeks. Harrison Ngau was arrested.

And, it was said, the government had placed a $15,000 bounty on Bruno.

He was, of course, nowhere to be found. Throughout 1988 he wandered and fished and hunted. He wrote thousands of words in his journal, cajoled the Penan to not give in, to keep the faith and erect new blockades. He went weeks without contact even with Mutang, who continued to sneak activists and journalists and filmmakers in, often from Brunei. They carried letters in to Bruno, ferried his letters out. His mood rose and fell. He managed to get a video camera and began shooting hours of tape of the Penan, which he smuggled out to Roger Graf and Georges Rüegg in Switzerland. His letters show a growing sense of political sophistication and clandestine operations, as his network— abetted by his Swiss friends—grew around the world.

Bruno had been gone for five and a half years now. He was

increasingly worried about his parents' health, the constant pressure from the Malaysian police, and doing something that might tip the balance for the Penan. He pondered turning himself in, an action that he believed might force the government's hand. And he continued to behave recklessly, wandering alone for long periods in the steepest mountains and deepest forest where a single mishap, a broken leg, a twisted ankle, a branch falling on his head—the most common Penan injury—might be deadly. And now he wasn't just catching pythons, but the deadliest snake in the forest: pit vipers. "In the company of two families, we go up the mountain into barely touched headwaters. Up on a crest is a poisonous green snake, located a bit up high on a path that is bordered by uwut palm trees. As I attempt to catch the reptile, my friends warn me and turn away and continue on their path. I am wondrously looking at the reptile. It looks mad and furiously out of a perpendicular pupil. I grab it by the neck and it turns and convulses and widely opens its mouth, even spreading each of its jaws and opening its toxic teeth. After I commit it to paper, I give the sulking reptile its freedom. One of the Penan calls the snake with the thick head and high arched back 'Utin Tassa.' A ten-year-old girl died the day after she was bitten. A boy had thrown the snake, which had been beaten and was assumed to be dead, after the girl to scare the girl."

In late summer 1989 he hiked a week, alone, to Batu Lawi, a pair of giant limestone pinnacles rising like rock smokestacks out of the endless and still roadless green. The higher one was nearly seven thousand feet tall, and it had only been summited successfully in 1986, by a joint British–Australian expedition. But, alone, with no technical gear, no ropes, no harness, Bruno free-climbed it. It was a crazy thing to do, utterly heedless. Three-quarters of the way up he got stuck, couldn't find a way higher, and as dusk came on and the sun dropped and night came, he settled in

and turned on his tape recorder. The hourlong tape he sent to Georges Rüegg begins with twelve minutes of singing, his voice a deep, haunting lullaby over the symphonic din of cicadas and frogs. "Look around you / Listen to your heart / Go your way / Go on your path."

"That was Bruno," Georges Rüegg said. "He looked around. He listened to himself, to his heart—that's important—and then he went on his way. That was his belief. You can't find a sentence that explains Bruno more. He had an idea and then he found people who could help him realize it. And he got into situations and wanted to share those situations."

The tape wound on for an hour, a running commentary made at intervals over three weeks. Bruno said he would find a new handhold in the morning, had spread some branches in a crook, had to be careful, and sang again, wishing all the people everywhere good night. When dawn broke he turned the recorder on again. "Good morning. The sun is down there; I can see the trees and fog is rolling. Gibbons are calling and the fog is moving through the trees. It's been a cool night and I've been asleep in the branches with my feet out in the air and they're asleep and my knees are cold and I still want to climb up and I hope I can find the way up to the top—it's not far now and if I can't make it I'll turn around and come near to the big river. Yes! How are you? I wish you a good day tomorrow!" Without mentioning whether or not he made it to the top, the tape wound on as Bruno described how he'd found the river and spent two days building a raft with his machete. The raft, however, was soon destroyed in huge rapids, forcing him to swim and climb out of a gorge. He became lost, was supposed to be back for a meeting, but was enjoying himself so much he decided to blow off the meeting. He found a twenty-foot python and pulled it out from the river and fought with it, and he held the huge head and shot

pictures of himself with it, but the film roll was finished, so he had to change the film with one hand while the other held the thrashing giant snake. He then lost his knife and almost starved, before finding his way back to a band of Penan three weeks later. "The Penan always told him never go alone in the jungle and they told him that over and over and he always ignored them," said Georges. "He had no food or water and that shows how he functioned. I was supposed to share that tape with his family, but when I listened to it I thought, 'How can he send that to his mother?' But Bruno wanted everything. He wanted adventure. He wanted to help the Penan. He wasn't crazy. But he once said to me 'What's life if you're not close to death? Life means to find out where the borders are.' It was always the same with him. He always wanted to know and to find out and that was his ego."

Then, in September 1989, it happened at last. As he slashed through the undergrowth at the bank of a river with his machete, he felt a sharp pain in his leg. One moment he was a healthy, preternaturally strong young man and the next he'd been bitten by a red-tailed pit viper. The snake was small, a thin green animal barely a few feet long. This one he hadn't even tried to catch. Alone, he sat down, tied a tourniquet above the tooth marks, and drove his knife into the wound to bleed out the toxin.

"I need to get to our hut as soon as possible before I can't walk anymore, and I limp hurriedly homewards. The pain in my leg increases rapidly and sharply and soon I can no longer put any weight on my foot. I carry on as best I can . . . groaning." His companion Jémalang appeared and Bruno urged him to dig farther into the bite marks with his knife. Afraid, Jémalang couldn't bring himself to do it, only making "numerous tiny slits in the skin around the wound. I push on towards home." With the venom coursing through him, he was as far from hospitals and antivenom as it was possible for a man to be.

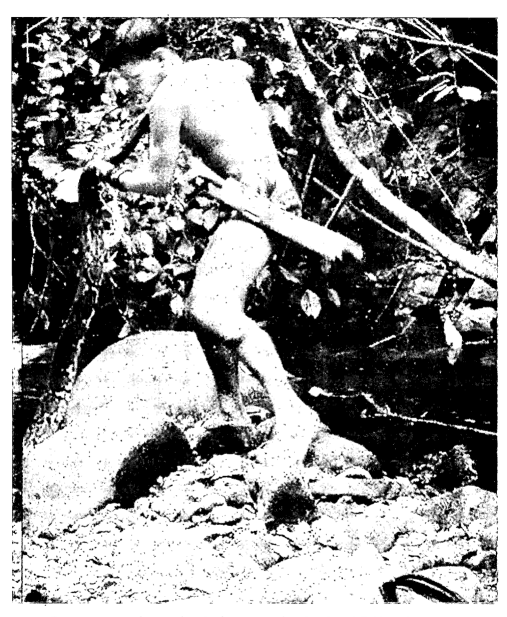

Bruno Manser wrestling a python; his fascination with snakes almost killed him when he was bitten by a pit viper in 1989. (Erich and Aga Manser)

ELEVEN

Pit vipers are not the world's deadliest snakes, but they inject hemotoxins that destroy red blood cells and surrounding muscle tissue, and prevent clotting, not to mention induce vomiting, dizziness, and splitting headaches. In extreme cases they can cause kidney failure and death. To read the *Merck Manual* about treating the victim of a pit viper bite is a like a cruel joke, a description of everything Bruno didn't have and did wrong. "In the field, patients should . . . avoid exertion and be reassured, kept warm, and transported rapidly to the nearest medical facility. Pressure immobilization to delay systemic absorption of venom . . . is not recommended . . . and may cause arterial insufficiency and necrosis. First responders should support airway and breathing, administer O_2, and establish IV access in an unaffected extremity while transporting patients. All other out-of-hospital interventions (e.g., tourniquets, topical preparations, any form of wound suction with or without incision . . .) are of no proven benefit, may be harmful."

Bruno's bite was a nightmare, the worst-case scenario. He wasn't even with a regular band of Penan, but with a young couple in the remotest forest. He was soon delirious, burning with a high fever, racked with intense, throbbing pain. The tissue around the bite withered and died, even as the toxin interfered with his blood's coagulation and his leg ballooned. His heartbeat slowed, his blood pressure sank, his breathing became labored, as flies swarmed during the day and tried to lay eggs in his wound and the no-see-ums attacked at night and the rain

poured down in floods. He lay on a floor of branches without blankets, clean bandages, or comforts of any kind, surrounded by a vision of deep green, the smell of moss and decay and earth.

Three weeks after the bite he was still alive, the wound a swollen, festering mass of dead tissue. He couldn't walk. While he was trying to massage his leg and squeeze the pus out one day, "a piece of flesh suddenly balloons out of the wound—as large as a squirrel's head. I can see the skin that surrounds the muscle and thickens in the middle to form tendons as shiny as silk. I am scared"—the only time he would ever use the word in thousands of pages of journals and letters. "The muscle, three fingers thick, protrudes farther every day and suddenly exits the wound, as long as a banana, together with pus. Then it becomes clear: the muscle between calf and shin has detached itself below the knee and is now hanging like a long horn out of my leg. The next day, the muscle feels cold. I pinch it with my fingernails—it is completely numb. Has a part of me really died? Quite possibly, after what I have been through in the past few weeks. The pressure of the heavy protrusion on the wound causes further pain. I decide to remove it. If only a doctor could visit me in this isolated place. . . . Fed up with the prolonged suffering, I am ready to do the operation myself and take potluck. Reluctantly, Nalin sharpens my knife and I carefully cut into my own flesh. I feel no pain and there is no blood. I sever the protruding mass of muscle piece by piece, cutting three more times; the parts of me lying on a leaf could be bits of fresh stewing meat, ready for the pan—just like those pieces of meat the butcher offers the housewife. My amazement continues. The pieces of meat do not rot; even five days later they look the same. Flies do not dwell on it and it doesn't smell foul. This shows the unimaginable power contained in two drops of yellowish clear venom. How many

times have I caught pit vipers and spit cobras just because I was curious?"

More muscle remained, however, and he wanted to extract it. He tried using a fishhook, but that failed and the hook kept hitting a piece of exposed bone. "What a weird sound and feeling!" But pus continued flowing out of the wound like spilled milk and he took that as a good sign. "The healing power of the Creator within each of us will do its best—and I look forward with confidence."

After a month, Mutang reached him, bringing antibiotics, which he declined. "He said," Mutang recalled, "that it was so painful, that he'd wanted to die, that he'd been hallucinating and praying to die and his head felt like it was going to explode." Mutang left a week later, carrying Bruno's first letters to friends and family about the bite. "As for me," he wrote laconically, "I was bitten by a poisonous snake four weeks ago and the wound is now healing slowly and the pain receding. But I still can't walk."

Everything was getting complicated in paradise. Unraveling. After seven weeks he still couldn't walk. He could neither put any weight on the one leg nor fully stretch it out. He felt depressed. "I can only dream of climbing on steep rock faces and in cave labyrinths."

At three months he could barely walk with a pair of crude wooden crutches. Bruno was handicapped in the worst place on earth to be an invalid. He could barely move through the wet, roadless wilderness of steep mountains and numerous rivers. He couldn't feed himself, much less carry his own pack. A fugitive, he had nowhere to go, there was no place safe for him. His photo had been plastered on all the newspapers in Malaysia. Every police official, immigration official, and taxi driver knew his face as surely as that of the prime minister himself.

Meanwhile, new blockades had broken out in September, just as he'd been bitten, but the authorities reacted swiftly, arresting 117 Penan and locking them up in the coastal city of Miri for two weeks. The blockades weren't enough; something else was needed. But what could he do? A big meeting of the International Tropical Timber Organization would be taking place in Miri soon and Bruno became obsessed with turning himself in. The idea, he wrote, wasn't to "rot passively on ice in a Malay prison—but an immediate and total hunger strike until I'm let free. . . . One has to risk something, otherwise one will not achieve anything. I think the Sarawakian government under pressure of publicity would not dare to end the fast. I have never told you [Georges and Roger] about this plan frankly, . . . but I thought that I had to now."

Then in mid-December Bruno wrote again. His parents were getting older; he hadn't seen them in almost six years. His father and mother were both hospitalized, and he had received tape recordings of them. "To hear the voice of my old parents dreaming . . . after all of this has hit me and gives me another nudge to decide upon the near future." Again, he mentioned his idea to give himself up. "An arrest would be answered with an immediate hunger strike to the last." The government, he thought, would either let him starve to death or free him after "worldwide protest."

Back home in Switzerland, Bruno's family and friends were becoming increasingly alarmed. Georges Rüegg and Roger Graf were adamantly against his surrender. The Malaysian government, too, had heard about the snakebite, and its secret service had informed the Swiss embassy, whose foreign affairs officer sent a letter to Georges, who felt Bruno was being selfish. "I couldn't believe he was sending these notes to his parents about getting bitten by the snake or being arrested; it was like he was

totally clueless about their welfare. We were all helpless. We didn't know what to do. Some people said we should send a helicopter in to get him out, but of course that was impossible."

In February 1990 some twenty of Bruno's closest friends and family convened at his parents' apartment in Basel: his brothers Erich and Peter, their wives, his sister Monika, his parents, now out of the hospital, Georges and his wife, a few others. "We tried to figure out what we could do," said Georges. "We talked all day and finally got to the point where we decided someone had to go bring him home." But who? One of his caving friends owned a drugstore and so had enough time and money to go. "But he didn't think it was a good idea," Georges said, "because he couldn't control Bruno. He wasn't strong enough to confront him." Which left Georges himself. "But I'd never been to Asia before. I knew nothing about the situation in Malaysia. Finally I said, 'Okay, I'll go, but only to talk to him. To let him do what he wants to do.'"

Georges's wife, Fabiola, argued against it. It was way too dangerous, she said. And she was right. Bruno was public enemy number one in Malaysia. Police, soldiers, special forces, the security services—all were looking for him. To meet him deep in the forest was one thing. To extract him from it across international borders was another. Who knew what might happen? How long a prison sentence might Georges face if he and Bruno were caught? And for what? Georges had a wife and son, a life he loved in Switzerland. "I thought and I thought. And I thought that as a friend it was necessary to do the right thing, even though I knew it would be complicated." But a kernel of resentment had been planted and was growing inside of him. "We were all Bruno's victims," Georges said. "Bruno did what he wanted to do and he depended on his friends and supporters. But he was our victim too. The films and tapes brought sounds and pictures

back and we pushed those pictures. Action gets reaction. What we created—sometimes I had the feeling that he tried to fulfill the pictures. He would say, 'I don't want to be the hero of the Penan or the environment,' but he was pulled and pushed. His image was growing in the public and we were pushing it and we were growing it, too, in certain directions. And I never had the feeling that he was a peaceful man like Gandhi. Bruno was a fighter. Inside himself. The picture that we all created was of a peaceful man, but that is just a picture. Why did he always have to be on top of the mountain? He was very competitive. Always seeking the border of everything. That's the key to understanding Bruno."

The group pooled their resources. The clock was ticking. It was now early March 1990, the ITTO meeting was fast approaching, and Georges had to get there before Bruno might turn himself in. Georges Rüegg was a middle-aged shepherd and carpenter, about as far from an international covert operator as someone could be. But what he did next is the stuff of legend. He moved with speed, sureness, and authority, not to mention with nerves of titanium.

Just before departing, he received a fax that an Australian woman, Anja Licht, who had been in and out of Sarawak and had met Bruno there, would be in Singapore. The two linked up and Georges explained his plan. He went to a series of travel agents and booked twenty-seven different flights in and out of various cities in Sarawak. To Singapore. To Brunei. Kuching. Miri. Every possible permutation of travel. Bruno's most distinctive feature was his round John Lennon glasses; with a copy of his prescription Georges had a new pair made: giant, 1980s-style. He went to a separate optometrist and bought a set of blue-tinted contact lenses. Anja purchased a packet of blond hair dye. Georges flew to Kuching. Anja flew separately and

met him there. Together, posing as a couple, they flew on to Miri. In Miri, Georges tried to reach Mutang, who knew he was coming, but Mutang was nowhere to be found. On the fourth day he appeared. Georges and Anja flew on to Limbang; Mutang drove and picked them up at the airport, took them to someone's house, and said he'd return the next day. He arrived with a pickup truck, buried Georges in the back under a tarp, and, leaving Anja behind, they drove for hours on logging roads, past timber camps. Finally they parked the truck and Mutang said, "Okay, now we're going into the forest." They walked for three or four hours and came to a hut with a corrugated tin roof the size of a one-car garage. "I put up my hammock and all of a sudden in walked Bruno."

They hadn't seen each other in six years. "It was good, but also strange. He had a Penan haircut. Like forty bracelets on his left arm. Was thin, not an ounce of fat on him. We talked. I told him about his parents, that his father had cancer and his mother had been in the hospital. I told him that Roger and I were completely overwhelmed—that we could barely keep up with our own jobs and what we were doing for the Penan. It was clear to him that the situation was not easy. He listened and looked into my eyes and said, 'I'm coming out.'

"It was too easy, too fast. I didn't like it. I thought, 'You must think about it, this decision is not to be made so fast; why don't you think it over?'

"'No, I don't have to take my time,' he said. 'I'm coming out.'

"And then suddenly I thought, 'How am I going to organize this?' I said, 'How do you want to do it?' And he said, 'I'm the baby now.' And at that moment I knew it was completely someone else's responsibility to organize it. Not him. He left the responsibility to others, to me. I said, 'You have to change your looks.'"

The next morning Georges cut Bruno's hair. Kneeling by a stream, Bruno dyed it; he soon had short, auburn-brown hair. "He had no emotional attachment," said Georges. "None. He did what was necessary." He put on a blue polo shirt. The big new glasses. For six years he'd been a wild man of Borneo, a nomad, a Penan tribesman, Penan Man, had dressed in a loincloth with bare buttocks and bare feet and long hair, Tarzan of the jungle. Now, just like that, he looked like anyman, anyone from anywhere, a tourist on a two-week holiday from an office in Switzerland, utterly indistinct. Georges snapped his picture, close-up headshots to be used as passport photos. Bruno said he had to go back into the forest for a few days, wanted his drawings and some bear claws and the skull of a bear. He said, "Come with me. It's wonderful." He was standing on the edge of the fields we know, the border between two worlds. Strange how easy it was to take off one costume, put on another. He could do it; the Penan could not. But he wasn't ready to leave yet, not fully. No, Georges said, I have no time. Bruno also had a detailed report he'd written in longhand to the ITTO; he'd missed the meeting, but he asked Georges to take it out with him and get it to London.

A day later Georges and Mutang returned to the car and drove back to Limbang, arriving at dawn. Georges flew on to Miri and then to Kota Kinabalu in the neighboring Malaysian state of Sabah. Borrowed a typewriter from the front desk of his hotel and typed Bruno's long letter and faxed it to the ITTO in London and to Fabiola in Switzerland. Went to the post office and mailed a hard copy. Went to a photo developing agency and suddenly realized Bruno was famous. What to do? He gave the film to the clerk and then talked to her nonstop, a stream of senseless tourist words about seeing Gunung Mulu and climbing mountains that kept her occupied until the pictures flopped out of the

developing machine, and she never even glanced at the photos. Flew to Bandar Siri Begawan in Brunei, where he checked into the Brunei Sheraton and where he'd arranged to meet Mutang with Bruno's things—they wanted Bruno to travel with nothing. Georges won't say exactly how he worked the passport, but he had a Swiss one and he switched the photo, slowly, carefully, and gave it to Mutang, who gave Georges Bruno's things. Next he went to a travel agency and booked a Qantas Airlines flight from Singapore to Frankfurt for Bruno, under the name on the passport. He gave the ticket and money to Mutang, who returned to the forest and drove Bruno out to Limbang, where Anja was waiting. His legs were covered in bruises and scratches, not to mention the gaping hole in his calf, so Mutang gave him his blue jeans, his best, most expensive pair. Anja and Bruno took a taxi to the airport for an early morning flight to Miri, just another tourist couple. Mutang's cousin went to check on them. "It was a big police sports day in Miri and the whole airport was filled with policemen. There were all these police looking for him but they didn't recognize him." Bruno, bearing the false passport, with his mousy short hair, his big glasses, carrying a briefcase, boarded his first plane. He sat next to a policeman, who failed to recognize him. They flew to Miri. There, he heard that some Penan would be putting on a cultural show in the city. He wanted to go. Anja, apoplectic, called Georges, who was still in Brunei, said Bruno wants to go to this dance. Georges said put Bruno on the phone. "I told him, 'You will *never* go there! Ever. What are you thinking? I've put my head in a noose and you're going to go to a dance where you might be recognized?'"

"Okay, okay," Bruno said. "I won't go."

Georges flew to Singapore. Bruno flew to Kuching and then on to Singapore. "It was strange for him. It was so bright. The jungle had been so dim." But he was shifting fast, stoic, showed

III

RETURN

What I was feeling then, such very
depressed feelings, my ancestors called
nelangsa—feeling completely alone, still
living among one's fellows but no longer
the same; the heat of the sun is borne by
all, the heat in one's heart is borne alone.

—PRAMOEDYA ANANTA TOER,
THE EARTH OF MANKIND

From beneath his mattress one day, Michael Palmieri pulled out a thick sheaf of carefully hand-drawn treasure maps, detailing the rivers, tributaries, rapids, and longhouse communities of Borneo. (Carl Hoffman)

TWELVE

It was February 2016, another perfect Bali morning, the air balmy and humid, yet before the heat of midday it felt almost womblike. To ride my rented motorcycle through the streets was a sensual feast of smells. Sudden drafts of plumeria so sweet it was like sniffing an open bottle of perfume. Cloves from Indonesian cigarettes replaced by acrid car exhaust replaced by incense from corner temples. Each smell came and went quickly, hitting my nose for a few moments of olfactory stimulation, before a whole new onslaught. A few weeks before, Michael had showed me a photo on his phone of an old Dayak shield. One of his contacts in Borneo had texted it to him, offering it for sale. It appeared, like most Dayak shields, as a long hexagonal shape, brown with hints of red. Big circular eyes under a smoky old brown patina. He'd leaned in close to the photo, outlined it with his finger, pointing out the eyes, the mouth, the fanglike teeth. "If this is real—well, it looks real, but it might be repainted—and if it's not . . . I have to buy it," he said. "Take a chance on it. I don't need any more. I have thousands of objects spread all over. I could never sell it all and when I leave this earth my son Wayan and my nephew will have it all. But the thing about art is it's an opiate. A drug. A need. For beautiful things. I love beautiful things with history and power. You see it and you have to have it and its power."

He'd sent the contact two hundred dollars, with the promise that if it was real and he wanted it, he'd send more. The shield had arrived, and I was on my way to Michael's to see it.

Thirty-five years had passed since he'd bought the big boat on the Mahakam. Logging, palm oil, coal mining, oil drilling had taken billions of dollars from Borneo's once pristine rain forests. Not to mention roads, television, Christianity, and mobile phones, all ubiquitous in even once remote places. Longhouses were rare in Indonesian Kalimantan; in Malaysian Sarawak they were often pink or purple concrete. Bali was no longer just the province of a handful of avant-garde artists and hippies, special people seeking original experience, but of masses of spiritual seekers whose experience was anything but original; riding through the streets of Ubud was like a slalom course around tanned, mala bead–bedecked men and women carrying yoga mats. Often if you didn't make an advance reservation for a class at Yoga Barn, the largest shala in Ubud, you'd be out of luck, the classes full. The main practice space, a hundred-foot-by-fifty-foot open-walled temple to Western hunger for Eastern solace, routinely filled with seventy-five souls in hundred-dollar spandex pants, many covered in tattoos, often vague "tribal" imitations of those ancient and powerful Dayak tree-of-life swirls. One evening during a class, primal screams and grunts and great heaving moans came from the smaller space below; ecstatic dance and Tibetan bowl meditation classes were offered weekly. Yoga teacher trainings and retreats in Bali were constant and everywhere. My social media feeds were lighting up with women in skintight pants and tiny tops striking natarajasana— dancer's pose—or shirtless dudes upside down in handstands in front of ornately carved stone Balinese temple gates. The message was clear: yoga asana was good, but asana mixed with Balinese traditional religion was a hundred times better, more powerful. It was all food for the soul, even though it was fare as common now as artisanal coffee at Starbucks. People were desperate for a world that no longer existed at all in the West and

barely existed anywhere else. I went on a date with an American woman who owned four villas, had undergone extensive plastic surgery, and looked me straight in the eye and told me she was a healer. On a date with another American, a woman with five thousand Facebook followers who traveled the world giving yoga retreats, we ended up drawing in a store-bought mandala coloring book after she read my fortune with tarot cards. The cutting-edge lives that Michael Palmieri and Bruno Manser had sought had now become another commodity. Westerners were hungry, thirsty, starving for the mystical sacred worlds of the Balinese, the Dayaks, Native Americans, Indian yogis, for something beyond themselves and the cold logic of science, for a meaning and connection to metaphor and the unknown and to nature. It was so big it had become big business.

Tribal art, art created to propitiate spirits and to call them forth to watch over ancestors and villages, art that was, in essence, a bridge between the material and spiritual worlds, had become big business too. In 2001 the total value of tribal art sold at auction (not including works sold privately) was $14 million; by 2014 sales exceeded $100 million. One statue alone, carved by a nameless African in Burkina Faso or the Ivory Coast—no one even knew which—who no doubt possessed nothing of material or technological value, but a gift for human form and an unsullied connection to his environment, sold at Sotheby's for more than $11 million. Indonesian tribal art represented a mere fraction of that, but still, a single Dayak carving fetched nearly $200,000 in 2014. It was a huge, unregulated, and legally gray market, with Bali the epicenter of objects from Indonesia and much of Oceania. And it was that much more opaque because the days of easy pickings were gone, villages and homes mostly emptied of their pusaka, architectural elements, and public village guardians. Which didn't mean there was nothing to be had. In the perfect

metaphor, deforestation and its accompanying erosion altered the courses and historical flows of rivers, turning up the occasional ironwood statue buried in preserving low-oxygen silt. Wholesale forest burning occasionally turned up ancient stone statues. And Borneo was dotted with thousands of caves, into which ornately carved Dayak ossuaries had been long ago placed, sometimes with accompanying guardian figures and artifacts. And things in caves can be incredibly well preserved. There was still stuff out there, and it was more valuable than ever.

To make matters more complex, the dearth of new objects on the one hand and the enormous prices they fetched on the other birthed a new industry of fakes. The popularity of auctions and the Internet and tribal art books brought clear, high-resolution photos of objects that sold for unimaginable prices to a local Indonesian who might live off of a few thousand dollars a year, and anyone could see the kinds of pieces most in demand. Dayaks, Balinese—the archipelago was rich with skilled carvers who could imitate anything. The best things had—usually, but not always—certain identifiable patinas, depending on what they were; things that had spent years outside were weathered with erosion, cracks, mold, and lichen; objects that were handled were deep black and shiny with human touch. With time, patience, and skill, however, a faker could sandblast a piece, could erode it with pressure washers, could even grow lichen and mold. You could even take an old, not very special piece and recarve it; if the wood was ancient, who could tell the difference?

Suddenly fakes were everywhere, and only the most trained eye could tell the difference, and even then it was hardly foolproof. At Parcours des Mondes in Paris, the world's most important annual tribal art show, in 2013, Judith Schoffel de Fabry, the daughter of one of the most respected dealers in tribal art, had offered a Dayak sculpture for $1 million that came with exten-

sive scientific analysis, including carbon-14 dating and high-resolution optical/stereo microscopy, electron microscopy, and infrared and X-ray spectrometry. Dealers and collectors broke into war, with some swearing the piece was real, others just as confident it was fake. The reality was, no one really knew, the whole enterprise so opaque the piece was withdrawn from sale.

The network behind all of this was sprawling and amorphous, a tangled web of rivers and tributaries along which art flowed from the jungle to the galleries and living rooms of the rich. Throughout Borneo there existed a network of runners, locals, often Dayaks, who still ranged throughout the villages and forests of their home territory on the island in search of new old objects. Freelancers at the bottom of the food chain, they sold to dealers in the cities of Kuching or Samarinda, or they called people like Michael directly. Or they got on an airplane and arrived in Bali to make the rounds. Dealers like Michael bought from them sometimes, sometimes from Indonesian dealers. Michael usually sold to other dealers, who had galleries in the West or showed at the annual tribal art shows in New York, Paris, Brussels, Geneva, San Francisco. It was not uncommon for a piece to go from some local who'd found it to a runner to a dealer in Kuching to another runner who'd take it to Bali and sell to someone like Michael who'd sell to a more public Western dealer who'd sell to a rich Western collector. Everyone took a percentage; the standard for making a deal was 10 percent of the sales price.

Michael was now seventy-two years old. His days of ranging into the farthest crevices and nooks of Borneo for months at a time were over. He still went in occasionally, but mostly only when he received word of something specific, and his destination was usually a city. Nor did he often attend the retail end of the market—the tribal art fairs in Europe or the United States;

these days his stock ran deep and he was content to let other collectors and dealers find him.

Genuine old Dayak shields were rare—a good one could easily fetch $20,000—so I was eager to see the piece that Michael had just been sent. I parked my bike and, as usual, his door was wide open. "It's a fake," he said, the minute I walked in. "Look," he said, handing it to me, wearing a pale pink-and-black Hawaiian shirt, faded blue Thai fisherman's pants, and a pair of black kung fu slippers. The shield appeared old, the paint faded, the back inside covered with dust and the odd lingering cobweb. To me it looked real, as genuine as the one he had sitting on a stand in his living room and that he'd owned for years. "It's way too heavy," he said, telling me to pick both of the shields up. I did; his was incredibly light, much lighter than the one that had just arrived. He turned it over. "Look here. The rattan isn't right," he said, pointing to thin bands of binding throughout the shield. "When rattan gets old it has this look." He handed me a bamboo poison arrow quiver that lived on his desk, with similar woven rattan, except the quiver's was burnished a deep brown; it glowed. The binding on the new shield was dark, lifeless. "There's all this dust on the insides along the bindings which they rub on it. It's fake, no question. I told him it was fake. Says he didn't know. I said I want my money back."

Word on the street, he said, changing the subject, was that there was a wealthy Swiss collector in town, one who he'd never met. Michael wanted to make contact with him. "Let's go," he said. "I've got to get the word out."

As we walked to his car, a man appeared out of the bushes in front of us. He held out a plastic baggie, like a drug dealer offering a bag of weed. "Gold dust," said Michael, taking the baggie, peering into it. "Just mix it with a binder and you've got

real gold paint." And then came another wad, this time a sheaf of brown papers, between each of which was a sheet of gold leaf as thin as tissue paper, shimmering in the morning sun. "Tidak mau"—don't want—he said, waving the man away.

We drove out to Kerobokan, through intersections so packed with motorcycles and cars it was almost a scene out of *Mad Max,* to Jalan Tangkuban Perahu, a winding street lined with antique shops, one after the other, for a solid mile. "All these used to be in Denpasar, first, then moved to Kuta, then Legian, and now they're out here," he said, a march that mirrored the frantic growth of southern Bali. "In the old days the runners from other islands came to Denpasar and stayed in a losman [cheap guest-house], and there were four or five all right there, and so I'd go from losman to losman and see who's there. They'd come with boxes and boxes of stuff. Had no phones then. Then they started coming to my house."

We parked the car outside of Daeng Iskandar's, the largest and oldest of Bali's dealers, a Sumbanese man who'd made a fortune in the trade. A group of young men in tennis shoes and blue jeans and T-shirts lounged outside the shop, another group across the street. I wouldn't have noticed them, and if I had, I would have thought nothing of them. Groups of people lounged everywhere in Bali. But like hustlers and their network of scouts and runners on an urban street corner, these men were all part of the antiques trade. "Pak Michael!" they yelled as he waded into their midst, exchanging fist bumps, clapping them on the shoulder. "This guy," he said, taking out his big iPhone 6 and opening a photo of a middle-aged white man in a suit, speaking in Bahasa Indonesia. "Do you know him? Have you seen him? I want to meet him. Five hundred thousand [about fifty dollars] if you get him to me. To my house!"

They nodded. A few said they'd seen the Swiss around, but none had spoken to him. "Five hundred thousand," he said again, as we headed into Iskandar's.

We passed through a gate into a shaded courtyard behind walls filled with men sitting on chairs smoking. They too were runners in the trade. Daeng, his wife said, was taking a nap. Objects filled the yards and four buildings, piled on tables, leaning on walls. Dayak coffins. Eight-foot stone megaliths from Sumba. Hampatong guardian figures from Borneo. Swirling roof finials. Earrings from Borneo and bracelets and beads and kris handles in brass and rubies and a room with a pile of folded pua textiles three feet tall and ten feet across and paintings stacked three feet deep lining the walls and benches—old Balinese paintings. "He doesn't even look at the artist's signature, he just buys everything now," Michael said. "He's rich. Very, very rich. In the early days he went to Samarinda and there was a statue and it was hugely expensive and no one would risk it. But he was bold and he bought it. Sold it for a lot of money. That made him. Had a little shop here. Then he moved. In old days the shop was filled with excellent masterpieces, but now it's all mediocre and who knows what."

We drove down the road to a shop owned by a woman named Nunu. More loungers. More rewards offered. Nunu's shop was small, uncluttered, and I could see things were better there. "Everything here is real," Michael says. "She has class, taste, and a reputation to uphold." I spotted a pair of bronze bracelets six inches long, oxidized to a lovely gorgeous blue-green. "Dong Son," Michael said. "Very old. Maybe two thousand years. These"—he picked them up, examined them—"these look like they came right out of the ground. A tomb. I bet someone took them right off an arm—probably a bone right in these. They were originally made in Vietnam, but Dong Son pieces went all through Borneo as trade items. Everywhere."

On a stand sat a Dayak ossuary, old, its sides carved, its once complex end pieces sawn off. "I saw pictures of it before it was cut. The people who got it sawed off the ends and sold them separately and then she got the box. I said she should cut it in half and make wall panels out of it."

We drove farther, went into another shop. "Andy Borneo, I call the guy who owns this place," Michael said. "Four brothers and this is one of them. From Kapuas River, Kalimantan. Sintang. West Borneo." We entered—two long rooms crowded with stuff, stuff of every kind, from furniture to baskets to statues, a smaller back room, stifling, hot, musty, filled with statues lined up like sentries. "Now we've got some old things." He bent down. Peered closely. Touched. "You have to look at details. See, this has the black line around it here," he said, showing me a patch of whitish lichen the size of a quarter, outlined with a thin black line, a natural growth that was hard to fake. Most of the statues he could identify quickly, easily. "This is old. Very old. Central Borneo. The way the erosion is, it's totally irregular. If processed with chemicals it's too uniform." A big stone piece, four feet tall. A figure. Large penis and eyes. "Could be a couple thousand years old." We moved on. "These," he said, picking up a statue that was heavily eroded, "are heavily processed. I don't know what they're using. Some chemical. This, it has lichen, but it's too light and patchy. The erosion is too uniform, the lines too straight."

He picked up a carved wooden hampatong so eroded you could make out the face and human figure only by squinting, the barest ghost of a human form. "This is original and old, but it's so fucked up and eroded there's nothing left of it. That's how desperate people are getting."

At yet another shop full of odds and ends, he spotted a fossilized mastodon molar, jet black, the size of a half-gallon jug of

milk. "Shit, man, that's ancient. If this was mounted, it would look beautiful," he said, holding it up. "He—the owner—is from Sumba and he owes me money. Sold me a statue for $2,000, but when I got it home I realized it was fake. Took it back, got credit. Took another huge molar like this for $1,000 and put it on a stand on my desk and an Italian guy came over and traded me·a great, heavy gold ring, so right away I made a profit."

While we waited for the owner to finish a phone conversation, a hip-looking Indonesian man in black Chuck Taylors and jeans and a ponytail walked up with a backpack. "Mau kain?"—want textiles?—he asked. Emptying the pack, he laid thin red-and-blue ikat cloths out on the ground, each five feet long, bordered by colorful stripes. "This is all natural," Michael said, running his finger along the pale gold and red print, "but this," he said, pointing to bright red threads in the border, "this is a commercial aniline dye. All the rest, though, is hand spun, and naturally dyed. I'd say it's over a hundred years old—those aniline dyes have been around a while. But it's nothing special."

"No," he said to the man, shaking his head, "I don't want any of this."

We ambled to the back of the store, where Michael spotted a two-foot-long carved wooden lion, full of rounded, lovely curves and a flowing mane, painted yellow and blue and green. "This is Chinese, from Singaraja [in the north of Bali]. Made of jackfruit wood. You can make good money off of it."

The owner hung up the phone. We sat on a burnished wooden bench in front of a huge Javanese desk. "You owe me seven hundred dollars!" Michael said. "Give me that," he said, pointing to the lion. "Let's finish this thing. Finish it! I'll give you three hundred."

"Please, man, this is my capital," the man said. "I'll take no

profit from that. Empat blas juta"—fourteen million rupiah, about a thousand dollars.

"C'mon," cajoled Michael, "let's finish the story. We're friends."

"Okay, four hundred."

"Three."

"Okay, three hundred and fifty."

"Three hundred and fifty . . . Okay."

"Okay!" They high-fived, lit cigarettes.

Michael jumped up, walked over to the molar.

"That's from East Java," the guy said.

"How much you want for it?"

All this was in Indonesian and the negotiation accelerated too quickly for me to follow. Michael picked it up again. Examined it. Flicked his ash on the floor. Picked it up. "Okay, I'll just take my singa. I just came back from America. My father died and my mother is ninety-four years old. She's sad. She wants to die now. Have you seen this guy?" he said, showing a picture of the Swiss collector.

We walked out to the car, the carved lion tucked under his arm.

Shop after shop, Michael surveying the goods, showing me the fakes and the genuine, always seeking information on the Swiss collector. The last shop was sleeker, shinier, a mix of old and new furniture, giant designer candlesticks and, on the second floor, a handful of big Bornean statues. "This one," he said, as we mounted the steps, "was owned by a couple of Chinese brothers, and the one brother was great but he was doing some electrical work and stepped in a puddle and zap he was gone. Everything here is too expensive, but you never know. Wow, look at this," he said as he walked up to a tall, round pillar of a statue, with aged black wood and striated lines of erosion running its length. His eye was quick and refined; while I slowly scanned the goods, looking for

something graceful, powerful, he zoomed in on details and the best pieces immediately. "This is probably five hundred years old. How much?"

"Saratus dua pulu juta." About $10,000.

"Fuck, look at this. Jesus. Look. A face and there's the tongue. Eyes." He outlined the faint lines of a face below a body on a piece that was eight feet high, gently and gracefully eroded. "How much?"

"Three hundred and twenty million." About $28,000.

"Ha, okay, let's get out of here and go meet Axel for lunch."

Axel was Alexander Goetz, one of Michael's closest friends, a legendary dealer in classical Southeast Asian Buddhist and Hindu art. German by birth, Axel had spent years on Bali back in the 1970s, and now lived with his young Vietnamese wife and three-year-old daughter in Vietnam. But, like so many in the antiques and art trade, he was constantly in and out of Bali and Java, buying, selling, meeting clients. We met, as usual, down by the beach on the second-floor verandah of Michael's favorite spot, literally feet from where he and Fatima had alighted from the horse-drawn cart forty-two years before. Goetz was in his seventies, six feet tall with slicked-back white hair, a row of perfect, white-capped teeth, and large-framed glasses, wearing an orange polo shirt and khaki shorts, a giant antique gold ring glinting with blue stones. Two packs of Marlboros lay on the table, one stacked on top of the other. "My father is 102 and still smoking and my mother died in her nineties, so I feel a bit safe," he said, lighting up.

Goetz exuded a sharpness, a confident, alert intelligence. "I came to Bali in 1971 with my wife," he said. "We stayed here at Blue Ocean and then moved up to Ubud, where we built an incredible house out of wood and bamboo right on the ridgetop over town. Had no electricity for ten years, just forty-five oil

lamps. The gardener would shine them and snip the wicks every day and light them in the evening and they were all over the property and it was beautiful."

At first, like so many westerners in Bali, he'd just come for the culture and lifestyle. But one day some Balinese found two bronze axes, dating to 400 BC, up in the mountains, and they contacted Samuel Eilenberg, who was in Bali at the time. Over decades beginning in the 1950s, Eilenberg, the chairman of the mathematics department at Columbia University, had amassed a collection of works made between the third century BC and the seventeenth century from Indonesia, Pakistan, India, Nepal, Thailand, Cambodia, Sri Lanka, and Central Asia. In 1987 he gave four hundred pieces to the Metropolitan Museum of Art, which put on a show from his collection, "The Lotus Transcendent: Indian and Southeast Asian Art from the Samuel Eilenberg Collection," in 1991 and 1992.

On the way to meet Eilenberg, the men passed through Ubud, heard Goetz was there, and figured maybe another white guy might want them. "I bought them right away," Goetz said, "and a few days later Sam came up and burst into my house and said, 'Let me see who bought my axes!' and he became my great friend and mentor."

At first he'd considered buying tribal pieces like Michael, but it didn't feel right to him. "I would be buying the family china, the family heirlooms, and, morally and ethically, I just couldn't do it. So I went to Java and bought Hindu and Buddhist bronzes, and those were coming out of the ground and it was now Muslim. You weren't raiding anyone or anything."

The legality of the art and antiques business is hardly straightforward. Laws on cultural patrimony are complex and vague,

depending on where objects are found, their country of origin, and their country of destination. In 1972, 186 nations signed the UNESCO Convention Concerning the Protection of the World Cultural and Natural Heritage, which, in essence, established a baseline: anything found or traded before 1972 was fair game; anything after could be subject to the individual laws established by each nation. For most countries, Indonesia included, that also extended to anything over a hundred years old. Which meant that, theoretically, much of what any dealer or even a tourist acquired could be claimed as the cultural patrimony of Indonesia. But so too could a nice piece of furniture or just about anything sold at any antique shop in Indonesia; that "aged-one-century" designation cast such a wide net that enforcing it was difficult and arbitrary.

The international conventions, however, were designed for outright theft, stealing, and pillaging—the raiding of tombs in Egypt or Peru, or the sawing off of stone Buddha heads from the temple of Angkor Wat in Cambodia, or the purchase of objects that had been stolen by others from those kinds of tombs and temples. People selling their own family heirlooms or private property? That wasn't really covered, not explicitly, anyway. And in any event, there is no worldwide, international police entity with the power to enforce the convention. It's up to an individual country to define and police its cultural property. If Indonesia, for instance, identifies an object being auctioned off that it believes to have been illegally exported to the United States, it must notify American authorities to try to get it back. To further complicate matters, many former colonies like Indonesia only became independent nations recently, Indonesia in 1949. Attorneys have successfully argued that old colonial laws governing cultural patrimony can still be relevant—theoretically anything exported from Indonesia after 1934, when a Dutch

cultural patrimony law went into effect, could be claimed by the Indonesian government—but that's hardly easy to do.

All of which means that if you bought a pair of carvings stolen in the dead of night right out of a temple in Bali, as an Italian dealer did recently, or sold objects stolen from temples in India, as a Manhattan dealer named Subhash Kapoor did—he was arrested in 2011 for allegedly trafficking in more than twenty-six hundred items worth more than $100 million—you're in a heap of trouble. But Kapoor was only arrested because India pursued him—he had been brazenly stealing antiquities straight from Hindu temples. Likewise the government of Cambodia has been aggressive in reclaiming stolen artifacts. If Indonesia wanted to make a claim on pretty much anything any dealer exported over the years, it might be able to do so. But while the country assiduously guards its classic Buddhist, Hindu, and Muslim heritage—the history of its Javanese majority—it's long regarded its indigenous minorities like Dayaks or Papuans with cultural disdain, and for the most part ignores the private trade in its indigenous objects. In Jakarta one day I met with the curator of the ethnology collection at the National Museum of Indonesia. She simply denied that there was any trade in culturally important objects at all.

"In Indonesia, you're not supposed to export anything older than one hundred years," Goetz said. "But from the 1960s to the 1980s, even into the '90s, curators would buy anything, no questions asked. And museums used to have a long list on the exhibit card, where a piece was from, and now that's gone. Or it's in code. They don't want questions." After World War II, he said, huge fortunes had been made and a whole new generation of collectors went buying. "[Arthur M.] Sackler, for instance. He bought anything and everything—huge seven-meter stone pieces. Originally there was only the Met, the Smithsonian, a

few places. But then the museums exploded with these guys' collections, when they all needed tax write-offs, and only when the museums were full did the U.S. finally sign the UN declaration."

These days, though, he said, "You have to make up a story if you sell anything to a museum. I say, 'This is from an old Dutch family collection and the family had Indonesian servants and when the owners died the Indonesians took it back to Java and sold it.' The curator knows it's a story and I know it's a story, but he says, 'Give me a story that I can use to get by the board.' That's the only way you can do it.

"Now I realize what Michael did with tribal art was good. Christian missionaries, loggers, palm oil plantation guys—they all destroyed so much. The Christians said burn your false idols, these things are bringing you bad luck, get rid of them. So much was destroyed. And then the fires—they put drums of oil in the forest and light them up and burn huge swaths and then say, 'Well, it's burned, let me plant palm oil and it'll be five hundred years before the forest returns, so let's do something.' Promise them a hospital, a mosque, tokens for the people, and who knows what gets burned. Whole hidden villages, statues. I realize that so much of what Michael brought out was saved before it could be destroyed."

It was now late afternoon and big gray clouds were rolling in; soon a tropical downpour would erupt. Michael had to get home to pay his gardener and maid, and I still had my bike at his house. As we parked, the rain holding off still, the air now pregnant with heat and moisture, Michael said, "C'mon inside for a second. I want to show you something." We padded past the shields and gongs and carvings, through the carved double

bedroom doors guarded by the fearsome mask with its tongue and braids of hair, to his bed. He bent down, lifted the mattress, slid his hands under, fished around, and brought out two-foot-by-three-foot sheets of paper. Maps. Hand-drawn. The rivers and villages, the rapids and little tributaries, of Borneo, beautifully rendered in Michael's neat hand. "I've been thinking," he said. "Maybe it's time to go to Borneo."

*Growing increasingly desperate, Bruno Manser tried to deliver a toy lamb to timber baron
and Chief Minister of Sarawak Abdul Taib Mahmud by paraglider in May 1999.
(Bruno Manser Fund)*

THIRTEEN

It's hard to imagine being Bruno Manser after his return to Switzerland. He had always felt drawn to the elementary life force of snakes. He had always been attracted to the darkness of caves and the danger of mountain precipices and the highest branches of trees. He had fantasized since he was a child about remote places like Borneo filled with wild animals and wild people, but in 1984 it was still just a dream and he had never even been outside of Western Europe. Lots of people explored caves and climbed trees and rock faces, and the life of an Alpine shepherd was inherently Swiss to begin with. His ego had always needed to prove something, to test itself. But to be Bruno walking through the streets of Basel or Zurich in the spring of 1990 after six years of living as he had was to be a man so removed, so apart from everyone else it was almost inconceivable. He had suffered extremes of cold and hunger and wetness and penetrating loneliness that would drive most people to despair. He had lived off of the brains of deer and week-old, blackened carcasses of wild boar or rats, food that violated every Western law of hygiene, not to mention taste. He had walked up to wild elephants and rolled on the ground with wild orangutans. He had lived for years as a hunted man, had been arrested twice, had escaped both times, had stood up to and outwitted an entire government and its security services, even across international borders. He had climbed limestone peaks without ropes, thrown himself into rivers and rapids with no idea of where the river flowed or what was beyond the next bend. He could track wild

game and build a shelter anywhere at any time. He had helped birth babies in falling rain, children whose first moments in the world weren't some antiseptic hospital but cold, rotting leaves crawling with ants. He had caught twenty-foot-long pythons and poisonous snakes with his bare hands and had been bitten by them and lived, had nursed himself back to life through searing pain without antibiotics or modern medicine, had even performed surgery on himself.

Can you imagine what that does to a man returned to a culture of seat belts, helmets, antiseptic wipes, and televised nature shows, where a single cockroach or dropped fork was cause for alarm? Where people got worried when the toilet paper ran out at inopportune times? He felt invincible. Powerful. Transcendent. The power of the explorer, the shaman, deep within himself, a charisma that radiated for all to see, even more so because he embodied those centuries of Western tropes, from Rousseau's noble savage to Edgar Rice Burroughs's Tarzan. Lord Greystoke wrestled lions; Bruno Manser wrestled snakes and orangutans. One was fiction, the other real.

"The hype was unbelievable!" said Roger Graf, who presented Bruno to the press seventeen days after his return home. He was seeking nothing less than a moratorium on logging in traditional Penan lands beginning September 1, 1990, leading to the creation of a permanent forest reserve. Bruno urged pressure on the Malaysian government, and the world responded. "If Greenpeace wanted to stage an action it took money and lots of organizing, but all I had to do was to put Bruno in a press conference and that was the action itself," Roger said. "Bruno *was* the action. He was remarkable and you could feel it the moment you met him. He was like Mahatma Gandhi or the Dalai Lama."

"He was so small but he seemed like a giant," said Martin Vosseler, a physician who went to see that first event.

"He smelled special," said Ruedi Suter, a journalist. "Like a shepherd. His clothes were self-made and rough homespun, but his words were so simple and direct you understood immediately what he wanted to say."

"He was like Jesus Christ," said Jacques Christinet, a mountaineer who when he was twenty-seven glommed on to Bruno during a period of dangerous, self-destructive risk taking— "psychological suicide," as he put it. "People just followed him, and I was one of them. He didn't have to convince people. That was Bruno. He dragged people in with no effort. He was a magnet. A funnel. A spin of energy. But when you went with Bruno you risked your life."

Now that he was back, the struggle and its organizing logistics escalated a hundredfold. Every environmental activist and human rights campaigner wanted to meet him. Thousands of pages of faxes were pouring into and out of Graf's office (he worked at a small publishing company that let him campaign as long as he got his work done) and Georges Rüegg's house, from all over the world. Phone calls at any hour of day or night. Both had jobs but worked full-time for Bruno and the cause for free. Bruno's correspondence became a flood, page after page of letters written on trains, in people's houses, at 2 a.m., 4 a.m., always with a personal touch in the language of brotherhood and struggle, skillfully urging his followers on even as he and Georges and Roger built an international movement. "Dear brothers and sisters, let the big spirit touch you," he wrote to Anja Licht in Australia.

By June protests were breaking out in Australia, and Bruno flew to join them. By July one hundred organizations in more than thirty countries conducted twenty-four-hour hunger strikes in front of Malaysian embassies. "Sisters and Brothers in struggle," he wrote to a group of activists in Australia. "I am just

touched by you, the Australian activists supporting the Penan people. If you do such a long fast, please eat one spoon of honey a day to strengthen your body. . . . Myself I feel a bit weak and empty after all these tasks and travels with lack of sleep. I am longing for the songs of nature, but cannot rest yet as long as there is no moratorium achieved. The light of the spirit may touch our souls and strengthen our circle."

With the help of volunteers around the world, Bruno organized the Voices for the Borneo Rainforests World Tour. Over six weeks he escorted two Penans and Mutang Urud to twenty-five cities in thirteen countries in North America, Europe, Asia, and Australia, raising awareness for the hoped-for moratorium on September 1. More press, more fame. In the United States, he and Mutang and the Penans met Vice President Al Gore, who in 1992 pushed through a toothless resolution in the Senate "calling upon the Government of Malaysia to act immediately" to defend the land of its "indigenous peoples" and asking Japan to investigate its logging companies. In Canada, Bruno met with the speaker of the Canadian House of Commons. In France, he and Mutang met First Lady Danielle Mitterrand. In London, they spoke before twenty thousand people at a Grateful Dead concert in Wembley Stadium. In Germany, they met Klaus Töpfer, environment minister. In Japan, the minister of environment apologized for Japan's hunger for tropical hardwood.

Women fell at his feet. "Thanks for your phone a moment ago," he wrote in English on the train from Basel to Aarau on August 20, just before the start of the tour, to Beth Lischeron, the Canadian volunteer who directed it. "Too short to ask you about what is more essential for you and me and more touching than all others: Are you going to be mother and myself father? You're really a beautiful woman—and I was just overwhelmed by your femininity and loved you. When I saw you standing there as a

human being with your own personality with your own center, that's the moment! Being enthusiastic and join [sic] for a beautiful night is of course much easier than joining the path of life for the whole future. . . . For my own experience I have to state that a man–woman relation has in my whole past always been secondary. Maybe I turned too independent as to go the way back; maybe I have other tasks." It was a classic Dear John letter. Behind the beautiful words and emotions, beyond the beautiful night, he was blowing her off. He didn't want a relationship, but wanted to keep her in the fight, and she assented.

A German publishing company brought out *Penan: Voices from the Borneo Rainforest,* a selection of Bruno's drawings mated with emotional Penan laments about the destruction of their Eden. On the World Tour he met Wade Davis, a Harvard-educated Canadian ethnobotanist, whose sister-in-law was married to Senator Jay Rockefeller and whose *Serpent and the Rainbow,* a narrative exploring the culture and pharmacology of Haitian voodoo, had been a bestselling book and was made into a movie. Although Davis was trained as a scientist, it was as a writer and raconteur bringing attention to endangered indigenous people and their sacred worlds that he became well known, largely from his perch as an Explorer-in-Residence at the National Geographic Society. He soon took up the Penan's cause and eloquently romanticized them in a series of books and articles, transforming a people with deep knowledge of their forest home into heroes of environmental wisdom and spiritual insight.

In reality the Penan conserved their forest not because doing so fit into some overarching age-old spiritual and ethical wisdom but because all they had were machetes and blowguns and they were few in number. The Eastern Penan had vague notions of mutually beneficial sago tree ownership and conservation and a general knowledge of the plants around them, but little con-

servation ethic in the Western sense. They were so attuned to
their bellies—their survival depended on it—and hunting was
so deeply ingrained in their psyches and sense of purpose and
joy that they routinely killed anything in their path, even if their
stomachs were full or they had too much meat to carry. "Gener-
ally, the natives shoot at anything that moves," Bruno wrote. "If
he had a gun and bullets, he'd shoot five boars in one day with-
out being able to utilize them properly." Bruno was always try-
ing to persuade them to kill only what they needed, an idea that
seemed laughable to them. And he was dumbfounded when, for
the first time, he saw his Penan companions spot a tree laden with
fruit and voraciously cut it down. As Western writers and film-
makers and environmentalists flooded into Sarawak, the Penan
themselves learned to parrot ideas and concepts of importance to
their Western visitors. The anthropologist Peter Brosius writes
how Davis took Brosius's research into Penan sago harvesting
and use of medicinal plants and embellished his "description
with reference to a form of ecological etherealism that is derived
entirely from the Western romantic tradition and has little rela-
tion to any set of ideas that would be recognizable to Penan."

Davis wrote a long, moving feature about Bruno for *Outside*
magazine, which in 1991 named Bruno its Outsider of the Year.
In a four-page single-spaced letter he urged Bruno to sell his
life story to Hollywood. "I realize Bruno that you are besieged
with offers and surrounded by well-intentioned advice and that
some part of you must want only to retreat into the wilderness
of the spirit. But I write these words to you in a sincerity and as
someone who has felt the same ebb and flow of desires, the same
sense of being under siege by people trying to reinvent who I am
or draw energy for their lives off of myself.

"My sense is that you have, for better or for worse, entered
into a course of action, a current of history that now has taken

on a life of its own. Whether you like it or not, your immediate fate has been tied to that of your Penan brothers and sisters. Your passions and dreams can never be realized until their lands and their future are secured. And we all know that one of the few strategies we have is to raise the profile of the tragedy so high that it cannot be ignored. I take that as a given—I know that you do not like having the spotlight upon you—it runs against everything you believe, everything you seek. Yet you must also know that, for whatever reasons, you are and have become the metaphor, the vehicle, through which people in Europe, North America, and Australia reach an understanding of who the Penan are and what it is that is being sacrificed upon this altar of greed."

On June 20, 1991, Bruno received an executed option contract from Warner Bros., negotiated by the William Morris Agency, and, soon after, a check for $27,000 after his agent's cut. The option was extended in 1996 for an additional $20,000. The film would never be made; Bruno objected to the initial script, because the studio, in the words of its writer, David Franzoni, "wanted the Bruno character to represent an EVERYMAN . . . an arrogant slightly obnoxious Western Man who will be won over by the Penan," and then the director, Art Linson, had a "falling out" with Warner Bros. Bruno wrote to Steven Spielberg in 1994, "From shepherd-life in the Swiss Alps to the last virgin jungles in Borneo: I heard that you have shown interest once to make a motion picture about my adventures there and the peaceful battle to safe [sic] some of that paradise, home to the Penan nomads. Your film 'Schindler's List' has convinced me. You are the best director to make it the best film! There are lots of impressing adventures not yet included in the script, which reflect the power of true life."

Bruno couldn't sit still. At the G7 Summit in London in June

1991, he somehow pierced the security cordon and chained himself to the top of a thirty-foot-high lamppost outside Westminster Abbey, dangling a banner that read G7? SARAWAK? FOREST? DESTRUCTION? HUMAN RIGHTS! VIOLATIONS! MORATORIUM NOW!, "further enhancing his status as Europe's newest environmental celebrity," reported the *New York Times*. The police cut him loose after ninety minutes and arrested him. "They sat me down at a table and asked me what I was protesting against," Bruno told the *Times*. "I pointed to the table and said: 'This is what I am protesting against. I am protesting the fact that you have this table made out of wood from the rainforest.'"

In Sarawak, more blockades broke out, with five hundred Penan blocking the road. Bruno sent money to Mutang, who increasingly felt afraid for his own safety. "I was nervous, there were a lot of rumors," Mutang said. But Bruno urged him on. "Brother," he wrote, "So happy to know that you are well and did not loose [*sic*] your smile in the hard times! International support slowly is rising, but it's just a question of time, and soon action, to safe [*sic*] as much as possible. Try your best to keep the spirit of the people up!"

Mutang's fears, however, were justified. On February 5, 1992, at 11:30 p.m., while sitting at home in Miri, he was arrested by eight plainclothed policemen and taken to his office, where the police went through his files until dawn. Then they locked him in Miri's prison. "I saw so many things. Shit and pee everywhere. You had to lie down in your underwear. No blankets. It was cold. I couldn't sleep. I had a Bible and they took it away. They came in the early morning and kicked or punched me." After a week he was made to dress, was bundled into a Land Rover and driven to Kuching. Ten miles from town they stopped at a police station. Outside of the car men in black clothes talked, whis-

pered, "making me really nervous. Are they going to kill me? I felt like a chicken about to be slaughtered." He was transferred to another Land Rover with one of the black-clothed officers, who told him to lie down with his head on his lap. They put a black bag over his head. "We drove and drove, we just went around and around." After an hour or two, he can't remember, they stopped. "Stand up. Left, right, jump, they were teasing me." In a narrow, windowless room they removed the bag, and the chief of the special branch interrogated him. "They wanted to know everything, wanted me to write about all of my contacts, and it went on for two nights with no sleep. They'd leave and come back. 'Mutang, you know how it is,' they said. 'You could be kept for three weeks or three months . . . But if you cooperate . . .' I had no communications with anyone, no lawyer."

With Mutang in prison, the Federal Reserve Unit of the Malaysian security services cleared the latest blockade. Pressure on Malaysia was mounting from all directions, and on March 3, 1992, Bruno received a personal letter from Mahathir Mohamed, the prime minister of Malaysia. "Herr Manser," it read. "If any Penan or policeman gets killed or wounded in the course of restoring law and order in Sarawak, you will have to take the blame. It is you and your kind who instigated the Penans to take the law into their own hands. . . .

"As a Swiss living in the laps [sic] of luxury with the world's highest standard of living, it is the height of arrogance for you to advocate that the Penans live on maggots and monkeys in their miserable huts, subjected to all kinds of diseases. It is fine for you to spend a short holiday taking the Penan way of life and then returning to the heated comfort of your Swiss chalet. But do you really expect the Penans to subsist on monkeys until the

year 2500 or 3000 or forever? Have they no right to a better way
of life? What right have you to condemn them to a primitive
life forever?

"Your Swiss ancestors were hunters also. But you are now one
of the most 'advanced' people living in beautiful Alpine villages,
with plenty of leisure and very high income. But you want to
deny even a slight rise in the standard of living for the Penans
and other Malaysians. The Penans may tell you that their prim-
itive life is what they like. That is because they are not given
a chance to live a better life like the other tribes in Sarawak.
Those of the Penans who have left the jungle are educated and
are earning a better living have no wish to return to their prim-
itive ways. You are trying to deny them their chance for a better
life so that you can enjoy studying primitive peoples the way you
study animals. Penans are people and they should be respected as
people. If you had a chance to be educated and live a better life,
they too deserve that chance.

"Stop being arrogant and thinking that it is the white man's
burden to decide the fate of the peoples in this world."

It was an extraordinary letter, revealing just how deeply
Bruno had gotten under the skin of the Malaysian government.
But it also cut to the heart of a complex issue, exposing both the
blatant racism and self-serving interests of the Malaysian major-
ity and that majority's profound resentment of the West, its for-
mer colonial overlord, which had grown rich off its colony's
natural resources. Bruno, in essence, wanted to stop time. From
his vantage point, it was clear: the quality of Penan traditional
life, a world in which food was plentiful and free for the tak-
ing, in which family bands lived close, intimate lives from birth
until death, in a rich, unsullied environment always without a
time clock or a boss or the constant empty quest for consumer
goods, was far superior. That's what all those people wandering

around Bali with their yoga mats and buying up the Dayaks' traditional art were in search of, after all. A spiritual connection with nature and each other and the great mysteries of life that science and reason and consumerism had snuffed out as surely as pouring water on a fire. Bruno could see that because he'd lived in the other world. But the Penan hadn't. And there were, of course, benefits to development: Health care. Longevity. Life in so many ways was easier with a solid roof and a warm bed and rice in the larder, not to mention education, literacy, and the powers that potentially came with them. Theoretically at least, education meant mobility, choices, a self-consciousness that the Penan didn't have. Who was Bruno or any rich Western environmental activist to deny the Penan that opportunity? In the best of all worlds the Penan could decide for themselves. But can a people who can't read or write and knew nothing of the larger world make informed decisions? It was the essential conundrum of white efforts to save rain forests and indigenous peoples throughout the world. To westerners Bruno was a selfless savior and the Penan the quintessence of noble savages. To the Malaysian government they were a primitive embarrassment who needed to be saved from their own primitiveness (a process that not incidentally meant enormous profits for Malaysia's elites).

Both, of course, were exaggerations.

On the very same day that Mahathir wrote Bruno, Mutang was brought to court, released, and rearrested that afternoon and again interrogated "day and night. They showed me electrical wires and said, 'Look!'" After two weeks he was suddenly made to shower and dress, blindfolded, taken by car to the VIP lounge of the Kuching airport, and, in handcuffs, put on a plane to Miri "surrounded by cops on all sides." Landing in Miri, he was taken to court, where he found his sister and a lawyer waiting. After

a frantic international campaign for his freedom, he was once again released and then immediately rearrested until, at five that evening, he walked free after nearly a month. But Malaysia was no longer safe for him. "My lawyer said I had to go, that the next time I got arrested it would be worse." He grabbed his passport and some books and clothes and went into hiding at a friend's house, leaving by ferry the day after to Brunei, where he stayed for a week. By luck, he'd been invited to speak in New York, an invitation that included a visa. Leaving his country, his family, the Kelabit Dayak man, born in a rice shed on the edge of the jungle in the Borneo highlands, fled to New York. Soon after, thanks to American supporters and Al Gore, he received a ten-year visa to the United States.

In June he rendezvoused for the first time in two years with Bruno at the Earth Summit in Rio de Janeiro. There, one of the most improbable meetings ever to occur took place: Bruno Manser and the prime minister of Malaysia sat down for an hour. Bruno left the meeting "depressed—I realized that Dr. Maha-thir cannot or does not want to face the true situation and my wish to touch his heart on behalf of the Penan was not (yet) fulfilled at this first meeting."

Then, straight out of the meeting, Bruno traveled to the top of the 120-foot-tall statue of Christ the Redeemer on the Corcovado high above the bay, and, in tandem, paraglided into Macarena Stadium, which was packed with a hundred thousand fans watching a soccer match, trailing a banner proclaiming: FROM BORNEO TO BRAZIL! SAVE THE RAINFOREST! RESPECT THE RIGHTS OF INDIGENOUS PEOPLE!

In December Mutang spoke to the UN General Assembly in New York. Soon after, partly due to the efforts of Wade Davis, the University of British Columbia offered him a full scholar-ship for a four-year degree in art and anthropology. He accepted

and moved to Vancouver. "I wanted to go back home, that was
where the fight was, but no one could be seen working with me.
What could I do? I was depressed for several years."

That same month, Bruno, dressed only in a loincloth, under-
took a ten-day hunger strike in front of the headquarters of
Marubeni, the largest tropical wood importer in Japan.

On the surface, the campaign was going well, Bruno's con-
stant stunts and speaking engagements generating ever more
publicity around the world. The spark was all Bruno, he was the
figurehead, but the organizing details fell to Roger and Georges,
his oldest and best friends, stalwarts, and the only people who
weren't acolytes. But they were working for free, becoming
exhausted, burnt out. "It was crazy," said Georges. "Like hell.
Bruno didn't even have a phone, so it was all at my house or
Roger's. TV. Radio. It never stopped. I had a job. Roger had a
job. And we were worried about Bruno." They corralled him,
made him promise to slow down and take two days a week off.
He didn't. "I tried to fence him in and that was a mistake," said
Georges. "You cannot do that with Bruno. The job grew bigger
and bigger and bigger." And they needed money, always more
money to fuel the struggle. Bruno's rescue from Sarawak alone
had cost $25,000. Now he was flying all over the world. Bruno
didn't think about money; Georges did, constantly, to keep
everything humming, and he started asking media for "con-
tributions" in order to interview Bruno. And for all of Bruno's
single-minded dedication, he also acted capriciously, selfishly,
sometimes disappeared for hours or even days at inopportune
times. One summer day a rally had been organized up in the
Alps, and Bruno was one of three featured speakers. Thousands
of people streamed up the hills for the event, and when it came
time for Bruno to speak, he had vanished. No one could find
him. Long after the event was over, in the dark of night, he

reappeared. He'd found a cave, he told Roger Graf, and he'd wanted to explore it. No apologies. "All of these people had worked for him and gone to see him speak and he just blew the whole thing off," said Roger. "It was incredible!"

Tension mounted. The journalist Ruedi Suter invited Roger and Bruno to his country house in the Black Forest to talk things through. It was raining, cold, and Suter's wife worked all afternoon cooking a hearty soup. They took a walk and once again Bruno vanished. Gone. No one could find him. They returned to the house. Waited. Night fell. The soup was long ready. Finally Bruno appeared with four big trout. He had caught them with his bare hands. "He was very proud and we had to grill the trout," said Suter, "but Roger was not amused."

He had, in fact, had enough; he quit his job and lit out for South America for the next two years. "I just wanted to have my own life," Roger said. Then Bruno and Georges's money quarrels increased, and Bruno said that that was all Georges cared about. "After all I've done for you, you think the only thing that interests me is money?" Georges shouted. He had given Bruno $5,000, his whole life savings, when Bruno was still in Sarawak. He had risked his freedom to rescue Bruno, had spent thousands on phone calls and faxes, had worked day and night. "I said, 'Okay, that's it! I don't want anything to do with the organization. If money is really important to me, you can pay me back every single cent I've spent, around $20,000.' I thought he'd come around and say he was sorry, to forget it, but he didn't. Not for years, anyway."

Bruno was now unleashed, surrounded by sycophants and followers who couldn't say no to him. And he was once again sneaking in and out of Borneo.

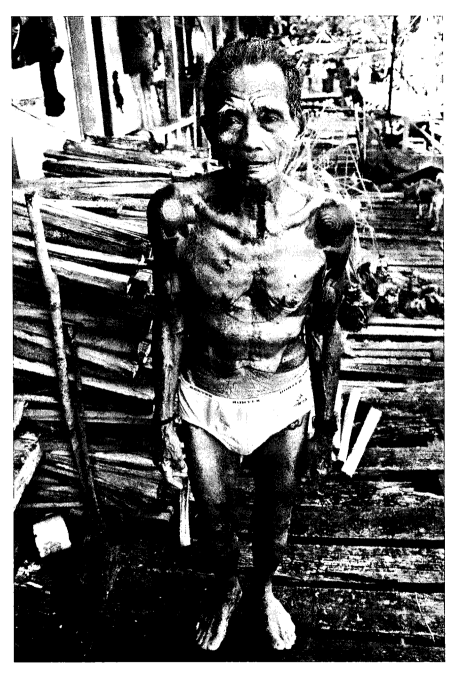

Four hours by boat from the nearest road, at an Iban longhouse, we found Lusan, covered in traditional hand-tapped tattoos. (Carl Hoffman)

FOURTEEN

The bell rang clear and high-pitched, the chant monotone, sound and words mixing with incense, which sent the words to the gods. Overhead, the leaves of a banyan tree, its silver-gray trunk six feet wide and wrapped in a black-and-white-checkered cloth, rustled in the merest whisper of breeze. Michael Palmieri and I sat cross-legged on a woven rattan mat next to Jiro Mangku Nuada, a mangku (a Balinese priest) with black Henry Kissinger glasses and buck teeth and a waiflike body dressed all in white. We wore batik sarongs, with traditional Balinese headdresses, or udeng, on our heads. Slightly behind me and to my right sat Michael's pembantu, his housekeeper, there to guide me through the ritual.

We were bound for Borneo the next day, and before leaving Michael insisted we "ask for permission."

Now, sitting in a walled temple courtyard built around the sacred banyan tree, he whispered in my ear as the mangku chanted. "He's saying we're going on a long journey and he hopes they'll watch over us." Two round trays lay at Nuada's knees. One held a plastic bag of frangipani blossoms, a round brass bowl of holy water, and a stick of burning incense. The other tray held more holy water, a container of uncooked white rice, a container of arak for the gods, and a banana leaf. In a plaited basket were three more sticks of burning incense, and neat piles of brilliant red, blue, and white flowers. The bell, its handle a Hindu vajra thunderbolt, rang and rang, the chants hypnotic. The only words I recognized were "Kalimantan" and

"Saraswati," the Hindu god of knowledge and wisdom. Nuada flicked holy water on us and we sipped it from a small cup three times. We tossed pinches of flower petals, red, white, and blue, for Brahma, Shiva, and Vishnu. Pressed grains of dry rice to our foreheads, throats, and hearts. Took a few bites. Tossed a few grains to the ground. Scooped the smoke from burning incense to wash it across our faces.

I was an atheist, but I was middle-aged and had experienced enough loss and existential angst to nurture a growing appreciation for ritual and metaphor. All was not logical. All was not understandable. Control was an illusion. In the swamps of New Guinea, far from the nearest road or store or even electrical light, I had once been present as men beat drums and chanted for twenty-four hours straight under the stars and flashes of heat lightning, communicating with the spirits and ancestors, spirits they could see and feel as surely as the shadowy trees around them. In Bali for months now I had watched and heard ceremonies in my neighborhood's temples and on street corners and sometimes even in the streets themselves. Every morning my pembantu placed a fresh little basket of offerings, including sometimes a coin, candy, a kretek cigarette, flower petals, and always incense, before my front door. Whether spirits were real or not wasn't the point, I was coming to understand. God, the ineffable, the great questions and wonders, could never be explained through science or technology or consumerism alone. The human spirit yearned for something bigger; it always would. That was its nature and its curse. We had all been cast out of singularity, oneness, Eden, and we were all, like Bruno Manser, restlessly trying to get back to the arms of the mother, as he put it, even if we didn't articulate it. The rituals and ceremonies of old, I realized, watching the banyan leaves rustle as the bell rang and the God-given rice—food, life itself—fed our

heads and hearts and souls, didn't explain anything, not logi-
cally, anyway, but in their action they said we didn't know and
that we hoped and acknowledged the beauty and mystery of our
existence. We weren't literally communicating with the gods;
we were doing something bigger. We were propitiating our own
questions, wonders, doubts, and imaginations, confirming our
very humanity in doing so.

That was the appeal of the Dayaks in Borneo, the Balinese,
the Asmat in Papua, the reason for our fascination with indigenous
people. And for the statues and artwork they produced and that
rich collectors wanted in their living rooms. The rituals, the
statues, created a continuum of past and present and future for
their makers. They anchored them. The Dayaks, the Balinese,
the Asmat, they were surrounded by their ancestors and they had
an intimate connection to the trees and birds, to the stars and the
animals they hunted. They knew who they were, where they
had come from, and where they were going. They experienced
a wholeness that we lacked. The rituals and their accompanying
works of art were, for westerners, the physical manifestations of
a lost world, a lost way of living. They had a treasure that had
slipped from our hands, but that we dreamed of still.

But there were two sides to that treasure. We westerners
flew onto the islands and admired the rituals and temples. We
snapped photos of ourselves in sacred spaces and made a show of
yoga asana against their stone carvings; a few of us even attended
a wedding or cremation. But we only wanted it when it suited
us, for we wanted our freedom too. We came, we ogled, we
left. Even the expats I knew who lived for years in Bali hired
mangkus when it suited them. But for the Dayaks of old, for
the Balinese even now, their religion and its sacred duties were
all-consuming. The average Balinese woman and man spent a
vast part of their energy and days preparing offerings, attending

to temple activities, weddings, funerals, cremations, teeth fil-
ings, baptisms, caught in a web of never-ending obligation to
family and community, temple and spirits that would suffocate
the average American as surely as a full Latin mass. Mutang,
the Kelabit Dayak who like most of the Dayaks in Sarawak had
become an evangelical Christian, acknowledged as much. "In
the old days you had to be so observant, so attuned to the envi-
ronment; it took *all* of your time and energy. When a certain
bird passed you had to know it and see it and if you didn't it
could cause a big injury. If you can't be that respectful of nature,
if that's not embedded in your heart, the old model doesn't work
anymore." For Mutang, Christianity was new, modern, and it
offered a much easier life without "fear" and "taboos," but for so
many westerners traditional Judeo-Christianity came laden with
too much baggage; *it* was the old model that no longer applied
with its old force. We New Age spiritual seekers loved the idea
of Balinese rituals or Dayak spirits in the leaves and trees, with
a dash of yoga and namaste. Bruno had been different because
he'd wanted it all the way. Owning a statue, even my participa-
tion in the ceremony, was "culture lite." A dabbling. A souvenir.
And that was good enough for most of us.

 In the middle of the chants Michael leaned over again and said,
"He's talking about the wild animals, and to keep us safe from
snakebites," and as the little ceremony ended, the mangku tied
a red string on our wrists, though he struggled with Michael's
thick arm. "Big banana!" he said in Indonesian, laughing.

When he'd first gone to Borneo in the 1970s, the trip from
Bali required a bus to Gilimanuk, a ferry to Java, and then
another bus or train to Surabaya, there to catch a flight to Balik-
papan, the largest city in East Kalimantan. If all went smoothly,

the journey took a full day. Now Michael and I were flying direct, nonstop from Bali in ninety minutes. From Balikpapan we'd travel to Samarinda, a city that I had last visited in 1987, and then maybe head up the Mahakam River, maybe not. It depended on how it all looked, what people said when we got there. He moved fast and he wanted to hit West Borneo and Sarawak too. From my trip there in 1987, I remembered Samarinda as a searingly hot, dusty backwater, a city-town of one- and two-story buildings and corrugated roofs and half-paved streets, a place that felt like the end of the earth. Times had changed, Michael warned me. Everything would be different now. Roads snaked everywhere. Oil and coal and timber had been pouring out of the island for decades. Fortunes had been made. "We'll be lucky if we find anything," he said. But the moment he'd contacted a few connections there, the texts and calls had been flooding in. "The jungle drums are beating!" he said. "They know we're coming."

I was eager to see Michael in action. His stories were fresh in my mind. Mon petit cowboy swaggering through the streets of Paris. Sailing across the Persian Gulf. The wheeling and dealing in Afghanistan. Fifty years of buying and selling and hustling across borders. In some ways it was all too much to believe. But travel has a way of stripping away the veneers, and now I was going to see how he'd done it. Michael was in his seventies; he rarely drank, he rarely stayed out past 9 or 10 p.m., he wore hearing aids, he sometimes referred to himself as "the formerly handsome Michael Palmieri," but he still had a certain swagger, or so it seemed on Bali, at least. The international tribal art market was a vast network that led from the jungles of one of the quintessentially romantic places on the planet to the most affluent galleries and auction houses and living rooms in the West, and Michael had long been a key figure in that economy.

An economy of not just objects, but ideas, myths, fantasies of jungles and head-hunters and wildness. It was the treasure of a myth, and now I was going treasure hunting at the source with the master himself.

The minute we hit the airport, it felt like a power switch went on. I could see it. Michael was the most outgoing person I'd ever experienced. He had no shyness, no fear, no reticence, no shame. He talked to everyone. Not just gate personnel and flight attendants, but children and old ladies in hijabs. A constant patter. In English. In Indonesian. A chatter that wouldn't slow down for nearly a month and that sometimes repulsed people but mostly drew them in, made them laugh, often uproariously. He wasn't a clown and he wasn't just another obnoxious American. He was something else, a giant, smiling force of nature whose sheer physical size and self-possession carried a whiff of danger laced with humor. The perfect buccaneer.

Michael's warnings about the pace of development in Borneo notwithstanding, Balikpapan shocked me. It might have been any big Indonesian city anywhere. Four-lane roads packed with cars and motorcycles. Canyons of ten-story glass-and-concrete buildings, tangles of overhead wires and satellite dishes and billboards. It was hard to imagine Dayaks or Penan anywhere, which was my own silly romanticism, for we would soon meet many and they all, or almost all, looked as modern as anyone else. We checked into a big white hotel with humming air conditioners and fifty channels of television and fought our way across the street—eight lanes of traffic—as the sun dropped, to a little half-outdoor street restaurant with plastic chairs and tables serving rendang, a slow-cooked dry curry originally from Sumatra that we both coveted.

"If you could be any age, what would you be?" I asked him

as we savored our spicy stew and moths crowded the bare light
bulbs above our head.

"Thirty," he said, without thinking. "Just coming into my
own powers and knowledge, but still young. Those first years,
it was hard. There were some really difficult times. When I was
lonely. Had no money. Was homesick. Wanted to go home, but
I couldn't." A look crossed his face, one that I hadn't seen before.
Inward-looking. A little bit sad. A rare crack opened. "Once I
left and the war, the draft, started, I couldn't go home. That
forced me to be bold and to persevere and to learn new lan-
guages. I was just a dumb surfer kid who knew nothing, and it
took me a long time to get knowledge. If the war hadn't been on,
I'm sure my life would have been completely different. I would
have left, yes—I had girl trouble and wanted to see Europe and
have adventures—but I'm sure after a year or two I would have
gone home. But I couldn't. I was stuck."

Those words hit me hard. That was something that happened,
in a certain way, to all of us. How the choices we made put us on
rivers that carried us to our fates, journeys that became harder
and harder to disembark from the older we got. But I hadn't
thought it had happened to him. I had always seen Michael as
pure boldness, admired that in him. And Bruno too. Men who'd
chosen such a profoundly different path, had followed their crazy
dreams in pursuit of the most intense adventures, a different
life entirely from the normal nine-to-five. In my imagination
I'd always just assumed every piece of Michael's life had been
pure choice, unlike the poor working schmucks stuck in offices
in Washington, D.C., or Basel, Switzerland, anchored down by
mortgages and meetings. But at that instant I realized the paths
Michael and Bruno had chosen had been just as hard to veer off
of. Seeking an obscure treasure, a sort of paradise, they were

chained to it just as surely. So many of the former hippies in Bali lived without permanent legal status, couldn't by law actually own their homes, had never paid a dime in taxes, and had no retirement benefits. Even keeping bank accounts was becoming harder in a post-9/11 world where governments tracked money. What could a buccaneer do at a certain point in his life but buccaneer? What could a middle-aged guy who really wanted nothing more than to live in the deepest forest with hunter-gatherers do when there were no more hunter-gatherers or rain forest left? Michael loved to watch college football and American TV from his house in Bali and he was pure American in so many ways, but he could never go home again. And that epiphany about Michael would soon help me understand what happened to Bruno perhaps more than anything else, a man who ended up on a cul-de-sac with nowhere to go, no way out.

In the morning we jumped in a taxi to Samarinda, arriving to what was now a big, sprawling city cut by the quarter-mile-wide brown Mahakam River, jammed with freighters and container ships and wooden Bugis schooners, their arching, high prows lining the docks. Looking down on it from my tenth-floor air-conditioned room, I tried to remember it thirty years ago and could barely do it. I didn't recognize anything. Its modernity and sprawl and traffic wiped my memory clean, felt disorienting, dislocating.

Michael's phone was buzzing like a vibrator with a broken off switch. "C'mon," he said, "we're being picked up right now!"

Ali Hajj jumped out of a waiting Toyota SUV in the hotel driveway. "Ah, Pak Michael!" he said, embracing him in a long, tight hug. He was late middle-aged, wearing white cotton slacks and a white T-shirt, a gray mustache and goatee on a meaty

face, a brushed steel watch the size of a small clock on his left wrist, his fingernails long and sharp. "This man," he said, as we lurched through the crawling traffic along the riverfront, "he taught me everything! He is my brother, my teacher." They had first met, he said, back in 1978 on the Samarinda waterfront when he was twenty and Michael needed a porter. "I carried for him, and now . . ." He had seen income and opportunity, had learned the business, had become wealthy, had been to Mecca, and owned a sprawling shop, which we pulled into a few minutes later. It was, to me, incredible, magical, every inch filled with carved, eroded statues and Dayak hats and mandaus and stone Buddhas and Dayak ossuaries and Chinese martavan jars and glass cases crowded with hornbill ivory and fetishes, brass earrings, rooms and rooms of it, two floors, floor to ceiling, the whole thing dusty and dark, the floors creaking.

A statue seven feet tall caught my eye. Weathered. Old. Real-looking, its face the classic East Borneo heart shape with wide eyes. "No!" snapped Michael. "It's been played with. The erosion isn't right."

"This is real," he said, pointing to a wooden post ending in a carved head. "Look, see the water erosion? But the eyes aren't real and the mouth has been altered."

I spied the end of a coffin, another beautiful piece to me. He shook his head. "I don't know . . ."

"It looks so good, so old," I said, pointing out the dust, the erosion marks.

He laughed. "It's *supposed* to look like that!"

"Yang ini"—this one—Ali said, pointing to another pair of coffin ends.

"No, no, no," said Michael. He moved with speed, precision, sureness. He was brazen, didn't hem or haw, didn't worry about offending Ali.

We climbed a rickety stairway in the rear of the store up to the second floor, then into another room in back. "There is always a back room," said Michael, "usually on the second floor. The first floor, that's all for tourists, always, in every shop. The good stuff is always hidden away," he said, eyeing a whole coffin—there were six of them—and then a statue. "Look, this is the one you want," he said, taking out a jeweler's loupe and peering close with the flashlight of his iPhone, "with this patina. Lama. Lama." Old. Old.

Ali went downstairs to make coffee. "Eighty percent of this shit is fake," Michael said, "or just not old. He made a fortune selling shit to the expat oil workers driving up from Balikpapan. Tons and tons of stuff."

We went back downstairs and sat around an old wooden desk sipping strong, black, sweet coffee brought from the kitchen by Ali's wife. They laughed, gossiped in Indonesian too fast for me to understand. "Laughter is good for the heart," Ali said to me. Next to the desk stood a massive carved stone Buddha five feet tall, with a broken nose. It looked beautiful, identical to ones I'd seen in the National Museum of Indonesia in Jakarta. "How much you want for that?" Michael said, pointing to the Buddha.

"That's sixteen hundred years old," Ali said.

"But the nose . . ." said Michael.

"No nose, no problem!" said Ali. "It's primitive!"

"How much?"

"Ten million"—about $10,000 U.S.

"If it had a nose it would be worth $30,000 easy. It's from the ground. Classic."

We headed off to lunch, Ali holding Michael's hand, a common Indonesian gesture of friendship and intimacy between men. "No matter if no business," Ali said to me. "We are brothers."

"He would do anything for me," Michael said, "but, yes, if I was in his shop and I went to buy a fake he'd swear up and down it was real and sell it to me. Business is business. Outside the shop is one thing, inside it another."

Ali smiled.

And so it went. For the next few days a continuous stream of dealers picked us up, drove us into Samarinda's maze, which in the back streets remained a warren of tight lanes, crumbling pavement, and open sewers, a hidden network of antiques and art. At the top level were dealers like Ali, who had brick-and-mortar shops. Below them were men who operated from their living rooms. We sat in wood-framed houses, always tidy and spotless, with plastic-paper-covered floors and threadbare furniture, sweating and drinking sweet black coffee, Michael cooling himself with a little folding fan. We entered a sprawling concrete network of rooms and levels, filled with children and women in hijabs, room after room filled with jars. People fished carved fetish boxes out of closets, brought necklaces dripping with boar and leopard teeth and strange tiny glass jars the size of thimbles filled with hair from under beds. The merchandise was dizzying—thousand-year-old jars with Aso dragons curling around their necks and deer antlers and pig sticks dark and shiny with age. Long after sunset the skies opened up and rain crashed down, a torrential downpour so thick and hard it felt like marbles dropping on my head, and we raced into a dark little house filled with men.

Hugs, fist bumps, more sweet black coffee, Michael huddled next to a man about his own age in plaid shorts and a red polo shirt. "He's a Dayak," Michael said. "From Apo Kayan"—the deep inland plateau of East Kalimantan—"and he's a carver." He had baskets of deer-antler mandau handles, intricately carved

into figures. "Takes him two days to do one of these," Michael said. They looked over pictures of classic pieces on Michael's iPad, oohing and ahhing, and finally we all climbed back into the car in the darkness and rain and inched through streets a foot deep in water, bumper-to-bumper traffic in the midst of stalled cars, soaked figures pushing motorcycles through the flooded streets. After nearly two hours we turned onto a road on which the power was out. It was pitch black, this road flooded as well, and we pulled into a large three-sided warehouse. In the light of the car's headlamps, lashed to a fence, stood a fifteen-foot-high pole whose top five feet were a carved squatting figure. Eroded rivulets and small cracks ran its length. Tiny white patches of lichen bloomed like little spots of ringworm on a man's skin. Its nose, though, was strange: protruding, almost bulbous.

"Modang," Michael said, peering at it. "It's real and it's old."

"Empat ribu juta," the Dayak said. Four hundred million. About $40,000.

"No," said Michael, without a pause. "That's only their first price, but still. What am I going to do with that thing?"

"No. No. No." It was Michael's refrain and the more he said it the more people tried to sell him things, especially the lowest rung of the trade, the youngest and poorest, who came to the hotel bearing backpacks full of objects wrapped in old newspapers, a stream of men waiting in the lobby, waiting in the driveway. Michael saw them all and always said the same thing: "No."

"I'm getting a serious case of heartburn here. It's all fake or it's not old or it's just mediocre. It's barren. I miss not knowing where I was going or what I'd find when I got there. No one has anything good."

Michael didn't want souvenirs or curios. He didn't want fakes. Nor did he want objects that, though old and original,

were so weathered and beaten up you could barely recognize them. He wanted masterpieces. The rarest of the rare, centuries-old pieces that were the best of the best even when they were carved, pieces that awed with their design and symmetry and power. He was looking for the physical manifestation of what Bruno hungered for, something that was pure, untouched by the West. Seminomadic Penan who hunted in the forest with blowpipes when they felt like it and caught a Malaysian soap opera on satellite TV in the evenings in villages didn't cut it. But the world had changed, and our romantic yearning for the past couldn't stop it. The longhouses were gone and the great pieces that lay tucked away in their eaves when Michael began ranging had vanished too.

My Indonesian was okay. I could understand a lot, but not everything, especially when Michael had rapid conversations, so I was surprised when he turned to me and said, as he was chattering with a Dayak named Onah, "Okay, he has a friend who's found a cave up in northeast Borneo. That's cool, but the thing is there's usually other stuff there too, carvings and beads and who knows what." He was excited. "There's no villages up there; that whole area has been abandoned for hundreds of years. But they're now planting palm oil up there with a road going up to access it all."

We drove across the Mahakam, turned left, upriver, the minarets of Samarinda's mosque, the second largest in Southeast Asia, reaching toward heavy gray clouds scudding across the sky. We were in the suburbs, new streets with broken curbs along two-story concrete buildings, the first floor shopfronts. We pulled into a driveway of a brand-new building, its bifolding metal door pulled tight. Onah slid the creaking door back, revealing a mostly empty shop, a glass case displaying a few

boxes of cereal and telephone SIM cards across the entrance. Inside, beyond the case, lay a figure on the floor beneath a layer of blankets in the ninety-five-degree heat. A boy, young, hollow-eyed, and grimacing, skin taut against his skull, made eerier with a white powder covering his face. Onah's son, dying of cancer.

We walked next door. The room was bare white, empty save for a red Honda scooter and, along one wall, five strange little wooden figures. Creatures with spidery arms and legs and skinny bodies clutching what had once been the ends of ossuaries, their faces half man, half animal, vaguely monkey or dog. Two had bright aqua beads as eyes, two eyes of cowrie shells. Oddest of all, each wore a little hat. One was an upside-down white ceramic bowl; the others appeared to be the lids of brass jars. They were roughly carved, a bit crude, some covered with white lichen. One displayed an erect penis and testicles. They were weird, haunting, otherworldly, and they unsettled me, those eyes staring lined against the white-painted concrete wall in the empty room. I felt sad they were here, sad they'd been butchered, sawed off; I wanted to see them whole, wished I could have seen the cave itself, and my mind wandered to the people who had carved them, the magic and imaginations from which their images had been drawn and what that time and place had been like, a people who'd lived out there, up there, deep in forests full of hornbills and leopards and rhinoceros and wild boar, wholly in their universe.

Michael knelt down. Pulled out his loupe. Examined them, turned them over. "He's got real stuff, but it's not the right stuff," he said. "Too crude and rough."

Just then a young man walked in. Maybe twenty years old, tall and handsome with perfect almond eyes, his hair thick and black, his body muscled—the Dayak who had found them, or at least

who'd brought them downriver to Samarinda. Michael clapped him on the shoulder, and they talked in rapid-fire Indonesian. We climbed a set of concrete stairs to a second floor: another empty room with three ossuaries lying on the floor. Whole ones. One was small, almost white, the other a bit larger, both with the spidery monkey-man creatures on their ends. The third was much bigger, with a lovely convex lid, the whole thing painted, instead of carved, with black swirling lines, the tree-of-life motif. Again Michael knelt, examined. He liked the pale little ossuary with the creatures on the ends. "The lichen is really good on this," he said. "This is a nice piece. It's ironwood and the patina is fantastic. But it's stock. You'll hold on to it for years before finding a buyer. Who wants a coffin in their living room? I know a guy who bought one and his wife made him return it. And you're really not supposed to trade in these."

Michael bought nothing. Onah drove us back to the hotel and in the morning we flew to Pontianak on the west coast of Kalimantan. The morning mists thinned and for the last twenty minutes the new reality of Borneo lay revealed below: mile after mile of perfect squares cut out of the jungle. Palm oil plantations, massive, endless monocultures of palm trees stretching to the horizon in every direction.

The scene in Samarinda repeated itself. Men streamed into the hotel with backpacks full of questionable objects; cars picked us up and took us to shops, where Michael was hugged and fawned over. "He inspired me!" said Haji Masri, holding Michael's hand over cigarettes and coffee in Masri's tidy, sprawling shop filled with jars and beaded Dayak tunics and statues. "We were young when we met and I said if he can do it, I can do it too, and I started going into the villages."

Late that afternoon we met with Raslan, the son of a dealer Michael had known for decades, on the rooftop terrace of our

hotel. His father had just died, and Raslan was trying to further the business. As we sipped frigid Bintang beer, the day's stulti-fying heat subsiding, the Kapuas River cutting through Ponti-anak's checkerboard of rusty-red corrugated roofs below, Raslan complained about the palm oil. "Even up in Putussibau"—a town hundreds of miles inland and an area with a strong Iban presence—"it is nothing but palm oil now. A lot of money. The forest is gone. The monkeys are gone. The longhouses are gone."

We all shook our heads. Sipped our beers and stared out over the urban sprawl.

"But there is a national park near there," Raslan said, "Danau Sentarum National Park, with no palm oil and many longhouses still."

Michael and I looked up. "Old ones?" he said.

"Asli," he said. Original. Old. Big. The lake was ringed with them. Michael said he'd been to Putussibau many times, but not for years, decades maybe, and never the lake. Putussibau was also near the Sarawak border and the border city of Badau where, Michael said, many Ibans came to trade.

"Let's go," Michael said. "Hard to believe there's anything there, but worth taking a look. And from there we can cross the border into Sarawak."

We jumped on a small plane to Putussibau the next morning, arriving to a little town of concrete houses and crowing roosters and searing heat. Geographically it was out there, deep in the mythic heart of Borneo, but it felt like any small town in Indo-nesia and you could now drive there on paved roads. The bus station stood next door to the hotel; buses left daily for Badau via Lanjak, the jumping-off point for reaching the lake and its longhouses, and by 8 a.m. we were rolling toward it. I had trav-eled on some of the worst buses in the world and this wasn't

one of them. There were twenty seats, but many were empty, and Michael had bought two seats for his own comfort. Syrupy Indonesian love songs mixed with American standards—"We had joy / we had fun / we had seasons in the sun . . ."—blared over speakers, the passengers a mix of women in green and pink hijabs and others uncovered, everyone in blue jeans. A hot wind washed over us as we rolled past little shops and food stalls, past walls of palm oil plantations, and modern longhouses two stories high made from concrete, with Toyota SUVs parked out front and satellite antennas lined up like some NASA facility. After an hour, the scenery reduced to walls of green secondary forest, but the road was perfect, freshly paved, new concrete bridges rising at every river crossing. We passed another longhouse, this one wood, but modern, an old woman standing by the road topless. "I bet thirty years [ago]," Michael said, leaning across the aisle, "these were all someplace else, by rivers up in the mountains, and they moved here because of the road."

We entered small mountains and climbed in first gear. Up, up, up. We crested a hill and shimmering water spread out far below, the lake of Sentarum. Descended and pulled into a ramshackle village of buildings along the road. Lanjak. The bus drove away. We were in the middle of nowhere, the sun burning. Dust. A few dilapidated, open-fronted warungs. People stared. But it was one thing to be in a place like this when you didn't speak the language, quite another to be with Michael. Within moments he was high-fiving and fist-bumping, and a man led us across the street and up a rickety flight of stairs to a low, narrow hallway fronted with tiny doors—a hotel of sorts. It was just after noon, the heat and humidity inside unbearable. Five men in their early twenties were crashing into each other, barking and grabbing us, stumbling drunk, alcohol seeping from their pores. The rooms

were barely eight feet square, windowless and stifling, contain-
ing only wooden planks topped with thin mattresses.

"I can't stay here!" Michael said. "This is terrible! We're outta
here!"

We recrossed the road, settled onto a wooden bench in one
of the warungs as the sky opened up, rain crashing down, and
fell into conversation with a man next to us. He worked for the
World Wildlife Fund, he said. Yes, there were some longhouses
on the lake. Yes, he knew a guide, an Iban, who could take us.
He made a call—cell service worked even here—and five min-
utes later Tamin appeared. He was short, with jet black hair,
a scar running from his right eye to his lips, and black hipster
glasses. "Come," he said, and a few minutes later we were in
a quiet little guesthouse of three simple rooms overlooking a
commercial fishpond up the road. Raslan's description of ten old
longhouses on the lake was hyperbole. There were, Tamin said,
two longhouses on the lake, both Iban, but only one was old, he
said. He had a boat and he could take us. We negotiated a price,
agreed to leave the next morning.

Tamin appeared just after dawn and drove us in two shifts on
his scooter to a rutted dirt road that ended at the edge of seep-
ing black water. Sentarum is less a lake than a giant floodplain,
a netherworld of water and trees fed by the Kapuas River. It
was now so high that half of Lanjak was flooded. We waded in,
walking in knee-high water past submerged steps and flooded
front porches of wood-framed houses on stilts, boats tied to
their railings. I plodded along silently; Michael waved to every-
one, shouted good mornings, posed for photos with strangers at
every other house. As the water deepened, we came to a bright
orange fiberglass speedboat with a fifteen-horsepower Johnson
outboard. Michael took up almost the whole boat; Tamin and I
squeezed in with him and we motored slowly through flooded,

tree-lined streets. The houses ended and Tamin throttled up, and we roared over water jet black with tannin and on a wide lake, tendrils of mist snaking down low surrounding mountains.

We crossed the lake and entered a river with no banks—a world of flooded treetops and shrubs, a green landless tangle. Brown-and-white proboscis monkeys with Karl Malden–like noses and long tails brachiated and crashed through the treetops. Flocks of white egrets covered the green tangles like Christmas ornaments. Blue kingfishers swept and hovered and darted. One minute we were hammering full power and the next we were gliding slowly through dangling vines and branches brushing against us and the boat, snaking passageways in which I would have been lost in moments. Then the green would open again and we'd be flying, banking and twisting, before entering the floating jungle again. Under a lowering sky we passed floating villages of Malayu, native ethnic Muslim Malays who had for centuries been living in Kalimantan, broad-shouldered eagles perched on fish traps and the gunwales of wooden boats. A pair of hornbills beat across the water, all body and giant beaks, an auspicious sign.

After four hours we emerged from a narrow cut to a wide lake, and there, rising along one side of it, stood a two-story wood-framed longhouse painted white with blue trim. Wooden shingles covered the roof. A narrow verandah topped with rusting corrugated tin ran along the front, covering a boardwalk; beneath was a crowded array of cut wood, drying clothes, old plastic bottles, outboard motors, fishing nets, and huge orange plastic cisterns in front of every door, of which there were twelve. As longhouses went, it was small, about a hundred yards end to end. Tamin said it was seventy years old, but I thought, with its machine-cut planks, it was far newer.

One long room ran its length, with a door every twenty feet or so into the apartments of individual families. It was dim, hot, smelled of wood; hardly anyone was around, save for a few women and little children. The nearest road was four hours away by boat. No electrical lines ran here, but generators supplied power and every apartment had a television and satellite dish. The men for the most part were away working across the border in Sarawak.

The great conundrum of visiting villages and longhouses is the awkwardness. You are walking through people's front doors into their living rooms unannounced, and you are expecting . . . what? That they'll put on a dance for you? Draw you into their mystical worlds, show you their stories and secrets, open their cabinets and shake out their jars? Stop their lives for you? The dirty secret of village life is that there is nothing to do there, if you're not integrated into the community and its daily rhythms. It can feel incredibly boring; time stops, the minutes tick by and you look at each other. It takes time and patience and repeated visits to pierce the awkwardness—it's what Michael had specialized in for so many years. What lay behind the veil, behind the veneer of the eleven pots of garish plastic flowers surrounding the TV (draped in white muslin) in the living quarters of the couple who were our hosts? There were hints. Fetishes hung outside every doorway, clusters of twisted roots and honeycombs of bees and plastic water bottles holding little unrecognizable things, a tied mass of animist mysteries. Dangling from the eaves outside our host's apartment—the sixty-something man and his wife, Michael said, were shamans—was a mobile-like hanging. A wooden box painted in red and green and yellow tree-of-life swirls, a classic Dayak motif, its ends carved, from which hung eight piñata-like figures in sparkling paper and foil. Next to it dangled a string of teeth, a knotted strand of rattan. Against

two walls of their back room stood twenty ceramic jars three feet high, some with Aso dragons winding around them, some green, others brownish gold. One was unlike anything I'd seen before, a simple dark brown jar encircled by twin rows of raised dots that Michael said was old, really old. "Could be a thousand years," he said. What was inside the jars? What made the couple shamans? I had no idea and we didn't have the time or patience to find out.

We sat and drank coffee and sweated and Michael talked a mile a minute, too fast for me to understand most of it. He whipped out his iPad, showed pictures of Iban textiles—that's what the Iban were known for—but they all shook their heads. A woman sitting on the floor with a pile of freshly cut rattan was weaving floor mats—they covered much of the longhouse floor—and she pointed to them. "Want to buy one of these?"

Within an hour he'd determined there was nothing old to buy here; either they didn't have anything or whatever they did have lay tucked away and wasn't for sale.

We sweated. Drank more coffee. "I've tried to send off signals, but there's nothing here. It's sad. Before, the search for cargo kept me going. There was so much of it, and if there wasn't anything at one village, there'd be something great at another. But now there's nothing. I can't stay here another night. It's unbearable. It's too hot and it's too uncomfortable."

We bathed in the lake. We wandered the boardwalk. We met Lusan, a tiny aged man in baggy blue bikini underpants who was covered in traditional Iban tattoos. His shoulders bore seven-petaled flowers, a spiral in their center, the Bungai Terung, the flower of the eggplant. Dark black swirls covered his biceps and a four-pointed star over a crescent boatlike symbol decorated his thorax. More ink covered his back and calves. It was the very definition of tribal, marks carried by millions of young western-

ers around the world now, but these had been hand-tapped and each represented an important life event. The most interesting was the stylized frog on his throat, a mark of bravery, usually associated with head-hunting. Lusan said he was ninety. "I was born up near Malaysia," he said. "Many Japanese came to Lake Sentarum and we killed them, took their heads!"

Michael towered over him. "Which one hurt the most?" he asked.

"They all hurt," he said, "but this one"—he pointed to his throat—"this one hurt the most!" I wanted to know more, wanted to sit and talk, had so many questions. Not just to Lusan, but to everyone. But, embarrassed and shy—we'd caught him in his underpants, after all—he quickly tottered away.

In the afternoon school let out and the longhouse filled with kids. The sound of villages is always the noise of a children's playground, and they ran and leapt and dived in the lake, as Michael showed photos and tried to get kids to recite "Peter Piper picked a peck of pickled peppers." We ate dinner in the back room of our hosts—fiddleheads of fern and tiny little minnows and white rice—and for some reason I asked if they ever ate crocodiles.

"No!" Tamin jumped in. "Never. They're family. My grandfather said when we died we'd come back as a crocodile. Same with barking deer and hornbill. They're family. Our ancestors."

It was shallow, the barest hints of deeper tradition and culture, but I couldn't get there, couldn't dive in; I wanted so much more but it was like a slideshow passing before me that I couldn't slow down. Maybe this was all there was, but I didn't know, couldn't tell. We didn't have enough time, and I felt deeply frustrated.

We spent a restless night on the floor, to the barking of dogs and voices carrying through the dark and the roosters exploding

long before dawn. And soon after daybreak we climbed in the boat and sped away, empty-handed, both literally and metaphorically.

We didn't find anything in Badau, crossed the border in a taxi to the Malaysian city of Lubok Antu, found nothing of interest in a couple of shops there, and traveled up the Rajang River on a rusting *Millennium Falcon*–like high–powered riverboat with airline-style seats and a TV blaring *Superman,* past modern longhouses painted pink and purple and great rents in the green banks, where giant yellow tractors and loaders moved two-story piles of logs. We spent two nights in Kapit, which had been a few dusty blocks of unpaved streets, accessible only by river, back when Michael first traveled there, and was now a bustling city that he didn't recognize, filled with traffic.

I felt caught between my own prejudices and nostalgic desires. I wanted what had been, a world that was gone, not the landscape that was in front of me. Kapit, Lubok Antu, even Badau, weren't forgotten backwaters, inaccessible and off the map, full of "natives" in exotic clothes and partaking in mysterious ceremonies and rituals. Well, that was the point—they *were* full of natives, Iban and other tribes were the very people around us, but they wore blue jeans and drove shiny Toyotas and went to church on Sunday. Kapit and the other places we'd passed through were cities on the rise, had money coursing through them. New buildings were going up on every block. Everyone had a new car, the latest mobile phone; they weren't covered in tattoos, living in creaky old handcrafted longhouses lit by damar resin with skulls hanging from the rafters.

I thought of Mahathir's letter to Bruno, who had been smack

in the center of one of the world's most iconic and romantic islands undergoing profound change, and had fought so hard to stop it. The trip with Michael had been disheartening; we were combing through the wreckage of acculturation. Yet at least he had his memories, his adventures, his stories to tell, not to mention the carvings and textiles he had squirreled away and that lay under the beam of halogen lights that others could see in museums. I didn't really want to live in a traditional jungle longhouse for one year, much less six. I wanted to visit them. I wanted to say I'd been there, to revel in outside adulation for my adventurous spirit, but no, I didn't want to be a Dayak and I didn't want to be a Balinese and Michael didn't want to be any of those things either. He was no purist, unlike Bruno. He loved the Dayak and their traditional culture, but he also loved the game, the hustle, the search for treasure and the sheer adventure of the hunt. He lived in Bali and was in many ways a stranger everywhere, but he loved American culture; in his eighth decade there he was leaning out into the wind on the narrow gunwales of an old riverboat in a pair of brightly striped cotton hippie pants, his hair flying, his face beaming. You could never go back. Not in time, not in culture, not to your old home country where you hadn't lived for any extended time in fifty years. But you could enjoy the ride, and I had to admire Michael's stamina and his passion for life. He was still at it, hadn't given up. Was that stubbornness or blindness or was it adaptation and success, a kind of happiness?

After three and a half weeks of travel we ended up in Kuching, in a lovely little hotel overlooking the river, lined with hundred-year-old two-story shopfronts and antique shops where, of course, everyone knew Michael. Kuching was the capital of Sarawak, and a rarity in fast-growing Asia, even more so in

Borneo—a city where everything old hadn't been bulldozed, where you could still feel a sense of history. The Astana, James Brooke's original palace, lay across the river, and the Hiang Thian Siang Ti Chinese temple in blazing red, built in 1863, stood a few blocks from our hotel. Brooke had stood before it, and so had Bruno, whose last, increasingly mad attempts to save its forests had occurred on these very streets, and every dealer in Dayak tribal art frequently combed the city's shops, for they were the hub where runners emptying the longhouses of Sarawak brought their treasure. Michael grew wistful in Kuching; it had changed so little that here he could feel, see, the past more clearly, could remember himself in specific places. He showed me the convent where he and the beautiful Fatima used to stay—they had divorced years ago, she'd returned to Los Angeles, and he was discreet about what happened—back in the early days when she traveled with him. Another shop he wanted to visit wasn't open. "It's never open and he never wants to sell anything," Michael said, "but he's got really fantastic stuff." He finally made contact with the owner, who agreed to meet us.

Richard Yang and his shop were different. Rather than a mad attic, as most were, it felt more like a gallery, its walls painted yellow, the floor Mexican tile, objects laid out with aesthetic care, old framed black-and-white photos of Kuching on the walls. Yang was sixty-eight, had a shaved head and a twinkle in his eyes, and spoke softly, as Michael ranged through the shop. "I worked for a company—it was 1977—and my colleague wanted an antique, so I went with him into a tribal art shop and I fell in love. I went every day, every night to that shop, and I bought with what little money I had, for myself, just for myself," he told me. "Only what I loved. After a year I opened a small shop and still kept my job, but then after another year I quit that. Runners

from all the little villages came and brought me beautiful things and I bought what I loved and I didn't have a lot of money." He paused. Smiled. "These things . . ." he said, falling silent again, "they were made with love. With beauty. With the heart."

"Michael," he said, "you wouldn't believe it. I have many things at my home and one day thieves came and they drilled under my floor and broke into my house and stole so many things. Beautiful things. Masterpieces. Luckily I had photos and my cousin went into a shop and saw one of my pieces. I went to the police, but they were afraid and refused to do anything. So I went to some other police and I had to pay, I paid 30,000 ringgit [about $6,700 U.S.] and they took care of it. I got 90 percent of it back."

He took a photo from his desk, showed it to Michael. An Iban pig stick, or tun tun babi, with a curving pregnant woman carved into the top, its patina dark black, shiny, glowing. "This is a beautiful piece. A masterpiece. One of the ones I got back."

"Want to sell that to me?" Michael said.

"No," Richard said, smiling. "It's not for sale." He took out another photo, of an Iban ikat textile, dark-wine red, its stylized figures sharp. "Another masterpiece, made with skill and patience and love. It will last forever. My whole life. The beauty. The culture. We see it and we want it, but for the woman who made it, she had no desire, unlike us. She had no desire, do you understand?"

"That's $100,000 U.S., easy," Michael said. "You only need to find one of those in your life."

"The pity is this: the local people don't appreciate it anymore," said Richard. "It's all gone. All gone to Western culture now. Money, money, money. They don't have any money and they want it, they want to be just like Americans now. And Americans, they become rich and they want something to show

off and they buy these, but there's nothing left in the end. A Western person can't appreciate this. Not really. They have no feeling. It's priceless! It is civilization and it should be treated like a treasure, not a tablecloth hanging there on the wall."

"Richard, how much you sell me one piece? One piece!"

"I'm sorry," he said. "I have nothing to spare."

We all walked out and Richard pulled the shutter down and locked his shop that was never open and from which he refused to sell anything. "C'mon," Michael said to me, "I'm hungry and I want to show you something." We walked along the river-front, cut inland for a block, and came to a roofed central square crowded with round Formica tables, a Chinese food court lined with stall after stall of fresh seafood on beds of ice. Fish. Clams and mussels. Little periwinkles. Squid, shrimp, and crabs, the bounty glistening next to piles of fern fiddleheads and little bok choi cabbages. In every little kitchen woks sizzled atop flaming stoves. "The tables used to be beautiful, shiny, and smooth iron-wood," Michael said. We pointed out what we wanted and sat down under bright fluorescent light to wait for it.

"I walked in here one day in 1999," Michael said. "There was a guy sitting at one of the tables alone. A Western tourist. A little guy with funny glasses. I said, 'Hey! Where you from?' 'Swit-zerland,' he said. He wasn't very friendly. I think he thought I was just another tourist, which is what I thought he was." But Michael, as I had seen, spoke to everyone and anyone; he was the master of striking up conversations and he couldn't care less if people wanted to be left to their own devices—he jumped right in, always. "I told him I came to Borneo a lot, that I'd been all over, that I'd been up the Mahakam and the Kapuas and the Baram and into the Apo Kayan and when I spoke to the wait-ress he could see I spoke Malay and he brightened up, said he had been too. Said he'd spent a lot of time up in the mountains

of Sarawak. It was nothing, really. We didn't say anything pro-
found. Just shot the shit. Two travelers out there in the world."

Only later did Michael realize he'd just met Bruno. It was
the briefest of encounters, a mere coincidence. Yet it also felt,
in hindsight, inevitable to me, a crossing of paths as natural as
gravity, two almost parallel tracks that were destined to cross.

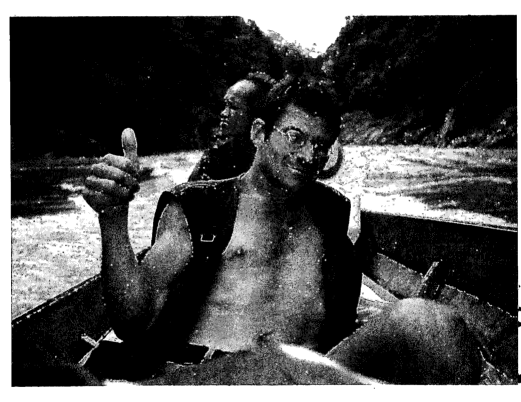

One of the last photos of Bruno Manser before he vanished. "He's communicating that
everything is okay when nothing is okay," said Georges Rüegg, one of his oldest friends."
(Bruno Manser Fund)

FIFTEEN

Jacques Christinet felt like Christopher Columbus. Even with his headlamp, he couldn't see a thing. The forest was pitch black, wet, trees and brush and fallen, rotting logs everywhere, and Christinet kept slipping and falling, thorns catching on his arms and clothes. Blood flowed down his legs from countless swelling, purple-red leeches. He already had a deep gash on his calf, which Bruno had sewn up the day before.

In the spring of 1996, Christinet was twenty-seven years old, with an angular face, intense green eyes, and the powerful, lean body of a climber. He lived in an unheated wooden shack without electricity in the mountains of Zermatt, Switzerland, after several years of wandering in South America. "I had no family, no attachments, had lots of question marks in my life, felt depressed, and I was just doing risky, dangerous things." He heard about Bruno, wrote him a letter, and a week later they walked along the Rhine in Basel together. "I was surprised by his aura. I could feel how this guy was special. When he spoke it was just so consistent and strong." They walked, gazed at the clouds and the birds overhead, and Christinet told Bruno of his adventures. "About galloping on horseback in the middle of nowhere. About free-climbing mountains without harness or ropes." At the end of the walk Christinet had found his savior.

Now, here they were, hiking into the mountains and forests with a train of Penan bearing a thousand pounds of ten-inch steel nails on their backs, each carrying two boxes of sixty pounds each. They had shipped the nails separately from Singa-

pore to Kuching, and then sneaked over the border from Brunei, rendezvousing with the nails in Limbang, where they met local contacts and drove up on logging roads into the mountains. In Brunei, before crossing over, the two had encountered a pilot in the Royal Brunei Air Force and Bruno talked his way onto a plane. "This guy thought we were two tourists and he agreed to take us up for a sightseeing flight. It was crazy. Bruno had a video camera and we're up they're flying around and the pilot said, 'Do you know a guy named Bruno?' and Bruno said, 'No, who's Bruno?' Then Bruno asked him to fly over Sarawak—he wanted to film the logging—and the pilot said, 'It's forbidden, I can't,' and Bruno said, 'Yes you can!' and the guy did it. The radio started crackling, calling the pilot back while Bruno was filming the areas that were logged and still uncut and, I don't know, but I don't think the pilot was stupid—I think he knew it was Bruno and did it for him. That was Bruno."

Now, as they hiked in the dripping night, Bruno and the Penan were laughing, telling jokes as they moved with speed and ease under the enormous loads. "I was good in the mountains, really fit, and I felt so small next to them—they and Bruno had no limits." After four hours they reached a camp and it all "just felt so real. They had monkeys and huts and fires burning and we ate a meal of black meat, and the next day we started spiking the trees."

They drove fifteen nails into each tree. It was one of the most basic antilogging techniques; the long nails were largely invisible, but destroyed a chain saw—and sometimes injured its operator—on contact. They spiked the biggest, oldest trees and the ones close to a logging roadhead that would soon push deeper. One day a Penan missed and struck his hand, cutting it to the bone. "I saw the blood squirting out—he was really injured—and he turned around and they all just laughed. He

just put some plant on it and continued to spike and Bruno said, 'They laugh to cut the pain,' and I thought, 'Where am I? What is this place?' They felt no pain, had no fears. They were aliens to me."

Bruno had now been coming in and out of Sarawak illegally for five years, in between ever more extreme direct actions in Switzerland. In 1993 he and the physician Martin Vosseler staged a sixty-day hunger strike in front of the Swiss parliament. They ate nothing and drank only water and unsweetened tea and knitted sweaters to give to every member of parliament to warm their hearts. "I got a very light and clear state of mind, a higher state of consciousness," said Vosseler. "It was beautiful, the most prime time of my life. To do something one hundred percent, and to do it together with Bruno, was so fantastic." After forty-two days Vosseler resumed eating, but after fifty-five days Bruno stopped drinking too. He'd lost thirty pounds, was barely conscious, and was dying. Vosseler tried to get him to go the hospital. "No," he said. "I can't. No, no, no."

"'Bruno,'" Vosseler said, "'you can die for the Penan, but not for your mother.' Ida was his hero. He loved her, and that was the turning point. On the sixtieth day he relented. The body is amazing; he recovered very quickly."

Bruno traveled to the Congo to meet the pygmies of the Ituri forest and to investigate Belgian logging there, but he hated Africa, its corruption, its dysfunction. He traveled to Mexico and went rafting in Chiapas, but machine gun–wielding bandits attacked the group and shot his friend. On a train in Switzerland he met and fell madly in love with Petra Bolick, but she was married and had a child with her husband. They carried on together for a while, but the love triangle was unsustainable,

and she committed to her husband and broke Bruno's heart, a wound that festered. He wrote a letter to Georges Rüegg, confessed that he was a child who didn't know how much his parents did for them, and the two made up, "found each other again," in the words of Rüegg. Roger Graf returned from South America and went to work half-time, on a salary this time, directing the now more or less functioning NGO that Bruno had created, the Bruno Manser Fund, operating out of an office in the old town of Basel. But "functioning" was a relative term—it remained a seat-of-the-pants organization whose nucleus was Bruno and his one-man charisma and uncontrollable idiosyncrasies.

He was a vortex pulling in new acolytes who would do anything, new girlfriends, people who would appear at the office full of his crazy ideas. "It was his character," said Graf. "When he came back from Borneo the first time there were three different women who believed Bruno wanted her as his girlfriend. They misunderstood him. For him, man or woman, he would give you his last T-shirt. He never said no. But when you tried to confront him and say, 'Bruno, we have to talk about the students having parties in the office,' he was a master of avoidance. He'd say, 'Tomorrow we will do it,' and then show up with wine and a huge wheel of cheese! And people would say, 'Oh, Bruno is so nice!' And nothing would get discussed.

"For a few years we were quite a good team," Graf said, "but people in power made so many promises and few were ever fulfilled. Bruno had this hope that something would change. He always believed in the goodness of humans, and he'd have a meeting with someone important and he'd come back and say, 'He was touched by our issue,' and I would say, 'But Bruno, what is he going to *do*?'"

One day Jacques Christinet had an idea. He worked for the

company that operated Zermatt's cable car, and he wondered if he might construct a kind of heavy-duty zip line to ride the cable from its peak of over twelve thousand feet. He played around, developed a system, and it worked. He sent a video to Bruno, who glommed onto the idea immediately. "Bruno was totally fascinated by the idea of hanging a huge banner from the cable," said Graf. "He said, 'Let's do an action against Japan because they're using tropical wood and a lot of Japanese tourists are in Zermatt.' But I said, 'What have tourists to do with logging in Japan? What's the point? Who will be able to react and solve the problem?'

"He said, 'Well, let's do it against the village of Zermatt because they're using tropical timber in their schools.'

"And I said, 'Did you write to the government of Zermatt and ask if they'll bar the use of tropical timber?' Of course, he hadn't, so I wrote a letter and the town government said that was a great idea and they'd put it on their agenda. Boom!"

"But Bruno said, 'Let's do it anyway!'"

Which he did; a TV channel sent a helicopter and filmed the whole action but didn't say a single word about tropical logging. "The TV only talked about these stupid Swiss guys doing this crazy thing!" Graf said. "Bruno was just becoming more and more frustrated. He was losing the battle and I had a bad feeling about his psychological strength. 'How is he going to find a way out?' I wondered. 'How is he going to get free?'"

Bruno's ideas grew grander, more fanciful and absurd, built around his belief that all people were brothers, had kind hearts that just had to be touched. Although he had corresponded with Malaysian prime minister Mahathir Mohamed, had even sat down alone with him in Rio, he had never broken through to his number one antagonist, Abdul Taib Mahmud, the chief minister of Sarawak and the country's largest timber baron. It

was Taib more than anyone else who was responsible for the destruction of the Penan's forest and it was Taib's heart he needed to touch. Which got him thinking: the chief minister's sixty-second birthday was approaching; why not give him a white lamb, symbolizing peace and friendship, as a birthday present? And even better, in 1998 Eid al-Adha, known as the Hari Raya Haji in Malaysia, the festival of sacrifice, the holiest Muslim holiday of the year, a time when sheep are sacrificed in remembrance of the willingness of Ibrahim to sacrifice his son as an act of submission to God's command, corresponded with Taib's birthday. Yes, Bruno thought, he would give a lamb to Taib. And why not deliver that lamb by parachute?

In typical fashion, he soon met an ex-member of the Swiss Special Forces, and the man who had gone to prison rather than serve in the military seduced him as surely as if he was seducing a tree-hugging college student. Free of charge, over months and hundreds of hours of expensive flight time, Ruedi Isenschmid, by then a 747 captain at Swissair, taught Bruno not just the rudiments of parachuting and free fall, but doing so with oxygen above twenty-five thousand feet and at night.

In April, Bruno filmed himself and the lamb, named Gumperli, jumping out of a plane over Switzerland, said he wanted to do the same in Kuching and present the lamb to Taib, and shipped a note and video to the chief minister in Kuching. He heard nothing back. He went anyway, but as he checked in to his flight at the Zurich airport, two security agents appeared and he and the lamb were prevented from boarding the plane. He tried again a month later. "Honored Chief Minister. Congratulation for your 62nd birthday!" he wrote on May 19 from Basel. "For your birthday-celebration in Kuching on May 21, I like to offer to your Excellency and to the public, a parachute-jump with the flags of Malaysia and of Sarawak.

"I reiterate my apology from Hari Raya Haji for my illegal stay in the state during the 1980s. Rather than staged protest, I am looking forwards for constructive dialogue with your Excellency. This can lead into concrete projects to help protect remaining virgin forests . . . and to help improve the living conditions of the Penan, if your Excellency wishes to do so." As proof of his sincerity, he offered to bring a check for $10,000 to start a mobile dental clinic for the Penan and Kelabit, and he hoped to "visit the Penan in the Ulu together with your Excellency as a friend.

"The white lamb Gumperli, symbol for peace, is in good health and remains a gift for you and your wife.

"My humble person can just offer a chance where all parties can win and smile—the decisions rest fully with you. Sincerely Yours, Bruno Manser. P.S.: My scheduled flight to Kuching is SQ 186 on May 20th, arrival-time 5:10 p.m."

It was a mind-boggling letter, utterly tone-deaf to a Southeast Asian timber baron, the most powerful man in Sarawak and one of the richest men in the world. It seemed mocking.

Taib didn't reply, so Bruno tried again, this time flying to Singapore without incident, where he telegrammed Taib again two days later. "Dear Chiefminister: Congratulations for your 62nd Birthday! Looking forwards for positive steps with each other. Please leave your instructions with the Malaysian High Commissioner here. Terima Kasih, yours, B.M." Once again, Taib didn't reply, and once again Bruno was prevented from boarding his flight.

Instead, he flew to Sumatra, where he and Christinet almost died floating down a jungle river on inner tubes—"Holy fuck," said Christinet of that trip, "Bruno was crazy and that river was like a washing machine"—and then Bruno flew on alone to Kalimantan. There he walked fourteen days across the Indonesian-

Malaysian border to find Along Sega and the Penan. Despite all
the actions, all the meetings, all the blockades, all the words, the
forest was being gobbled up as fast as ever. Penan were splitting
apart, many working for logging companies, the old ways fast
disappearing. Along Sega's own family would soon rebel, set-
tling in the village of Long Gita when the old man needed to
be hospitalized for a few weeks. Only a few hundred remained
nomads. Upon Bruno's return to Switzerland, his father died of
cancer.

The world was marching on, time passing, yet Bruno remained
quixotically obsessed with giving a lamb to Taib. Getting the
real lamb, Gumperli, into Malaysia was too difficult. But why
not a child's plush toy? He obtained a Swiss passport under the
name Markus Bähler. Cut his hair. Replaced his glasses with
contact lenses. Put on his father's old pinstriped suit. Bought a
faux leather briefcase and flew unimpeded to Kuching in May
1999. This time his plan was to fly a paraglider and land on
Taib's compound for Hari Raya Haji and present the toy lamb
to the chief minister.

As he prepared for the stunt, he went to eat at the Chinese
food stalls by the river, where he encountered Michael Pal-
mieri. He also ran into the journalist James Ritchie, who alerted
authorities that Bruno was in Kuching. With the help of sup-
porters on the edge of town, however, he assembled the para-
glider and tried to take wing. The chute filled, a crosswind hit,
and he fell over, one of the motor's propellers hitting the ground
and breaking. No matter. Bruno called a Royal Malaysian Air
Force pilot he'd once met who agreed, unwittingly, to lend him
his paraglider.

Bruno tried again. As Ritchie raced around trying to find
him, Bruno took flight, trailing a banner that read BEST WISHES,
TAIB + PENAN, EID MUBARAK, along with the flags of Malaysia

and Sarawak. He sailed over the city, flew by Kuching's mosque, headed for Taib's compound 'where nine Penan and Along Sega were waiting, hoping to meet with Taib upon landing. At the last minute he decided not to set down in the compound, but swept to the ground just outside. He'd barely unhitched his chute when police zoomed up, bundled him in a car, and drove him straight to the airport, where he was put in a first-class seat to Kuala Lumpur next to James Ritchie, who'd bought and paid for the ticket. Upon arrival in KL, he was immediately taken to prison, and two days later deported to Switzerland.

Bruno had failed, the last ten years of his life a fruitless whirl-wind of energy that had yielded nothing. Yes, the whole world knew of the Penan and their plight largely because of him. He'd met and had deep conversations with heads of state, diplomats, royalty, journalists, had been on television and in films. He had an army of supporters from Switzerland to Japan to Australia to South America who thought he was a saint, who would do any-thing he asked. He had become, along with Brazilian rubber tap-per Chico Mendes in the Amazon, one of the two most famous rain forest activists of all time. But Taib didn't even acknowledge his existence, and not one acre of traditional Penan land had been saved as a reserve. The chain saws roared as relentlessly as if he'd never uttered a word. In a way, the Malaysian govern-ment's failure to arrest him and lock him in prison had been the lowest blow of all. He had envisioned either a life-changing meeting with Taib or a brutal incarceration and trial that would martyr him, that he and his supporters could milk for publicity purposes and use to shame the government. Instead he'd just been squished like a gnat, sent packing without comment to his affluent first-world redoubt. What could he do? Where could

he go? What kind of life could he live? "Bruno and I were soul mates," said Georges Rüegg. "He couldn't hide from me, and I could see he had failed. Nothing worked out as expected. He was desperate. He was depressed. He was broken."

"Bruno was a very funny guy," said Roger Graf. "He was always laughing, but that became rarer and rarer. He always told me that his duty was to save the forest for the Penan, so they could survive. But if the forest was gone, then it wasn't his duty anymore. 'There are plenty of NGOs out there,' he said, 'but my only job is to save the forest and its culture.'"

On November, 28, 1999, Bruno sent Georges and his wife, Fabiola, a postcard. "Really soon I'm going back to Borneo for an uncertain amount of time." In two decades of friendship and especially in the last ten years of Bruno's wanderings—countless trips to the United States, Canada, Japan, Borneo, Mexico, the Congo—he'd never alerted Georges to his departures, unless it was specifically related to work they were undertaking together. Never. In two weeks, he said, he'd be in the neighborhood for a film screening. Would Georges like to get together?

Georges said no. "I knew him so well," he said, "I knew that postcard and what he wrote wasn't good. I knew him. I knew he wanted to show up at my house and have a whole night together. He was a master of involving you and I knew he had something in mind, but I didn't want any part of it."

Bruno sent similar notes that felt strange, that seemed to telegraph something, to everyone he knew. He was going to Borneo and he didn't know when he'd be back. They left all who received them or saw him unsettled. He straightened the BMF office, tied up loose ends in a way he had never done before. Went to say goodbye to Martin Vosseler, the doctor he'd fasted

with, and they walked along the Rhine and up through the nar-
row streets of old Basel, to a thousand-year-old crypt in a church
basement that had haunting, resonant acoustics where they liked
to sing together. The crypt was closed, so they sang in the hall-
way, and then he said, "Goodbye, Martin. Take care."

"If you don't come back, I'll come look for you," Vosseler
said. "I don't know why I said that to him, but I had the feeling
that that might be necessary. His saying goodbye was so differ-
ent from other goodbyes. It was so definitive. We both knew
we'd never see each other again—it just hung in the air. I felt a
deep sadness. He was so overwhelmed and so dissipated."

"We had a phone call," said Jacques Christinet. "He was
depressed. He said he'd been doing actions for ten years and
didn't know what to do anymore. He was hopeless."

The Swedish filmmakers who in the 1980s produced *Tong
Tana,* the first major documentary about Bruno and the Penan,
were making a sequel, and Bruno agreed to meet them in Kali-
mantan. For the past few years he'd been in a deepening rela-
tionship with Charlotte Belet; they'd even spoken of having a
child. She refused to drive him to the airport. "He was tired and
humanity was making him more and more pessimistic," she told
the journalist Ruedi Suter. "I took him in my arms once more
and as always had the feeling that something could happen. He
used to say: When I come back, we will do this or that. But this
time he didn't say anything."

On February, 16, 2000, he rendezvoused with Edmund Grund-
ner in Balikpapan. Grundner, from Hallein, Austria, had grad-
uated from art school and apprenticed as an antique furniture
restorer, skills that he soon turned to making fake fifteenth- and
sixteenth-century Gothic furniture for unsuspecting buyers. A
fascination with indigenous cultures and jungles led him to Bor-
neo, where he began buying and selling Dayak art (he now spe-

cializes in Chinese ceramics), and in 1989 he tried hiking into Sarawak to find the Penan, but failed. He tried again in 1990, this time flying from Miri to Bario, near Long Napir and Long Seridan, where he met a Kelabit Dayak who took him walking in the forest for three weeks. There he met groups of Penan "and all I heard was Bruno, Bruno, Bruno." When he returned to Austria, he contacted Bruno. The two became friends and Grundner turned messenger, bringing cassette tapes in and out of Sarawak during his annual winter journeys there over the next ten years. "Bruno would draw me a map and I would walk many weeks to different groups and Penan would come from all over to hear his voice." They are strange, haunting tapes: Bruno playing his flute, then talking, hourlong exhortations in fluent Penan. Twice they traveled in Kalimantan together, Grundner showing Bruno the way over the mountains from Long Bawan in Kalimantan to the Penan. Edmund had traveled deeply throughout Kalimantan in search of Dayak poison arrow quivers—he has the world's largest collection, more than three hundred line the walls of his house in Hallein—and he and Bruno agreed to scout locations together for the Swedish filmmakers.

Edmund flew in from Bali and he and Bruno traveled for a month; for the final leg they bought a boat for the downriver return. "On the last night the moon was very bright and we could see in the dark, so we decided to keep going. The boat leaked and we had to keep bailing and we were tired and then we hit rapids. Bruno was in the front and I was in the back and he had fallen asleep"—a moment of inattention so unlike the jungle savant—"and there was a very big tree and we hit it and capsized." They swam to shore, searched the banks, and finally found the boat upside down. Their bags were still strapped inside, but Bruno's drawings and his cameras were destroyed. Except for one roll of exposed film in a waterproof bag, the

photos would be the last of Bruno alive. They walked two days to a road and hitched a ride to Samarinda on March 13, where they said goodbye. Grundner was heading back to Bali; Bruno planned to meet the filmmakers and, when that was done, cross into Sarawak from Long Bawan.

A month later, Grundner received his last postcard from Bruno, who had been traveling on the east coast of Borneo, between Tarakan and Samarinda. "In this area there are no more nomads. Logging companies have been here for twenty to thirty years. All the Basap people have been settled for generations. I wanted to get two arrow quivers for your collection, but the owners didn't want to give them away, which was understandable: they are one of their most beautiful belongings, with leopard teeth, tortoise shells, and rare stones, that they use everyday for hunting. If one was mine I wouldn't have sold it for $5,000! Maybe on one of your next visits you will be luckier. I only ask what you would offer them as a gift in exchange? It would have to be useful and precious as well! Now I'm going to go over the mountain. Lots and lots of love, Bruno."

As he traveled on this last journey, Bruno sent postcards home, as he usually did, but these were unlike any he had ever sent before. They were photos of himself, many taken by Edmund on that last saved roll of film, and they showed Bruno staring into the camera or giving thumbs-up; one, to Roger, showed a Penan girl with tears streaming down her face. "Those pictures of him with his thumb up," says Georges Rüegg, "he *never ever* showed signs like that. It's theater. It's not him. He's communicating that everything is okay when nothing is okay. Nothing is okay for him. Bruno was always true. Always himself. He never used these kinds of gestures—they are a show! Nothing was okay. They say that Bruno is leaving, that he's leaving us and telling us goodbye."

"He sent me a postcard of himself," said Roger Graf. "He'd
never done that before. It was always a snail or a monkey, but
never a photo of himself!"

Months later Charlotte Belet received a postcard dated May
23, 2000, the world's last word from Bruno Manser. "Charlotte,
you little big star. As soon as I arrive in a beautiful place, tired,
I will think of you, enjoy the landscape, and with a bit of luck
hunt a small wild boar." He wrote no salutation, no hint of a
return date, and didn't even sign his name. Instead, he drew a
picture. A character sticking out its tongue and thumbing its
nose.

Bruno walked across the mountains into the Kelabit High-
lands and made it to Bario, from where he sent the postcard to
Charlotte. He told some Penan friends he wanted to climb Batu
Lawi, and they headed off together. When the great peaks rose
into sight out of the jungle, he said he wanted to push on alone,
that he would return soon.

And then Bruno Manser vanished.

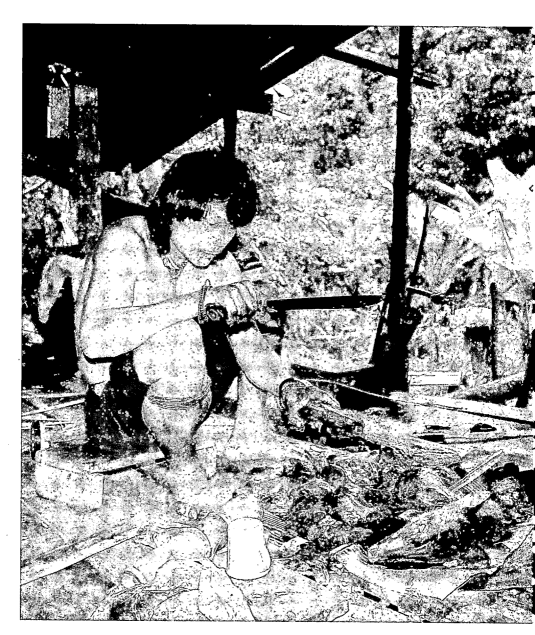

Peng Megut butchering a freshly killed deer. (Carl Hoffman)

SIXTEEN

The Limbang River flowed silvery brown and swift, a hundred yards wide, deep green forest on either side. Trees leaned over the riverbanks, which were tangled and impenetrable in some places, rocky with smooth, rounded boulders and little sandy beaches in others. The air felt thick, hot, moist, and smelled rich. Like moss, earth, water, like sticking your nose in a terrarium and inhaling. Peng Megut pulled my duffel from the narrow wooden longboat and deftly fastened it to his hand-woven back-pack with loops of rattan. His wrists were thick with black- and blue-beaded bracelets and thin strips of braided rattan and, on his left wrist, a black plastic analog Timex watch frozen at 9:10. Encircling each of his legs, just below his knees, were seven more braided loops. His hair was jet black, a tousled shoulder-length mullet. Tied around his waist by a nylon rope dangled a twenty-four-inch parang in a handmade wooden sheath banded with alternating black and brown fiber. He wore baggy black cargo shorts and a brown T-shirt with "Shit Happens" in big let-ters. The Western clothes were a costume that couldn't hide the most powerful body I'd ever seen, a body honed from a life of pure physicality. His calves were the size of his head. His thighs were as thick as an NFL running back's. His feet were shoeless freaks of nature, seven inches wide at the balls, a half-inch space between each of his toes.

Peng shouldered the pack, picked up his six-foot-long wooden blowpipe tipped with an eight-inch steel blade, and walked into the forest. I followed. I had no idea where we were going, who

I'd be with, what I'd see. All I knew was that Peng was the last of his kind. That here in the Ulu Limbang, the upper reaches of the Limbang River, supposedly lay patches of the last unlogged primary forest in Sarawak. That this had been the home of Along Sega and where Bruno had roamed. That Peng's father, Suti Megut, had been close to Bruno. And that Peng promised to deposit me in Long Seridan, about thirty miles as the crow flies, in three weeks.

The email had arrived without warning from Simon Kaelin, field director of the Bruno Manser Fund, whom I'd met in Basel before moving to Bali. "I am going to Long Gita, the exact area where Along Sega lived before with Bruno," he wrote. He was only staying two nights, but if I met him in Limbang in four days, he'd take me into the forest and introduce me to people. The BMF was now a well-run, books-balanced, nine-person NGO operating out of a stately house in Basel working on behalf of the Penan in a much quieter and more systematic way. During a visit there, Simon had said he might be able to connect me with Penan who'd known Bruno. But he was often on the move and rarely replied to my messages. I hadn't spoken to him in months. And I didn't even really know what "meeting Penan" meant. It had been sixteen years since Bruno's anguished, desperate attempts to deliver the lamb to Taib, who'd finally stepped down as Sarawak's chief minister in 2014 after thirty-three years. By all accounts the forest was gone and the Penan were settled, and my sojourn with Michael in Kalimantan and Sarawak left me feeling that only the barest hints of traditional ways of life remained. At best, I hoped, Simon might introduce me to some old Penan who remembered Bruno and

who might still occasionally go for a day of hunting. But it was worth a try.

I flew from Bali to Kuala Lumpur, and then on to the coastal city of Miri. A Starbucks greeted me in the airport, not a good sign. From there it was a thirty-minute hop to Limbang, a small, quiet city on the banks of the river of the same name. "Danger!" warned a sign on the city's docks. "Beware of crocodiles." Toyota Hilux pickup trucks with off-road tires and five-gallon tanks of gas strapped in their beds rattled through town kicking up dust. Limbang still had a frontier feeling, a place on the edge of something bigger. That night from my hotel room window I watched a huge fire glow in the hills in the distance.

Simon pulled up in a taxi the next morning with Anne Pastor, a French radio reporter. We drove to a wooden house on stilts a little outside of town, changed cars and drivers, and headed toward the city of Lawas; to get there we had to cut through Brunei. "The Penan are having a meeting near Long Adang to talk about various issues, including a new dam being proposed," he said, as Cyndi Lauper and Adele crooned from the radio. "It's their meeting—they're the ones organizing it—but I'm going to just be a presence, to show our support. Anne and I will stay one night, but you can stay as long as you want." We drove on smooth-paved two-lane roads winding through green hills; this was the same route that Bruno and Mutang and Georges and even James Ritchie had all taken many times. We cut back into Sarawak and after three hours our driver dropped us off in front of a hotel in Lawas. A few minutes later five men appeared in two jacked-up four-door black Hiluxes. Though they wore jeans and T-shirts, they were Penans. We climbed into the backseat of one of the trucks and took off, the other truck following. A single-barrel shotgun rested between the seats. In ten minutes

the pavement ended, and we began bumping over dirt logging roads, the road ever climbing, past low green hills, most covered in palm oil trees. The sky turned dark, clouds descended into the valleys, and a gray rain fell. Komeok, the driver, shifted into four-wheel drive. "What kind of shoes do you have?" said Simon.

"Just these," I said, pointing to my tennis shoes.

"Shit, you can't use those." Komeok reached an arm behind his seat, fished out a plastic bag holding a pair of cheap molded plastic soccer spikes. "I have an extra pair," he said. "Size thirty-nine." Exactly my size. "You can have them. And you need these," he said, dangling a pair of thick knee-high socks. "For the leeches."

"If you look at satellite maps of Sarawak," Simon said, "through the 1980s and '90s there's all this forest, but by 2000, when Bruno disappeared, it's gone, or mostly. Bruno and the trees vanished together. They called him Penan Man, but now they call him the man who's gone."

The road cut through thick green jungle, but it was secondary, post-logging growth, a tangled thicket so dense it was almost impossible to walk through or hunt in. A motorcycle sped by, the passenger on the back clutching a long blowpipe.

The sun fell; we were in total darkness. Toward 9 p.m., after driving for five hours, we turned off the road, bumped and slid down a steep, deeply rutted tunnel of green so narrow that trees brushed the truck, forded a river, and stopped a few hundred yards later at a wooden clapboard house the size of a one-car garage, locked tight with a padlock. Long Adang lay on the other side of the Limbang River, which was too high to drive across. "The Malaysian gas company Petronas is building a natural gas line near here," Simon said, "and is supposed to maintain the road, but clearly that's not happening. Because of all the rain

the water is too deep to drive across tonight. We'll sleep here and try tomorrow."

Komeok pried off the lock with a hammer and screwdrivers. The floor was dirt, now oozing mud. Rain poured from black skies, the air cold. The night buzzed with millions of cicadas and crickets. Fireflies flashed above the trees, everywhere, in every direction. But as soon as our hammocks were hung, Komeok tied a board across the bed of the truck behind its roll bar and fished out a six-volt battery wired to a searchlight. "We're going hunting!" he said. "Pig. Deer. Bear. Leopard. Porcupine. What-ever is out there." He and another Penan jumped in the cab, a third Penan grabbed the gun and climbed into the back of the truck, sitting on the jury-rigged bench, and off they roared into the dripping darkness. I never heard them return, but in the morning two furry bodies lay outside the hut: a civet and a bearcat.

Just after dawn we climbed in the trucks and bumped ten minutes to the Limbang River. It was one hundred feet across, a brown surging mass with swirling eddies and standing waves. "We have to cross on foot," said Simon.

I gulped. Changed into shorts, pulled my new plastic spikes on. A Penan grabbed my bag and plowed into the river fully clothed. I stepped in gingerly. Within three steps the water was up to my waist, pulling me hard. Komeok grabbed my hand and step by step we edged across, stumbling over hidden rocks, the current powerful.

In the 1990s, Penan had settled in Long Adang, a cluster of simple frame houses on stilts with corrugated roofs, at the urging of the government and the Methodist Church. Chickens pecked underfoot. Packs of dogs roamed. While Simon huddled in discussions, Komeok took us to drink sweet hot tea around a long table in a neat little house with plastic floor covering

and a simmering wood fire. A tiny, thin, bent, ageless couple entered the house. Their earlobes dangled six inches, empty of the weights that used to hang from them. The woman had long gray hair in a ponytail, her wrists thick with bracelets, a red-beaded choker around her neck. She clutched my hand, rubbed my arm, hugged me, rubbed her cheeks on my shoulder. They could barely hear and they spoke no Malay. Twenty billion dollars' worth of timber had been cut from these forests, but still no road led to the village and it had no school. I thought of Mahathir's letter to Bruno, how he'd excoriated him for denying the Penan access to development and a better life. His point might have been valid, except it hadn't happened. The logs and forest that had so long sustained the Penan were gone; the profits had been extracted, but almost none of it had gone to the community. So much money—why weren't there perfect roads, gleaming schools and health clinics, public transportation, running water in every house? Long Adang had little frame houses and a smattering of light bulbs, a church, a community water faucet drawing from the river, but nothing else to show for so much that had been taken away.

Simon returned quickly. The people had decided to move the meeting from Long Adang to the forest itself. "You'll see," he said.

Fifteen of us piled into two narrow, tippy thirty-foot long-boats and sped upriver against the current. The water flowed fast, strong. Emerald forest lined the banks. I thought of Michael Palmieri and the endless hours he'd spent in boats like this. I thought of Bruno crossing and swimming in this very river. Mist clung on mountaintops and clouds scudded overhead and for the first time I felt Borneo's wildness, the weight of its fecundity. We hit rapids, the motor revving at full power, Penans standing amidships and at the bow poling us forward, water sloshing in

over the gunwales. At a sweeping bend in the river, shallow and filled with rocks, the inside curve a field of boulders, we had to disembark and walk as the boatmen dragged the vessel through.

After an hour we came ashore on a sandy beach beneath overhanging trees. The Penans jumped out, climbed up the banks, walked into the forest, returned, and said this was the spot. We were at an unmarked riverbank in the middle of the forest. I don't know how they knew, where they'd heard, how they traveled, but more Penan soon began appearing out of nowhere. Out of the woods. Emerging, materializing as if by magic from all directions. All day in groups of two or three, wearing T-shirts and blue jeans and baseball caps and singlets and polo shirts and Chuck Taylor shoes, the whole panoply of Western casual wear. They arrived and they whipped out their parangs and went to work. A fire soon blazed on the beach, Komeok singeing the hair off the bearcat, another man chopping up the civet into little pieces. "This is Menyit Along," Komeok said, "one of Along Sega's sons," introducing me to a thin man with a salt-and-pepper mustache. "Bruno was like my brother," Menyit said. "When we see the animals, when we see the river, we always remember Bruno. We hunted. We gathered sago. But then he was gone." Perhaps it was due to language difficulties, but all my efforts to talk about Bruno were like this one—short, curt, almost rote—and I had the feeling he had been gone so long now that he'd become a myth even to those he'd once lived with.

Men and women—there was no obvious division of labor—chopped down small trees, dragged them through the forest, stripped pliable lianas, and tied them together into a thirty-foot-long, three-sided structure a foot off the ground, with overhanging eaves. They hardly spoke. They made fireplaces on beds of mud. They built another house, this one just for Anne.

They laid out food. The civet and the bearcat. Plastic bins of cooked rice. Pots of black meat in boar fat. Big slices of cucumber. And then, as evening fell and the cicadas roared and the fireflies blinked, they gathered—forty or so at this point—knee to knee in the hut, and started talking. They talked and they talked and they talked, about God, religion, cooperating with the Kelabits on opposing the government-proposed dam. Simon spoke briefly. Komeok next. The preacher led them in prayer (I heard the Malay word for God, or Lord—Tuan) and talked more. I felt overcome with sadness. Though wearing Western clothes, though all at least semi-settled and living in villages like Long Adang, they retained a powerful essence of who they had always been. Much of their culture remained intact. They could navigate with ease through the forest, build shelter in minutes, hunt, dine on game, had a deep sense of community. But where was Bruno? Why wasn't he here, enjoying them as they were? Why did it have to be all or nothing for him? And yet it also seemed clear that compromise and compensation hadn't worked, that none of the fantastic wealth accrued by Taib and so many others had flowed back into the community, back to the people whose land had been taken.

I crept off to my hammock and fell asleep to soft voices mixing with the sounds of the forest, wondering if Bruno hadn't been right. They spoke uninterrupted until dawn.

When I woke, many had already disappeared, back to wherever they'd come from. It was then that Simon took me to Peng. "He's the one you want," he said, introducing us. I'd noticed him, his crazy powerful legs and his giant bare feet and splayed toes—he was the only Penan there without shoes and the only one with a traditional mullet. Bahasa Indonesia is similar to Bahasa Melayu, which Peng spoke a bit of, so we could communicate at a basic level. But in Penan, which Simon spoke well,

Simon told him that I wanted to walk through the forest to Long
Seridan, where there was an airfield from where I could fly out
to Miri. For the Penan, it was a two- or three-day journey. For
westerners like us, he said, maybe five days. I said I needed two
people, someone to carry my bag, because I wasn't sure I could
make it on my own. Peng nodded. Counted on his fingers. He
still hadn't looked me in the eye. He spoke in the barest whisper.
"Okay," he said, "but if we don't want to walk, we won't. And
when we want to hunt, we'll hunt."

"The eighteenth," I said. "I just need to be in Long Seridan
in eighteen days." He counted on his fingers again. Nodded.
That was it. Thirty minutes later we strolled into the forest. We
followed a sandy, well-worn path enveloped by trees, roughly
parallel to the river. Peng moved smoothly, deliberately, pausing
to check on me every few minutes. The walking was easy; in
an hour we emerged into hot sunshine and the village of Long
Gita. "Village," though, seemed an overstatement for a grassy
clearing of three or four rough plank houses, a new wooden
house missing a wall atop ten-foot-high stilts holding three thin
mattresses, a simple planked church, and three traditional Penan
huts made of logs and tied together with vines, one of which
appeared to be Peng's.

Long Gita sat in a bowl surrounded by low green mountains
in profound quiet. It had no store, no electricity, no road to
access it. Peng dumped my bag in the house with the mattresses,
then led me to his. Three little huts stood in a semicircle around
a black plastic water pipe sticking out of the ground. Each had
a monkey tied to a post. We climbed a notched log. The hut
was the size of a king-size bed, covered by ragged blue plastic
tarps. His wife, Uen—the daughter, as it turned out, of none
other than Along Sega—squatted by a smoldering fire in a batik
sarong and T-shirt, long, thick black hair cascading down her

shoulders and back. A rack above the fire held black chunks of meat and neat piles of kindling. The complete, fur-covered head of a wild boar lay on the floor. Uen lifted a soot-blackened kettle off the fire and poured me a cup of sweet black instant coffee. Peng inspected the chunks of meat, carved off a few pieces into a plastic bowl, and said, "Kumon." Eat. Today was Friday. On Monday, he said, we would leave Long Gita for the forest. He looked at my naked wrists. Removed half of his bracelets and gave them to me. Uen followed; both my wrists were now covered in bracelets of blue, black, and yellow beads. "Penan!" he said, smiling.

By the afternoon Peng's two sons and his nephew appeared. They were beautiful—there's just no other word for it—about thirteen, fifteen, and seventeen years old, though they didn't know their ages. They had dimples, legs like pistons, feet nearly as splayed as their parents', and (with shoes on, anyway) you would have barely noticed them on the streets of Manhattan. They wore blue jeans, T-shirts. Ulin, the youngest, a coiled spring of laughter and energy, liked to put his hair up in a sort of samurai topknot. Udi, his older brother, had a cheap Nokia phone with wires running to a string of four D batteries taped together, from which he'd play Malaysian pop songs, and he usually sported a bandana on his head. I didn't know what to make of any of it. They'd wander off in the morning with their parangs and poison arrow quivers and blowpipes, returning in the evening with their pockets full of squirrels and beautiful little birds, all of which Peng held in his hands, examined closely, reverently, before plucking their feathers or scorching the hair off. We ate it all, along with brown, gelatinous sago that tasted like smoky liquid air. I felt anxious to start walking, wondered who the second hiking partner would be, tried to ask Peng how long he'd been

settled here in Long Gita, but I couldn't understand the answer. And fearing I was imposing on their tiny household, I spent long hours sitting by the edge of the river or reading in my house.

On Sunday evening Peng took a rectangular sort of brownie pan made of leaves off the drying rack over the fire. It held a thick, brownish-black goop. "Bahaya!" he said. Dangerous! He pricked his arm with his finger, pricked his leg, shook his head. "Bahaya!" A fresh batch of poison. He and the boys worked late into the night dipping the tips of little arrows—some with tiny metal points cut and hammered from soda cans—in the poison and carefully laid them aside to dry.

On Monday, a bright, hot, cloudless morning, I walked to Peng's for breakfast. "Kumon," he said. "Kumon! You must eat a lot, because today we are going walking in the forest." Then it all became clear. There was no second porter. The whole family was coming with us. And they were taking everything. They peeled off the roofing tarp, stuffed it in a rattan backpack. Packed up the kettle and the wok and the cheap plastic bowls and cups. Wrapped up the blackened chunks of meat and powdered sago flour and some rice. All of Peng's belongings, the sum total of his worldly goods, fit in a cheap tin trunk that he strapped to his rattan pack, on top of which he tied my bag. It was so heavy I could barely lift it—about a hundred pounds, I estimated. He shouldered it with ease. Uen's pack was nearly as heavy; she too picked hers up like it was weightless. The boys shouldered packs and each carried a blowpipe, a quiver of poison arrows, parangs hanging from their belts. They untethered the monkey. Someone from the village rowed us across the river, at the foot of a steep mountain wall of green. Five Penan, four blowpipes, three dogs, a monkey, and I climbed into the hills.

The forest enveloped us. Peng and his family, I soon came to

understand, didn't live in Long Gita. They didn't live anywhere. Or, rather, they lived everywhere, in the forest, as surely and easily, as at home there, as the birds and the boar and the hornbills, and their joy in it and with each other moved me in a way I hadn't anticipated. It felt so big, so rotting with dead leaves and broken logs and spiderwebs and termite mounds and giant ants and leeches and moths and butterflies and birds brimming with life, and Peng and his family lived in it so easily, so organically, took such joy from it.

The place we entered was, at last, virgin, primary rain forest, uncut, and it hadn't been logged because it was so steep and mostly at high elevations, an environment unchanged and more ancient than the pyramids. We climbed straight up, along a barely noticeable path. Giant trees, their bases covered in moss, arched a hundred feet overhead, their trunks ten feet across. Wet, rotting leaves and broken, decaying wood covered the forest floor. Untold numbers of ants marched in organized lines snaking across the path. Little blue butterflies flitted past. The monkey, dragging a six-foot chain, skittered about like a two-year-old super-athlete with ADD; whenever the chain caught on something he pried his own leash loose with his perfect little fingers and bounded off again. The boys and Peng cooed and twittered, calling to the birds, imitating the sound of the argus pheasant, and the birds answered back. After an hour my rubbery legs shook, and I was carrying a ten-pound knapsack. We paused and Peng took out cucumbers as fat as my arm, carved off slices, and handed them around. We walked on. They were maniacal hunters, calling to the birds, stopping silently, staring into the trees, dashing off the trail to fire arrows into the canopy, returning with little blue and yellow and green songbirds and squirrels, which they tucked in their packs. If it moved, if it had a heartbeat, Peng and his family wanted to kill it and eat it.

We walked all day, climbing up steep paths, descending, sometimes traversing precipitous trails a few inches wide, on which one slip would have sent me tumbling down hundreds of feet. The trails were slippery, muddy; I was glad to have the cleats, which the boys also wore. Giant half-inch-long thorns lunged at me, ripping into my legs and arms. Peng marched through it all barefoot, a hundred pounds on his back, his legs covered with blood from scratches and wiggling purple leeches that attacked all of us, working their way into my shoes, into my socks, latching on to my arms. We hit impenetrable forest—an area that had been cut down and had regrown into a clutching thicket difficult to move through—and soon broke out onto a logging road. The sun felt too bright. Too hot. We walked a half mile along the road and then turned into primary forest again. Peng cut six gashes in a tree at the roadside and placed a sapling into another cut, pointing into the forest. A sign. There were six of us, heading that way. Who was it for? I wondered.

In midafternoon we descended a slope and emerged at the bank of a river about ten feet wide, the color of zinc, that swirled and pooled in a natural dam of rocks. We dropped our packs and plunged in. Peng and Uen and the boys leapt and splashed and laughed, played and frolicked, the cool, fresh water washing away the blood and sweat of the jungle. The monkey watched from a rock. The dogs drank deeply. A canopy of green arched overhead, dappled with sunlight. Bathing, swimming in streams deep in the forest, was like elixir, alchemy, the best part of the day, and I took joy in their joy.

By 4 p.m., as the sun lowered, the forest became dimmer, shadowed. Near the barest trickling stream of water—it wasn't even a half inch deep—they stopped, laid their packs down, and built a house. Peng, Uen, the boys, they swung their machetes with powerful strokes and in thirty minutes flames danced inside

a replica of the house in Long Gita, the monkey climbing around the rafters, attacking the dogs, then settling down next to me, carefully combing through my hair with delicate fingers, searching for lice. They hardly spoke. I hung my hammock between two trees and Peng rigged a tarp over it, suspended from the trees by vines. Night dropped suddenly. Uen disappeared and retuned a few minutes later, her hair long and glistening wet, topless, free, not the slightest self-consciousness in my presence. I felt spent, my legs ached; I hadn't hiked like that in years. The night turned cool. A cacophony erupted, a roaring hum and buzz, and fireflies danced, and as I huddled by the fire, Udi and Dui suddenly stood up and disappeared into the blackness with their blowpipes to do what they loved more than anything else: to hunt. I have no idea how they knew where they were going, how they'd find their way home. Peng lit little chunks of demar resin, the flame cozy, the smoke sweet-smelling, and we crowded close together and ate and ate and ate; I have never seen people eat so much. Sago and rice and birds and squirrels and old blackened strips carved from the boar's head. We shared everything: the tiniest bird divided into even pieces the size of a quarter. They laughed. Carved arrows. Carved the little corks that acted as fletching.

Peng pointed to objects, said their Penan name, I repeated the word, wrote it down. Rain fell, the teenagers out there somewhere in the night free and unencumbered by rules or curfews. I shivered; the night had turned cold. Peng was shirtless; he seemed impervious to cold or tiredness. I thought of Bruno. I was deep, as he put it, in the belly of the mother. We were on a family camping trip that never ended, the adolescents never sullen, never resentful, never checking out to stare at a television or their phones. Peng and his family had no time clocks to punch, no bills to pay, nowhere to be, no obligations except to one

another, and they seemed to never tire of being in one another's company. They lived in a giant grocery store, stocked with all the food they could ever want. They farted loudly, giggled, spoke in whispers. Never argued. They had everything they needed, were fabulously wealthy. The Penan had nothing, but they had everything. They and their forest were incalculably rich. They lived in a giant bank vault stuffed with rubies and diamonds and gold. Indeed, their forest had become so rare, so valuable, that rich people who could never get enough had come and taken it away, a violent redistribution of wealth. And now Peng and his family were freaks, the last holdouts in the last patch of what had not so long ago covered the third-largest island in the world. The boys returned out of the darkness, interrupting my reverie, soaked, empty-handed, but if they were disappointed, they didn't show it. We ate again, and I lay down in my hammock, the rain pattering on the tarp overhead.

We breakfasted on squirrel and the boys went off to hunt again, this time returning with a lovely barbet, with a long black beak and emerald body and brilliant ruby forehead. Again Peng cupped it in his hands, spread its wings, as if assessing its life as a living bird, before ripping its feathers off and plopping it on the fire. We packed the house up again and set off. Climbed higher and higher, walking along ridgetops. A pair of hornbills flew by, the whooshing beat of their wings primal. High on a ridge the trees suddenly opened, undulating green hills in every direction. Peng pointed. The gash of a pipeline being constructed, running from Sabah to Miri. And to the north, a bulge with two limestone spires rising out of the green. "Batu Lawi," he said. The peak Bruno had climbed, where he'd slept and sung into the tape recording that Georges Rüegg played for me. And in the vicinity of which he had been spotted for the last time. It was close, maybe twenty miles in a straight line.

We walked on, descending again into dense forest. Maybe we were following a trail, maybe not. I couldn't tell and I could barely see the sky. I couldn't figure out which direction was north or south. Peng slashed thin saplings every few feet. Stringy shrubs with half-inch-long thorns grabbed my clothes. Leeches were everywhere. We turned around. Retraced our steps. No, we were on no trail at all. I felt anxious, was sure we were lost. I imagined being alone here. Being Bruno. It seemed impossible. Imagined stumbling and twisting my ankle. Breaking a leg. What then? The light grew dimmer. We walked and climbed and descended and slashed and Peng was doing it all with one hundred pounds on his back and bare feet. Then suddenly we were on the dimmest of trails again. It seemed a miracle. But Peng knew his way, of course; he seemingly knew every inch of this forest, had been living in it and walking through it and pursuing boar in it his whole life.

The more time I spent with him, the more he appeared like the Daniel Boone of Eagle Scouts. He could walk all day on slippery trails up and down mountains with that massive pack on his back, never get lost, then build a house and then hunt all night in the dark; he spoke in whispers, never raised his voice, shared everything he had, led his boys by example. That afternoon, I could barely take another step after seven hours of walking when we dropped our packs and, boom, they built a house and Peng swung a little rattan backpack holding his shotgun on his shirtless shoulders and walked off—barefoot, of course—into the blackest of nights. He returned a few hours later, empty-handed. "Babui." Pig. Boar. "I saw their tracks. I walked far. Far!" He wasn't upset. Didn't seem anxious. We ate what little we had, a few bits of bird, a pot of smoky, bland sago, and then he slipped into the night again, this time in a different direction, returning hours later with a civet, which Uen immedi-

ately chopped up and dumped in a pan of water. Meals in the
dark were the hardest for me. I couldn't see what I was eating.
"Kumon!" said Peng. "Kumon!" said Ulin. I had no choice;
I reached into the pan and pulled whatever it was out. Feet.
Tail. Jaw. Intestines. Food was life and nothing was wasted and
the Penan were fatless caloric powerhouses. The intense family
closeness, the overwhelming forest and its richness and decay felt
sublime; their deep connectedness to it was like nothing I'd ever
seen. But I was constantly cold and wet and hot. There wasn't
a comfort, save the warmth of the fire and each other. Cock-
roaches and ants invaded and crawled through the hut minutes
after we ate. Biting sand flies attacked me all night long as I
shivered under every piece of clothing I had. In the heat of the
afternoons, sweat bees by the thousands swarmed and buzzed
and covered my arms and legs and neck; I was stung daily. The
Penan lived like animals in the forest and that was their beauty,
but I couldn't imagine spending a year here, much less six years,
as Bruno had.

We paused for several days without moving, Peng and the
boys traveling in different directions to hunt, often before the
sun rose. We ate when they returned, ate a few hours later, and
again after dusk and again before going to sleep. We spent hours
huddled in the hut, talking, laughing, the boys and Peng whit-
tling new arrows, Uen deftly weaving a new backpack from
strips of blond and black rattan. One day, physically the hardest
day of my life, we hiked in pouring, cold rain, fording rivers and
climbing over moss-covered, rotting fallen trees, and scrambling
up hillsides so steep I could reach out and touch the ground in
front of me, and in my misery and exhaustion I felt closer to
God. Not to some all-seeing being, but to the great primordial
soup from which we sprung, to the very idea that we knew
nothing, that it was all a big mystery.

I felt overcome with admiration for the Penan and their complex forest and its raw, sublime, terrible weight, and our deep, urgent need to express it, explain it, accommodate it, grapple with how we fit into it. That was the essence of the statues and carvings and textiles that Michael had ranged far and wide to acquire and 'that wealthy westerners wanted. I thought of an incident that Biruté Galdikas had written about—of tracking and watching a particular orangutan and her son for years, only to discover that they'd simply starved to death one day. "Our original home," she wrote, "was not a garden but a wild place, where nature reigned. I was learning that nature clean and pure was also nature brutal, ruthless, and savage. . . . It was the serpent in Judeo-Christian tradition that offered Eve the apple from the tree of knowledge. That apple symbolized the beginnings of culture, hunting and gathering, the domestication of plants and animals, and ultimately modern science and technology. For the first time, I was glad that Eve had tasted the forbidden fruit. Nature had offered humans a way out, through the development of culture. As I visualized one lone nest swaying somewhere in the green canopy with Carl's bones and another with Cara's maggot-ridden remains, I wept. Nature had not offered them a way out."

The rain forest we were trekking through was brutal, as was the life the Penan lived. I was scratched all over, covered with leeches and bug bites, was soaked and tired and cold and there would be no sofa on which to lounge at the day's end. But those lovingly carved ossuaries and guardian statues and swirling, stylized tattoos represented the pure expression of human culture in this brutal, ruthless environment of such complexity that we could never hope to understand it, that gave our lives meaning and differentiated us from our primate ancestors. To be with

indigenous people like the Penan deep in the forest was to touch, feel, in a palpable way, that essential truth, moment—the weight of savage nature and the human response to it—a truth that was long buried and thus much harder to feel in affluent industrial societies. Not everybody could live in a jungle like Bruno did or travel up great rivers like Michael had, but anybody could buy a statue. And the greatest works of tribal art had the most power, articulated the tension between us and the overwhelming, mysterious world in which we lived.

That long, difficult day was a transition for me; I gave up, gave in, surrendered, stopped thinking about time and distance and where we were going or when we'd get there. We spent a few days in an open-sided frame house that lay in a little clearing with a few other houses, all abandoned or empty. I swung in my hammock. Looked at the sky. Let the bees drink my sweat. Took long baths, naked, in the river, perched on polished, rounded boulders while the water cooled and calmed. Leapt across the rocks with Ulin, who'd found and repaired a nylon cast net, as he caught little river fish a few inches long, which Uen cooked. Peng and the boys hunted, and we feasted—gorging on civet and a deer that Peng disemboweled and dismembered in a bloodbath on the floor.

One night Peng dug around in his pack, brought out a sheaf of papers in a plastic file folder, and handed me a creased letter, its edges tattered, dated 1999. I recognized the handwriting. Bruno's whimsical block letters, headlined "Message from the Penan for the CM of Sarawak. Honoured Datuk Patinggi Tan Sri Abdul Taib Mahmud: We the Penan live in big problems: Samling and LLT Co., who work on your land, command to exploit our forest in Ulu Limbang, have destroyed our clear drinking water, our food-resources and our graveyards. We ask you to

act like our father who cares for his children: please withdraw
the logging licences within all Penan homelands and protect our
virgin forest, who gives us life. Thank you. We send greetings
to you and your wife." Five thumbprints lay next to five names,
including Along Sega and Lakei Suti Megut, Peng's father. For
sixteen years he'd been carrying that letter.

Mountains surrounded the clearing we were staying in, and
as soon as we left, we headed straight up. We climbed all day,
emerging onto a deeply forested ridgetop that my GPS said lay
at thirty-five hundred feet. We were in misty clouds, the air
chilled, the ground a carpet of rotting trees and deep leaves.
The skeletal remains of three Penan huts lay in a cluster, and
as Peng investigated which one to repair for the night, a man
emerged from the trees. He too was leading a monkey and he
wore a traditional Penan loincloth, his buttocks bare, his hair in
a long mullet. He and Peng sat down opposite each other, each
clutching their monkeys. They didn't look at each other, but
spoke quietly, in a hush. After a few minutes the man walked
off, vanishing into the forest, and the family cut and hauled and
tied, rehabilitating one of the shelters. Darkness hit and thick,
cold, clammy clouds rolled in, a white mist enveloping every-
thing. The temperature dropped, and Uen built two fires and
a little dome of ferns under the house for the dogs, who curled
into tight balls around the flames.

Out there in the black forest I saw a light. Then another, and
another, bobbing and weaving in the mist. Like apparitions,
ghosts, a line of figures bearing flaming torches solidified out
of the clouds. The man in the loincloth, it turned out, had
been with a whole family and now here they were, come to
visit. Children, adults, an old woman, barefoot, in a flowered
sarong and black blouse, high cheekbones, long gray hair past

her shoulders. She radiated. Beauty. Elegance. Grace. Nobility.
She looked me in the eyes and took my hand, held it softly,
smiled, drew my hands to her face and stroked them across
her warm cheek. "Family," Peng said. They crowded into our
hut—there were fifteen of us in the tiny space—and Peng lit
more chunks of damar resin and Uen stoked the fire and boiled
water for tea and the children lay across laps and dozed and
soft voices filled the night, warm bodies pressed against me. I
heard "Tong Tana," the forest, in Penan; "babui," pig; "Lakei
Ja'au," big man—that was me, the patriarch's soft, warm hand
resting on my leg. It was beautiful and disorienting. They
were like hippies, idealized rainbow people with really good
camping skills, living up here in the forest. Though I felt far
removed from the modern world, the reality was that we were
in a tiny postage stamp of wilderness that wasn't even really
wilderness—logging roads and settled communities lay a short
walk in every direction.

"We have a house in Long Tebagan"—a recent Penan set-
tlement nearby—said the man, whose name was Agan. "But
here in the forest is home. I walked with Bruno. I hunted with
Bruno. Company tidak bagus," he kept saying. The company—
the logging company—is no good. They had solid frame houses
just down the mountain and yet here they were, living up in the
cold and rain and mist for no other reason than that's where they
liked to be.

We broke camp, walked a day, cut through the tangled hyper-
growth of secondary forest, and popped out onto the sudden
harshness of a rocky, rutted logging road. It felt strange to walk
along it, such a hot, violent contrast, a tear of rocks and bar-
ren hardness compared to the soft, cool, damp forest. "Tidak
bagus," Peng said. Not good. At a high bend over a precipice,

Peng pointed into the distance. A gash in the trees. Another. The brown of buildings. "Long Seridan," he said. We walked on, escaping into the forest toward evening, where they quickly built another hut. But our time was ending. The next day, Peng said, we would reach town. We pushed on in the morning along the logging road, and after an hour of walking the boys disappeared into the jungle and reemerged with a Yamaha scooter. They bent over it. Fiddled. Lifted the seat and took out a foot-powered air pump and pumped up the front tire. Dui mounted and Ulin hopped on back and they sped off. Ten minutes later Dui returned, without Ulin, and I climbed on board for a mile. And so it went, with backpacks and blowpipes, six of us, three dogs, and a monkey, hopscotching at death-defying speed, skidding and sliding a mile at a time until we reached the outskirts of Long Seridan. Peng and I were the first to be dropped off, and as we waited for the others, thinking to take advantage of the privacy, I paid Peng the two hundred dollars in Malaysian ringgit we'd agreed upon. The minute the rest of his family arrived, he took the money out, divided it into five portions, and gave everyone equal shares. I should have known. To share equally was the most essential Penan trait.

Everything felt wrong. The road, now paved, too hard. The lack of trees barren. We walked to the Magoh River, one hundred yards wide, the river where Bruno was fishing when Roger Graf first met him. Waded across in the current, the water to my waist. Walked into civilization. A concrete, two-story longhouse. A little concrete airport terminal. A fence and shimmering black runway. This was also where Bruno had met James Ritchie. The longhouse was empty, now all cool white tile floors and curtains and pictures of Jesus. Peng and I lay down on the floor, so clean and shiny and straight-edged. The boys disap-

peared, returned soon after with plastic bags full of Coca-Cola and candy and cookies. Peng looked so small and quiet and shy. I went out, started walking, found a guesthouse with a squeaky clean living room lined with sofas and chairs, a big TV, a table laden with food under little screen covers to keep away the flies. This was the guesthouse Bruno had once stayed in, though in those days it had been simpler and by the runway, and it was owned by Mutang's cousin.

"Bruno stayed off and on many times," Sinah Siren said. "He helped me repair the ceiling and would go into the jungle with the Penan and then come out and stay for a month here. But the police from Limbang came and arrested him and after that we couldn't have him stay with us. For a long time I took his letters and give them to people flying to Miri or Marudi, but then I couldn't anymore. We loved him."

I took a room, a room with walls and a door you could shut and a real bed and no bugs in my hair, and I booked another room for the Meguts. The guesthouse was simple, but it seemed like a temple of excess, and when I got the gang there, they stood in that shiny room armed with their spear-tipped blow-pipes and parangs and poison arrow quivers, Peng in his giant bare feet and mullet, the boys in jeans that I now saw were filthy, ragged, full of tears and holes. They were all muscle and dirt. None of them had their upper two front teeth. They looked feral. They *were* feral. Pure hunters. The wild men and women of Borneo. The real thing. The last, most valuable trea-sures of all. I had walked twenty-five miles in a straight line, perhaps many more on the ground, covered thousands of ver-tical feet, over eighteen days. As promised, Peng had brought me into and out of the forest. We'd probably exchanged no more than five hundred words in almost three weeks. I had, for

hours and hours and hours, just sat with them and walked with them and listened to them, and I felt like I knew them, at least a little. Ulin with his constant joking and laughing. Dui the consummate older cousin, stoic, quiet. Uen, who could swing a parang with power and precision, and who always made sure I had a hot cup of coffee or tea or, when we ran out of those, just hot water. We sat down under bright fluorescent lights on chairs at a plastic table, with serving trays piled high with fried fish and rice and fresh paku paku, and suddenly I wasn't the clumsy one, the klutz, anymore. Now everything was upside down and I moved with sureness, while this family who had seemed like supermen to me a few hours earlier were painfully shy, barely looked up, barely touched their food. Everything they knew, every skill they possessed, everything they stood for was useless in my world, the world that was taking over everything everywhere. The Malaysians around Long Seridan looked like overdressed, citified dandies with their bright clothes and hip haircuts and motorcycles, a world of excess and artifice. The Meguts had beds, but that night the family slept on the floor.

I n the morning we walked to the airport, me, oddly, it felt, leading the way, leading the hunters to one of my temples, through a routine at which I was an expert. The airport was one room, open-walled, but the family didn't want to go inside. I checked in and then we all sat on a bench outside, a lump in my throat. I kept saying that I was fine, that they should go, but Peng insisted on staying to the very end. A plane swooped in, roared overhead, landed, turned, and taxied over. It was time to go. I said thank you over and over in English and Malay and shook warm, dry hands that barely squeezed at all, and walked

onto the twenty-seat plane, a strange cocoon of artificial white plastic. An alien world in every way from Peng's forest hut. The door thunked shut. We taxied slowly to the end of the tarmac, swiveled, and as we hurtled down the runway I caught a glimpse of Peng and Ulin, blowpipes and monkey by their side, with their faces pressed against the chain link.

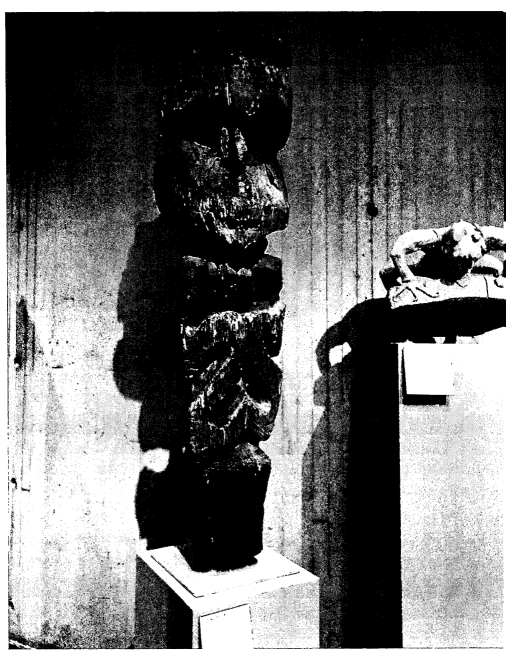

A powerful Dayak guardian spirit carved hundreds of years ago, collected by Michael Palmieri in the late 1970s, and now in the Yale Art Museum. (Max Hoffman)

SEVENTEEN

More and more, as I grew older, I felt surrounded by ghosts. Memories. Of people and places and encounters, of the love whose hand I held walking along a certain beach, or sitting with my father over a bowl of Vietnamese pho; I think it's what Michael felt walking with me through the streets of Kuching, pointing out where he'd stayed with Fatima, where he'd met Bruno. The longer you lived, the more you loved and lost, the more the world at times turned surreal, Felliniesque, history and experience coalescing into moments of circuslike magical realism: the here and now in front of you even as your memory and imagination populated the scene with crazy pastiches of all you'd taken in, read, seen, experienced. Time is linear, but your imagination and memory are not. That's how I felt walking the streets of Saint-Germain-des-Prés in Paris during Parcours des Mondes, the most important tribal art gathering in the world, after a year of living the stories of Michael and Bruno.

Everyone was here. Men in round horn-rimmed glasses and blue suede driving loafers, elegant women in tippy heels and silk scarves, sipping coffees and glasses of red wine at the packed little round tables of La Palette or Le Balto, on the corners of rue de Seine and rue Mazarine. I spotted Bruce Carpenter, fresh off the plane from Bali, in black jeans and a black sports coat. Perry Kesner, wearing a velvet corduroy sports coat and red-and-black-striped slacks, looking vaguely like an Elizabethan court jester. The American dealers Bruce Frank and Mark Johnson. The Schoffels. There was Jean Fritts, Sotheby's worldwide

director of African and Oceanic Art, and Katherine Gunsch, the Boston Museum of Fine Arts' Teel Curator of African and Oceanic Art. Rodger Dashow from Boston, one of the world's foremost collectors of Indonesian tribal art. Paris sparkled under a cloudless September sky, the air warm, the laughter and voices and tink of spoon on rim, the sound of the heights of Western wealth and culture. Next to me sat a man, tan, thin, of a certain age, across from a woman. "Yes, that is lovely," he said to his tablemate, fingering her ring. "Khmer. Original. Very lovely." He didn't know me, but I recognized him from news reports in the *Jakarta Post* and local Bali press: Roberto Gamba, an Italian arrested in 2010 in Bali for trafficking in pratima, small carved figures often adorned in gold and precious stones, that live in the heart of Balinese Hindu temples—living gods to the Balinese. The Indonesian police found him, the *Post* recounted, in possession of 110 of the effigies, with another twenty-four in a nearby warehouse. When one of their own was arrested, many of the dealers in Bali immediately jumped on planes and left the country, a man in Paris told me, fearing a crackdown that never came. But Gamba, the rich foreigner, hired the best lawyers money could buy. He served five months in prison; his seven local accomplices received sentences of between six and a half and seven years. Clearly, his conviction hadn't slowed him down.

It was the ghosts that interested me, the shadows of what wasn't here, that I couldn't shake out of my peripheral vision, my memory. The long-dead carvers and shamans from the other side of the world, from a different time altogether, who floated over every glass case or geometric white cube holding shrunken heads and Dayak hampatongs and coffin ends. The galleries— sixty of them nestled within a few blocks—were all stripped down, minimalist spaces of halogen lights and pale wood floors

and white walls, but I looked at their wares and saw once great rivers strewn with rounded boulders and dripping jungle. I saw the longhouse in Ehing, off the Mahakam River, that I'd spent the night in, in 1987, and I saw Peng Megut and his family, the final holdouts in that vanishing wildness, that disappearing wilderness, huddled in the cool mountain air carving blackened meat off a deer skull, oblivious to so much of what was valued and worshiped in Paris. I saw Michael, in cowboy boots and flowing brown mane, prowling these same streets in the 1960s, and then I ran right into him, in a more literal sense. There, in Tom Murray's gallery beneath the track lights, glowed a two-foot-high piece of an ossuary, a squatting figure with a big penis, holding his palms up in supplication. A lovely, alive piece carved long ago among great trees and humming insects. Michael had collected it years before, and I could picture him doing so, the days on the river and in the rain, and I imagined the journey it had traveled to finally reach here. It was Murray's now and he was selling it for $125,000. Against another wall stood another Dayak carving; Michael had brought that one out too, and now Murray was offering it for $60,000.

Floating over it all I saw the ghost of Bruno Manser, in and out of every gallery, and every champagne-fueled discussion of tribes and sacred worlds and "the way it used to be," and his desperate, mad attempt to save it for real, to live it; this last treasure.

Whenever Bruno traveled in Borneo, his friends and family often didn't hear from him for long periods. That was normal. So it wasn't until six months after the date of his last postcard to girflfriend Charlotte Belet that anyone realized this time was different, that something was wrong. And six months is a long time in the hot, wet, biologically teeming environment of

the rain forest. The trail was cold. Over the next several years, seven searches were carried out. The Penan tracked him. Helicopters scanned the peaks of Batu Lawi and surrounding forest. His brother Erich and a band of Penan hiked to the peaks and scoured the area around them. They found not a sign. Martin Vosseler, keeping the promise he'd made to Bruno to come look for him, spent a month in the Kelabit Highlands asking about him, searching for him. Nothing.

No trace of Bruno has ever been found. Not his big green backpack, not a single piece of cloth; something should have been visible if he'd fallen or injured himself while climbing the peak. His most romantic followers like to imagine him out there still, a man who went rogue, became his soul mates, became a Penan, living nestled in some Edenic virgin patch of forest. But that's the biggest fantasy of all, for the untouched forests of Borneo are gone. There is nowhere there left to hide. Erich, his family, his followers, cling to the idea that he was captured and murdered by agents, official or unofficial, of the Malaysian government. Which is certainly plausible.

But those who worked with him the longest, who loved him yet also resisted his charms, people like Georges Rüegg and Roger Graf, believe he chose to die. Not by hanging himself or shooting himself or slitting his wrists, but by recklessness, provocation. That he wandered far off by himself, intending this journey to be his last. I thought of Michael Palmieri's words, of getting stuck, and who was more stuck than Bruno? The Penan had believed in him and he had let them down. And he had believed in the Penan and they had let him down every time they settled or put on a T-shirt or went to work for a logging company. He couldn't bear to live in a quiet Swiss village, work in some office. He had left his own culture, but nothing lay on the other side. The wilderness was gone. The forest was gone.

The nomads of the rain forest were nomads no more. That he loved and was loved matters little. He could be reckless. Selfish. Self-absorbed. Single-minded and pure, uncompromising.

"I'm convinced that he killed himself," said Roger Graf. "It's from my gut and it's not out of character for him. I saw him interviewed in the Swedish film shortly before he vanished and I was shocked by how aggressively he answered the questions. I didn't recognize him."

"He said he wanted to go to Batu Lawi," said Georges Rüegg, "but when he was there before, when he was living in Sarawak, he still got lost in the jungle for three weeks, and if that happened when he was used to living there, well, he was fit but he was ten years older. I hitchhiked all over North and South America, and when I was in a good mood, it was great, but if I wasn't, no one picked me up. Things didn't go my way. Why is that? It's all about your mental condition. If you're not in good mental shape, you'll have difficulties, and he was not in a good condition to move in Sarawak. You can see it in his body, his face. He traveled a lot, in and out, in and out, but you cannot always expect it to be the same. My feeling when he left was that he was no more himself, no longer in harmony with himself.

"I was a herdsman for so many years and it was beautiful, but then I couldn't do that anymore because my knees were bad. The end was sad, yes, but only the end—the whole thing wasn't. How can you say that life is sad just because one piece of it ends? For me, it's really important—if you lose your beliefs, then it's a really sad moment. Then you're really a poor person. I had the feeling that by the end Bruno had no more beliefs. The art of life is to grow old, but not to lose your beliefs as you do. Or if you lose them, to find new ways to be glad to be alive. That's the art of life. But Bruno lost all his beliefs and he crashed. He couldn't evolve, and that's the tragedy."

I could picture him out there in the end. Alone, walking with clarity and resolve, maybe even a kind of happiness, throwing himself into rivers, climbing too high into trees, reveling in the freedom of his own ultimate escape, the purity and finality of death. Maybe he sat down to die in a beautiful, hidden place. Maybe he encountered some loggers and confronted them, forced his own fate. Maybe he grabbed another pit viper and was bitten again. For the uncompromising ascetic it was the ultimate trip.

Georges's words about growing old and not losing faith came to me while gazing at the statues in Tom Murray's gallery, imagining Bruno alone up there in those mountains and how he'd reached so deeply for the greatest of Western fantasies, how he'd gotten it, achieved it, held it in his hand, far more than any of us in that gallery or in any of the gallieries at Parcours des Mondes. I thought of all those people with their yoga mats and asana in Bali and I thought of Michael Palmieri and how the best pieces of tribal art exuded the most power to their buyers and observers, even here in Paris, so far removed from the place and the time and people who had created it.

Standing there looking at Michael's former carving glowing under a halogen beam, Murray said, "This was carved when there was no question about whether God exists. We have the benefit of Descartes and scientific reasoning and we can fly through the air and we have the Hubble Telescope, but the power of the sun, the moon, the tree of life, storms, lightning, the bamboo that sprouts eighteen inches in one night, well, we still have a yearning for that time of seamless belief. Missionaries went to all these places trying to save souls, but the irony is that it is the art of these tribal people that saves our souls now."

A few weeks later I traveled to the Yale University Art Gallery in New Haven, Connecticut. Even as Thomas Jaffe, the nephew of publishing magnate Walter Annenberg, engaged in a vicious family feud and battle in court over a tribal art collection worth more than $25 million, he gave to his alma mater what many considered the finest collection in the world of Indonesian and Southeast Asian carvings, gold, and textiles. The donation in 2009 endowed the Thomas Jaffe Curator of Indo-Pacific Art and a whole new gallery. This was the end of the line, the final resting place, where the last treasures of the Dayaks and others ended up on their epic journey from longhouse and rain forest to the pinnacle of Western culture, absent any trace of Michael or Perry, the former hippies, and all they represented, who'd brought it out.

The space and presentation were lovely: deep blue walls, light wood floors, glass cases atop white squares, and cubes under rays of soft lighting. There, against one wall, stood a striking wooden figure, six feet tall, expressive, enigmatic, brooding. Powerful. "Ancestor Figure," its tag read. "Borneo, 18th Century or earlier." I recognized it immediately from photos—a young, mustachioed Michael Palmieri standing next to it among a crowd of Dayaks—and its story stretched back decades, centuries. The sacred rituals surrounding its carving, the years it stood guarding a village on the upper reaches of the Mahakam River, its purchase by one of the great treasure hunters of our time, now standing here, sanctified by the imprimatur of the Ivy League and all it represented. So many collectors and dealers and museum curators wrung their hands over the ethics of field collecting, but they had no problem with buying objects once that initial transaction was completed. Michael's statue was now in the hands of scholars, lending glory to the hallowed halls of Yale. "The heydays are over," said Ruth Barnes, an Oxford PhD

who'd been brought in from the Ashmolean Museum in Oxford to be the Thomas Jaffe Indo-Pacific Curator. "The good stuff isn't around anymore. But I come up with a justification for what I do, what I love, which is that we make the material accessible to scholars who want to study it, and for the public to enjoy it."

It was beautiful and it moved me, but more so because I knew its story, its journey, its connection to that surfer kid who'd struck out for Mexico so long ago when he and the world were so different. It gave me a sense of wonder and a lump in my throat. Then, as if the gods themselves were looking down from Bali, a message popped up on my phone. It was Michael Palmieri. He'd flown home to Los Angeles to spend two months with his ninetysomething-year-old mother, but had blasted back to Bali after just six weeks. He couldn't live in America, couldn't really stand it anymore. He'd grown older, had successfully navigated a lifetime, but he hadn't lost his faith, his dream. "Good to be home in my little grass shack in Bali!" he wrote. I could picture him there—the geckos barking and the statues and shield and gongs surrounding him, his front door wide open to the humid evening.

ACKNOWLEDGMENTS

Key to this book are Bruno Manser's journals, and I'm forever indebted to Ruth Boggs, who translated almost three hundred thousand words of them, and charged me a fraction of her usual rate.

Lukas Straumann and Erwin Zbinden at the Bruno Manser Fund in Basel gave me unfettered access to its archives containing hundreds of pages of Bruno's correspondence, important contact information for friends and relatives of Bruno, an early version of the English translation of Bruno's biography, and photos, not to mention crucial insight. I'm especially appreciative of the BMF's Simon Kaelin for setting me up with Peng Megut in Sarawak.

Thanks to Sophie Biglar for coming to Bali and translating the bulk of Bruno's letters, and for her hospitality in Switzerland, and to Nicole Ganzert for finishing the last translations in Bali.

I'm heavily indebted to Ruedi Suter and his biography, especially for the segments on Bruno's early life. Suter's intimate knowledge of and years spent covering Bruno make him the go-to source, and I'm grateful not only for his book, but also for his generosity in sharing so many thoughts and stories.

In Switzerland, a small army of people generously shared their memories of Bruno. I'm particularly thankful to Erich and Aga Manser and Monika Niederberger, who spent hours with me, took me into the Alps where Bruno herded sheep, fed and sheltered me, and shared their family stories, not to mention Georges and Fabiola Rüegg, Roger Graf, Martin Vosseler, and

Jacques Christinet for sharing their memories. And a big thank-you to Mutang Urud, who generously met me in Montreal to tell me his story.

Needless to say, this book could never have been written without Michael Palmieri, who unfurled his tales over many days and nights, agreed to take me with him to Borneo, and helped me in countless small ways to navigate the twists and turns of Bali. I will be forever grateful to him.

A special thanks to Jane Cornelius Platford for friendship in Bali and introductions to so many people who had important roles in this story; had we not met this book wouldn't exist.

Thank you to Janet Deneefe, whose invitation to the wonderful Ubud Writers and Readers Festival in 2014 led me to this story in the first place.

In the tribal art world, so many people were generous with their time and insight, including Perry Kesner, Thomas Murray, Bruce Carpenter, Alexander Goetz, Mark Johnson, Rodger Dashow, Katherine Gunsche, Victoria Reed, and Ruth Barnes.

Many thanks to Chuah Guat Eng, who helped guide me in researching Malaysian newspapers, not to mention always giving sage advice about Malaysian politics.

Thank you to Tess Davis for taking the time to explain to me the nuances of cultural patrimony laws.

My time in Bali was made richer by Lixie Michaelis, Lawrence Blair, Mary Lou Pavlovic, and Deborah Vanderhoek. A big thanks to Julie Barber, who rented me her house. And thank you to Cheria Sailendra for her friendship and patient teaching of Bahasa Indonesia.

I am deeply indebted to my agent, Joe Regal, who doesn't just ably look after business things, but whose careful and patient editing made this book, and all of my books, so much better. I owe my book-writing career to him. And thank you to every-

one at Regal Hoffmann Literary who help in big ways and small, including Markus Hoffmann, Claire Anderson-Wheeler, Barbara Marshall, and Tiffany Regal.

I'm so thankful for the unrelenting support and enthusiasm from Lynn Grady and Peter Hubbard at my publisher, William Morrow, who have now sent me out into the farthest corners of the world twice; it is the greatest privilege a writer can have. And Peter's insights and edits made the book much stronger. Sharyn Rosenblum is the best publicist anywhere and I've never felt in such good hands; she is an alchemist. Many thanks to Emily Homonoff.

I'm particularly thankful to Jean Hoffman, Clif Wiens, Iwonka Swenson, Edwina Johnson, Scott Wallace, and Kim Smolik for reading and commenting on early drafts of the manuscript, not to mention friendship and support.

Last, but in no way least, I'm deeply grateful to my children, Lily, Max, and Charlotte, for their love, patience, and support, not to mention enriching my days in Bali.

NOTES

Prologue

1 *Michael Palmieri heard a crash*: I lived a few blocks away from Michael Palmieri in Bali, Indonesia, between October 24, 2015, and May 12, 2016, and spent many hours with him talking and taking notes. Unless otherwise noted, all quotes or information attributed to Palmieri came from our discussions. Where possible, I tried to verify the information, often through photographs.

2 *He'd even appeared in* Playboy *magazine*: Ibid. Palmieri showed me a photograph of the tear sheet.

4 *The bells tinkled sweetly*: I first met Alexander Goetz and Perry Kesner at a dinner on October 7, 2014, during a visit to Bali for the Ubud Writers and Readers Festival.

4 *In 2016, for instance*: Tom Mashberg, "Prominent Antiquities Dealer Accused of Selling Stolen Artifacts," *New York Times*, December 21, 2016.

5 *"Defendant used a laundering process"*: Ibid.

6 Outside *magazine named him its Outsider of the Year*: William W. Bevis, *Borneo Log: The Struggle for Sarawak's Forests* (Seattle: University of Washington Press, 1995), 154.

6 *"What had happened?"*: "Vanished!," *Time* (Asia), vol. 158, no. 10 (September 3, 2001).

8 *recent carbon-14 tests*: Thomas Murray, *C-14 Dating of Dayak Art* (private catalog, 2015).

One

17 *He carried a backpack stuffed*: Bruno Manser, *Tagebücher aus dem Regenwald 1984–1990* (Basel: Christoph Merian Verlag, 2004), 73. Bruno's journals are in German and were translated for me by Ruth Boggs, a professional translator from Fairfax, Virginia.

18 *Southeast Asia's forests are the oldest on earth*: Wade Davis, Ian Mackenzie, and Shane Kennedy, *Nomads of the Dawn: The Penan of the Borneo Rain Forest* (San Francisco: Pomegranate Artbooks, 1995), 30.

18 *"The tropical rain forests"*: Biruté M. F. Galdikas, *Reflections of Eden: My Years with the Orangutans of Borneo* (Boston: Little, Brown, 1995), 91.

18 *"The term 'cathedral forest'"*: Ibid, 81.

19 *He had left Switzerland six months earlier*: Manser, *Tagebücher aus dem Regenwald*, 23.

19 *On the train*: Ibid, 26.

19 *He wandered off the road*: Ibid., 26.

19 *He explored Thai caves*: Ibid., 28.

19 *In one he spotted a strange-looking*: Ibid., 27.

19 *had been haunted by dreams of them*: "Robin Hood Is Still Fighting," *L'Illustré,* April 18, 1990.

19 *"It was nice meeting you"*: Manser, *Tagebücher aus dem Regenwald,* 28.

19 *Hearing there were wild elephants*: Ibid., 56.

19 *Arriving with just six pounds*: Ibid., 30.

19 *"I threw the root far"*: Ibid., 35.

19 *Another plant made him so sick*: Ibid., 37.

20 *He was bitten in the hand*: Ibid., 36–37.

20 *"Indeed," writes the anthropologist Bernard Sellato*: Bernard Sellato, *Nomads of the Borneo Rainforest: The Economics, Politics, and Ideology of Settling Down,* trans. Stephanie Morgan (Honolulu: University of Hawaii Press), 15.

20 *which Bruno saw in a library in Basel*: Wade Davis, "The Apostle of Borneo," *Outside,* January 1991.

20 *about seven thousand lived in two distinct populations*: J. Peter Brosius, "Endangered Forest, Endangered People: Environmentalist Representations of Indigenous Knowledge," *Human Ecology* 25, no. 1 (1997): 49.

20 *The majority had become semi-settled*: Ibid.

21 *He'd grown up working class*: Author's interview with Monika Niederberger, Aesch, Switzerland, August 5, 2015.

21 *His father, though, had a hard edge*: Author's interview with Roger Graf, Zurich, Switzerland, September 17, 2016.

21 *He touched everything*: Author's interview with Monika Niederberger.

22 *Under his leadership*: Ruedi Suter, *Rainforest Hero: The Life and Death of Bruno Manser* (Basel: Bergli Books, 2016), 32.

22 *One day when Monika went to take a bath*: Author's interview with Monika Niederberger.

22 *He often escaped out to the little balcony*: Suter, *Rainforest Hero,* 33.

22 *He created a nest*: Ibid.

22 *He disemboweled an old sleeping bag*: Ibid., 30.

22 *He started carving*: Ibid.

22 *"My profession"*: Ibid., 33.

23 *In the seventh grade his class went to the Alps*: Ibid., 34–35.

23 *The boom of 1945 to 1973*: Nicholas Crafts and Gianni Toniolo, "'Les Trente Glorieuses': From the Marshall Plan to the Oil Crisis," Oxford Handbooks Online, http://www.oxfordhandbooks.com/view/10.1093/oxfordhb/9780199560981.001.0001/oxfordhb-9780199560981-e-18, accessed April 17, 2017.

23 *"It was a wild time"*: Author's interview with Erich and Aga Manser, Masein, Switzerland, August 5–7, 2015. I spent three days with Erich and Aga, staying at their home, hiking with them to the hut where Bruno lived in the Alps, and visiting the village of Nufenen, where Bruno lived off and on for several winters. Unless otherwise noted, all quotes and information attributed to them came from our daily discussions during this time.

24 *As Bruno neared graduation*: Suter, *Rainforest Hero,* 40.

24 *"Each of us wants to be ourself"*: Ibid., 35.

24 *"It is the task of every individual"*: Ibid.
25 *"He could be so funny and childlike"*: Author's interview with Edmund Grund-
 ner. I spent parts of two days with Grundner at his house in Halien, Austria,
 August 8–9, 2015, and we met three more times in Bali in February 2016.
25 *Judge Lieutenant Riklin watched*: Suter, *Rainforest Hero*, 46.
25 *"At the moment he has not succeeded"*: Ibid.
26 *"the energy I have to expend is very high"*: Manser, *Tagebücher aus dem Regenwald*,
 73. Unless otherwise noted, all the descriptions and quotes related to Bruno's
 search for the Penan in this chapter are from chapter 3 of his journals.

Two

32 *It was a half mile wide, chocolate brown*: I have filled in some details of Palmieri's
 descriptions of the Mahakam River between Samarinda and Melak from my
 own experiences on that same stretch of river in a similar vessel in 1987.
34 *Gardner McKay, the show's hero*: Episodes of *Adventures in Paradise* are widely
 available on YouTube.
35 *Those last summers in California*: My understanding of the cultural and politi-
 cal backdrop of what Michael Palmieri and Bruno Manser were going through
 as teenagers was deepened by Todd Gitlin, *The Sixties: Years of Hope and Rage*
 (New York: Bantam, 1987).

Three

43 *Bruno woke, heard those quiet voices*: Bruno Manser, *Tagebücher aus dem Regen-
 wald 1984–1990* (Basel: Christoph Merian Verlag, 2004), 73. Unless otherwise
 noted, all the descriptions and quotes related to Bruno's search for the Penan
 in this chapter are from chapter 3 of his journals.
45 *When Bruno emerged from jail*: Ruedi Suter, *Rainforest Hero: The Life and Death of
 Bruno Manser* (Basel: Bergli Books, 2016), 49.
45 *"The hippies all had this idea"*: Author's interview with Erich and Aga Manser,
 Masein, Switzerland, August 5–7, 2015. Unless otherwise noted, all quotes and
 information attributed to them in this chapter came from our daily discussions
 during this time.
48 *"We sat and talked and talked"*: Author's interview with Georges Rüegg, Gun-
 zwil, Switzerland, September 12, 2016. Unless otherwise noted, all quotes and
 information attributed to Rüegg came from this interview.
48 *Bruno learned to read the weather*: Ibid.
48 *He carved a face*: Author's first-person observation in the Alps with Erich and
 Aga Manser, August 6, 2015.
48 *His mother and sister visited*: Author's interview with Monika Niederberger,
 Aesch, Switzerland, August 5, 2015.
49 *"Lately I've realized how far removed"*: Suter, *Rainforest Hero*, 57.
51 *In late 1983*: Wade Davis, "The Apostle of Borneo," *Outside,* January 1991.
51 *The Mulu caves had first been discovered*: "The Mulu Caves Project," http://www
 .mulucaves.org/wordpress/history-of-exploration, accessed April 14, 2017.
51 *In 1978 Britain's most famous speleologist*: Author's telephone interview with

Andy Eavis, September 16, 2015. Unless otherwise noted, all quotes about Bruno's sojourn with the expedition and Eavis came from this interview.

Four

55 *It was late June 1967*: Many of the descriptions in this chapter are validated and heightened by Palmieri's photographs.

63 *The Marxist People's Democratic Party of Afghanistan*: "Afghanistan Profile—Timeline," BBC News, http://www.bbc.com/news/world-south-asia-12024253, accessed April 14, 2017.

68 *It was Charles Sobhraj*: The story of Sobhraj has been widely told in articles, a film, and a book, including Andrew Anthony, "On the Trail of the Serpent . . . The Fatal Charm of Charles Sobhraj," *GQ*, April 11, 2014, http://www.gq-magazine.co.uk/article/charles-sobhraj-serial-killer-interview, accessed April 14, 2017.

Five

73 *The day after Bruno made contact*: Bruno Manser, *Tagebücher aus dem Regenwald 1984–1990* (Basel: Christoph Merian Verlag, 2004). Unless otherwise noted, all the descriptions and quotes related to Bruno's search for the Penan in this chapter are from chapter 3 of his journals.

73 *Two hard swings of the machete*: Author's observation during his eighteen-day walk through the forest with Peng Megut, December 2015.

78 *"In my search to understand the deep essence"*: Wade Davis, "The Apostle of Borneo," *Outside*, January 1991.

79 *"The most outlying lands"*: "Arimaspoi," Theoi Greek Mythology, http://www.theoi.com/Phylos/Arimaspoi.html, accessed April 17, 2017.

79 *"Man is born free"*: Rousseau, quoted in Jamie James, *The Glamour of Strangeness: Artists and the Last Age of the Exotic* (New York: Farrar, Straus, and Giroux, 2016), 26.

79 *"I want to go to Tahiti"*: Paul Gauguin, quoted in ibid.

79 *"I believe that the art"*: Ibid.

79 *"For my temperaments"*: James Brooke, quoted in Nigel Barley, *White Rajah: A Biography of Sir James Brooke* (London: Abacus, 2003), 31.

80 *Even better if you could go so deep*: Victor Segalen, *Essay on Exoticism*, trans. Yael Rachel Schlick (Durham, NC: Duke University Press, 2002), 34.

80 *The British government*: Barley, *White Rajah*, 105.

81 *It was one thing, after all, to take home natives*: Kenn Harper, *Give Me My Father's Body: The Life of Minik the New York Eskimo* (South Royalton, VT: Steerforth Press, 2000), 21.

81 *The Native Americans Christopher Columbus*: Kirkpatrick Sale, *The Conquest of Paradise: Christopher Columbus and the Columbian Legacy* (New York: Alfred A. Knopf, 1990), 100.

81 *"the Brazilian cannibals"*: James, *The Glamour of Strangeness*, 36.

81 *"all the pictures"*: Michel de Montaigne, quoted in ibid.

81 *"the very words that signify lying"*: Ibid.

81 *"Shakespeare lifted passages"*: James, *The Glamour of Strangeness*, 36.

81 *"It is noteworthy"*: Barley, *White Rajah*, 45.

81 *Either one was myth, oversimplification*: Andrea Lee, "Notes on the Exotic," *New Yorker*, November 3, 2014.

82 *In the early days of her research in Borneo*: Biruté M. F. Galdikas, *Reflections of Eden: My Years with the Orangutans of Borneo* (Boston: Little, Brown, 1995), 252.

82 *Yet he also said that in being among the Penan*: Manser, *Tagebücher aus dem Regenwald*, 226.

Six

85 *"their craters studded with serene lakes"*: Miguel Covarrubias, *Island of Bali* (New York: Alfred A. Knopf, 1937), 4.

86 *The American writer Hickman Powell*: Powell, quoted in Adrian Vickers, *Bali: A Paradise Created* (Berkeley, CA: Periplus Editions, 1989), 2.

86 *The island "dripped and shone"*: Colin McPhee, quoted in ibid., 1.

86 *"No other race gives the impression"*: Covarrubias, *Island of Bali*, 11.

86 *"The slender Balinese bodies are"*: Ibid.

87 *"For the Balinese, everything that is high"*: Ibid., 10.

87 *Two Australians had just opened*: Author's interview with Michael Palmieri. For more information and a good history of the surfing scene and development of Kuta, Legian, and the beaches of southern Bali, including the Blue Ocean, see Phil Jarratt, *Bali: Heaven and Hell* (Melbourne: Hardie Grant Books, 2014).

89 *Right there in the palms*: Norman Lewis, *An Empire of the East* (New York: Henry Holt, 1993), 92.

89 *the highest concentration of killings*: Howard Palfrey Jones, *Indonesia: The Possible Dream* (New York: Harcourt Brace Jovanovich, 1971), 386.

90 *The Dong Son of Vietnam*: Reimar Schefold and Steven G. Alpert, eds., *Eyes of the Ancestors: The Arts of Island Southeast Asia at the Dallas Museum of Art* (New Haven, CT: Yale University Press, 2013), 20–21.

90 *The Portuguese, the first westerners*: Barley, *White Rajah: A Biography of Sir James Brooke* (London: Abacus, 2003), 34.

90 *In 1841 the rich British adventurer*: Ibid., 57.

90 *In Dayak consciousness*: There are many good sources on Dayak religion and culture. Unless otherwise noted, the sections in this chapter come from: Sian Jay, *Art of the Ancestors: Nias, Batak, Dayak: From the Private Collections of Mark A. Gordon and Pierre Mondolini* (London: Alliance Française de Singapour, 2007); Christina F. Kreps, *Liberating Culture: Cross-cultural Perspectives on Museums, Curation and Heritage Preservation* (London: Routledge, 2003), 32–42; Jean Paul Barbier and Douglas Newton, eds., *Islands and Ancestors: Indigenous Styles of Southeast Asia* (New York: Metropolitan Museum of Art, 1988); Henri Chambert-Loir and Anthony Reid, eds., *The Potent Dead: Ancestors, Saints and Heroes in Contemporary Indonesia* (Honolulu: Allen and Unwin and University of Hawaii Press, 2002); and Schefold and Alpert, *Eyes of the Ancestors*.

91 *Integral to this idea was*: Biruté M. F. Galdikas, *Reflections of Eden: My Years with the Orangutans of Borneo* (Boston: Little, Brown, 1995), 231.

91 *"as antimatter is to physicists"*: Ibid.

93 *Especially valued were brass gongs*: Kreps, *Liberating Culture,* 36.

94 *Carl Bock, whose 1882 account*: Carl Bock, *The Head-Hunters of Borneo: A Narrative of Travel Up the Mahakkam and Down the Barito* (Singapore: Oxford University Press, 1995 [1881]), 198.

94 *Others said that the jars themselves were fruits*: Kreps, *Liberating Culture,* 36.

94 *By the time of Michael's forays*: Richard Lloyd Parry, *In the Time of Madness: Indonesia on the Edge of Chaos* (New York: Grove Press, 2005), 17–84.

95 *Flying into Pangkalan Bun*: As he traveled over the years, Michael Palmieri kept sporadic journals; in addition to the author's interviews with him, much of the information in this chapter is based on those journals.

Seven

105 *For centuries, what is now Peninsular Malaysia*: Lukas Straumann, *Money Logging: On the Trail of the Asian Timber Mafia* (Basel: Bergli Books, 2014), 75–103.

105 *The Brookes' reign in Sarawak*: Barley, *White Rajah: A Biography of Sir James Brooke* (London: Abacus, 2003), 46–94.

106 *The Penan, who for generations*: Peter G. Sercombe and Bernard Sellato, eds., *Beyond the Green Myth: Hunter-Gatherers of Borneo in the Twenty-First Century* (Copenhagen: NIAS Press, 2007), 303–11.

106 *And as huge rubber plantations were created*: Straumann, *Money Logging,* 69.

106 *At the turn of the nineteenth century*: Ibid.

106 *James Brooke's nephew turned Sarawak over*: Ibid., 75.

106 *And in 1963 Britain finally ceded*: Ibid., 82–83.

106 *Here Malaysian and Sarawak politics become complex*: Ibid., 87–97.

107 *In 1966 the Malaysian government*: Ibid.

107 *Logging in Sarawak exploded*: Ibid., 109–11.

107 *In his first six years in office*: Ibid.

107 *In 1987 the* Wall Street Journal *reported*: James P. Sterba, "Malaysian Tribe Fights to Preserve Forests, Win Native Rights," *Wall Street Journal,* July 22, 1987.

108 *Six tropical timber conglomerates*: Straumann, *Money Logging,* 111.

108 *In 1965 loggers cut down*: Ibid., 110.

108 *To keep it sustainable*: Ibid.

108 *But by 1981 the number had climbed*: Ibid.

108 *Annually, that is*: Ibid.

108 *Not long after Bruno's arrival*: Author's interview with Mutang Urud, Montreal, Canada, September 28, 2017. Unless otherwise noted, all quotes and information attributed to Mutang came from this interview.

109 *In a letter to his brother*: Bruno Manser to Peter Manser, March 9, 1985. Unless otherwise noted, all letters between Bruno and others quoted here came from the archives of the Bruno Manser Fund, Basel, Switzerland, accessed September 3–5, 2015, and translated from German and Swiss German by Sophie Biglar and Nicole Ganzert.

110 *"I had just completed my second-to-last year"*: Harrison Ngau quoted in Straumann, *Money Logging,* 112.

110 *"As the meeting was taking place"*: Straumann, *Money Logging,* 112.

111 *After "a friendly talk"*: Sterba, "Malaysian Tribe Fights to Preserve Forests."

111 *In October 1984, a twenty-five-year-old*: Author's interview with Roger Graf, Zurich, Switzerland, September 17, 2016. Unless otherwise noted, all quotes and information attributed to Graf came from this interview.

115 *"Now we're walking"*: Bruno Manser, *Tagebücher aus dem Regenwald 1984–1990* (Basel: Christoph Merian Verlag, 2004), 149.

116 *"Any appeals by the Penan"*: Ibid., 166.

117 *"Big Man, that's how he greeted me"*: Ibid., 306.

117 *"A child wants to come into the world"*: Ibid., 160.

119 *"Huddled closely together"*: Ibid, 275.

Eight

121 *Kim Kardashian's ninety-eight million*: Kim Kardashian West's Instagram account, accessed April 17, 2017.

121 *Malaysia's politically powerful and majority Muslims*: Comments in newspapers and books by Malaysians are filled with condescending statements, no more so than in James Ritchie's book *Bruno Manser: The Inside Story* (Singapore: Summer Times Publishing, 1994)—the Penan are "untidy and skimpily dressed" (109); "the deplorable conditions of this poverty stricken group" (30); "the hopeless, illiterate native children" (142)—and in Prime Minister Mahathir's own statements: "the Penan live on maggots and monkeys in their miserable huts." Mahathir Mohamed to Bruno Manser, March 3, 1992.

121 *To Malaysians they were the lowest of the low*: Mahathir Mohamed to Bruno Manser, March 3, 1992.

122 *In early August 1985, James Ritchie*: Ritchie, *Bruno Manser*, 1.

122 *"WHAT. . . . You must be joking"*: Ibid.

122 *"He is stirring a hornets nest"*: Ibid, 2.

123 *Malaysian newspapers are government-controlled*: Derek Jones, ed., *Censorship: A World Encyclopedia* (Abingdon, UK: Routledge, 2001), 1702.

124 *A police inspector named Lores Matios*: Bruno Manser, *Tagebücher aus dem Regenwald 1984–1990* (Basel: Christoph Merian Verlag, 2004), 409–13. This story is related over those five pages. James Ritchie also provides a secondhand account of Bruno's escape from Matios in *Bruno Manser*.

127 *Rolf Bokemeier, the editor from GEO*: "Ihr habt die Welt-laßt uns den Wald!," *GEO*, October 1986.

127 *Those images were powerful*: Andrew Revkin, *Burning Season: The Murder of Chico Mendes and the Fight for the Amazon Rain Forest* (Boston: Houghton Mifflin, 1990).

129 *He had, finally, gone to see James Wong*: Ritchie, *Bruno Manser*, p. 2.

130 *"'If he is here, please tell me'"*: Ibid., 25.

130 *They still wouldn't tell Ritchie*: Ibid., 27.

130 *As Ritchie left the camp*: Ibid., 30–31.

131 *On September 15, 1986*: Ibid., 34.

131 *The only reason to meet, he said*: Ibid., 40.

131 *Ritchie refused to go*: Ibid., 41.

131 *Two weeks later, however, Ritchie's first story*: Ibid., 50.

131 *Word of the piece*: Ibid., 51–55.

132 *As the two continued to correspond*: Ibid., 238.

132 *"The petition," wrote Ritchie*: Ibid., 60.

132 *Five days later Ritchie went to see Abdul Taib Mahmud*: Ibid., 61.

132 *"A reporter of the largest Malaysian daily"*: Manser, *Tagebücher aus dem Regenwald*, 225.

132 *In mid-November, Ritchie and a crew*: Ritchie, *Bruno Manser*, 63.

134 *At the meeting the next day in the forest*: Ibid., 91.

134 *"On the next day I even dare"*: Manser, *Tagebücher aus dem Regenwald*, 225.

135 *"Before they arrive, they shoot"*: Ibid.

135 *"Oh, Lakei Ja'au!"*: Ibid. All of the descriptions of this escape are from this same section of Bruno's journals.

137 *The next morning*: Ibid., 226.

Nine

143 *These "cult objects and other savage utensils"*: Robert Goldwater, *Primitivism in Modern Art* (Cambridge: Belknap Press of Harvard University Press, 1986), 5.

143 *Back then public museums and art galleries didn't exist*: Michael M. Ames, *Cannibal Tours and Glass Boxes: The Anthropology of Museums* (Vancouver: UBC Press, 1992), 16.

143 *Or even, in many cases*: Kenn Harper, *Give Me My Father's Body: The Life of Minik the New York Eskimo* (South Royalton, VT: Steerforth Press, 2000), 21.

144 *In 1753 the physician Sir Hans Sloane*: Ames, *Cannibal Tours and Glass Boxes*, 18.

144 *Many of the original ethnographic objects*: Ibid., 17.

144 *The cabinet of curiosities*: Ibid.

144 *Exotic flora and fauna*: Ibid., 51.

144 *"the touchstone of artistic value"*: Goldwater, *Primitivism in Modern Art*, 17.

145 *At the Chicago Columbian Exposition in 1893*: Ames, *Cannibal Tours and Glass Boxes*, 51.

145 *"All alone in that awful museum"*: Widely quoted and originating in André Malroux, *La tête d'obsidienne* (Paris: Gallimard, 1974), 17–19.

146 *In March 1935 the Museum of Modern Art*: MoMA press release, March 9, 1935, https://moma.org/d/c/press_releases/W1siZiIsIjMyNTAzNCJdXQ.pdf ?sha=640f4315112d8f36, accessed April 17, 2017.

146 *"My interest in primitive art"*: Kathleen Bickford Berzock and Christa Clarke, eds., *Representing Africa in American Art Museums* (Seattle: University of Washington Press, 2011), 125.

147 *In Europe, with its long history*: "The Story Behind a Collection," Musée Barbier-Mueller, http://www.barbier-mueller.ch/vie-du-musee/presentation/historique /?lang=en, accessed April 17, 2017.

148 *"There became an underlying embrace"*: Author's interview with Jean Fritts, Paris, France, September 9, 2016.

148 *Bruno and Michael weren't outliers*: Author's interview with Lawrence Blair, Legian, Bali, Indonesia, January 7, 2016.

148 *"Bruno wasn't unique in what he wanted"*: Author's interview with Bruce Carpenter, Sanur, Bali, January 29, 2016.

148 *"My generation came of age"*: Multiple author interviews with Thomas Murray in Paris in 2015 and 2016; Washington, D.C., in 2015; and Bali in 2016. Unless otherwise noted, all quotes and information attributed to Murray came from those interviews.

150 *He found Perry Kesner*: Author's interviews with Perry Kesner on many occasions in Paris in 2015 and 2016 and in Bali in 2015 and 2016. Unless otherwise noted, all quotes and information attributed to Kesner came from those interviews.

157 *"Shortly before ten in the morning"*: Carl Bock, *The Head-Hunters of Borneo: A Narrative of Travel Up the Mahakkam and Down the Barito* (Singapore: Oxford University Press, 1995 [1881]), 57, 65.

157 *"In the evenings there were always some amusements"*: Ibid., 77.

157 *Bock's curiosity had been "keenly excited"*: Ibid., 78.

158 *"Here, surrounded by the graves"*: Ibid., 78–79.

158 *Bock drew an intricately detailed color sketch*: Ibid., plate 8.

160 *"Indonesia's finest traditional sculptors"*: Reimar Schefold and Steven G. Alpert, eds., *Eyes of the Ancestors: The Arts of Island Southeast Asia at the Dallas Museum of Art* (New Haven, CT: Yale University Press, 2013), 134–35.

Ten

165 *"On secret paths"*: Bruno Manser, *Tagebücher aus dem Regenwald 1984–1990* (Basel: Christoph Merian Verlag, 2004), 327.

165 *In January, not long after Bruno's second escape*: James Ritchie, *Bruno Manser: The Inside Story* (Singapore: Summer Times Publishing, 1994), 238.

165 *"The communities that signed"*: Ibid.

166 *In a coordinated action*: Manser, *Tagebücher aus dem Regenwald*, 326.

167 *On paper, at least*: Tim Bending, *Penan Histories: Contentious Narratives in Upriver Sarawak* (Leiden: KITLV Press, 2006), 4.

167 *"Police squads appear repeatedly"*: Manser, *Tagebücher aus dem Regenwald*, 326.

168 *"I was part of that"*: Author's interview with Mutang Urud, Montreal, Canada, September 28, 2017.

170 *"In a way," said Lukas Straumann*: Author's interview with Lukas Straumann, Basel, Switzerland, August 3, 2015.

171 *There is increasing belief*: Scott Wallace, *The Unconquered: In Search of the Amazon's Last Uncontacted Tribes* (New York: Crown, 2011), 398.

172 *Since at least the first European explorers*: Peter G. Sercombe and Bernard Sellato, eds., *Beyond the Green Myth: Hunter-Gatherers of Borneo in the Twenty-First Century* (Copenhagen: NIAS Press, 2007), 303–11.

172 *They supplied forest products*: Ibid.

172 *In exchange they received*: Ibid.

172 *Amid the warring Dayak tribes*: Ibid.

172 *"Longhouse aristocrats"*: Ibid.

172 *"The relationship between longhouse people"*: Ibid.

172 *The Brooke regime*: Ibid.

173 *The Brooke government also forbade*: Ibid.

175 *"I give my friend the name Spring"*: Manser, *Tagebücher aus dem Regenwald*, 325.

176 *The first blockades broke out*: Wade Davis, Ian Mackenzie, and Shane Kennedy, *Nomads of the Dawn: The Penan of the Borneo Rain Forest* (San Francisco: Pomegranate Artbooks, 1995), 132.

176 *"The bulldozers are quiet now"*: Manser, *Tagebücher aus dem Regenwald*, 314.

177 *"Furiously, some of the mad women"*: Ibid., 330.

178 *"He wears John Lennon spectacles"*: James P. Sterba, "Malaysian Tribe Fights to Preserve Forests, Win Native Rights," *Wall Street Journal*, July 22, 1987.

178 *"The Wild Man of Borneo Leads in Blowpipe War"*: Andrew Drummond, "The Wild Man of Borneo Leads in Blowpipe War," *Observer*, April 1987.

178 *James Ritchie helicoptered in*: Ritchie, *Bruno Manser*, 109.

180 *"I've built a hideaway"*: Manser, *Tagebücher aus dem Regenwald*, 320.

181 *In June, after Sahabat Alam Malaysia brought*: Ritchie, *Bruno Manser*, 110–11.

182 *Penans "say yes to logging"*: Quoted in Ruedi Suter, *Rainforest Hero: The Life and Death of Bruno Manser* (Basel: Bergli Books, 2016), 107.

182 *Finally, in October*: Bending, *Penan Histories*, 99.

182 *A few weeks later the Sarawak State Legislative Assembly*: Ibid.

182 *"The Europeans should blame the Penans"*: Mahathir Mohamed quoted in Philip Hirsch and Carol Warren, eds., *The Politics of Environment in Southeast Asia: Resources and Resistance* (London: Routledge, 1998), 96.

183 *In July the European Parliament*: Lawrence S. Hamilton, "Tropical Forests: Identifying and Clarifying Issues," Food and Agriculture Organization of the United Nations, http://www.fao.org/3/a-u3500e/u3500e05.htm, accessed April 17, 2017.

183 *In November eleven Penan and Kelabit*: Bending, *Penan Histories*, 100–101.

183 *In January even more blockades sprang up*: Ibid.

183 *Harrison Ngau was arrested*: Lukas Straumann, *Money Logging: On the Trail of the Asian timber Mafia* (Basel: Bergli Books, 2014), 115.

183 *And, it was said, the government had placed*: Ibid., 118.

184 *"In the company of two families"*: Manser, *Tagebücher aus dem Regenwald*, 445.

184 *In late summer 1989 he hiked*: Author's interview with Georges Rüegg, which included listening to the tape Bruno sent, with Rüegg translating.

186 *As he slashed through the undergrowth*: Ibid., 657.

Eleven

189 *Pit vipers are not the world's deadliest snakes*: Jim McGuire in email to author, November 15, 2016; also "Haemotoxic Venom," Snake Bite Assist, http://snakebiteassist.co.za/venoms/haemotoxic-venom/, accessed April 4, 2017.

189 *"In the field"*: "Snakebites," *MSD Manual*, http://www.msdmanuals.com/professional/injuries-poisoning/bites-and-stings/snakebites, accessed April 4, 2017.

190 *While he was trying to massage his leg*: Manser, *Tagebücher aus dem Regenwald*, 657–58.

191 *"I can only dream"*: Ibid.

192 *Meanwhile, new blockades*: Straumann, *Money Logging*, 126.

193 *Georges's wife, Fabiola*: Author's interview with Georges Rüegg.

Twelve

203 *In 2001 the total value of tribal art*: "The Rise of the Tribal Art Market," Art Media Agency, https://en.artmediaagency.com/116776/the-rise-of-the-tribal-art-market/, accessed April 18, 2017.

203 *One statue alone*: Ibid.

203 *Indonesian tribal art*: "The Collection of Allan Stone: African, Oceanic, and Indonesian Art—Volume One Totals $11.5 Million," http://files.shareholder.com/downloads/BID/4317127130x0x709921/357E446C-2D0E-4CA5-9EB3-00B4EAABDD14/709921.pdf, accessed April 17, 2017.

204 *At Parcours des Mondes in Paris*: Mark Johnson, "Tale of a Sculpture in Paris," *Science & Tribal Art,* http://scienceandtribalart.com/discovery/tale-of-a-sculpture, accessed April 17, 2017. Also see "Report from Paris," *The Tribal Beat,* October 16, 2013, http://thetribalbeat.blogspot.fr/2013/10/report-from-paris.html, accessed April 17, 2017.

212 *Goetz exuded a sharpness*: Author's multiple interviews with Alexander Goetz in Bali, Indonesia, in 2015 and 2016.

213 *Over decades beginning in the 1950s*: Eric Pace, "Samuel Eilenberg, 84, Dies; Mathematician at Columbia," *New York Times,* February 3, 1998, http://www.nytimes.com/1998/02/03/nyregion/samuel-eilenberg-84-dies-mathematician-at-columbia.html, accessed April 18, 2017.

214 *In 1972, 186 nations signed*: Although information about the UNESCO Convention and cultural property laws is widely available, my understanding of them was strengthened by interviews with Tess Davis, director of the Antiquities Coalition and an attorney specializing in cultural property; and Victoria Reed, Monica S. Sadler Curator for Provenance at the Museum of Fine Arts, Boston. Unless otherwise noted, all information comes from those conversations.

214 *Attorneys have successfully argued*: Ibid.

215 *All of which means*: Tom Mashbert and Max Bearak, "The Ultimate Temple Raider?: Inside an Antiquities-Smuggling Operation," *New York Times,* July 23, 2015.

215 *Likewise the government of Cambodia*: Author's interview with Tess Davis.

215 *In Jakarta one day*: Author's interview with the curator of the ethnology collection at the National Museum of Indonesia, Jakarta, March 14, 2016.

Thirteen

220 *"He was so small"*: Author's interview with Martin Vosseler, Basel, Switzerland, September 16, 2016. Unless otherwise noted, all quotes and information concerning Vosseler and his activities with Bruno came from this interview.

221 *"He was like Jesus Christ"*: Author's interview with Jacques Christinet, Basel, Switzerland, September 13, 2016. Unless otherwise noted, all quotes and information concerning Christenet and his activities with Bruno came from this interview.

222 *In the United States, he and Mutang*: S.Res.280—A resolution to express the sense of the Senate concerning the tropical rain forests of Malaysia, https://www.congress.gov/bill/102nd-congress/senate-resolution/280, accessed April 4, 2017.

222 *In Canada*: Ruedi Suter, *Rainforest Hero: The Life and Death of Bruno Manser* (Basel: Bergli Books, 2016), 143.
222 *In France*: Ibid.
222 *In London*: Ibid.
222 *In Germany*: Ibid.
222 *In Japan*: Ibid.
223 *The Eastern Penan had vague notions*: J. Peter Brosius, "Endangered Forest, Endangered People: Environmentalist Representations of Indigenous Knowledge," *Human Ecology* 25, no. 1 (1997): 56–59.
224 *As Western writers*: Ibid., 62.
224 *The anthropologist Peter Brosius*: Ibid., 59.
224 *"I realize Bruno that you are besieged"*: Wade Davis to Bruno Manser, undated, archives of the Bruno Manser Fund, Basel, Switzerland, accessed September 3–5, 2015.
225 *On June 20, 1991, Bruno received*: Executed contract, archives of the Bruno Manser Fund, Basel, Switzerland, accessed September 3–5, 2015. Unless otherwise noted, all information concerning Bruno's Warner Bros. film options came from these archives.
225 *At the G7 Summit*: Stephen Kinzer, "Swiss Protester Fighting for World's Forests," *New York Times*, July 28, 1991.
227 *Pressure on Malaysia was mounting*: Mohamed Mahathir to Bruno Manser, March 3, 1992, archives of the Bruno Manser Fund, accessed September 3–5, 2015.
232 *The journalist Ruedi Suter*: Author's interview with Ruedi Suter, Basel, Switzerland, September 14, 2016. Unless otherwise noted, quotes from Suter come from this interview.

Fifteen
265 *"I had no family"*: Author's interview with Jacques Christinet, Basel, Switzerland, September 13, 2016.
267 *"I got a very light and clear state of mind"*: Author's interview with Martin Vosseler, Basel, Switzerland, September 16, 2016.
267 *Bruno traveled to the Congo*: Ruedi Suter, *Rainforest Hero: The Life and Death of Bruno Manser* (Basel: Bergli Books, 2016), 221–233.
267 *He traveled to Mexico*: Ibid., 217.
267 *On a train in Switzerland*: Ibid., 155.
268 *"It was his character"*: Author's interview with Roger Graf, Zurich, Switzerland, September 17, 2016.
270 *In typical fashion*: Author's interview with Rudi Suter, Basel, Switzerland, September 14, 2016. Unless otherwise noted, quotes from Suter come from this interview.
270 *In April, Bruno filmed himself*: Suter, *Rainforest Hero*, 269–270.
270 *He went anyway*: Ibid., 273.
272 *He obtained a Swiss passport*: James Ritchie's Facebook page, accessed April 18, 2017.
272 *He also ran into the journalist*: Ibid.

272 *As Ritchie raced around trying to find him:* Ibid.
273 *Upon arrival in KL:* Ibid.
275 *The Swedish filmmakers:* Author's interview with Edmund Grundner. I spent parts of two days with Grundner at his house in Halien, Austria, on August 8–9, 2015, and we met three more times in Bali in February 2016. Unless otherwise noted, all of the quotes and information, including letters, about Grundner and Manser in this chapter came from those interviews.
275 *"He was tired":* Suter, *Rainforest Hero,* 292–93.
278 *Months later Charlotte Belet:* Author's interview with Georges Rüegg, who had a copy of the letter.

Sixteen
298 *"Our original home":* Biruté M. F. Galdikas, *Reflections of Eden: My Years with the Orangutans of Borneo* (Boston: Little, Brown, 1995), 252.

Seventeen
308 *He didn't know me:* Ni Komang Erviani, "Sacred Art Thefts Anger Balinese Hindus," *Jakarta Post,* July 6, 2013, http://www.thejakartapost.com/news/2013/09/06/sacred-art-thefts-anger-balinese-hindus.html, accessed on April 18, 2017; and "International Cooperation Requested to End Theft," *Jakarta Post,* October 4, 2010, http://www.thejakartapost.com/amp/news/2010/10/04/international-cooperation-requested-end-theft.html, accessed April 17, 2017.
313 *After a vicious family feud:* Kate Taylor, "A Collection of Tribal Art Is Embroiled in a Modern Family Feud," *New York Times,* October 5, 2008.
313 *The donation in 2009 endowed:* "Yale Indo-Pacific Art," Council on Southeast Asia Studies, http://cseas.yale.edu/links/yale-indo-pacific-art, accessed April 17, 2017.
313 *"The heydays are over":* Author's interview with Ruth Barnes, New Haven, Connecticut, November 4, 2016.

SELECT BIBLIOGRAPHY

Ames, Michael M. *Cannibal Tours and Glass Boxes:The Anthropology of Museums.*
 Vancouver: UBC Press, 1992.

Barbier, Jean Paul, and Douglas Newton. *Islands and Ancestors: Indigenous Styles
 of Southeast Asia.* New York: Metropolitan Museum of Art, 1988.

Barclay, James. *A Stroll Through Borneo.* Wellington: January Books, 1988.

Barley, Nigel. *White Rajah:A Biography of Sir James Brooke.* London: Abacus,
 2003.

Bending, Tim. *Penan Histories: Contentious Narratives in Upriver Sarawak.*
 Leiden: KITLV Press, 2006.

Bevis, William W. *Borneo Log:The Struggle for Sarawak's Forests.* Seattle:
 University of Washington Press, 1995.

Blair, Lawrence. *Ring of Fire:An Indonesian Odyssey.* Singapore: Editions Didier
 Millet, 2011.

Bock, Carl. *The Head-Hunters of Borneo:A Narrative of Travel Up the Mahakkam
 and Down the Barito.* Singapore: Oxford University Press, 1995. Reprint;
 originally published 1881.

Campbell, Joseph. *The Hero with a Thousand Faces.* Novato, CA: New World
 Library, 2008.

————. *The Power of Myth.* New York: Anchor, 1991.

Carpenter, Bruce. *Indonesian Tribal Art:The Rodger Dashow Collection.*
 Singapore: Editions Didier Millet, 2015.

Chambert-Loir, Henri, and Anthony Reid, eds. *The Potent Dead:Ancestors,
 Saints and Heroes in Contemporary Indonesia.* Honolulu: Allen and Unwin
 and University of Hawaii Press, 2002.

Covarrubias, Miguel. *Island of Bali.* New York: Alfred A. Knopf, 1937.

Davis, Wade, Ian Mackenzie, and Shane Kennedy. *Nomads of the Dawn:The
 Penan of the Borneo Rain Forest.* San Francisco: Pomegranate Artbooks,
 1995.

Feldman, Jerome. *Arc of the Ancestors: Indonesian Art from the Jerome L. Joss
 Collection at UCLA.* Los Angeles: Fowler Museum of Cultural History,
 1994.

Fischer, Joseph, ed. *Threads of Tradition:Textiles of Indonesia and Sarawak.*
 Berkeley: Lowie Museum of Anthropology, University Art Museum,
 University of California, 1979.

Galdikas, Biruté M. F. *Reflections of Eden: My Years with the Orangutans of Borneo*. Boston: Little, Brown, 1995.

Goldwater, Robert. *Primitivism in Modern Art*. Cambridge: Belknap Press of Harvard University Press, 1986.

Hansen, Eric. *Stranger in the Forest: On Foot Across Borneo*. Boston: Houghton Mifflin, 1988.

Harper, Kenn. *Give Me My Father's Body: The Life of Minik the New York Eskimo*. South Royalton, VT: Steerforth Press, 2000.

Harrisson, Tom. *World Within: A Borneo Story*. London: Cresset Press, 1959.

Hersey, Irwin. *Indonesian Primitive Art*. Singapore: Oxford University Press, 1991.

Hose, Charles. *The Pagan Tribes of Borneo*. E-book, Nisyros Publishers, 2015. Reprint; originally published 1912.

James, Jamie. *The Glamour of Strangeness: Artists and the Last Age of the Exotic*. New York: Farrar, Straus and Giroux, 2016.

Jay, Sian. *Art of the Ancestors: Nias, Batak, Dayak*. From the Private Collections of Mark A. Gordon and Pierre Mondolini. London: Alliance Française de Singapour, 2007.

Jarratt, Phil. *Bali: Heaven and Hell*. Melbourne: Hardie Grant Books, 2014.

Jensen, Erik. *Where Hornbills Fly: A Journey with the Headhunters of Borneo*. London: I. B. Tauris, 2013.

Jones, Howard Palfrey. *Indonesia: The Possible Dream*. New York: Harcourt Brace Jovanovich, 1971.

Kila, Joris D., and Marc Balcells. *Cultural Property Crime: An Overview and Analysis of Contemporary Perspectives and Trends*. Leiden: Brill, 2015.

Klokke, A. H., ed. *Traditional Medicine Among the Ngaju Dayak in Central Kalimantan: The Writings of a Former Ngaju Dayak Priest*. Phillips, ME: Borneo Research Council, Inc., 1998.

Kreps, Christina F. *Liberating Culture: Cross-cultural Perspectives on Museums, Curation and Heritage Preservation*. London: Routledge, 2003.

Lewis, Norman. *An Empire of the East*. New York: Henry Holt, 1993.

Manser, Bruno. *Tagebücher aus dem Regenwald 1984–1990*. Basel: Christoph Merian Verlag, 2004.

O'Hanlon, Redmond. *Into the Heart of Borneo*. New York: Random House, 1984.

Parry, Richard Lloyd. *In the Time of Madness: Indonesia on the Edge of Chaos*. New York: Grove Press, 2005.

Puri, Rajindra K. *Deadly Dances in the Bornean Rainforest: Hunting Knowledge of the Penan Benalui*. Leiden: KITLV Press, 2005.

Revkin, Andrew. *Burning Season: The Murder of Chico Mendes and the Fight for the Amazon Rain Forest.* Boston: Houghton Mifflin, 1990.

Ritchie, James. *Bruno Manser: The Inside Story.* Singapore: Summer Times Publishing, 1994.

Sale, Kirkpatrick. *The Conquest of Paradise: Christopher Columbus and the Columbian Legacy.* New York: Alfred A. Knopf, 1990.

Segalen, Victor. *Essay on Exoticism.* Translated by Yael Rachel Schlick. Durham, NC: Duke University Press, 2002.

Schefold, Reimar, and Steven G. Alpert, eds. *Eyes of the Ancestors: The Arts of Island Southeast Asia at the Dallas Museum of Art.* New Haven, CT: Yale University Press, 2013.

Sellato, Bernard. *Nomads of the Borneo Rainforest: The Economics, Politics, and Ideology of Settling Down.* Translated by Stephanie Morgan. Honolulu: University of Hawaii Press.

Sercombe, Peter, and Bernard Sellato, eds. *Beyond the Green Myth: Borneo's Hunter-Gatherers in the Twenty-First Century.* Copenhagen: NIAS Press, 2007.

Straumann, Lukas. *Money Logging: On the Trail of the Asian Timber Mafia.* Basel: Bergli Books, 2014.

Stohr, W. *Art of the Archaic Indonesians.* Dallas: Dallas Museum of Fine Arts, 1982.

Suter, Ruedi. *Rainforest Hero: The Life and Death of Bruno Manser.* Basel: Bergli Books, 2016.

Taylor, Paul Michael, and Lorraine V. Aragon. *Beyond the Java Sea: Art of Indonesia's Outer Islands.* Washington, DC: National Museum of Natural History, 1991.

Vickers, Adrian. *Bali: A Paradise Created.* Berkeley, CA: Periplus Editions, 1989.

Wallace, Alfred Russel. *The Malay Archipelago.* Singapore: Periplus, 2008. Reprint; originally published 1869.

Wallace, Scott. *The Unconquered: In Search of the Amazon's Last Uncontacted Tribes.* New York: Crown, 2011.

INDEX

Note: Page references in *italics* indicate photographs.